POP

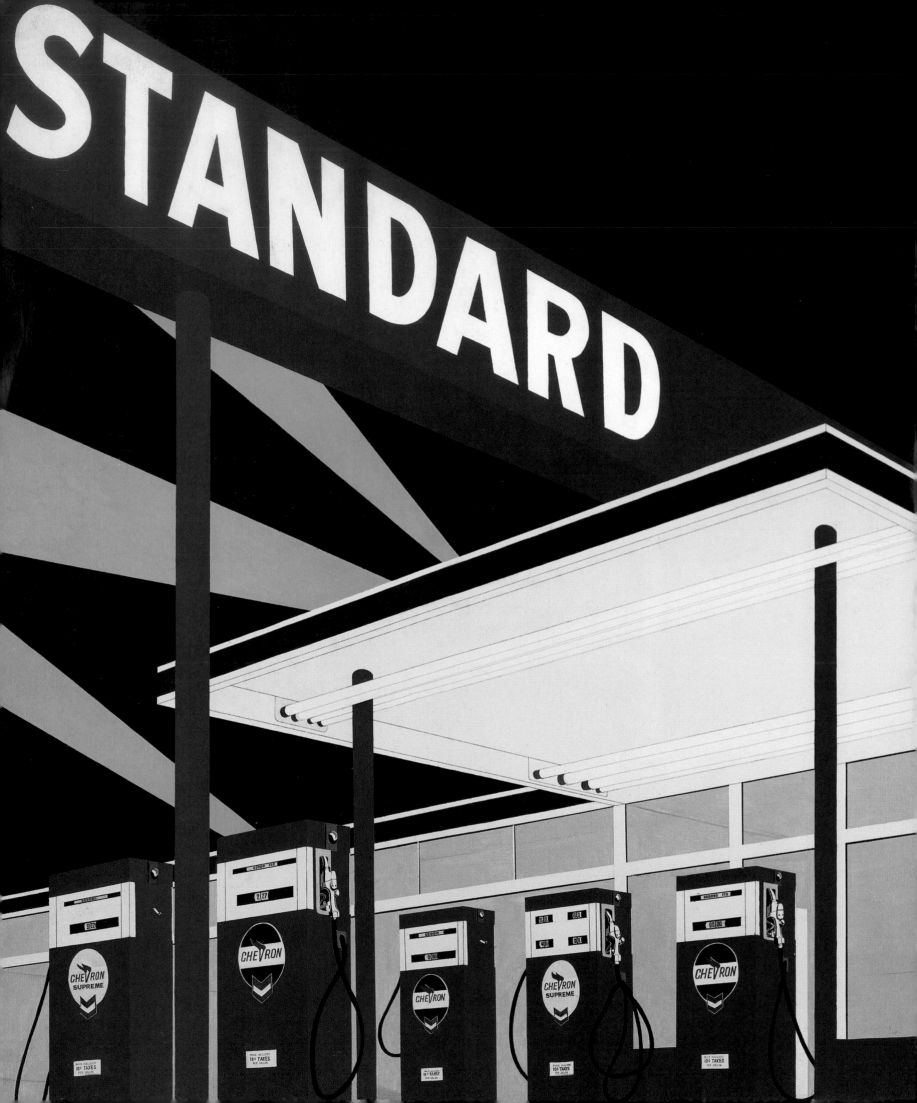

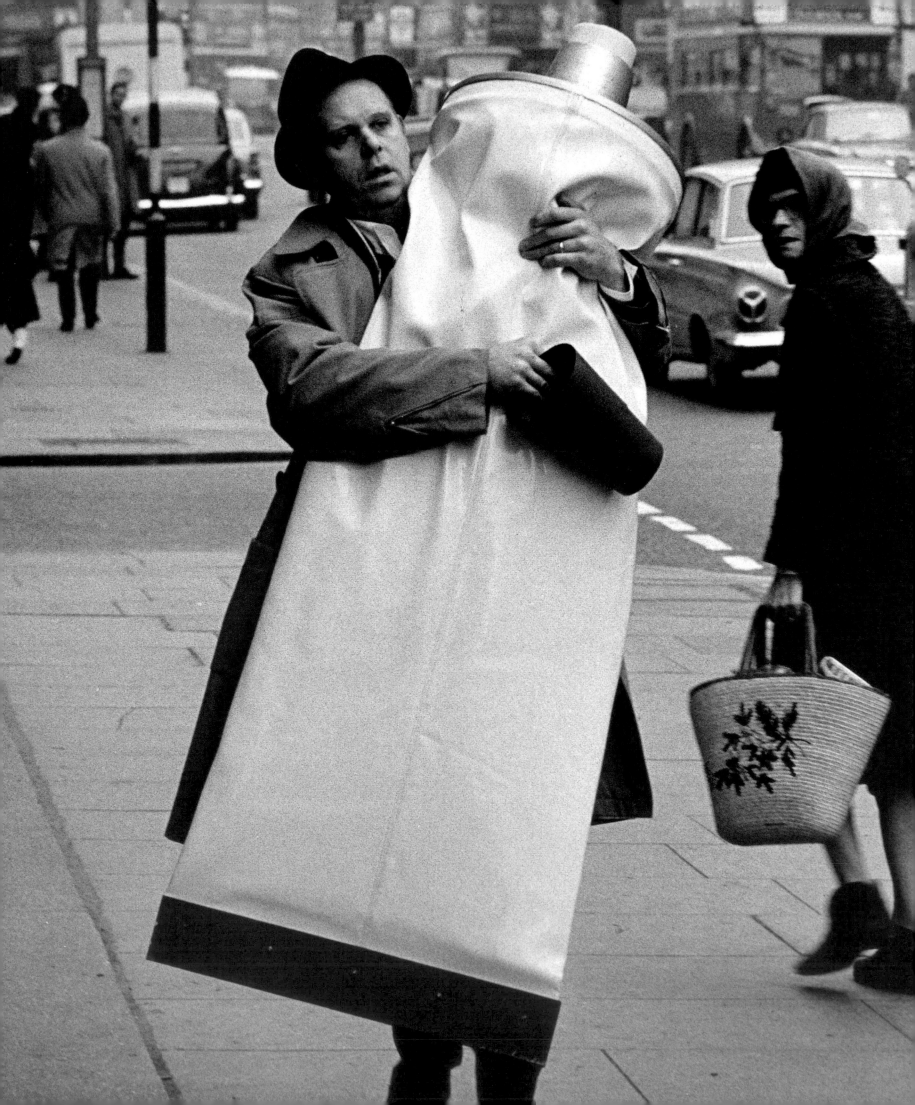

POP

EDITED BY MARK FRANCIS
SURVEY BY HAL FOSTER

Φ

COLONIZATION OF THE MIND
page 118

SPECTACULAR TIME page 160

HELTER SKELTER page 180

PRE-
FACE

BY MARK FRANCIS

'It was drizzling and mysterious at the start of our journey. I could see that it was going to be one big saga of the mist. "Whooee!" yelled Dean. "Here we go!" And he hunched over the wheel and gunned her; he was back in his element, everybody could see that. We were all delighted, we all realized we were leaving confusion and nonsense behind and performing our one and only function of the time, move. And we moved!'

Jack KEROUAC, *On the Road*, 1957

'At worst, one is in motion; and at best,

Reaching no absolute, in which to rest,

One is always nearer by not keeping still.'

Thom GUNN, *On the Move*, 1957

'*Ce n'est pas une image juste, c'est juste une image.*' ('This is not a just image, it's just an image.')

Jean-Luc GODARD, *Vent d'est*, 1970

'Pop is for everyone,' said Andy Warhol in 1967. At once derided and celebrated from the moment of its appearance as the most ephemeral and insignificant of cultural phenomena, Pop has never gone away. This is at the heart of its paradox. Fifty years later, the supposedly fleeting spectacle of Pop is omnipresent and of global dimension. The artists who define Pop have genuinely entered a popular consciousness that transcends the traditional audiences for art, film or music. Nowadays museums, critics and historians can no longer be merely fastidious guardians of an elite culture, founded to protect the status quo from the depravations of kitsch, the vernacular and the popular, but are themselves a constituent part of the culture industry. We can now recognize that the classic period of Pop from 1956 to 1968 is the culmination and apotheosis of the modern period that Manet and Baudelaire, themselves habitués of a nineteenth-century Paris of bars, café-concerts and the life of the streets, were the first to identify and to represent.

Pop was not a movement or a single group of artists, or a style; nor is it confined to a historical moment, though it flourished in certain historical and social circumstances. Its earliest definition, in a letter by Richard Hamilton in 1957, actually describes not the art that would be produced in the name of Pop, but the salient characteristics of modern popular culture itself, the ads, comics, movies and objects which were of such fascination to artists. Pop has a subject – the epic and the quotidian, the real and the surreal – and it has an attitude to this material, an art of attention to the world at hand, in particular to the apparently trivial, insignificant or overlooked. This is then treated in a relatively uninflected manner so that the resulting work is capable of sustaining complex, even contradictory, readings. Even apparently simple

enlargement could 'make strange' a motif, as the Pop artists learned from signs and billboards.

In art the antecedents of Pop were largely European. After Manet's and Degas' exploration of modern urban and suburban life, Eugène Atget's photographs of shop windows and melancholy streets were important to the Dadaists and Surrealists, and to the American photographer Walker Evans. Marcel Duchamp's readymades, René Magritte's disquieting suburban banalities, and Salvador Dalí's extravagant and meticulous paintings of repressed sexuality had a delayed but potent impact in post-war America. In different ways, the graphics of El Lissitzky and the collages of John Heartfield and Kurt Schwitters were Pop *avant la lettre* and were important for the cumulative 'pinboard' aesthetic used by Nigel Henderson, Bruce Conner, Richard Hamilton, and later in Gerhard Richter's *Atlas*. Comics such as *Krazy Kat* by George Herriman, and later Marvel Comics artists such as Jack Kirby and Stan Lee, had both cult and popular audiences. Automobile stylists such as Harley Earl, and customizers like Ed 'Big Daddy' Roth were recognized early as tastemakers in a field in which taste had initially mainly signified class. The animated cartoons of Walt Disney, Chuck Jones and others were admired by artists for their wit and precision. Hollywood was an endless source of beauty and glamour, comedy, camp and Babylonian excess. Elvis Presley's illicit hybrid of white country music and black rhythm and blues, created in Sam Phillips' Sun studios in Memphis from 1954, formed a myth of origin for rock 'n' roll, though Harry Smith's edited 1952 'Anthology of American Folk Music' was a Joycean epic of compilation and juxtaposition which had a formative effect on Robert Frank, Bob Dylan and many other musicians and artists of the 1960s. Dylan himself cites Robert Johnson, Woody Guthrie, the poems of Rimbaud and Brecht's *Pirate Jenny* as the key revelations of his early years, and it is perhaps this combination that gives both a flavour of Pop's cultural richness and depth, and a resolution of its American and European creative sources.

The pinboard or collage was a defining technique of Pop, and the principle of an anthology (such as this) can to a limited extent respect these juxtapositions. The technique was common to art, film and music, and it enabled artists to encompass feelings of nostalgia or ironic distanciation which distinguished Pop from the earlier collages of Dada and the Surrealists. Also common to a great deal of Pop is a recognition of the epiphanic, where banality is at the source of the most vital instances, and the most sublime, such as Richard Hamilton's *Epiphany* of 1964, where a tiny badge reading 'Slip it to me', picked up in Pacific Ocean Park (POP), is enlarged to become a monumental heraldic form, yet retains the lightness of songs by the Drifters or the Beach Boys. There is nothing heavy about the profundity of Pop.

Pop art was intricately linked to other fields, and each fed off the vitality of the other. The Independent Group brought together artists, architects and critics, while Andy Warhol was consecutively a fashion illustrator, painter, sculptor, film maker, producer of the Velvet Underground, magazine publisher, philosopher, historian, diarist, model, photographer and archivist of his times. Photography and film were essential media for many artists, and within film itself, one could consider four genres to be variants on Pop, even if at the same time they were more than that. Hollywood productions created stars such as Marilyn Monroe, who became without doubt the greatest icon of Pop. New Wave European films by Godard, Antonioni, Cammell and Roeg, Pasolini and others, treat modern urban life in the manner of artists. Documentary

films such as D.A. Pennebaker's *Don't Look Back* and *Monterey Pop* undermined traditional barriers between performers and audiences, and are valuable as records of otherwise poorly documented events (Andy Warhol's crucial but ephemeral *Gesamtkunstwerk* that was the 'Exploding Plastic Inevitable' with the Velvet Underground in 1966 survives only in a few photos by Billy Name and a short film by Ronald Nameth). Finally, experimental films by Warhol, Anger, Conner and others used or discarded techniques of montage and editing in ways that were fundamental to Pop, and much later to music television also.

To re-examine Pop at a distance of fifty years it is clear that certain images and themes are pervasive throughout the period: the cars, the movies, the freeways and motels, neon signs and tattoos, the social spaces of the city and the open space of the road, all recur obsessively, and connect the art to wider traditions. Pop was not a set of monolithic assumptions. The mystery, strangeness and innocence in the writing of Jack Kerouac and the early photographs of Robert Frank is replaced by the corrosive humour and violence of Godard's *Weekend* where the road trip ends in destruction and mayhem. But such a productive and provocative period can still only be defined or mapped partially. This book does not encompass Pop work that emerged in Spain, Brazil, Japan and elsewhere. Certain figures are nevertheless indisputably linked to the term, even as they all transcended the limitations of definition in their later work: Andy Warhol, whose films and paintings created a new and simple idea of beauty; Richard Hamilton, whose visionary images were fundamental to each shift from *Just what is it…?* in 1956 to the Beatles' 'White Album' and *Swinging London* in 1968; Jean-Luc Godard, who moved from an image of Jean Seberg in a white T-shirt in *À bout de souffle* (*Breathless*, 1960) to the Rolling Stones interminably rehearsing 'Sympathy for the Devil' in *One plus One* (1968); and finally Bob Dylan, the lyric and tragic poet of his generation, still condemned, forty years later, to haunt the highways and motels of the world as if he was the central figure of his own odyssey.

SUR-
BY HAL FOSTER
VEY

Pop Art is: Popular (designed for a mass audience)·Transient (short-term solution)· Expendable (easily-forgotten)·Low cost· Mass produced·Young (aimed at youth)·Witty ·Sexy·Gimmicky· Glamorous·Big business·This is just the beginning ...

Richard HAMILTON Letter to Alison and Peter Smithson, 16 January 1957

In the beginning Pop art was an Anglo-American affair that thrived in the latitudes of London, New York and Los Angeles, the primary capitals of the consumer society that developed in the West after World War II. Originally 'Pop' referred to this popular culture at large, not to any particular style of art. The term was first used in this general sense in the early 1950s by the Independent Group (I.G.) in London, a motley milieu of young artists, architects and critics (chiefly Lawrence Alloway, Reyner Banham, Toni del Renzio, Richard Hamilton, Nigel Henderson, John McHale, Eduardo Paolozzi, Alison and Peter Smithson and William Turnbull), who explored the implications of popular culture as a dissident movement within the Institute of Contemporary Arts, which was

otherwise focused on the legacies of pre-war modernisms. Only in the later 1950s and early 1960s did 'Pop' begin to signify a style of art that drew on popular imagery from comics, advertisements and the like. It was applied in this specific manner first to former I.G. artists such as Hamilton and Paolozzi and then to a subsequent generation of British artists trained mostly at the Royal College of Art (primarily Peter Blake, Derek Boshier, Pauline Boty, Patrick Caulfield, David Hockney, Allen Jones, R.B. Kitaj, Richard Smith and Joe Tilson) and of American artists based mostly in New York (chiefly Allan D'Arcangelo, Jim Dine, Robert Indiana, Roy Lichtenstein, Claes Oldenburg, Mel Ramos, James Rosenquist, Andy Warhol, John Wesley and Tom Wesselmann). Other figures sometimes associated with the style emerged at this time in France (e.g., Arman, Alain Jacquet, Martial Raysse, Daniel Spoerri) and a little later in Los Angeles (e.g., Billy Al Bengston, Joe Goode, Ed Ruscha) and in Germany (e.g., Gerhard Richter, Sigmar Polke).[1] However, these artists often diverged from the first two waves of Pop artists, especially from their mostly affirmative posture vis-à-vis consumer society.[2]

The contexts of Pop art were different enough in the United Kingdom and the United States alone. In the early 1950s

Britain remained in a state of economic austerity that made the brash world of American consumerism appear seductive and exotic and I.G. artists treated its images accordingly, that is, as so much cult cargo. For the American artists who emerged ten years later, this consumerist landscape had become almost second nature and they often treated it dispassionately ('the death of affect' is an important topic in Pop art). This difference in perspective underwrote others. The Brits were attracted to new commodities as harbingers of the future, while the Americans sometimes represented products that were slightly dated, already touched by nostalgia. And while both groups were trained in art schools, several Americans also worked as commercial artists: Warhol was an acclaimed illustrator, Rosenquist a billboard painter, Ruscha a graphic designer and so on – and they seemed to transfer such techniques to their art rather directly. As might be expected, then, Warhol and company faced some resistance from an art world dedicated to the lofty principles of Abstract Expressionism and yet the opposition encountered by I.G. artists

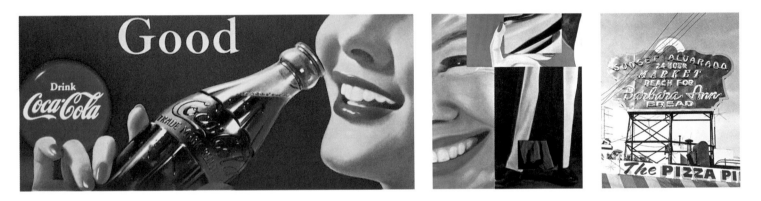

Coca-Cola Advertisement, USA, 1945
James ROSENQUIST Look Alive [Blue Feet, Look Alive], 1961
Ed RUSCHA Sunset Alvarado, Market Sign [Corner of Sunset and Alvarado Looking West], 1961

was deeper still. For British Pop was a 'long front' in a general war between new and old cultures, while American Pop was already at home, so to speak, in the commercial look of the land, if not in the restricted discourse of the art world.[3] (The Los Angeles evoked by Ruscha, for example, appears as if it were always already Pop.)

Yet what unites the different strands of Pop art might be found right here as well: in a common recognition that consumerism had changed the appearance of the world, perhaps even the nature of appearance, and that art must draw on new contents and develop new forms accordingly. (Ironically, this imperative came at a moment when abstract art had won general acceptance for the first time – another point of resentment for some artists and critics opposed to Pop.) Semblance as such appeared to be *mediated* and Pop found its primary subject in this new look of the world, in an iconic visibility that appeared to transform select people and products into so many personalities with special powers. The consumerist superficiality of images and seriality of objects also

affected the mediums of painting and sculpture structurally and Pop registers these alterations as well. For instance, much Pop painting manifests an utter conflation of the painterly and photographic, the handmade and the ready-made, in which the modernist opposition of abstraction and figuration is also greatly complicated. For all its visual immediacy, the typical Pop image is usually produced through various transfers of images and mediums (usually from magazines, comics or news photos to painting, collage or assemblage) that involves still other techniques (such as projectors and silkscreens) in a complex layering of different sources, formats and effects. Juxtaposition remains central, but the Pop image rarely possesses the material hetero-geneity of a Dadaist collage (e.g., a Kurt Schwitters) or a Neo-Dadaist assemblage (e.g., a Robert Rauschenberg). Often in Pop art collage is rendered photographic, painterly or both at once: a diversity of image might be maintained, but usually within a consistency of surface.

under the changed conditions of a 'Second Machine Age' in which 'imageability' becomes the principal criterion.[4] And near the end of the period, the designers Robert Venturi and Denise Scott Brown, who were influenced by Pop art, advocated a postmodern architecture that returned this imageability to the built environment from which it arose.[5] In effect Pop exists in the interval between those two moments – between the decline of modern art and architecture on the one hand and the rise of postmodern art and architecture on the other. Distinctive in its own right, Pop is thus also a crux between two great epochs of twentieth-century culture.[6]

Reyner Banham, the Independent Group and Pop Design

In November 1956 the I.G. architects Alison and Peter Smithson published an essay that included a little poem of early Pop: '[Walter] Gropius wrote a book on grain silos, Le Corbusier one on aeroplanes and Charlotte Perriand brought a new object to the office every morning; but today

Installation view, Group 2 [Richard Hamilton, John McHale, John Voelcker], 'This is Tomorrow' [reconstruction], 'The Independent Group: Postwar Britain and the Aesthetics of Plenty', 1990
Installation view, Group 2 [Richard Hamilton, John McHale, John Voelcker], 'This is Tomorrow', Whitechapel Art Gallery, London, 9 August – 9 September 1956
MGM poster for Forbidden Planet, 1956

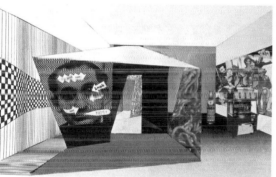 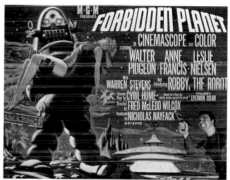

The greatest achievement of Pop art lies in its various transformations of the pictorial image under the pressure of socio-economic changes at large. Here, then, I will focus on a few models of the Pop image developed by key artists from the early 1950s to the early 1970s. Such a view comes with its own costs, such as a scanting of some painters (e.g., Blake, Hockney, Rosenquist, Wesselmann) and a bracketing of all object-makers (e.g., Arman, Dine, Oldenburg, Spoerri); but the gain in concentration may compensate a little for the loss in coverage (certainly such figures are represented elsewhere in the book). What I propose is a partial typology of the Pop image, not a comprehensive history of Pop art as such. My discussion is also framed with brief remarks on design, since Pop emerges in a new space of cultural presentation entailed by a new mode of economic produc-tion. Near the beginning of the period, the I.G. ringleader Reyner Banham imagined a Pop architecture as a radical updating of the modern design of the 'First Machine Age'

we collect ads.' The point here is more polemical than historical (Gropius, Le Corbusier and Perriand were also media-savvy). The Smithsons want to mark a difference, to open up a space: *they*, the old protagonists of modernist design, were cued by functional things, while *we*, the new celebrants of Pop culture, look to 'the throw-away object and the pop-package' for inspiration. This is done partly in delight, the Smithsons suggest, and partly in desperation: 'Today we are being edged out of our traditional role [as form-givers] by the new phenomenon of the popular arts – advertising … We must somehow get the measure of this intervention if we are to match its powerful and exciting impulses with our own.'[7]

This was one battle cry of the Independent Group, which formed as an informal laboratory dedicated to cultural research through private seminars and public exhibitions. The seminars focused on the effects of science, technology and media, while the exhibitions consisted of collaborative displays of often found images and objects, where the ideas

developed in the seminars were put into practice. The crucial I.G. shows were 'Parallel of Life and Art', directed by Paolozzi, the Smithsons and Henderson in 1953; 'Man, Machine and Motion', produced by Hamilton in 1955; and, most famously, 'This is Tomorrow', which grouped artists, architects and designers in twelve teams in 1956. By this time the I.G. had more or less dissolved in order that its members might develop their work individually. In January 1957, two months after the Smithsons published 'But Today We Collect Ads', Hamilton responded with a letter that summed up the concerns of the I.G.: 'technological imagery' (as explored in 'Man, Machine and Motion'), 'automobile styling' (as stressed by Banham), 'ad images' (as investigated by Paolozzi, McHale and the Smithsons), 'Pop attitudes in industrial design' (as exemplified by the *House of the Future* proposed by the Smithsons in 1956) and 'the Pop Art/ Technology background' (the entire I.G., especially in 'This is Tomorrow').[8]

The I.G. is known for its claim that these different expressions are roughly equal in value, that culture is no longer a hierarchical 'pyramid' of high and low arts, but rather a horizontal 'continuum' of cultural practices.[9] This quasi-anthropological view, which anticipates some aspects of cultural studies today, was championed in print by Alloway, who popularized the term Pop, as well as by Banham, who theorized a Pop Age.[10] This egalitarianism of the I.G. countered both the elitist notion of civilization (as represented by Kenneth Clark) and the academic status of modernism (as represented by Herbert Read); it also rejected the sentimental regard for a folk worker culture (as represented by Richard Hoggart). 'American films and magazines were the only live culture we knew as kids,' Banham once remarked of his I.G. associates. 'We returned to Pop in the early fifties like Behans going to Dublin or Thomases to Llaregub, back to our native literature, our native arts.'[11] This comment captures a key paradox of I.G. members: they launched a return to

American Pop as if it were their mother-tongue and in doing so they signalled the partial displacement of 'folk' by 'Pop' as the basis of a common culture.[12] For better or worse, the I.G. was near enough to this American culture to know it well, but also distant enough to desire it still, with the result that they did not question it much. And this apparent paradox points to another also indicated by Banham: that the group was both 'American-leaning' and 'Left-orientated'.[13]

'We have already entered the Second Machine Age,' Banham wrote in *Theory and Design in the First Machine Age* (1960), 'and can look back on the First as a period of the past.'[14] In this classic study, first conceived as a dissertation in the midst of the I.G., Banham also exploited his distance from the initial framers of modern design such as Gropius, Le Corbusier, Siegfried Giedion and Nikolaus Pevsner (his advisor at the Courtauld Institute). He challenged the rationalist biases of these figures – that form must follow function and/or technique – and recovered other imperatives, especially Expressionist and Futurist ones, neglected by them. In doing so Banham advanced the imaging of technology as a principal criterion for design – of the First Machine Age certainly, but also of the Second Machine (or First Pop) Age. According to Banham, the modernists had taken the machine as a model of modern architecture, only to smuggle in a classical aesthetic in the process – a move evident, for example, in *Vers une architecture* (1923) where Le Corbusier juxtaposed a Delage sports-car with the Parthenon. For Banham this was absurd: cars are Futurist 'vehicles of desire', not Platonic type-objects, and only a designer who thrilled to the machine as 'a source of personal fulfillment and gratification' could capture its spirit.[15]

In this regard Banham the Pop prophet was not at odds with Banham the revisionary modernist. In the 1920s and 1930s a passion for an industrial America of Fordist production had influenced much modernist art and architecture; in the 1950s and 1960s this was gradually supplanted by a fascination with a consumerist America of imagistic impact, sexy packaging and speedy turnover that was incipiently post-Fordist. These qualities became the design criteria of the Pop Age for Banham. Far from academic, then, his revision of architectural priorities sought to reclaim an 'aesthetic of expendability', first proposed in Futurism, for the Pop Age, where 'standards hitched to permanency' were no longer so relevant.[16] More than any other critic, Banham led design

Pierre KOENIG Kitchen, Case Study House No. 21, Los Angeles, 1958
Advertisement for the Pedestal or Tulip range of plastic shell furniture designed by Eero Saarinen, 1956
Advertisement for the 1955 Plymouth, *Life* magazine, 11 April 1955. Used as source by Richard Hamilton for his painting *AAH!*, 1962

theory away from a modernist concern with abstract, machinic forms to a Pop language of commercial, mediated images and this was in keeping with a shift in influence away from the architect as a consultant in industrial production to the ad-man as an instigator of consumerist desire. 'The foundation stone of the previous intellectual structure of Design Theory has crumbled,' Banham wrote in 1961; 'there is no longer universal acceptance of Architecture as the universal analogy of design.'[17]

Yet Banham did not regard the passage from the First to the Second Machine Age as a complete break: 'The cultural revolution that took place around 1912 has been superseded', he wrote in *Theory and Design*, 'but it has not been reversed.'[18] Rather, a dialectical transformation of technologies had occurred: from 'the age of power from the mains and the reduction of machines to human scale' (as in the transition from public trains to private automobiles) to 'the age of domestic electronics and synthetic chemistry' (as in

ARCHIGRAM [Peter Cook] Plug-in University Node, 1965. Section elevation drawing
Cedric PRICE Fun Palace, 1961–67. Aerial view drawing

televisions and plastics), technologies had become both more popular and more personal. 'A housewife alone often disposes of more horsepower today than an industrial worker did at the beginning of the century,' Banham argued.[19] And if architecture was to remain relevant in this world – where the dreams of the austere 1950s had become the products of the consumerist 1960s – it had to 'match the design of expendabilia in functional and aesthetic performance': it had to go Pop.[20]

Initially Banham supported the Brutalist architecture of the Smithsons and James Stirling, who pushed given materials and exposed structure to a 'bloody-minded' extreme. 'Brutalism tries to face up to a mass production society', the Smithsons wrote in 1957, 'and drag a rough poetry out of the confused and powerful forces which are at work.'[21] Yet perhaps this very insistence on an 'as found' aesthetic rendered Brutalism too modernist to serve for long as the model style of the Pop Age. As the Swinging Sixties unfolded (in part driven by the technological investments of the Labour Government under Harold Wilson), Banham began to stress imageability and expendibility above all other values. For Banham Archigram (Warren Chalk, Peter Cook, Dennis Crompton, David Greene, Ron Herron and Michael Webb) best fitted this revised bill and in 1963 this adventurous group did proclaim 'throwaway architecture' as the future of design. Archigram took 'the capsule, the rocket, the bathyscope, the Zipark [and] the handy-pak' as its models[22] and celebrated technology as a 'visually wild rich mess of piping and wiring and struts and cat-walks'.[23] Its projects might appear functionalist – the Plug-in City (1964) proposed an immense framework in which parts could be changed according to need or desire – but, finally, with its 'rounded corners, hip, gay, synthetic colours [and] pop-culture props', Archigram was 'in the image business'.[24] Like the Fun Palace project (1961–67) proposed by Cedric Price for the Theatre Workshop of Joan Littlewood, Plug-in City offered 'an image-starved world a new vision of the city of the future, a city of components … plugged into networks and grids'.[25] Herein lies the ultimate imperative of Pop design for Banham: that it not only express contemporary technologies but also advance them, however delirious the effects might be.

Richard Hamilton and the Tabular Image

If the Smithsons, Archigram and Price 'got the measure' of Pop culture in architecture, who did so in art? What artists reflected on the shift from an industrial vocabulary of 'grain silos and aeroplanes' to a consumerist idiom of 'throwaway objects and pop-packages'? One I.G. member 'to collect ads' early on was Eduardo Paolozzi, who called the collages made from his collection of fragments 'Bunk' – perhaps in an ambivalent homage to Henry Ford, who once remarked that 'History is Bunk'.[26] Many post-war artists refashioned the pre-war device of collage, such as Rauschenberg with his 'combines' and silkscreens of found objects, art images and print reproductions, as well as the *décollageistes* (e.g., Raymond Hains, Mimmo Rotella and Jacques de la Villeglé) with their layered and lacerated posters taken directly from the city streets. Yet in these instances collage evoked a distracted mind bombarded by media messages, whereas Paolozzi deployed collage to make specific connections within Pop culture, especially between product salesmanship

and sex appeal. In one early work, *I Was a Rich Man's Play Thing* (1947), a cover girl of *Intimate Confessions* magazine appears on the same plane as ad fragments for Coca-Cola, Real Gold fruit juice and cherry pie. The sexual innuendos are obvious enough, as is the phallic bomber below the woman with its inscription 'Keep 'Em Flying'. Paolozzi keys the associations among consumption, sex and war by the little explosion of the gun pointed at the cover girl: 'The "Pop!" gunshot cements these terms into equivalence, interchangeability', the critic Julian Myers has argued. 'The body *is* a commodity; advertisement *is* propaganda; propaganda *is* pornography.'[27]

This 'pinboard aesthetic' was also practised by others within the I.G. (Henderson, Turnbull, McHale …), but it was Paolozzi who, one night in April 1952, projected his ads, magazine clippings, postcards and diagrams, in a catalytic demonstration that underwrote the distinctive method of the I.G. exhibitions to come: an anti-hierarchical constellation

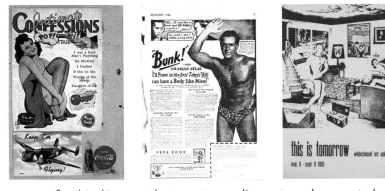

of archival images that are at once disparate and connected. Foreshadowed in summer 1951 when Hamilton projected multiple photographs of natural structures in the show 'Growth and Form', this collage principle was foregrounded in the autumn of 1953 when Paolozzi, the Smithsons and Henderson presented roughly 100 reproductions of modernist paintings, tribal art, children's drawings and hieroglyphs, as well as anthropological, medical and scientific photographs, in 'Parallel of Art and Life'. However, the epitome of the pinboard aesthetic was reached in summer 1956 with 'This is Tomorrow', for which Hamilton constructed his famous little collage, *Just what is it that makes today's homes so different, so appealing?* (enlarged in black and white, it served as a poster for the show). In his own words, the work tabulates the Pop iconography of 'Man, Woman, Humanity, History, Food, Newspapers, Cinema, TV, Telephone, Comics (picture information), Words (textual information), Tape recording (aural information), Cars, Domestic appliances, Space' (Richard Hamilton, *Collected*

Words: 1953–1982, 1985, 24; hereafter *CW*). Clearly indebted to the 'Bunk' collages of Paolozzi, *Just what is it?* also prepares the distinctive version of the Pop image soon developed by Hamilton: a spatial compilation of found figures, commodities and emblems that is 'tabular as well as pictorial' (*CW* 24). Whereas Paolozzi stuck to the material heterogeneity of collage, Hamilton exploited the fetishistic effects of painting, which he used to mimic the lush surfaces of media images. These interests and strategies guided his great suite of tabular pictures that followed: *Hommage à Chrysler Corp.*, *Hers is a lush situation* and *$he*.

Hommage à Chrysler Corp. (1957) takes up the automobile as core commodity of the mid twentieth century, but as a metamorphic 'vehicle of desire' à la Banham, not as a Platonic type-object as in Le Corbusier. '[The car] adopts its symbols from many fields and contributes to the stylistic language of all consumer goods,' Hamilton wrote in 1962.

'It is presented to us by the ad-man in a rounded picture of urban living: a dream world, but the dream is deep and true – the collective desire of a culture translated into an image of fulfillment. Can it be assimilated into the fine art consciousness?' (*CW* 35) *Hommage* is his first attempt to do so; it is also an early instance of his 'ironism of affirmation', a phrase borrowed from his mentor Duchamp, which Hamilton defined as a 'peculiar mixture of reverence and cynicism' (*CW* 78). Here this mixture is not as paradoxical as it sounds, for *Hommage* is so affirmative of automobile imaging, so mimetic of its moves, as to ironize its fetishistic logic – that is, to expose the manner in which both bodies on display, the new Chrysler and the vestigial showgirl, are broken up into sexy details whose production is obscure. Not only does Hamilton associate body parts by analogy (the breast, say, with the headlight), but in doing so he demonstrates a conflation of commodity fetishism with sexual fetishism, as the two bodies exchange properties (as in commodity fetishism according to Marx) in a way that charges them with erotic force (as in sexual fetishism according to Freud). Foreseen in Surrealism, this doubling of fetishisms is foregrounded throughout Pop.[28]

Signal characteristics of the tabular picture are announced in *Hommage*. First, the composition is 'a compilation of

Eduardo PAOLOZZI *I Was a Rich Man's Plaything*, 1947
Charles Atlas advert in *Mechanics and Handicrafts* magazine, December 1936, from scrapbook of Eduardo Paolozzi, 1949
Richard HAMILTON Poster for 'This is Tomorrow' exhibition, 1956
Richard HAMILTON *Hommage à Chrysler Corp.*, 1957

themes derived from the glossies', several images each for the car, the woman and the showroom (*CW* 31). Not just broken up, the car is also rotated for purposes of display (headlight and bumper from the front, fin and fender from the rear). This manipulation is practised on female figures, too, in other pictures such as *$he*, as if Hamilton wanted to suggest that the skill of Old Master drawing had become a device of semi-pornographic presentation. And in *Hommage* he is fetishistically specific: 'pieces are taken from Chrysler's Plymouth and Imperial ads; there is some General Motors material and a bit of Pontiac' (*CW* 31). At the same time Hamilton also smoothens these parts into near abstraction: if the woman caresses the car in the painting, so too does he caress both figures in paint. Like the car, the woman is reduced to charged parts within a curvaceous line, to breast and lips (which Freud counted among 'the secondary sexual characteristics'), here represented by an 'Exquisite Form Bra' and the big lips of one 'Voluptua', a star of a late-night

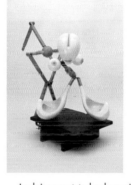

American TV show at the time. This is representation *as* fetishization, an almost campy version of what Walter Benjamin once called 'the sex appeal of the inorganic'.[29] Such is the fetishistic crossing of this tabulation – a car is (like) a female body, a female body is (like) a car – and the two commingle in this chiasmus as if naturally. (This crossing is also suggested by the sexist lingo of the time: 'nice chassis', 'great headlights' and so on.)

Everything here is already designed for display: 'The main motif, the vehicle, breaks down into an anthology of presentation techniques' (*CW* 32) and Hamilton does highlight, in paint, the print effects of glossy car panel and shiny chrome fender. They appear as already screened by a lens, as though there were no other mode of appearance but a mediated one. Space is also thus transformed: it has become display-space alone, specifically a showroom based on 'the International Style represented by a token suggestion of [Piet] Mondrian and [Eero] Saarinen' (perhaps in the vestigial grid and the

curvy lines respectively [*CW* 32]). In this showroom not only have traditional line, colour and modelling become means of product display, but so too have aspects of modern art and architecture become devices of commercial exhibition (again, 'Mondrian' and 'Saarinen').[30] This is another key insight of Pop: that avant-garde and mass cultures have intersected, indeed converged. (As we will see, Lichtenstein shows us a modernism appropriated by the media, in his case in the comics.) Hamilton also mentions 'a quotation from Marcel Duchamp' in *Hommage* and at the time he was busy with his translation of the *Green Box* of notes that Duchamp had prepared for *The Bride Stripped Bare by Her Bachelors, Even* (a.k.a. the *Large Glass*, 1915–23). Perhaps, like the *Large Glass*, the conjunction of Chrysler and showgirl in *Hommage* produces a kind of 'Bachelor Machine', a category of avant-garde representation in which woman and machine, sexuality and commodity, are bound up with one another.[31] But if *Hommage* is a pictorial updating of the *Large Glass*, which is 'the bachelor' and which is 'the bride'? Unlike Duchamp, who keeps the two figures separate, Hamilton lets them meet, as if to suggest that consumerism had transformed the very rapport of male and female, the very nature of (heterosexual) desire.[32]

In his next tabular picture, *Hers is a lush situation* (1958), Hamilton actually commingles the body parts of woman and car: the curves of the implicit female driver become one with the lines of bumper, headlight, fin, windshield and wheel. Another tabulation of magazine images, the painting is generated from a sentence in an *Industrial Design* review of a Buick: 'The driver sits at the dead calm centre of all this motion: hers is a lush situation' (*CW* 32).[33] Perhaps this painting marks the next stage in the Pop evolution of the Bachelor Machine, one that here aligns Hamilton with the Surrealism of Hans Bellmer, for *Hers is a lush situation* can be seen as a graphic updating of *Machine-Gunneress in a State of Grace* (*La Mitrailleuse en état de grâce*, 1937), where Bellmer renders woman and weapon one.[34] But what is still perverse in Bellmer has become almost beautiful here: a lush situation, not a surreal threat. Although Hamilton works to 'assimilate' design into 'the fine art consciousness', the flow can run in the opposite direction too and *Hers is a lush situation* does

show the genre of the Odalisque subsumed in an ad for a Buick (all that remains of the nude, as with the Cheshire cat, is her smile), as if a nude by Matisse were here reworked by an automobile stylist. In the process Hamilton presents line, which is still individual and expressive in Matisse, a medium of rapport between artist and model, as almost engineered and statistical: for all its lushness, 'line' has become 'the right line' for 'the new line' of Buick.

If line is revalued here, so is plasticity, in a way that makes the animate and the inanimate difficult to distinguish. 'More than a substance, plastic is the very idea of its infinite trans-formation,' Roland Barthes wrote in *Mythologies*, his collection of critiques of consumerist 'myths' published in 1957, a year before *Hers is a lush situation* was painted; 'the whole world can be plasticized and even life itself ...'[35] 'Sex is everywhere', Hamilton argued in 1962, 'symbolized in the glamour of mass-produced luxury – the interplay of fleshy plastic and smooth, fleshier metal' (*CW* 36). This erotic

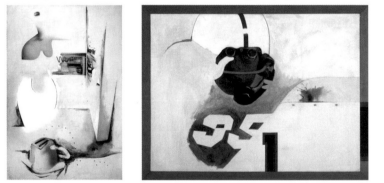

plasticity is a matter not only of charged details but also of abstract analogies: it is as though Hamilton wanted to track the desirous eye in its saccadic jumps across associated forms. Together these two operations inform the hybrid space of his tabular pictures: specific yet sketchy in content, broken yet seamless in facture, collaged yet painterly in technique.

This combination of effects is again at work in *$he* (1958–61), which Hamilton describes as another 'sieved reflection of the ad man's paraphrase of the consumer's dream' (*CW* 36). If a magazine image of a Chrysler provides the layout of *Hommage*, here it is one of a Frigidaire: the home has become another kind of showroom.[36] Hamilton lists no less than ten sources, all credited to particular designers and brands, for the fridge, the woman and the hybrid of toaster and vacuum cleaner below. Yet, like *Hommage*, *$he* draws principally on the magazine genre of the woman or wife who proffers the vehicle or appliance; here, however, it is the product that seems to sell the person (that she has

commodity status is also signalled by the dollar sign in the title). The woman is again reduced to an erotic 'essence' – not breast and lips as in *Hommage*, but eye and hips. As in *Hers is a lush situation*, the hips are in whitened relief, while the eye is a plastic one taped into position: like painting, relief and collage are exploited for fetishistic effect, not the opposite. The eye opens and closes like the fridge, turns on and off like the toaster: apparently in the animate world of Pop products, things can look back at us, even wink at us.[37]

What are the implications of the tabular picture? 'Tabular' derives from *tabula*, Latin for table, but also for writing-tablet, in which, in antiquity, both painting and printing figured as modes of inscription. This association must appeal to Hamilton, who has used both techniques in large part because he finds them, already combined, in the media. 'Tabular' also invokes writing, which Hamilton has involved in his lists and titles. Moreover, his pictures contain traces of the visual-verbal hybrid characteristic of the magazine

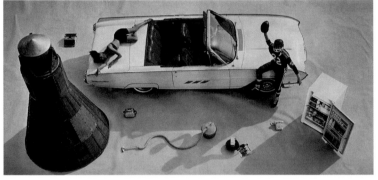

spread and the tabloid layout (perhaps 'tabular' connotes 'tabloid' as well), a hybrid that anticipates the mixed sign that pervades electronic space today – all the 'icons', 'pop-ups' and other lush images that carry insistent directives.[38] Again, some of these pictures are tabular in another sense too – generated by a table of terms, as with *Just what is it?*, or of images, as in *Hommage* and *$he*, or of jingles, as in *Hers is a lush situation* or *Towards a definitive statement on the coming trends in men's wear and accessories* (1962), where the title derives from a *Playboy* review of male fashion.

More directly, 'to tabulate' is 'to set down in a systematic form' (OED) and Hamilton is often concerned with an 'overlapping of presentation styles and methods' – styles and methods that are at once commercial (as in the various display techniques that he evokes), modernist (as in the various abstract signs that he cites) and modernist-turned-commercial. In his own words, 'photograph becomes diagram, diagram flows into text' and all is transformed

Richard HAMILTON *$he*, 1958–61
Richard HAMILTON *Towards a definitive statement on the coming trends in men's wear and accessories* [b], 1962
Richard HAMILTON with Robert FREEMAN [photographer] 'Self-portrait', cover for *Living Arts*, 2, 1963

William OVERGARD Drawing for the cartoon *Steve Roper's Casebook*, 6 August 1961. King Features Syndicates Inc.
Roy LICHTENSTEIN I Can See the Whole Room and There's Nobody in it, 1961. Not to scale: canvas size 122 × 122 cm [48 × 48 in]
Article on Roy Lichtenstein *Life* magazine, 21 January 1964

by painting. At the same time Hamilton wants 'the plastic entities [to] retain their identity as tokens' and so he uses 'different plastic dialects', such as photography, relief, collage, 'within the unified whole' of painting (*CW* 38). Like an ad-man, then, he tabulates (as in correlates) different media and messages and tabulates (as in calculates) this correlation in terms of visual appeal and psychological effect.

It is not always clear when this redoubling of images is analytical and when it is celebratory – in Hamilton in particular or in Pop at large. Yet one thing seems clear enough: his pastiche is not disruptively random, as it is in much Dada and Neo-Dada work. Another insight of Pop (or 'Son of Dada' as Hamilton calls it) is that 'randomizing' had become a media device, a logic within the culture industry.[39] Sometimes he pushes this logic of the random to a demonstrative extreme; at other times his tabular pictures are logical in another sense, that is, typological: for example, the suite of images *Towards a definitive statement on the*

 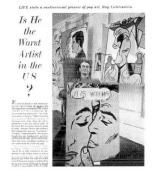

coming trends … is a 'preliminary investigation into specific concepts of masculinity' (*CW* 46), here typified by President Kennedy, a Wall Street broker *cum* American football player, a weightlifter *cum* track athlete and astronaut John Glenn, each of whom is wired to a particular mechanism of sport, entertainment or media.[40] Suggestively, the word 'tabular' refers not only to graphic inscription; in ancient use it also connotes 'a body of laws inscribed on a tablet' (OED). Might these tabular pictures be seen then as investigations into a new body of laws, a new inscription of subjects, which the society of the First Pop Age requires?

Roy Lichtenstein and the Screened Image

Hamilton intimates a historical convergence between abstract painting and commercial design.[41] Similarly, Roy Lichtenstein suggests that, in composition and in effect, the differences between a grand painting and a good comic or ad have narrowed and, like Hamilton, he exploits this diminished

difference nonetheless. If Hamilton drew on glossy magazines for his images, Lichtenstein turned to tabloid newspapers, a tawdrier resource: in 1960 he began to paint cartoon characters such as Mickey and Popeye and generic products such as tennis shoes and golf balls (Andy Warhol did much the same thing, first independently, at much the same time). Almost immediately Lichtenstein was charged with superficiality; and when he moved to comic strips, mostly of romance and war, the accusations grew more shrill: clearly the apparent banality of his work threatened the assumed profundity of art – of its cultural significance and its ethical effect.[42] His cold surfaces seemed to mock the feverish gestures of Abstract Expressionism in particular and mainstream critics, who had come to appreciate such painting, were not happy.[43] In 1949 *Life* magazine had showcased Jackson Pollock with the not-yet-convinced question 'Is He the Greatest Living Painter in the United States?' In 1964 the same magazine profiled Lichtenstein under the not-altogether-ironic heading 'Is He the Worst Artist in the U.S.?'

The charge of banality centred first on content: Pop appeared to overwhelm fine art with commercial design. Modern artists had long sampled popular culture (posters in Toulouse-Lautrec paintings, newspaper fragments in Picasso collages and so on), but they did so mostly to reinvigorate staid forms with feisty contents. With Pop, on the other hand, the low seemed to overrun the high – despite the fact that, like Hamilton, Lichtenstein only wanted to 'assimilate' his ads and cartoons into fine art. The accusation of banality also concerned procedure: since Lichtenstein seemed to reproduce such images directly, he was branded with a lack of originality and, in one case at least, accused of copyright infringement. (In 1962 Lichtenstein adapted a few diagrams of portraits by Cézanne made by an art historian named Erle Loran in 1943; Loran surfaced to protest loudly.) Lichtenstein did copy, of course, but in a complicated fashion. In the case of the comics, he would select one or more panels from a strip, sketch one or more motifs from these panels, then project his drawing (never the comic) with an opaque projector; next he would trace the image on the canvas, adjust it to the

picture plane and finally fill in with his stencilled dots, primary colours and thick contours – the light ground of the dots first, the heavy black of the outlines last. Thus, while a Lichtenstein painting might look readymade, it is actually a layering of mechanical reproduction (comic), handwork (drawing), mechanical reproduction again (projector) and handwork again (tracing and painting), to the point where distinctions between hand and machine are difficult to recover.[44] Again, Hamilton, Warhol, Rosenquist, Richter, Polke and others produce related conundra of the painterly and the photographic; it is a prime characteristic of Pop art.

Lichtenstein's work abounds in manually made signs of mechanically reproduced images, but it is his signature dots that crystallize the paradox of 'the handmade readymade'. These stencilled marks are a painted depiction of a printed code, the Ben-Day dots devised by Benjamin Day in 1879 as a technique to reproduce an image through gradations of shading translated into a system of dots. The Lichtenstein

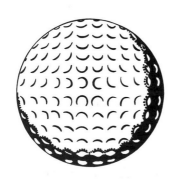

version of these dots underscores the transformation of appearance under mechanical reproduction into screened images – printed, broadcast or otherwise represented beforehand. As we saw with Hamilton, this too is a central concern of Pop, with significant variations again wrought by Warhol, Rosenquist, Richter, Polke and others. But where does the artist as creator stand in this world of reproduction? When Lichtenstein appropriated product images, he effaced the brand names (by contrast Warhol retained 'Campbell's', 'Brillo' and so on); as the critic Michael Lobel has argued, he 'Lichtensteinized' his sources in order 'to make the comics look like his images'.[45] This tension between traces of authorship and signs of its eclipse is pronounced in Lichtenstein, but it was not very anguished for him. 'I am not against industrialization', he remarked modestly in 1967, 'but it must leave me something to do … I don't draw a picture in order to reproduce it – I do it in order to recompose it. Nor am I trying to change it as much as possible. I try to make the

minimum amount of change.'[46] This is the ambiguous line that Lichtenstein hewed: to copy images from print media but to adapt them to the parameters of painting; to recompose them in the interest not only of pictorial unity but of artistic subjectivity; or, more precisely, to recompose them in such a way as to register these values of unity and subjectivity – to register them precisely as pressured.

The other charge of banality, the one concerning the content of ads and comics, is more difficult to deflect, but here too the Lichtenstein case is not as simple as it seems. His lowly subjects did offend aesthetic taste attuned to Abstract Expressionism, but, formally speaking, Lichtenstein did not put his content to very contrarian purposes. In fact he worked to show that comics could serve some of the same lofty ends set for high art from Rembrandt and Jacques-Louis David to Mark Rothko and Barnett Newman: not only pictorial unity and dramatic focus (as advocated since Diderot and Lessing, if not before) but also 'significant form' and 'the integrity of the picture plane' (as urged by Clive Bell and Clement Greenberg respectively). Jasper Johns had played a similar trick with his paintings of flags, targets and numbers of the mid to late 1950s: those works met the Greenbergian criteria for modernist painting (that it be flat, self-contained, objective and immediate) by means that Greenberg found utterly alien to such painting (the kitschy images of mass culture).[47] Lichtenstein pushed together the poles of fine art and commercial design with equal force: his comics were almost as flat as any flag or target and more vulgar to boot.

Thus Lichtenstein seemed to challenge the oppositions on which pure painting was founded: high versus low, fine versus commercial, even abstract versus figurative. Consider *Golf Ball* (1962), a circle outlined and dimpled in black on white – to signify shadow and light – on a light grey ground. A golf ball is a prime object of suburban banality, but here it also recalls the pristine plus-and-minus abstractions that Mondrian painted forty-five years before. On the one hand, the near abstraction of *Golf Ball* tests our sense of realism, which Lichtenstein shows to be a conventional code, a matter of signs that sometimes possess only scant resemblance to actual things in the world.[48] On the other hand, when a Mondrian begins to look like a golf ball, then the category of abstraction is surely in trouble too. Modernists like Mondrian worked to resolve figure and ground in painting, to collapse illusionist space into

Roy LICHTENSTEIN Golf Ball, 1962
Piet MONDRIAN Pier and Ocean [Sea and Starry Sky], 1914

material flatness. Lichtenstein gives us both the impression of space and the fact of surface (as do most comics) and if there is a radical edge in his Pop it lies here: less in his thematic opposition of low content and high form and more in his structural superimposition of cartoons and commodities with exalted painting. One can see why, when Mickey and Popeye popped up in the metaphysical space once reserved for the numinous rectangles of Rothko and the epiphanic 'zips' of Newman, art lovers were rather upset.

In this way Lichtenstein performed a visual short-circuit: he delivered both the immediate effect of a modernist painting and the mediated look of a print image.[49] Consider another early work, *Popeye* (1961), which shows the spinach-strong sailor knocking out his rival Bluto with a roundhouse left, like a Pop upstart taking a tough Abstract Expressionist to the canvas with a single blow. Most important here is the blow: nearly as impactful as a Pollock painting, *Popeye* smacks the viewer in the head as well. (Lichtenstein liked to

underscore this blow with the onomatopoeic terms of the comics: his punches go 'Pow', his guns go 'Blam', 'Takka-Takka', 'Brattata'.)[50] Thus at the level of effect too, he suggests that Pop is not so different from modernist painting: they propose a similar viewer, one that is projected as all eye, one that takes in the image in a single flash or 'pop'.[51] But to what end is this demonstration made? For the most part Lichtenstein put high and low together less to undo the opposition than to reconcile it; he was proud of his formal sense, his tasteful ability to make good paintings out of mawkish stuff. Yet this 'reconciliation' was hardly his doing alone; like Hamilton, Lichtenstein registered a convergence of old binaries of high and low, modernist and mass, a historical process that transcended all the Pop artists as individuals (perhaps the implacability of this process can be sensed in the impersonality of their canvases).

Lichtenstein was well prepared to gauge the convergence of high and low arts. In the 1950s, first in Cleveland and then

in upstate New York, he worked through several styles of modernism: he painted along Expressionist lines, then in a faux-naif manner (in which he adapted Americana themes, as in *Washington Crossing the Delaware*, I, *c.* 1951) and briefly in an abstract mode. In other words, he became adept in avant-garde devices, not only the expressionist brushstroke and the cubist play with signs (black lines to signify a shadow, a white patch to signify a reflection and so on), but also the monochrome painting, the readymade object and the found image, all of which he received as second-hand (sometimes literally so in art magazines). These devices appear in his work in the same way, as mediated, as if quoted; and they are held together by the iconic shapes supplied by the ad or the comic, that is, ironically, by the very representational mode that avant-garde art had worked so hard to overthrow. This is another aspect of his Pop that retains a critical edge – critical in the sense that a historical condition is revealed to us through the very form of the work.

Like Hamilton, then, Lichtenstein demonstrates a commonality between the codes of ads and comics and the styles of the avant-garde. 'Mine is linked to Cubism to the extent that cartooning is,' Lichtenstein once remarked of his pictorial language. 'There is a relationship between cartooning and people like [Joan] Miró and Picasso which may not be understood by the cartoonist, but it definitely is related even in the early Disney.'[52] He might have added Matisse, Mondrian and Fernand Léger (among others), for they all appear in his paintings, read through the language of the comics: the ambiguous signs of light and shadow in Picasso, the bold but suave contours in Matisse, the strict primary colours in Mondrian, the already semi-cartoonish figures in Léger. Of course, these elements are put to different purposes: if in Mondrian the primaries signify pure painting, in Lichtenstein yellow might also signal a beautiful blonde, red a flashy dress, blue a perfect sky and so on. Certainly he recomposed his ads and comics in such a way as to fit them to the picture plane, but, more importantly, he did so both to expose and to exploit these modernist connections.[53] One can draw a dire conclusion from this commingling of modernist art and comic strip: that by the early 1960s most devices of the avant-garde had become little more than gadgets of commercial design. This is a predicament for Pop, indeed for any post-war avant-garde: again,

some of the anti-art measures of old avant-gardes like Dada had become the stuff not only of the art museum but of the culture industry. Or one can take a benign view of this situation: that both fine art and commercial design benefited from this exchange of forms in the interest of values that, in the end, are rather traditional – unity of image, immediacy of effect and so on. Evidently this is how Lichtenstein saw things.

Lichtenstein was adept not only in modernist styles but also in different modes of seeing and picturing, some of which date from the Renaissance, if not antiquity – adept in specific genres like portraiture, landscape and still life, all of which he Lichtensteinized, as well as in general paradigms of painting, such as painting as window, as mirror and (within modernist art) as abstract surface. Not long before him, Rauschenberg and Johns had suggested a further paradigm, 'the flat bed picture plane' (as it was termed by Leo Steinberg): the picture no longer as a vertically oriented frame to look at or through as on to a natural scene, but as a

horizontally worked site where different images might be brought together textually, a 'flat documentary surface that tabulates information'.[54] Lichtenstein proposed his own variant of this model: the picture as an already-screened image and, as such, a telling sign of a post-war world in which everything seemed subject to processing through mechanical reproduction. This screening bears on the actual making of his art, its commingling of handmade and readymade; yet it also addresses the mediated look of the consumerist world at large, which affects perceiving and imaging *per se*. Emergent here, then, is a mode of seeing that has become dominant only in our own time of the computer screen, in which (as we saw with Hamilton) reading and looking take on the hybrid character of scanning. (Lichtenstein often chose comic-strip figures placed in front of gun sights, televisual monitors, windshields and dashboards, as if to 'compare or correlate the surface of the canvas' with such screens.)[55] Today this is how we are trained to sweep through information, visual, verbal, or both: we scan it and it scans us, tracking keystrokes, counting web hits and so forth. Might Lichtenstein have sensed this shift, both in semblance and in seeing, already latent in the comic strip?

Andy Warhol and the Seamy Image

Andy Warhol also drew on comic strips and newspaper ads, but to different effects. If Lichtenstein worked to recompose his Pop sources in the interest of pictorial form, Warhol tended to decompose such form through repetition and accident. Moreover, when Lichtenstein put Popeye in the place of Pollock, it was a lite sort of subversion; when Warhol repeated photographs of gruesome car crashes or poisoned housewives in the exalted space of such painting, it was scabrous and it remains so forty-plus years later.

For all his radicality, Warhol is the one Pop artist whose name resonates well beyond the art world (he has Pop status in this extended sense too). From his rise in the early 1960s to his death in 1987, he served as the often-still centre of various sub-worlds of art, advertising, fashion, underground music, independent filmmaking, experimental writing, gay culture and star culture. Along with art work that ranges from the extraordinary to the bathetic, Warhol made movies that are *sui generis*, produced the first album of The Velvet Underground and founded *Interview* magazine, among many other ventures (his studio was appropriately dubbed 'The Factory'). He exploited a new way of being in a world of commodity-images where fame is often subsumed by celebrity, newsworthiness by notoriety, charisma by glamour and aura by hype. A native-informant in this spectacle, Warhol had a look of blank indifference that concealed an eye for killer images.

Born in 1928 in Pittsburgh to immigrants from eastern Slovakia (his father worked in coal mines, then in construction), Warhol studied design at the Carnegie Institute of Technology (now Carnegie-Mellon). In 1949 he moved to New York, where he achieved early success as a commercial artist with magazine ads, window displays, stationery, book covers and album jackets for a range of classy clients from *Vogue* and *Harper's Bazaar* to Bergdorf Goodman and Bonwit Teller. He had money enough to buy work by Duchamp, Johns and Stella before he could sell his own art; and he collected all kinds of other things as well: every day was a time capsule for Warhol (he left 612 boxes of ephemera at his death). He did his first paintings of Batman, Nancy, Dick Tracy and Popeye in 1960, the year before he saw Lichtenstein canvases with similar subjects; yet whereas Lichtenstein was clean and hard in his copies of comics and ads, Warhol initially played with manual mistakes and media blurrings. His wonder year was 1962–63: he did his first 'Campbell's Soup Can' and 'Do It

Roy LICHTENSTEIN *Frightened Girl*, 1964

Yourself' paintings, his first silkscreens of Elvis, Marilyn and other stars, his 'Death and Disaster' images and his first films (*Sleep*, *Blow Job* and *Kiss*, the titles of which declare about all the action that appears on the screen). In 1963, too, Warhol used a Polaroid for the first time and he moved The Factory to East 47th Street, where it became a notorious hangout for bohemian scene-makers and wannabe 'superstars' (the term is another Warhol invention).

His greatest period of art work occurred between his first silkscreens in 1962 and his near-fatal shooting in 1968 (on the third of June, two days before Robert Kennedy was assassinated, Valerie Solanas, a Factory hanger-on, shot Warhol several times).[56] Most important readings focus on this early body of images, especially on the 'Death and Disaster' silkscreens, which are based on news photographs, often too gruesome for publication, of car wrecks and suicides, electric chairs and civil-rights confrontations. These accounts tend either to connect these images to actual

account referential depth and subjective interiority are also victims of the sheer superficiality of Warholian Pop.

The referential view of Warhol is advanced by critics based in social history who relate the work to diverse phenomena, such as the civil rights movement, gay culture, the fashion world and so on. In 'Saturday Disasters: Trace and Reference in Early Warhol' (1987), Thomas Crow disputes the simulacral account of Warhol as impassive and his images as indiscriminate. Underneath the glamorous surface of commodity fetishes and media stars lies 'the reality of suffering and death': the tragedies of Marilyn Monroe, Liz Taylor and Jackie Kennedy prompt 'straightforward expressions of feeling' from the artist. Here Crow finds not only a referential object for Warhol but an empathetic subject in Warhol and here he locates the artist's criticality as well. For Crow this criticality lies not in an attack on 'that old thing art' made through an embrace of the simulacral commodity-image (as Barthes and others would have it); rather, it rests in an exposé of

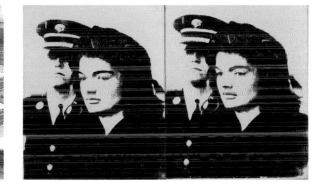

events in the world or, conversely, to propose that the world of Warhol is nothing but image, that Pop images in general represent only other images. Most readings of Warhol – indeed of post-war art based on photography – divide somewhere along this line: the image is seen either as *referential*, a document tied to the world, or as *simulacral*, a copy without an apparent original in the world.

The simulacral reading of Warholian Pop is advanced by critics for whom the notion of the simulacrum is crucial to the critique of representation as bound directly to the world. 'What Pop art wants', Barthes writes in 'That Old Thing, Art' (1980), 'is to desymbolize the object', that is, to relocate the meaning of the image away from any deep significance (within the image, beyond the image) towards its own blank surface. In the process, Barthes argues, the artist is also repositioned: 'The Pop artist does not stand behind his work and he himself has no depth: he is merely the surface of his pictures, no signified, no intention, anywhere.'[57] In this

'complacent consumption' made through 'the brutal fact' of accident and mortality. In this way Crow pushes Warhol beyond humanist sentiment to political engagement. 'He was attracted to the open sores in American political life,' Crow writes, in an interpretation of the electric-chair images as agit-prop against the death penalty and of the race-riot images as a testimonial for civil rights. 'Far from a pure play of the signifier liberated from reference', Warhol belongs to the popular American tradition of 'truth-telling'.[58]

In part this reading of Warhol as empathetic and engaged is a projection, but so is the account of Warhol as superficial and impassive, even though Warhol seemed to agree with the latter view: 'If you want to know all about Andy Warhol, just look at the surface of my paintings and films and me and there I am. There's nothing behind it.'[59] Warhol was very savvy about this process of projection, of the way that we fabricate stars and celebrities through our idealization of their iconic force. In any case, neither argument is wrong; in fact they are both

right: his early images of death and disaster are *both* referential and simulacral, connected and disconnected, affective and affectless, critical and complacent.

'I want to be a machine' is a famous utterance of Warhol and it is usually taken to confirm the blankness of artist and art alike. But it might point less to a blank subject than to a shocked one, who takes on what shocks him as a defence against this same shock. 'Someone said my life has dominated me,' Warhol told Gene Swenson in an important interview of 1963. 'I liked that idea.'[60] In this conversation Warhol claims to have had the same lunch every day for the last twenty years (what else but Campbell's soup?). Together, then, the two statements suggest a strategy of pre-emptive embrace of the very compulsive repetition that a consumerist society demands of us all. If you can't beat it, Warhol implies, join it; more, if you enter it totally, you might expose it; you might reveal its enforced automatism through your own excessive example. Deployed critically by the Dadaists vis-

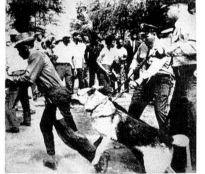 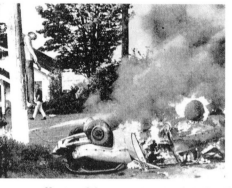

à-vis the military-industrial catastrophe of World War I, this strategy of 'capitalist nihilism' was performed ambiguously by Warhol vis-à-vis Cold War consumerism after World War II.[61]

These remarks reposition the role of repetition in Warhol. 'I like boring things' is another signature saying. 'I like things to be exactly the same over and over again.'[62] In *POPism* (1980) Warhol glossed this embrace of boredom and repetition: 'I don't want it to be essentially the same – I want it to be *exactly* the same. Because the more you look at the same exact thing, the more the meaning goes away and the better and emptier you feel.'[63] Here repetition is both a draining of significance and a defending against affect, and this strategy guided Warhol as early as his 1963 interview with Swenson: 'When you see a gruesome picture over and over again, it doesn't really have any effect.'[64] Clearly this is one function of repetition in our psychic lives: we recall traumatic events in order to work them into a psychic economy, a symbolic

order, a life narrative. Yet the Warhol repetitions are not restorative in this way; they are not about a mastery of trauma, for his repetitions not only reproduce traumatic effects but sometimes produce them as well. Thus several contradictory operations can occur in his work at one time: a warding away of traumatic significance and an opening out to it, a defending against traumatic affect and a producing of it.

Repetition in Warhol, then, is neither a simple representation of a worldly referent nor a sheer simulation of a superficial image. Often his repetition serves to screen a reality understood as traumatic ('screen' in the senses of both 'view' and 'filter'); but it does so in a way that points to this traumatic reality nonetheless. In *Camera Lucida* (1980) Barthes calls this traumatic point of the photograph its *punctum*, which he locates strictly neither in the image nor in the viewer. 'It is this element which rises from the scene, shoots out of it like an arrow and pierces me,' he writes. 'It is what I add to the photograph and what is nonetheless already there.' 'It is acute yet muffled, it cries out in silence. Odd contradiction: a floating flash.'[65] Barthes is concerned here with straight photographs and so he relates the effects of the *punctum* to details of content. This is seldom the case in Warhol; yet a *punctum* does exist for me in the indifference of the passer-by in *White Burning Car*, III (1963). This indiffer-ence to the crash victim impaled on the telephone pole is bad enough, but the repetition of this indifference is galling and this points to the distinctive operation of the *punctum* in Warhol: it works less through content than through technique. Often it appears in the 'floating flashes' of the silkscreen process, in the repetitive 'popping' of the images: it is in these ruptures and repetitions – these nasty seams – that a traumatic reality seems to poke through. In this way different kinds of repetition are put into play by Warhol: repetitions that show a traumatic reality, that screen it and that produce it. And this multiplicity makes for the paradox not only of images that are both affective and affectless, but also of viewers who are made to feel neither whole (which is the ideal of most modern aesthetics: the subject composed in contemplation) nor dissolved (which

Andy WARHOL Race Riot, 1964
Andy WARHOL White Burning Car, III, 1963
Andy WARHOL White Burning Car [detail], III, 1963

is the effect of much popular culture: the subject given over to the dispersive intensities of the commodity-image). 'I never fall apart', Warhol remarks in *The Philosophy of Andy Warhol* (1975), 'because I never fall together.'[66] This is often the effect of his work as well.

The *punctum* is not only a private affair; it can have a public dimension too. Indeed, the breakdown of the distinction between private and public is also traumatic and no one points to this breakdown as incisively as did Warhol. 'It's just like taking the outside and putting it on the inside', he once said of Pop art in general, 'or taking the inside and putting it on the outside.'[67] However cryptic this remark is, it does suggest that a historically novel confusion between private fantasy and public reality is a primary concern of Warholian Pop. Clearly he was fascinated by the subjectivity produced in a mass society. 'I want everybody to think alike,' Warhol said in 1963, at the height of the Cold War. 'Russia is doing it under government. It's happening here all by itself.'[68] 'I don't think

Donahue, and portraits of criminals such as *Thirteen Most Wanted Men* (1964) can be *double entendres* for gay viewers.[71]

However, Warhol did more than evoke the mass subject through its kitsch, commodities and celebrities. Paradoxically enough, he also represented it in its very absence and anonymity, in its very disaster and death, the democratic levellers of famous media icon and unknown mass subject alike. Here again is Warhol in the 1963 interview:

'I guess it was the big crash picture, the front page of a newspaper: 129 DIE. I was also painting the Marilyns. I realized that everything I was doing must have been Death. It was Christmas or Labor Day – a holiday – and every time you turned on the radio they said something like, '4 million are going to die.' That started it.'[72]

And here is Warhol in a 1972 conversation:

'Actually you know it wasn't the idea of accidents and things like that ... I thought of all the people who worked on the pyramids and ... I just always sort of wondered what happened to them ...


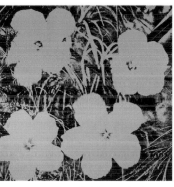



art should be only for the select few,' he added in 1967. 'I think it should be for the mass of American people.'[69] But how does one represent 'the mass of American people'? One way at least to evoke this 'mass subject' is through its proxies – that is, through its objects of consumption, as Warhol did in his serial presentations of Campbell's soup cans, Coke bottles and Brillo boxes from 1962 on, and/or through its objects of taste, as he did through his kitschy flower paintings of 1964 and folksy cow wallpapers of 1966. But can one *figure* this mass subject – that is, give it a body? 'The mass subject cannot have a body', the critic Michael Warner has argued, 'except the body it witnesses.'[70] This principle suggests why Warhol evokes the mass subject through its media icons – from celebrities and politicians such as Marilyn and Mao to all the lurid people that he placed on the covers of *Interview*. At the same time Warhol was also concerned to specify this subject, often along subcultural lines: the Factory was a virtual workshop of queer reinventions of heart-throbs such as Troy

Well, it would be easier to do a painting of people who died in car crashes because sometimes you know, you never know who they are ...'[73]

Here his primary concern is not disaster and death so much as the mass subject in the guise of the anonymous victims of history – from the drones of the pyramids to the statistics of the highways. Yet disaster and death are necessary to evoke this mass subject, for in a society of spectacle this subject often appears only as an effect of the mass media (e.g., the newspaper), or of a catastrophic failure of technology (e.g., the plane crash), or, more precisely, of *both* – that is, of the news of such a catastrophic failure. Along with icons of celebrity such as Marilyn and Mao, reports of disastrous death such as '129 Die' is a primary way that mass subjecthood is produced.

For the most part, then, Warhol evoked the mass subject in two opposite ways: iconic celebrity and abstract anonymity. But he might have come closest to this subject through a

figure somewhere between celebrity and anonymity, that is, through the figure of *notoriety*, the fame of fifteen minutes that, in another famous remark, Warhol predicted for us all. Consider this implicit double-portrait of the mass subject: the most wanted men and the empty electric chairs, the first a kind of American icon, the second a kind of American crucifix. What more exact representation of the dark side of the public sphere at this time could there be than this twinning of iconic criminal and abstract execution?[74]

Gerhard Richter and the Photogenic Image

Warhol points to an unexpected discovery of Pop: affect is not necessarily blocked by banality; in fact a traumatic charge might be conveyed through banality. This effect is probed further by Gerhard Richter, perhaps the greatest artist associated with Pop outside its main axis of London, New York and Los Angeles. Born in East Germany in 1932, Richter was trained in Socialist Realist painting at the Kunstakademie in Dresden. In 1959 he travelled for the first time to West Germany, where he visited the international survey of contemporary art, documenta 2, in Kassel; there he was struck by the gestural abstractions of Pollock and Lucio Fontana, among others. Two years later Richter moved to Düsseldorf in order to retrain in such modernist art at its Kunstakademie (he began to teach there a decade later); at this time he met Konrad Lueg, Sigmar Polke and Blinky Palermo, students of the charismatic Joseph Beuys, who was then involved in Fluxus performance. Richter collaborated briefly with Lueg and extensively with Polke in various events sometimes dubbed 'Capitalist Realist' or 'German Pop'. It was thus in a double crucible – of East and West and of realist painting, Fluxus performance and Pop art – that Richter developed his complex aesthetic.

Richter encompasses not only different styles, from representational to abstract, but also diverse classes of image. Influenced by Warhol in particular, many of his early canvases are blurry renditions of banal photographs of everyday life, such as newspaper photos, magazine ads, family snaps, soft-porn shots and aerial views of various cities (Richter is best known for these images), while many of his later canvases recall the old genres of academic painting seen through a fuzzy optic: still lifes, landscapes, portraits, even history paintings. Richter does not collapse low and high categories, as many Pop artists do, so much as he ranges from low to high and back again – back again in so far as his high genres, the landscapes in particular, sometimes approach low forms once more, such as the pretty postcard or the sentimental photo.

In this way Richter places photography and painting at the same level ('I consider many amateur photographs better than the best Cézannes,' he remarked in 1966), even as he also affirms the fragile autonomy of 'traditional art' as such ('in every respect, my work has more to do with traditional art than anything else,' he commented in 1964, not long after the blurry representations first appeared).[75] Along similar lines Richter shows contradictory allegiances to divergent traditions of art, historical and avant-garde, with echoes of the romantic landscapes of Caspar David Friedrich as well as the conceptual provocations of Duchamp, of the colour-field abstractions of Newman as well as the murky media images of Warhol. It is as though Richter wanted to run these different strands together, to put the exalted pictorial formats of the 'Northern Romantic Tradition' from Friedrich through Newman through the anti-aesthetic paces of Warholian Pop.[76] 'All that I am trying to do in each picture', Richter has stated in a characteristic manner at once modest and grand, 'is to bring together the most disparate and mutually contradictory elements, alive and viable, in the greatest possible freedom' (Gerhard Richter, *The Daily Practice of Painting: Writings 1962–1993*, 1995, 166; hereafter *DP*). Yet to what ends does he juxtapose painting and photography, handmade and readymade, abstraction and figuration? Often his Pop peers seem to celebrate the convergence of these terms; Richter also registers this convergence, but only to complicate it – as if to demonstrate that lyrical painting can still exist not only after Auschwitz but after Warhol as well.

Richter presents not only different kinds but also great numbers of images. In 1962 he began to assemble his *Atlas*, a vast compendium of public and private photos, a fraction of which has served as the basis of his paintings. In 1989 Richter described the *Atlas* as 'a deluge of images' with no 'individual images at all', that is, as a compendium whose sheer number of pictures relativizes each one (*DP* 199). Benjamin Buchloh has written incisively of this archive as an 'anomic' repertoire without apparent law or rule and, except for an early juxtaposition of concentration-camp and porn photos, it does not contain much in the way of significant montage.[77] 'It's not a just image', Jean-Luc Godard once remarked, famously, in

his 1970 film *Vent d'est*, 'it's just an image'; and throughout his early period Richter seemed to participate in this same questioning of the truth-claims of photographic representation. In 1964, for example, he appeared to subscribe to a Warholian aesthetic of indifference: 'I like everything that has no style: dictionaries, photographs, nature, myself and my paintings' (*DP* 35). And in 1972 he spoke of the photograph as a 'pure picture' 'free of all the conventional criteria I had always associated with art: It had no style, no composition, no judgment' (*DP* 73). This indifference was a common stance in the 1960s and it was often approached through 'deskilling' operations, such as the appropriations of media images in Pop paintings; the use of everyday photos was a related move. 'I hate the dazzlement of skill,' Richter stated in 1964; painting from photos was 'the most moronic and inartistic thing that anyone could do' (*DP* 23). At the same time, of course, he is a virtuoso painter and his paintings are painstakingly produced. Thus Richter worked not to undo the

truth-claims of representation so much as to suspend the Godardian alternative mentioned above – to make 'a just painting' (à la Lichtenstein perhaps) that is also 'just a painting' (à la Warhol perhaps).

More is involved in Richter, then, than the cool pose of the typical Pop artist. For one thing he regards the partial disconnection between work and self effected by his found images and mechanical facture as a kind of *protection*. Throughout the 1960s he spoke of his encounter with photography in traumatic terms: 'For a time I worked as a photographic laboratory assistant: the masses of photographs that passed through the bath of developer every day may well have caused a lasting trauma' (*DP* 22). The trauma here is not simply the photographic usurpation of the representational function of painting anticipated long ago by Baudelaire; in fact Richter unsettles the certainty of this historical fact. Nor is it quite the psychic shock delivered to the subject by the camera as described by Barthes in *Camera*

Lucida. Rather, the trauma of photography for Richter lies both in its sheer proliferation ('the masses of photographs') and in its transformation of appearance ('the bath of developer'). As Buchloh has suggested, this reaction brings him closer to Siegfried Kracauer than to Baudelaire or to Barthes. 'The world itself has taken on a "photographic face",' Kracauer wrote in his great essay on photography (1927): *'It can be photographed because it strives to be absorbed into the spatial continuum which yields to snapshots ... That the world devours them is a sign of the fear of death. What the photographs by their accumulation attempt to banish is the recollection of death, which is part and parcel of every memory image.'*[78]

Like Warhol, Richter documents the 'photographic face' of the modern world disclosed by Kracauer; in some ways he accepts the Kracauerian opposition between the photograph and the 'memory image'. Yet, intermittently, Richter also works to reveal the deathliness of this photographic face, to overcome the apparent opposition of photography and memory, indeed to render the photograph mnemonic *in* painting, *as* painting.[79] For instance, his 1988 suite of images concerning the demise of the radical Baader-Meinhof Group, *18. Oktober 1977*, revives, however momentarily, the old category of history painting, for here Richter effectively transforms ephemeral media photographs into potent memory images. These paintings reveal a historical condition of post-war Germany – that these radicals remain 'unburied', that the question of fascism persists.

How are we to understand his intimation of both a traumatic dimension in photography and a protective potential in painting? For Richter the trauma seems to involve banality – this is a key concern of his Pop too – which he treats both in content and in form. One instance of banal content is the candelabra in *Flemish Crown* (1965), an epitome not only of a homey thing but of petit-bourgeois taste at its homeliest. Yet Richter is also interested in banality that is formal, such as when a camera turns us into an image, congeals our life-being into a cliché. This banalization occurs in the existential flashing of the camera stressed by Barthes, but also, even before, in our automatic posing in front of the apparatus – that is, in our formal conformity with the photographic face of the world. Richter has long tracked our self-fashionings according to stereotypes, sometimes in a manner that borders on artistic travesty. For example, his can-can

... has a great deal to do with imprecision, uncertainty, transience, incompleteness' (DP74). 'All that is, seems and is visible to us because we perceive it by the reflected light of semblance. Nothing else is visible. Painting concerns itself, as no other art does, exclusively with semblance (I include photography, of course)' (DP181). For Richter the photograph cannot deliver semblance because 'the camera does not apprehend objects, it sees them' (DP35). That is, he regards photography as too implicated in contemporary semblance to capture it on its own; indeed it provides the very consistency of 'reflected light' that it is the task of the painter in turn to reveal; and it is this 'photo-genesis' of the world that Richter strives to paint.[80] Thus his art is less a critique of spectacle than a phenomenology of mediated appearance, of a world become Pop. The semblance that concerned the Romantic painter Friedrich is of a primary nature still illuminated by the light of God; this light is still numinous. The semblance that concerns the Pop

painter Richter is of a second nature bathed in the glow of the media, a culture of visualities that are photographic and filmic, videographic and electronic. 'Photographs are almost Nature,' Richter has commented (DP187) and many of his natural subjects are presented as already mediated – through magazine ads, tourist scenes and otherworldly landscapes, such as his brilliant *Moonscapes* (1968), images that exist in the first instance only as relayed.

The penetration of appearance not only by photography but by the commodity-image is a given of the Pop moment out of which Richter developed. Just as Minimalist art often adapted the serial logic of industrial production, so Pop art often adapted the simulacral nature of the commodity-image. As we saw with Warhol, such simulation is often taken to trump representation, to undercut its referential claims. Yet, like Warhol, Richter does not simply surrender painting to the simulacral order of our image-world: just as he sometimes wrests an auratic uniqueness from tacky

Ballet Dancers (1966) and soft-porn *Bathers* (1967) are degraded descendants of related subjects by Degas and Cézanne and the travesty is patent in the young strip-teaser of *Olympia* (1967), which updates and transplants the Manet prostitute to the middle-class home. This formal banality is most evident in *Eight Student Nurses* (1966), his Warholian rendering of the young victims of the serial killer Dr Richard Speck who were already 'shot' serially in the nursing yearbook that Richter used as his media source. Yet such banality is perhaps most chilling in *Three Sisters* (1965): posed in matching dresses on a family couch, these girls appear nearly cloned, as if conformity in appearance were the only way for them to attain social recognition, to be seen, at all.

'It's all evasive action,' Richter once remarked of such banality in his art (DP62). Perhaps its role, then, is defensive as well as traumatic; and perhaps holds the same for the function of photography in his art. Painting from photographs

freed Richter from 'conscious thinking', he wrote early on; it is neutralized and therefore painless' (DP30). Again like Warhol, he transforms the photograph, the very vehicle of the traumatic threat here, into a defence against this same threat; certainly the greys and the blurs in his painting, both of which register as photographic, can be muting in effect. Of course these elements can function in other ways too: the greys can suggest both the material actuality of paint and the mediated appearance of print, and the blurs can evoke both a memory and a fading of memory, both an obscene scene and an occluded one and so on. Yet, however different these effects, they are all common aspects of the photographic face of the world: they suggest how our very perception, memory and unconscious have become, at least in part, photographic in semblance, and again this is a fundamental demonstration of Pop. For Richter this photographic semblance produces a form of doubt (epistemological, even ontological) that his painting also works to register: 'My own relationship to reality

reproductions, so too does he sometimes restore a piercing referentiality to flimsy representations. Even more than his Pop peers, then, Richter insists on painting as the medium that can still reflect on semblance. 'In order for history to present itself', Kracauer wrote, 'the mere surface coherence offered by photography must be destroyed.'[81] Similarly for Richter 'the picture is the depiction and painting is the technique for shattering it' (*DP* 227). In other words, the photograph delivers a resemblance that the painting in turn must open up, even break apart, in order that semblance – the characteristic nature of contemporary appearance – might be revealed to us. In Richter Pop art reflects not only on how appearance is transformed in consumer society, but also on how we can see, even understand, this transformation: here Pop becomes a philosophical art.

Ed Ruscha and the Cineramic Image

Ed Ruscha also reflects on a world transformed in appearance,

but in his case the primary medium of the transform-ation is not the magazine, the comics, the news photo or the snapshot, but a combination of the automobile, the storefront, the billboard and the cinema, or rather the effects of this combination on the distinctive visuality of Los Angeles, the capital of spectacle in post-war America. Ruscha varies some themes of his Pop colleagues and invents others: like Lichtenstein, he presents banal subjects, but with an enigmatic twist and, like Hamilton, he superimposes design and painting, but with an apparent integration that seems finally to resolve seeing and reading into one form of scanning. 'I began to see the printed word', Ruscha once remarked, 'and it took over from there.'[82]

Born in 1937, Ruscha left Oklahoma in 1956 to attend Chouinard Art Institute in Los Angeles. During the Depression and after World War II, Okies often struck out for California, but artists have tended in the opposite direction, towards New York.[83] His relative disinterest in the East

includes Europe (Ruscha travelled there in 1961, only to remark, rhetorically, that 'there was no art anywhere except in America' –Ed Ruscha, *Leave Any Information at the Signal: Writings, Interviews, Bits, Pages*, 2002, 121; hereafter *LA*) and it was indeed in L.A. that the two events most formative to his art occurred: the first Warhol exhibition at the Ferus Gallery in summer 1962 (where the full array of single 'Campbell's Soup Cans' was first exhibited) and the Duchamp retrospective curated by Walter Hopps at the Pasadena Museum of Art in the autumn of 1963.[84] An earlier catalyst was his discovery of Johns (specifically *Flag*, 1954–55, and *Target with Four Faces*, 1955) in *Print Magazine* in 1957; tellingly, this influence came to him through reproduction.

During this initial period Ruscha worked as a graphic artist: he designed ads briefly, then book covers and magazine layouts (including *Artforum* from 1965 to 1967). While other Pop artists used fragments of print sources, Ruscha often adapted an entire graphic look. As a result some of his early paintings, such as *Annie* (1962), partake equally of abstraction (two broad fields of primary colours – yellow above, blue below) and of design (both the name of the Little Orphan and the plump font of her comic, here in red on the yellow field). In his formats Ruscha registers a convergence between abstract painting and commercial design that is even more thorough than in Hamilton or in Lichtenstein. Yet in his procedure there is no such convergence at all: 'Abstract Expressionism collapsed the whole art process into one act', in a manner foreign to the methodical calculation of design work, Ruscha has suggested; 'I wanted to break it into stages, which is what I do now' (*LA* 228).

His work is indeed premeditated, especially the photo-books, which include *Twentysix Gasoline Stations* (1962), *Some Los Angeles Apartments* (1965), *Every Building on the Sunset Strip* (1966), *Thirtyfour Parking Lots* (1967), *Nine Swimming Pools and a Broken Glass* (1968) and *Real Estate Opportunities* (1970). 'I don't even look at it as photography,' Ruscha comments; 'they're just images to fill a book' (*LA* 49), the parameters of which are set beforehand. Although the subjects are hardly random – several books survey characteristic spaces of L.A. – the presentation is as 'neuter general' as possible: 'they're a collection of "facts" … a collection of "readymades" ' (*LA* 40, 26). Like Warhol and Richter, the young Ruscha dampened his style and statement

('it is not important who took the photos' – *LA* 25) in a way that nonetheless conveys a distinctive version of both. A deadpanness – funny, desolate, usually both – is conveyed in the homely shots of solitary gas stations, the aerial images of empty parking lots and so on; and the apparently arbitrary numbers (why exactly nine pools?) only add to the effect of blank absurdity.

Although his designs are predetermined, an ambiguity often exists within the images or the words or (more often) between the two: both the photo-books and the paintings can produce a flat sort of enigma (here too one feels a connection to Johns). Ruscha speaks of this effect as 'a kind of "huh?" ': 'I've always had a deep respect for things that are odd, for things which cannot be explained' (*LA* 65, 305). Often the 'huh' stems from his use of words, which, as in a 'misspelled grocery sign', might appear both obvious and incorrect, as so many 'incomplete sputterings' or noisome puzzles (*LA* 91, 156). Yve-Alain Bois has underscored how often Ruscha is

drawn to 'noise', to cracks in communication, and some of his verbal works do evoke the poetic figure of the calligram, in which the shape of the text is designed to reinforce the meaning, only to unravel this figure altogether (as Michel Foucault once argued that the word paintings of René Magritte do as well).[85] In Ruscha images and words do not often support one another; rather they stand apart or even in opposition and these crossings cross up the viewer as well.[86] Frequently his words are as suspended in meaning as they are in space. In 1985 he did a painting for a library rotunda in Miami that borrowed a line from *Hamlet*: 'words without thoughts never to heaven go'. This might be taken as his motto, minus the possibility of heaven.

The interest in the odd thing began as an appreciation of the common thing. Early on Ruscha painted some objects 'actual size' (as they are often painted in folk art). For example, in *Actual Size* (1962; see page 91) a fiery can of Spam flies through the space below, while the word 'Spam' appears

in yellow on dark blue in the space above. This image renders the common odd, to say the least (it is also a joke – early astronauts were called 'spam in a can' – that takes on additional meaning with junk e-mail today), and its ambiguity persists: one reason why Ruscha depicts words is that they 'exist in a world of no size' (*LA* 231) and his juxtaposition of 'actual size' and 'no size' renders the pictorial space very uncertain. Does the lower space of *Actual Size* suggest outer space? Does the upper space convey commercial space? How do the two spaces, with paint drips from the upper to the lower, relate to one another?

The potential role of the common as an ambiguous term somewhere between the folk and the Pop is important to consider here. 'Duchamp discovered common objects' (*LA* 330), Ruscha has suggested and, like Johns, Ruscha made them 'the foreground central subject' of his art (*LA* 289).[87] He did so, moreover, in a period when the common had become ever more commodified, the ordinary

REAL

ESTATE

OPPORTUNITIES

ever more standard. (Warhol once suggested the term 'Commonist' as a replacement for 'Pop', as if a collective viewer might still be wrested from consumerism.)[88] Like Hamilton, Lichtenstein and Rosenquist, Ruscha also plays with reified language – with slogans, jingles and the like. He is drawn to terms that hover on the edge of cliché and sometimes he paints them as if to pull them back from this condition via ambiguity and sometimes to push them over, once and for all, into the status of a logo or a brand, along with 'Standard', '20th Century Fox' and the other trademarks that he has depicted. Occasionally, too, Ruscha underscores the paradoxical animation that words and things assume as they become reified in this way: he presents them, sometimes keyed up like special effects, as if they were the only public figures left to portray, the truly dominant features of the landscape, and in L.A. this some-times seems to be the case (the famous Hollywood sign that presides over the city recurs in his work). Ruscha is attracted to hybrid word-images, or

Ed RUSCHA *Every Building on the Sunset Strip* [detail], 1966
Ed RUSCHA *Real Estate Opportunities*, 1970

what he calls 'the icon/logo concept' (*LA* 275); perhaps, like Hamilton, he anticipates our contemporary version of this mixed sign in the computer icon and pop-up.[89] Ruscha also depicts other things in the grip of commodification; indeed, he renders landscape *in toto* as so much real estate (e.g., 'some Los Angeles apartments'). Perhaps in landscape painting, at least since Thomas Gainsborough, land has appeared as property, but with Ruscha landscape becomes real estate *tout court*: in some of the photo-books it is even gridded and numbered as such (e.g., 'every building on the Sunset Strip').[90]

Ruscha often features structures typical of L.A., that 'ultimate cardboard cut-out town': 'Los Angeles to me is like a series of storefront planes that are all vertical from the street and there's almost like nothing behind the façades' (*LA* 244, 223). This flat frontality makes his strange photo-books like *Every Building on the Sunset Strip* suddenly appear to be obvious ways to present the material (here the even buildings

appear in a strip along the top edge of the book and the odd appear, upside down, along the bottom edge). His L.A. is also a city of billboards and Ruscha seems to fashion his painting after these large screens suspended in the landscape too. Like a painting, Ruscha comments, a billboard is 'paint on a lifted-up surface', 'a backdrop for the drama that happens' and this is how the space in his paintings often serves as well (*LA* 165, 265). Certainly his focus on storefronts and billboards implies an automotive point of view and as Rosalind Krauss has suggested, the car might be his primary 'medium', the unseen vehicle of the L.A. paintings that depict various signs at different scales amid broad horizons and vast skies. The car is also 'a missing link in the [photo] books', Henri Man Barense remarks, 'the conduit between the pools, apartments and, of course, the parking lots and gas stations' (*LA* 213). 'I think of your work', Bernard Blistène comments to Ruscha, 'as a huge field in which you drive – and of the canvas as a kind of windshield' (*LA* 304).[91] Along with the billboard, Ruscha

does rethink the old window model of painting in terms of the windshield. More than most cities, Los Angeles is a horizontal expanse across which one drives from horizon to horizon: 'It's the idea of things running horizontally and trying to take off,' Ruscha remarks. 'The scale and the motion both take part in it' (*LA* 161).[92] This spatiality is a prime subject of his art.

Ruscha also evokes a design culture characteristic of L.A.: '"Hollywood" is like a verb to me,' he has commented. 'They do it with automobiles, they do it with everything that we manufacture' (*LA* 221). Clearly such connoisseurship of car models, surfboards and the like is important to Ruscha (among his studio notes is this one worthy of Banham or Hamilton: 'Core of my aesthetic is the shape of 48 Ford gearshift knob vs 48 Chevy gearshift knob' – *LA* 399).[93] Yet even more than this customizing of special consumer items, Ruscha draws on the specific visuality of cinema, its 'celluloid gloss' and space (*LA* 277). This visuality is at once

deep and superficial, illusionist and flat: in the movies space is surface and vice versa and the words (as in credits and subtitles) can appear in the same register as the images. This is to say, simply, that film is projected space and Ruscha intimates this space often in his work. In *Large Trademark with Eight Spotlights* (1962) the yellow spotlights seem to originate in the distance, cut diagonally across the deep space towards us and arrive on the picture plane as though on a movie screen: the lights align with its surface, around the emblem of 20th Century Fox, which also appears to be projected – as if pictorial light and space were here subsumed by the cinematic versions of these qualities. 'I've been influenced by the movies, particularly the panoramic-ness of the wide screen,' Ruscha has remarked. 'Most of my proportions are affected by the concept of the panorama' (*LA* 291, 308). Committed to the landscape mode, he shows us horizontal spaces transformed by Cineramic spectacle, with brilliant sunsets and vast dimensions that often convey a 'deeply Californian version of infinity'.[94] 'Close your eyes and what does it mean, visually?' Ruscha asks about this Hollywood Sublime; 'it means a way of light.' It is a light that is true and

illusory at once, the stuff of Hollywood dreams: 'If you look at the 20th Century Fox, you get this feeling of concrete immortality' (*LA* 221). Yet at the same time Ruscha presents this dream-space as thin and fragile (one of his stretch sunsets contains the words 'eternal amnesia' in small print at the bottom) and sometimes there is a hint of catastrophe or 'crash' in his pictures too (*LA* 214). Like Nathaniel West and Joan Didion, Ruscha suggests that Los Angeles is a mirage and California a myth – a façade about to crumble into the desert, a set about to liquefy into the sea.

Robert Venturi, Denise Scott Brown and the Postmodern Absorption of Pop

If Ruscha registers how the nexus of cars, commodities, advertising and movies had transformed the built environment by the moment of Pop, Robert Venturi and Denise Scott Brown in turn assume this transformation as the basis of further architecture and urbanism. If his *Complexity and*

Contradiction (1966) was an early critique of the apparent disconnection of modern design from society and history alike, their *Learning from Las Vegas* (1972; hereafter *LV*) was an early advocacy of postmodern design as a rapprochement with both, and Pop influenced their thought (*Learning from Las Vegas* cites Ruscha in particular).[95] According to Venturi and Scott Brown, modern design lacked 'inclusion and allusion' – inclusion of popular taste and allusion to architectural tradition – and postmodern design came into being to correct these faults. Above all, the failure of modern architecture stemmed from its refusal of 'symbolism', or historical ornament, in favour of 'expressionism', or the use of 'architectural elements' alone to convey the meaning of a building (*LV* 101). In this way, they claim, the modern paradigm of 'the duck', in which the form expresses the building abstractly, must cede to the postmodern paradigm of 'the decorated shed', a building with 'a rhetorical front and conventional behind'. 'The duck is the special building that

is a symbol,' Venturi and Scott Brown write in a famous definition; 'the decorated shed is the conventional shelter that *applies* symbols' (*LV* 87).

Learning from Las Vegas originated as a studio, conducted at Yale and in Las Vegas, in autumn 1968. Like Banham a decade before them, Venturi and Scott Brown mark their difference from the modern movement through a strategic turn to Pop imageability:
'*We came to the automobile-oriented commercial architecture of urban sprawl as our source for a civic and residential architecture of meaning, viable now, as the turn-of-the-century industrial vocabulary was viable for a Modern architecture of space and industrial technology 40 years ago*' (*LV* 90).
Yet Banham sought to update the expressionistic imperative of modern architecture vis-à-vis a futuristic commitment to technology – as such his position is truly Pop. For their part Venturi and Scott Brown shun both the expressionistic and the futuristic; indeed they oppose any 'prolongation' of the modern movement and as such their position is distinctly postmodern (*LV* xiii). They accept, not only as given but as desired, the identification of 'the civic' with 'the commercial': however 'ugly and ordinary' the strip and the suburb are, they are taken not merely as normative but as exemplary. In short, theirs is an architectural-urbanist apologia for the consumerist landscape produced by the nexus of car, commodity, advertising and movies.

'Architecture in this landscape becomes symbol in space rather than form in space,' Venturi and Scott Brown declare. 'The big sign and the little building is the rule of Route 66' (*LV* 13). Given this 'rule', *Learning from Las Vegas* often conflates trademarks with public symbols: 'The familiar Shell and Gulf signs stand out like friendly beacons in a foreign land' (*LV* 52).[96] It also often leaps to conclusions: given the vast and fast 'autoscape', only a scenographic architecture can 'make connections among many elements, far apart and seen fast' (*LV* 9). In effect, Venturi and Scott Brown translate important insights concerning this 'new spatial order' into an affirmation of 'the brutal auto landscape of great distances and high speeds' (*LV* 75). This is to naturalize a landscape that

Ed RUSCHA Hollywood Study # 8, 1968

is neither natural nor necessary; it is also to instrumentalize a sensorium of consumerist distraction in design, as they urge architects to think in terms of 'a sequence played to the eyes of a captive, somewhat fearful, but partly inattentive audience, whose vision is filtered and directed forward' (*LV* 74).[97] Here the Miesian motto of modernist clarity in architecture – 'less is more' – becomes a mandate of post-modernist distraction in design – 'less is a bore' (*LV* 139).

Despite its critique of modern architecture, *Learning from Las Vegas* draws its strategy from Le Corbusier. Again, in *Vers une architecture* and elsewhere, Le Corbusier juxtaposed classical structures and machinic commodities, such as the Parthenon and the Delage sports car, in order to advance the new monumentality of the Machine Age. Here, unlike Banham again, Venturi and Scott Brown propose a series of related analogies and they are not altogether ironic: 'Las Vegas is to the Strip what Rome is to the Piazza' (*LV* 18); billboards punctuate Las Vegas as triumphal arches

punctuate ancient Rome; signs mark the Strip as towers mark San Gimignano; and so on (*LV* 106, 107, 117). (Is it coincidental that Venturi and Scott Brown favour the Rome of the Counter-Reformation, the capital of churchly spectacle?) If Le Corbusier moved to classicize the machine (and vice versa) in the First Machine Age, Venturi and Scott Brown move to classicize the commodity-image (and vice versa) in the First Pop Age. Sometimes the analogy between Las Vegas and Rome slips into an equation: the Strip is our version of the Piazza and so the 'agoraphobic' autoscape might as well be accepted (*LV* 49). 'Americans feel uncom-fortable sitting in a square,' Venturi and Scott Brown tell us; 'they should be working at the office or home with the family looking at television.'[98]

On this point *Learning from Las Vegas* is nothing if not straightforward: Venturi and Scott Brown wish to 'enhance what is there', that is, to affirm the common-as-commodified – a slight yet significant difference from the 'Commonist' Pop

of Warhol, Ruscha and others (*LV* 3). And here they quote the developer Morris Lapidus as a guide: 'People are looking for illusions ... Where do they find this world of illusions? ... Do they study it in school? Do they go to museums? Do they travel to Europe? Only one place – the movies. They go to the movies. The hell with everything else' (*LV* 80). A new mode of social inscription is affirmed here, one that Pop works to explore, if not critically, then at least ambivalently (as we saw with Hamilton especially). For its part postmodern architecture à la Venturi and Scott Brown is placed in its service – to design its appropriate byways, in effect. Here, too, the postmodern critique of cultural elitism becomes a problematic form of manipulative populism. And yet how popular, let alone sincere, is this populism? If Hamilton practised an 'ironism of affirmation', Venturi and Scott Brown propose an affirmation of irony: 'Irony may be the tool with which to confront and combine divergent values in architecture for a pluralist society' (*LV* 161). But this 'double-functioning' of postmodern design is actually a double-coding of cultural cues – 'allusion' to architectural tradition is offered to an educated elite, 'inclusion' of commercial kitsch to everyone else – that reaffirms rather than over-comes class lines. This pseudo-populism only became dominant ten years later under Ronald Reagan, as did the neo-conservative equation of political freedom and free markets presented in *Learning from Las Vegas*. In this regard Venturi and Scott Brown do count as an avant-garde, but an avant-garde of the Right.

Venturi and Scott Brown cycle Pop icons back to the consumerist environment from which they first emerged – they are built back in, as it were, structurally. Here, then, Pop becomes tautological and the popular no longer challenges the official. In the form of postmodern design, Pop becomes a recipe of accommodation to the 'ugly and ordinary' relieved, again for elite taste, by a spicing of historical allusions. At this point Pop loses whatever edge it had: in its postmodern make-over it is a style of the status quo.

Robert VENTURI, Denise SCOTT BROWN, John IZENOUR Caesars Palace sign, Las Angeles, c. 1965–66, from *Learning from Las Vegas*, 1972

Peter BLAKE Road scene, from *God's Own Junkyard: The Planned Deterioration of America's Landscape*, 1964, reproduced in Venturi, et al., *Learning from Las Vegas*, 1972

1 This list overlooks many singular artists who developed Pop-like positions before, after or during the Pop heyday, such as the Americans Bruce Conner, Jess, Ed Keinholz, Ray Johnson and Jack Smith, the Swede Öyvind Fahlström, the English Malcolm Morley, the French Niki de Saint Phalle, the German Richard Lindner, the Swiss Peter Stämpfli – and this is only a beginning. For helpful readings of this text I thank Ian Farr and Mark Francis.

2 This is particularly true of French and German artists. If some associated with Nouveau Réalisme, such as Arman and Spoerri, were ambivalent about this consumer society, others such as Jacques de la Villeglé and Raymond Hains were critical of it. Yet, on the score of opposition to consumer society, the true enemy twins of the Pop artists were the Situationists led by Guy Debord. A figure such as Jean-Luc Godard, then, might be positioned somewhere between the Situationists, who were contemptuous of 'spectacle', and the Pop artists, who were often seduced by it. Godard was close enough to the Situationist critique of spectacle to be condemned by the Situationists, but also close enough to the Pop exploration of spectacle to count among the great inventors of the Pop image (at least from *Breathless* [À bout de souffle, 1960] through *Week-end* [1967]). I regret that my focus on art prevents an account of his extraordinary cinema, which is nonetheless represented elsewhere in the book.

3 Lawrence Alloway, 'The Long Front of Culture', *Cambridge Opinion*, no. 17 (1959).

4 See Reyner Banham, *Theory and Design in the First Machine Age* (London: Architectural Press, 1960).

5 See Robert Venturi, Denise Scott Brown and Steven Izenour, *Learning from Las Vegas* (Cambridge, Mass.: MIT Press, 1972); hereafter abbreviated *LV* in the text.

6 A brief note on the historiography of Pop art. The key group exhibitions (see bibliography for full details) include: 'New Painting of Common Objects', Pasadena Art Museum, 1962; 'The Popular Image', ICA, London, 1963; 'Six Painters and the Object', Guggenheim Museum, New York, 1963; 'The New Generation: 1964', Whitechapel Art Gallery, London, 1964; 'New York Painting 1940–1970', Metropolitan Museum, New York, 1969; 'American Pop Art', Whitney Museum, New York, 1974; 'Blam! The Explosion of Pop, Minimalism and Performance 1958–1964', Whitney Museum, 1984; 'Made in USA: An Americanization in Modern Art. The 50s and 60s', University Art Museum, Berkeley, Los Angeles, 1987; 'The Independent Group: Postwar Britain and the Aesthetics of Plenty', ICA, London, 1990; 'Pop Art: An International Perspective', Royal Academy of Arts, London, 1991; 'Hand-Painted Pop: American Art in Transition 1955–1962', Museum of Contemporary Art, Los Angeles, 1993; 'Les Années Pop', Centre Georges Pompidou, Paris, 2001; and 'Pop Art: US/UK Connectons, 1956–1966', Menil Collection, Houston, 2001. Besides the catalogues of these exhibitions, the key histories and source books (again in English alone) include: Lucy R. Lippard, ed., *Pop Art* (1966; revised 1970); John Russell and Suzi Gablik, eds, *Pop Art Redefined* (1969); Simon Frith, *Art into Pop* (1987); Paul Taylor, ed., *Post-Pop Art* (1989); Marco Livingstone, *Pop Art: A Continuing History* (1990; revised 2000); Steven Henry Madoff, ed., *Pop Art: A Critical History* (1997); and Cecile Whiting, *A Taste for Pop: Pop Art, Gender and Consumer Culture* (1997).

7 Alison and Peter Smithson, 'But Today We Collect Ads', *Ark*, no. 18 (November 1956). Also see Beatriz Colomina, *Privacy and Publicity: Modern Architecture as Mass Media* (Cambridge, Massachusetts: MIT Press, 1994).

8 Richard Hamilton, *Collected Words 1953–82* (London: Thames & Hudson, 1982), 28; hereafter abbreviated *CW*.

9 Alloway, 'The Long Front of Culture'.

10 Banham revised the notion of a cultural continuum slightly: he thought in terms of a plurality of hierarchies, which safeguarded critical judgment. For an excellent account see Nigel Whiteley, *Reyner Banham: Historian of the Immediate Future* (Cambridge, Massachusetts: MIT Press, 2002).

11 Reyner Banham, 'Who is This Pop?' *Motif*, no. 10 (Winter 1962-63), 13

12 One exception here is folk music, the basis of much pop music and common culture from Elvis to Dylan and beyond.

13 Reyner Banham, 'The Atavism of the Short-Distance Mini-Cyclist', *Living Arts*, no. 3 (1964), 92. The second paradox is only apparent in the sense that the embrace of American culture was construed as a critique of high art and to this extent 'Left-orientated'.

14 Banham, *Theory and Design*, 11.

15 Reyner Banham, 'Vehicles of Desire', *Art*, no. 1 (1 September 1955), 3; *Theory and Design*, 132.

16 Banham, 'Vehicles of Desire', 3.

17 Reyner Banham, 'Design by Choice', *The Architectural Review*, 130 (July 1961), 44. I am indebted to Whiteley on this point.

18 Banham, *Theory and Design*, 12.

19 This sentence appears in the original introduction to Banham, *Theory and Design*, 10. Banham betrays little sense that this shift might involve subjugation as much as control.

20 Banham in 1960 cited in Whiteley, *Reyner Banham*, 162.

21 Alison and Peter Smithson, 'Thoughts in Progress', *Architectural Design* (April 1957), 113.

22 Peter Cook, 'Zoom and "Real" Architecture', *Archigram*, 4 (1964).

23 Reyner Banham, *Megastructure: Urban Futures of the Recent Past* (New York: Harper and Row, 1976), 17.

24 Banham in Peter Cook, ed., *Archigram* (London: Studio Vista, 1972), 5.

25 Reyner Banham, 'A Clip-On Architecture', *Design Quarterly*, no. 63 (1963), 30.

26 Paolozzi also made a collage titled *Bunk! Evadne in Green Dimension* (1952), which looks ahead to the famous Hamilton collage *Just what is it that makes today's homes so different, so appealing?* (1956); it also seems to include the image of a Ford. To say 'history is bunk' might be, here, to suggest that 'history' can also be made from 'bunk' – i.e., from the apparent 'nonsense' (one meaning of 'bunk') of media images.

27 Julian Myers, 'The Future as Fetish', *October*, 94 (Fall 2000), 70.

28 For an early critique of this doubling of fetishisms – as a compounding rather than as a critique – see Laura Mulvey, 'Fears, Fantasies and the Male Unconscious, or "You Don't Know What is Happening, Do You, Mr Jones?"', in *Spare Rib* (1973); reprinted in Laura Mulvey, *Visual and Other Pleasures* (Bloomington: Indiana University Press, 1989). Along with the institutional inequality of the art world at the time, this hyper-fetishism might account for the scarcity of Pop artists who are women, though, as Surrealism suggests, women can also produce fetishistic representations of women. One can count prominent female Pop artists on one hand: Pauline Boty (whose life was cut short by leukemia in 1966), Niki de Saint Phalle, Marisol ... Perhaps the economic redomestication of middle-class women as housewives after the war also made Pop representations of consumption less available to women. There is, however, the partial exception of women who were designers – though the best-known, such as Alison Smithson and Ray Eames, were partnered with their husbands. See Cecile Whiting, *A Taste for Pop: Pop Art, Gender and Consumer Culture* (Cambridge: Cambridge University Press, 1997).

29 Walter Benjamin, 'Paris, the Capital of the Nineteenth Century' (1935), in *The Arcades Project*, trans. Howard Eiland and Kevin McLaughlin (Cambridge, Massachusetts: Harvard University, Press, 1999), 8.

30 Foucault once remarked that with Manet the art museum becomes the institutional frame of painting, and Benjamin that its primary value becomes exhibition value; with Hamilton this frame is more purely one of exhibition – the showroom – and exhibition value is pushed towards consumption value. See Michel Foucault, 'Fantasia of the Library' (1967), in *Language, Counter-Memory, Practice* (Ithaca: Cornell University Press, 1977). Benjamin writes of exhibition value, of course, in the 'Artwork' essay (1936) and alludes to consumption value in other notes.

31 See Michel Carrouges, *Les Machines célibataires* (Paris: Éditions Arcanes, 1954).

32 Perhaps Hamilton also had in mind another note concerning the *Large Glass* in which Duchamp speaks of 'the interrogation of the shop window' and 'the coition through the glass pane.' If this is the case, then the 'interrogation' here becomes the enticement of the showroom, a total environment. See *The Essential Writings of Marcel Duchamp* (London: Thames & Hudson, 1975), 74.

33 Banham cited this line in 'Vehicles of Desire'

34 The tabular pictures also suggest an updating of *The Story of the Eye* (1928), where Bataille plays with different conjunctions of sexual objects, human and not.

35 Roland Barthes, *Mythologies* (1957), trans. Annette Lavers (New York: Hill & Wang, 1972), 99. The relation here is one not of direct influence but of parallel responses to similar changes in the object-world.

36 Perhaps not coincidentally, the famous 'Kitchen Debate' between Khruschev and Nixon at the Moscow World's Fair occurred in 1959.

37 In this way Hamilton evokes a world in which artistic aura, fetish objects and the gaze have become confused. For a discussion of this confusion emergent in Surrealism, see my *Compulsive Beauty* (Cambridge, Massachusetts: MIT Press, 1993), 192–206. I stress the fetishistic use of relief and collage here because, in the different context of Constructivism after the Russian Revolution, they were taken up precisely to defetishize the 'bourgeois fetishism' of painting.

38 See T.J. Clark, 'Modernism, Postmodernism and Steam', *October*, 100 (Winter 2002). Early on Hamilton calls this hybrid 'a poster' (*CW* 104).

39 As William Turnbull recalled in 1983: 'Magazines were an incredible way of randomizing one's thinking (one thing the Independent Group was interested in was breaking down logical thinking) – food on one page, pyramids in the desert on the next, a good-looking girl on the next; they were like collages' (in David Robbins, ed., *The Independent Group: Postwar Britain and the Aesthetics of Plenty* [Cambridge, Massachusetts: MIT Press, 1989], 21). On the culture industry see Theodor Adorno and Max Horkheimer, *The Dialectic of Enlightenment* (1944), trans. John Cumming (New York: The Seabury Press, 1972).

40 Perhaps more than any others, these images recall the media collages of Rauschenberg, yet the tabular picture should not be confused with his 'flat-bed picture plane', as Leo Steinberg termed it in 'Other Criteria' (*Other Criteria* [New York: Oxford University Press, 1972]). Both types of picture might be 'horizontal' in operation, not only in the practical sense that they might be assembled on the studio floor, but also in the cultural sense that they might scan across 'the fine/pop art continuum' (as Alloway called it in 'The Long Front of Culture'). Nevertheless, as Hamilton states as early as *Just what is it?*, the tabular image remains pictorial: it is still a vertical picture of a semi-illusionistic space, even though this orientation might be associated with the magazine layout as much as with the painting rectangle (this association might also be distinctive of Pop, especially in Rosenquist and Ruscha). Moreover, the tabular picture is iconographic in a way that Rauschenberg images are not; and in keeping with the I.G., it is also communicative, almost pedagogical, again as Rauschenbergs are not. Further, the desirous eye that Hamilton charts in his pictures is different from 'the vernacular glance' that Rauschenberg evokes in his collages. For further discussion of Rauschenberg see Branden W. Joseph, *Random Order: Robert Rauschenberg and the Neo-Avant-Garde* (Cambridge, Massachusetts: MIT Press, 2003) and Branden W. Joseph, ed., *Robert Rauschenberg* (Cambridge, Massachusetts: MIT Press, 2002).

41 Also in 'Other Criteria' Steinberg argues that, for all its claim to autonomy, late-modernist abstraction (e.g., Kenneth Noland and Frank Stella) is informed by a logic of design, in fact by the very logic of car styling so admired by Banham and Hamilton – again, imagistic impact, fast lines and speedy turnover. That is, he suggests that under the historical pressure of consumer society an ironic identity was forged between modernist painting and its mass-cultural other, whether this other is called 'kitsch' (Greenberg), 'theatricality' (Michael Fried) or 'design'. In this regard what Greenberg and Fried theorize as a strictly optical space of pure painting, Hamilton pictures as a

strictly scopophilic space of pure design; and what Greenberg and Fried theorize as a modernist subject, fully autonomous and morally alert, Hamilton projects as its apparent opposite, a fetishistic subject, openly desirous.

42 'Banality' is a lightning-rod term of the time: witness the controversy sparked by Hannah Arendt with her thesis, in *Eichmann on Trial* (New York: Viking Press, 1963), of 'the banality of evil'.

43 In fact most American Pop artists were deferential to the Abstract Expressionists, whom they felt they must work through, which they sometimes did by way of Johns.

44 See Michael Lobel, *Image Duplicator: Roy Lichtenstein and the Emergence of Pop Art* (New Haven: Yale University Press, 2002); and David Deitcher, 'Teaching the Late Modern Artist: From Mnemonics to the Technology of Gestalt' (Ph.D. dissertation, Graduate Center, City University of New York, 1989).

45 Lobel, *Image Duplicator*, 47.

46 Roy Lichtenstein in John Coplans, 'Talking with Roy Lichtenstein', *Artforum* (May 1967), 34.

47 See Steinberg, 'Jasper Johns: the First Seven Years of His Art', in *Other Criteria*.

48 In this respect Lichtenstein is current with the investigation of realism that Barthes begins to produce in the early 1960s or, in a different vein, with that of Ernst Gombrich, whose *Art and Illusion* (1960) he read at the time.

49 As we will see, Ruscha achieves a related effect with different means.

50 Lichtenstein kept a hand-written list of such terms that begins with 'Thwack' and ends with 'Pok Pok'. Apparently he was interested in how such non-words can also be conventionalized.

51 On this point see the exchange between Michael Fried and Rosalind Krauss in Hal Foster, ed., *Discussions in Contemporary Culture* (Seattle: Bay Press, 1987).

52 Lichtenstein in Coplans, 'Talking with Roy Lichtenstein', 36.

53 When he begins to Lichtensteinize some of these masters directly, with paintings after Picasso, Matisse, Mondrian and others, these connections become too obvious.

54 Steinberg, 'Other Criteria', 88; also see note 40 above. For Steinberg this paradigm signalled a 'postmodernist' break with modernist models of picturing (he was one of the first critics to use the term cogently).

55 See Lobel, *Image Duplicator*, 118–19. As suggested, Hamilton is also alert to the emergence of a hybrid word-image that we scan, as is Ruscha.

56 This is not to say that Warhol did no great work after his shooting: on the contrary, his 'Skulls' (1976) and

'Oxidations' (1978), to name just two series, are magnificent.

57 Roland Barthes, 'That Old Thing, Art', in Paul Taylor, ed., *Post-Pop* (Cambridge, Massachusetts: MIT Press, 1989), 26. With variations this reading is repeated by other theorists such as Michel Foucault, Gilles Deleuze and Jean Baudrillard.

58 Thomas Crow, 'Saturday Disasters', in Annette Michelson, ed. *Andy Warhol* (Cambridge, Massachusetts: MIT Press, 2001), 51, 55, 58, 60.

59 Andy Warhol in Gretchen Berg, 'Andy: My True Story', *Los Angeles Free Press* (March 17, 1963), 3.

60 Andy Warhol in Gene Swenson, 'What is Pop Art? Answers from Eight Painters, Part I', *ARTnews*, 62 (November 1963), 26.

61 Cynical artists such as Jeff Koons and Damien Hirst have since exhausted it vis-à-vis our own hyperconsumer-ist moment. On 'capitalist nihilism' see Benjamin Buchloh, 'The Andy Warhol Line', in Gary Garrels, ed., *The Work of Andy Warhol* (Seattle: Bay Press, 1989) and my 'Dada Mime', *October*, 106 (Fall 2003).

62 Andy Warhol, undated statement cited in Kynaston McShine, ed., *Andy Warhol: A Retrospective* (New York: Museum of Modern Art, 1989), 457.

63 Andy Warhol and Pat Hackett, *POPism: The Warhol 60s* (New York: Harcourt Brace Jovanovich, 1980), 50.

64 Warhol in Swenson, 'What is Pop Art?', 60.

65 Roland Barthes, *Camera Lucida*, trans. Richard Howard (New York: Hill and Wang, 1981), 26, 55, 53. For an account of this connection between Barthes and Lacan, see Margaret Iversen, 'What is a Photograph?' *Art History*, 17, no. 3 (September 1994).

66 Andy Warhol, *The Philosophy of Andy Warhol* (New York: Harcourt Brace Jovanovich, 1975), 81.

67 Warhol in Berg, 'Andy: My True Story', 3.

68 Warhol in Swenson, 'What is Pop Art?', 26.

69 Warhol in Berg, 'Andy: My True Story', 3.

70 Michael Warner, 'The Mass Public and the Mass Subject', in Bruce Robbins, ed., *The Phantom Public Sphere* (Minneapolis: University of Minnesota Press, 1993), 242.

71 See Richard Meyer, 'Warhol's Clones', *The Yale Journal of Criticism*, 7, no. 1 (1994).

72 Warhol in Swenson, 'What is Pop Art?', 60.

73 Andy Warhol in David Bailey, *Andy Warhol: Transcript* (London, 1972), quoted by Benjamin Buchloh in 'Andy Warhol's One-Dimensional Art', in McShine, ed., *Andy Warhol*, 27.

74 When Warhol made his *Thirteen Most Wanted Men* for the 1964

World's Fair in New York, men in power – such as Governor Nelson Rockefeller, Commissioner Robert Moses and elite architect Philip Johnson, who not only helped to design the society of the spectacle, but also sought to represent it (in symbolic events such as the World's Fair) as the fulfilment of the American dream of success and self-rule – could not tolerate it. Warhol was ordered to cover up the image, literally to repress it (which he did, in mockery, with his signature silver paint) and they were not amused when he offered to substitute a portrait of Robert Moses instead.

75 Gerhard Richter, *The Daily Practice of Painting: Writings 1962–1993*, ed. Hans-Ulrich Obrist, trans. David Britt (Cambridge, Massachusetts: MIT Press/London: Thames & Hudson, 1995), 55, 23; hereafter abbreviated *DP* in the text. I am indebted here, as all engaged viewers of Richter are, to the writings of Benjamin Buchloh on the artist.

76 See Robert Rosenblum, *Modern Painting and the Northern Romantic Tradition: Friedrich to Rothko* (New York: Harper & Row, 1975). Especially in his colour-chart paintings Richter seems to fold the etiolated tradition of constructivist painting (e.g., Max Bill) into his mix as well.

77 Benjamin Buchloh, 'Gerhard Richter's *Atlas*: The Anomic Archive', *October*, 88 (Spring 1999).

78 Siegfried Kracauer, *The Mass Ornament*, trans. and ed. Thomas Y. Levin (Cambridge, Massachusetts: Harvard University Press, 1995), 59.

79 Perhaps this ambition is implied, cryptically, in his intention 'not [to] use [photography] as means to painting but [to] use painting as a means to photography' (*DP*, 73).

80 For Richter the semblance of the world is not given; the painter must 'repeat' it or, more exactly, 'fabricate' it in order to capture 'reflected light' as we experience it today, to make it 'valid'. ('I would like to make it valid, make it visible,' he remarked early on of the photograph, in the sense less of affirmation than of understanding [*DP*, 33].) Semblance according to Richter is thus about our apprehension of appearance; it is about human perception, embodiment, agency – not as they are for all time but as they are transformed with social change and technological development.

81 Kracauer, *The Mass Ornament*, 52.

82 Ed Ruscha, *Leave Any Information at the Signal* (Cambridge, Massachusetts: MIT Press, 2002), 151; hereafter abbreviated *LA*.

83 Ruscha: 'In the early 1950s I was awakened by the photographs of Walker Evans and the movies of John Ford, especially *Grapes of Wrath* where the poor 'Okies' (mostly farmers whose land dried up) go to

California with mattresses on their cars rather than stay in Oklahoma and starve. I faced a sort of black-and-white cinematic identity crisis myself in this respect – sort of a showdown with myself – a little like trading dust for oranges. On the way to California I discovered the importance of gas stations. They are like trees because they are there ...' (*LA*, 250).

84 The retrospective coincided with the second Warhol show at Ferus Gallery, which included silkscreens of Elvis and Liz. At this time Ruscha also met Richard Hamilton, who was in town for the Duchamp show.

85 Yve-Alain Bois, 'Thermometers Should Last Forever', in *Ed Ruscha: Romance with Liquids 1966–1969* (New York: Rizzoli, 1993); Michel Foucault, *This is Not a Pipe*, trans. Richard Howard (Berkeley: University of California Press, 1983), 19–31. Ruscha is sometimes called 'the Magritte of the American Highway'.

86 Even his early paintings that spell out onomatopoeic utterances like 'oof' and 'smash' do not appear motivated or grounded.

87 Above I suggested a shift from folk to Pop as the basis of a common culture; although first glimpsed by Banham, this process was more pronounced in the US than in the UK. It is registered, for example, by Johns and, more strongly, by Ruscha. His first group show also curated by Hopps, was called 'New Painting of Common Objects' and it included other connoisseurs of the common such as his friend Joe Goode. On the affirmation of the ordinary in Ruscha see Dave Hickey, 'Available Light', in *The Works of Edward Ruscha* (San Francisco: San Francisco Museum of Modern Art, 1982), 24.

88 Warhol in Swenson, 'What is Pop Art?', 60.

89 As early as 1967 Ruscha depicted the numbers '1984' in a font suggestive of the computer to come. In a late text, 'The Information Man', he mocks, hilariously, another kind of reified language that is statistical and bureaucratic in nature (see *Los Angeles Institute of Contemporary Art Journal*, no. 6 [June–July 1975], 21).

90 Here the suburban, eastern complement of the real-estate photo-books is the Dan Graham piece *Homes for America* made for the December 1966/January 1967 issue of *Arts Magazine*.

91 In at least one instance in Ruscha's work a painting shows a rear-view mirror perspective, with the Hollywood sign seen in reverse at sunset.

92 Also important here is the distracted attention of the driver, which Ruscha also evokes with details that leap out from expanses that go by almost unseen: in the car 'things are automatic ... They go by you so fast

that they seem to have a power.' (*LA*,304).

93 Or again: 'I believe an innocuous piece of industrial design can shape your attitudes of the world. In my case that could be the gearshift knob from a 1950 Ford sedan. It's the little things that matter' (*LA*, 400). His 1975 film *Miracle* tells 'a shaggy dog story about a guy who works on a 1965 Mustang, repairing the carburetor. In the beginning, he's a crude mechanic; but he undergoes a transformation from being this crude mechanic to being a lab technician' (*LA*, 172). 'Finish fetish', the artistic version of this customizing, is evident in several other L.A. artists at this time – Billy Al Bengston, Ron Davis and Craig Kaufmann, to name only a few, who experimented with lacquers, polymers, fibreglass, Plexiglas and the like. On this culture of customizing see the title essay in Tom Wolfe, *The Kandy-Kolored Tangerine-Flake Streamline Baby* (New York: Farrar Strauss & Giroux, 1965); also see Reyner Banham, *Los Angeles: The Architecture of Four Ecologies* (New York: Harper & Row, 1971).

94 Dietrich Dietrichsen in Marika Magers, ed., *Ed Ruscha: Gunpowder and Stains* (Cologne: Walter König, 2000), 9. Ruscha: 'I have a very locked-in attitude about painting things in a horizontal mode. I think I'm lucky that words happen to be horizontal.' Already in Oklahoma 'everything was horizontal' (*LA*, 290, 300).

95 Venturi and Scott Brown might share less with Ruscha on Los Angeles than with Tom Wolfe on Las Vegas, especially the Pop language of his Gonzo journalism. See his 'Las Vegas (What?) Las Vegas (Can't hear you! Too noisy) Las Vegas!!!' in *The Kandy-Kolored Tangerine-Flake Streamlined Baby*). Previously Venturi made the connection to Pop in 'A Justification for a Pop Architecture' in *Arts and Architecture*, 82 (April 1965), as did Scott Brown in 'Learning from Pop' in *Casabella*, 359–360 (December 1971).

96 One might argue that this conflation of trademark and public sign is another lesson of Pop. And yet it is rarely affirmed there: for example, in the 'Monuments' of Oldenburg – his giant baseball bats, Mickey Mouses, hamburgers and the like – the radical inadequacy of such a substitution is underscored.

97 From Donald Appleyard, Kevin Lynch and John R. Myer, *The View from the Road* (Cambridge, Massachusetts: MIT Press, 1964), 5.

98 Robert Venturi, *Complexity and Contradiction in Architecture* (New York: The Museum of Modern Art, 1966), 131.

WORK-S

KEN ADAM
KENNETH ANGER
MICHELANGELO ANTONIONI
DIANE ARBUS
ALLAN D'ARCANGELO
ARCHIGRAM
ARCHIZOOM
& SUPERSTUDIO
ARMAN
RICHARD ARTSCHWAGER
DAVID BAILEY
CLIVE BARKER
BEN
BILLY AL BENGSTON
WALLACE BERMAN
PETER BLAKE
DEREK BOSHIER
PAULINE BOTY
MARK BOYLE
& JOAN HILLS
GEORGE BRECHT
MARCEL BROODTHAERS
R. BUCKMINSTER FULLER
RUDY BURCKHARDT

DONALD CAMMELL
& NICOLAS ROEG
PATRICK CAULFIELD
CÉSAR
JOHN CHAMBERLAIN
BRUCE CONNER
SISTER CORITA
ROGER CORMAN
ROBERT CRUMB
GUY DEBORD
JIM DINE
WALT DISNEY
IMAGINEERING
ROSALYN DREXLER
MARCEL DUCHAMP
WILLIAM EGGLESTON
ERRÓ
ÖYVIND FAHLSTRÖM
ROBERT FRANK
LEE FRIEDLANDER
JEAN-LUC GODARD
ERNÖ GOLDFINGER
JOE GOODE
DAN GRAHAM

RED GROOMS
RAYMOND HAINS
RICHARD HAMILTON
DUANE HANSON
NIGEL HENDERSON
DAVID HOCKNEY
HANS HOLLEIN
DENNIS HOPPER
ROBERT INDIANA
ALAIN JACQUET
JESS
GÉRARD JOANNÈS
JASPER JOHNS
RAY JOHNSON
ALLEN JONES
ASGER JORN
ALEX KATZ
EDWARD KIENHOLZ
R.B. KITAJ
WILLIAM KLEIN
YAYOI KUSAMA
GERALD LAING
JOHN LENNON
ROY LICHTENSTEIN

KONRAD LUEG
JOHN McHALE
CHARLES MOORE
MALCOLM MORLEY
CLAES OLDENBURG
EDUARDO PAOLOZZI
D.A. PENNEBAKER
PETER PHILLIPS
MICHELANGELO PISTOLETTO
SIGMAR POLKE
CEDRIC PRICE
ARTHUR QUARMBY
MEL RAMOS
ROBERT RAUSCHENBERG
MARTIAL RAYSSE
RON RICE
GERHARD RICHTER
LARRY RIVERS
JAMES ROSENQUIST
MIMMO ROTELLA
ED RUSCHA
LUCAS SAMARAS
PETER SAUL
CAROLEE SCHNEEMANN

KURT SCHWITTERS
GEORGE SEGAL
COLIN SELF
MARTIN SHARP
JACK SMITH
RICHARD SMITH
ALISON & PETER SMITHSON
DANIEL SPOERRI
FRANK TASHLIN
PAUL THEK
WAYNE THIEBAUD
JOE TILSON
JEAN TINGUELY
THE VELVET UNDERGROUND
VENTURI, SCOTT BROWN &
ASSOCIATES
JACQUES DE LA VILLEGLÉ
WOLF VOSTELL
ANDY WARHOL
ROBERT WATTS
JOHN WESLEY
TOM WESSELMANN
ROBERT WHITMAN
GARRY WINOGRAND

REVOLT INTO STYLE

During the 1950s the idea of Pop was formed through a focus on the specifically American vernacular cultures of ads, movies, automobile styling and popular music. Hollywood and Disneyland turned American family life into melodrama and cliché, while the look of magazines, especially the widespread use of photography, was absorbed into the field of visual art, as it turned away from a dependence on European archetypes, and towards an analysis of the epic and iconic qualities of the everyday. The defining figure of the teenager was invented, while a bohemian rebellion against the stasis and complacency of family values was articulated, especially in San Francisco, the city of the Beats, by artists and writers such as Jess, Allen Ginsberg, Jack Kerouac and Kenneth Anger. Ironically it was in Europe that the first intellectual and visual critiques were made of modern American culture, especially in London, through the activities and influence of the Independent Group. Just as the attitude of Marlon Brando, James Dean and Elvis Presley turned into an image, so the revolt against bourgeois standards was itself transformed into style.

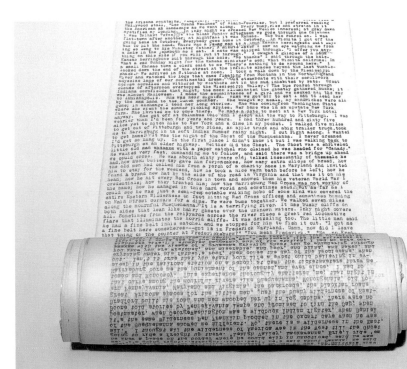

Jack KEROUAC
Original typescript of *On the Road*
1951
Teletype printed paper scroll
1. 36.5 m [120 ft]

Preserved as a 120-foot long scroll, this manuscript is the relic of Kerouac's frenetic typing of *On the Road* during three weeks of caffeine-induced wakefulness in 1951 at the New York apartment of Carolyn, wife of his friend Neal Cassady, on whom the book's young narrator Dean Moriarty is modelled. A continuous stream of prose, using no paragraph marks and little punctuation, its jump-cut, fast-paced fictional narrative conveys Kerouac's first-hand experience of travelling across the United States, like a 'beat' down-and-out, in an aimless search for life and intensity. Edited and published six years later, *On the Road* soon became a cult book, turning the values of the Beat poets, musicians and artists (for whom 'beat' had many more connotations, such as the rhythm of blues and jazz) into a widespread social phenomenon. In another manuscript (*c.* 1952–54), for the *Book of Dreams*, Kerouac cut and pasted newspaper fragments of headlines, hip slogans and advertising jingles. Media messages typeset in display fonts were transformed into collage-poems.

opposite
Robert <u>FRANK</u>
Santa Fe, New Mexico
1955–56
Gelatin silver print
30 × 40 cm [12 × 16 in]
One of 83 photographs published in *Les Américains*, Robert Delpire,
Paris, 1958; *The Americans*, Grove Press Inc., New York, 1959, with
an introduction by Jack Kerouac

Originally from Switzerland, after travelling the world Frank came to the United States in 1953. From 1955 to 1957, aided by a Guggenheim grant, he traversed the country observing with his camera the ordinary realities that were seldom if ever portrayed by mainstream photography of the time. The resulting book, *The Americans*, was originally published in France as a socio-political survey with a text by Alain Bosquet, then reissued in the US without the text and with a new introduction by Jack Kerouac, in which he described the photographer as sucking 'a sad poem right out of America on to film, taking rank among the tragic poets of the world'. Vastly influential as a document of real, lived experience, *The Americans* also closely observed post-war capitalism's rapid transformation of the landscape. Here Frank captures the iconic quality of a gasoline station, with its huge double-message sign and robot-like pumps – a subject later explored in different ways by Pop artists such as Ed Ruscha, Allan d'Arcangelo and Alain Jacquet.

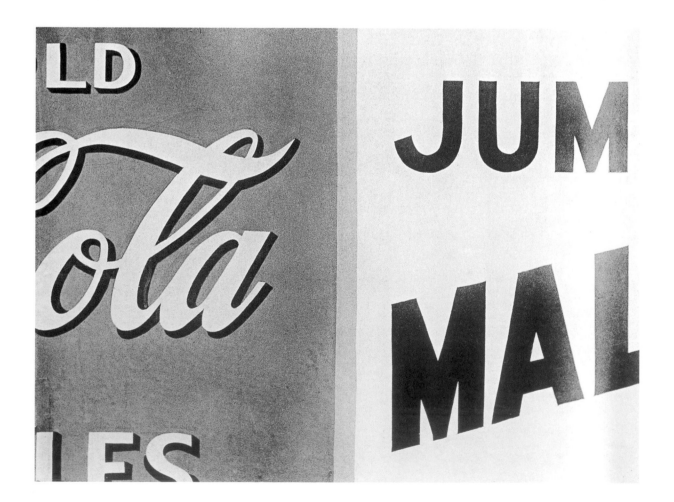

opposite

Rudy BURCKHARDT

Jumbo Malted, New York

c. 1940

Gelatin silver print

28 × 35.5 cm [11 × 14 in]

Like Walker Evans before him, in the early 1940s Swiss-born Rudy Burckhardt began
to photograph the hand-painted advertising billboards that increasingly dominated
American roadsides and city main streets. One famous photograph of Astor Place,
New York (1947) he nicknamed the 'Coca-Cola Goddess', its central subject being
the huge advertisement that dwarfs and conceals most of the buildings over which
it looms. The photograph shown here is composed of a detail from one of Burckhardt's
series of views of New York street stalls and shops, where he focused on the smaller-
scale advertising logos and painted signs designed to lure passers-by in a more
subliminal way. Here he zooms in on details of the brand signs for Coca-Cola and
a popular malted milk drink of the time, in a composition that foreshadows the work
of Pop painters in the early 1960s.

opposite
William <u>KLEIN</u>
Broadway by Light [details]
1958
35mm film, 14 min., colour

Klein's first film, *Broadway by Light* was released two years after the publication of his photo book *Life is Good and Good for You in New York: Trance Witness Revels* (Éditions du Seuil, Paris, 1956), a project financed by *Vogue* magazine. Klein laid it out using their state-of-the-art photostat machine, enabling him to enlarge his street photos and combine them with his own typography in an unprecedented way, creating one of the first examples of a sustained 'Pop' approach to word and image. The title of his film is a play on words: Broadway has no night due to the saturation of neon and illuminated signs around Times Square. Shot with a borrowed camera over a series of nights, the film progresses from electric signs to various movie marquees, framing technicians while they dismantle and arrange the names of film stars and titles of upcoming features. The first film with a recognizably Pop subject and process, it explores an integral part of Manhattan's visual rhythm through a non-narrative method. It was through Klein's contacts in France, such as Chris Marker and Alain Resnais, who had assisted publication of the book, that post-production was funded and the film distributed.

Bruce <u>CONNER</u>
A MOVIE
1958
16mm film, 12 min., black and white, sound
Two consecutive stills from torpedo sequence

In his first film, Conner montaged and juxtaposed found footage in a way that derived from his practice of assemblage and collage. His selection emphasizes the existence of readymade filmic moments from newsreels, Hollywood out-takes and home movies. The montage of melodramatic and shocking images suggests a hostile critique of modern life. Destruction, death and sex are dominant references. The film was a landmark in the history of avant-garde cinema, both for its liberating technique and its engagement with contemporary mass-media forms of representation.

Kenneth <u>ANGER</u>
Puce Moment
1949
16mm film, 6 min., colour, soundtrack
With Yvonne Marquis

Released as a self-contained fragment from *Puce Woman*, an abandoned feature-length production centred on the image of faded Hollywood actresses decaying in their mansions, this short film focuses on one such subject and the fetishistic ritual and magic surrounding her. Joseph Cornell's earlier silent film *Rose Hobart* (1936) had edited a 1930s B movie down to isolate just those scenes in which the heroine appears centre frame, beautiful and mysterious. In Anger's film an actress (played by Yvonne Marquis) in exaggerated make-up and art deco-style atire, parodies silver screen glamour while exuding a powerful mystique, conveyed through extreme camera angles, a distorted musical soundtrack and a magical, eroticized sequence where she seems to be floating through space on her puce couch. The film's imagery anticipates the later work of Jack Smith and Andy Warhol.

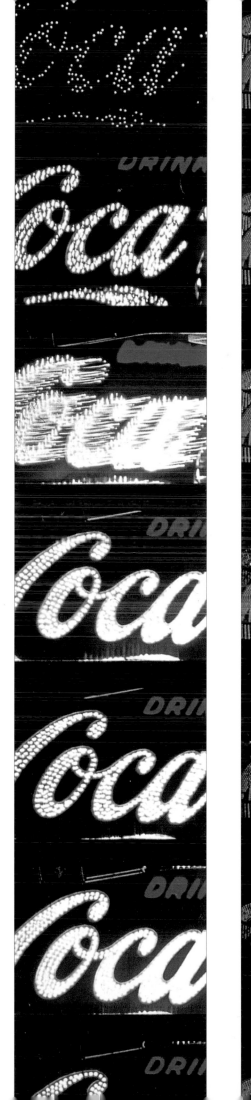
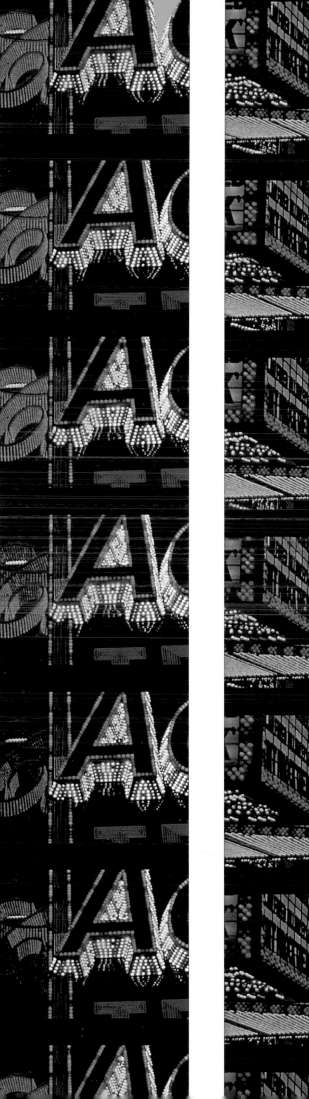

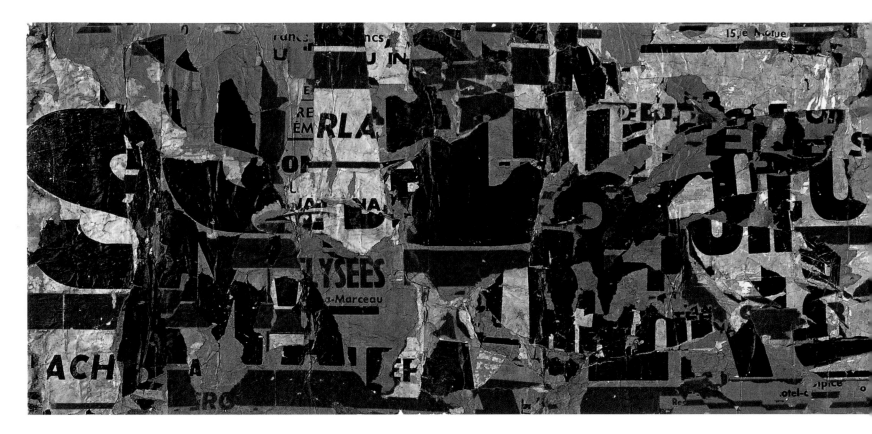

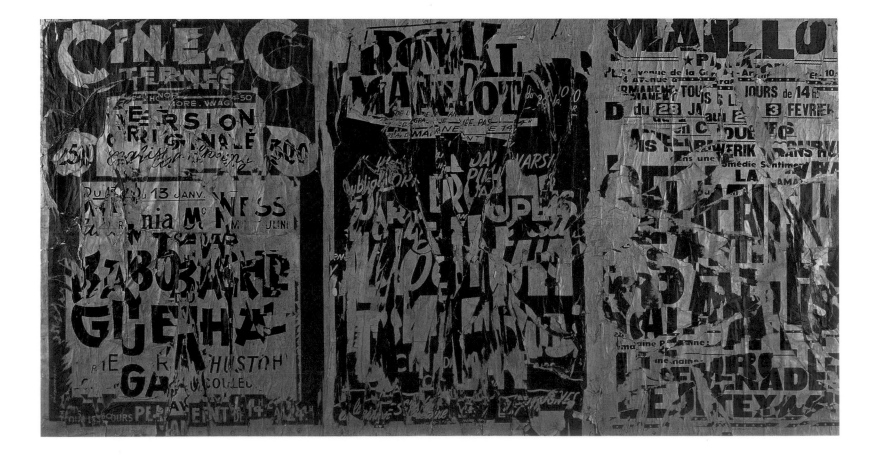

Raymond <u>HAINS</u> and Jacques de la <u>VILLEGLÉ</u>
Ach Alma Manetro
1949
Décollage: torn posters collaged on paper, mounted on canvas
68 x 256 cm [27 x 101 in]
Collection, Musée National d'art moderne, Centre Georges
Pompidou, Paris

Drawing its title from the three word-fragments still legible in a vast field of lacerated street posters, *Ach Alma Manetro* was Hains and Villeglé's first collaboration. Reversing the constructive build-up of layers characteristic of collage, they began to use large-scale, found posters which they peeled away to reveal the graphic residues of older posters underneath. Described as *décollagistes* (literally, 'un-collagists'), these artists worked with the advertising material that was proliferating in the Paris streets, obliterating the traces of fascist propaganda that had covered the city during the wartime occupation. As the commodity-driven era of the 1950s approached, public space was transformed by the new billboard advertising made possible through the development of large-scale colour offset lithography. Deliberately oppositional, *décollage* presented the remains of these consumerist signs and messages in a fragmented and already obsolescent state.

opposite
Jacques de la <u>VILLEGLÉ</u>
Les Triples de Maillot
Triples of Maillot
1959
Décollage: torn posters collaged on paper, mounted on canvas
117 × 224 cm [46 × 88 in]
Collection, Museum Moderner Kunst Stiftung Ludwig, Vienna

Villeglé became engaged with ideas of urbanism and public space when working for an architect in the early 1950s. Around 1954 he met the poet and artist François Dufrêne, then involved with Lettrism, who was also working with torn posters. The Lettrists focused on written or spoken individual letters as the core of a new poetic language which they believed could be the basis of a new culture. Villeglé saw *affiches sauvages* (literally, 'wild posters', implying both real defaced or unofficial flyposted bills and his own meticulously fabricated works) as 'a site of confrontation between those in charge of maintaining the order of public space and those who seize the liberty of speech in the same location … The anonymous passer-by re-routes the message, opening up a new arena of freedom.'
– Jacques de la Villeglé, interview, Centre d'art contemporain d'Istres, 2004

Kurt SCHWITTERS
Untitled [For Käte]
1947
Collage on paper
10.5 × 13 cm [4 × 5 in]
Collection, Kurt Schwitters Archiv, Sprengel Museum, Hannover

As a refugee in wartime London Schwitters began to use in some of his Merz assemblages the comics that came into circulation via American servicemen. In this intricate, small-scale work a cartoon drawing of a woman is surrounded by a cluster of male figures from various other comic strips, evoking different time periods and cultures. Some of the hands, arms and heads of the figures are taken from several sources and recombined together. The postage mark and inscription suggest a meaningful, personal rearrangement of these stereotyped figures and gestures. In his 1962 *Artforum* article 'The New Painting of Common Objects', the critic John Coplans listed this work as one of the hidden landmarks in Pop's development: it was part of a series to be shown in 1947 at Rose Fried Gallery, New York. Schwitters died a week before the opening and the show was cancelled.

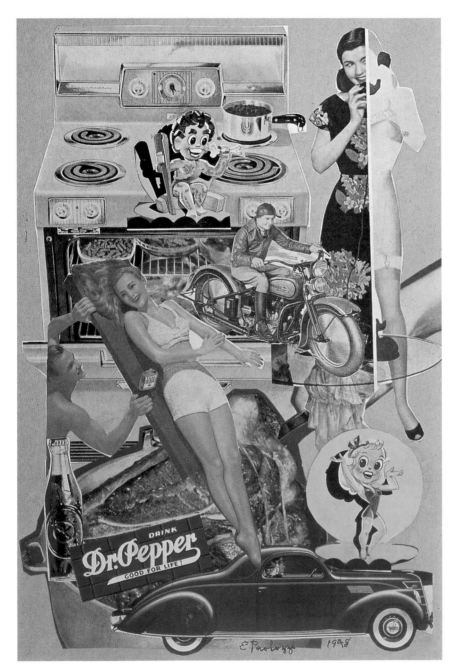

Eduardo PAOLOZZI
Dr Pepper
1948
Collage on paper
36 × 24.5 cm [14 × 9.5 in]

From childhood Paolozzi had collected pictures from popular magazines. After studying art in London he spent two years (1947–49) in Paris, where he became acquainted at first hand with surrealist collage and saw Mary Reynolds' Duchamp collection which included Duchamp's walls covered with magazine images. Paolozzi acquired the latest magazines from American ex-servicemen studying in the city and filled several scrapbooks with images, calling one *Psychological Atlas* (*c.* 1947–53). He later called his collages 'readymade metaphors'. While the playful Freudian symbolism of the juxtaposed icons draws on surrealist precedents, Paolozzi maintains the integrity of each figure or object so that it still conveys much of the intended effect of the original. The titles, as here, usually come from the most conspicuously advertised product in the composition. The figure of the young woman at right holding a telephone comes from an advertisement for Ivory Flakes washing powder for delicate garments. The tagline was 'What makes a gal a good number?' The ad was later decoded in Marshall McLuhan's text 'Love Goddess Assembly Line', in *The Mechanical Bride: Folklore of Industrial Man* (1951).

Eduardo PAOLOZZI

Meet the People

c. 1948

Collage on paper

36 × 21 cm [14 × 8.5 in]

Collection, Tate, London

From 1947 to 1951, former Hollywood B-movie star Lucille Ball, whose portrait
is a focal point in this collage, played the wacky wife of a straight-laced banker on
the popular CBS radio programme *My Favorite Husband*. Its success led to her
famous pioneering sitcom *I Love Lucy*, which CBS launched on television in 1951.
Paolozzi may not have known or intended this reference (the photo is promoting a
1944 film) but it happens that 1948 was the year she became a household name, at
least in the USA, due to the radio show: a commonly recognized icon in magazines
and on the airwaves, like the food and drink products, the serving suggestion and the
mouse cartoon character, which all seem to be vying for equal billing in the artist's
composition. This and the collage below are among those which Paolozzi reproduced
in *Bunk*, an edition of 47 silkscreen prints and lithographs, in 1972. Before this date
the originals were generally considered as working materials and rarely exhibited.

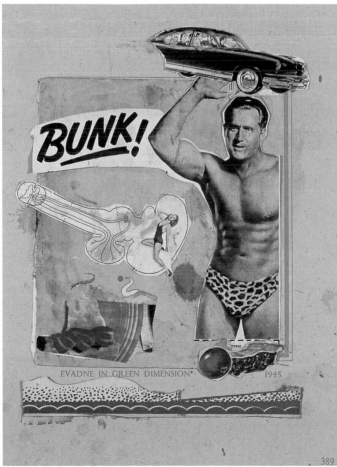

Eduardo PAOLOZZI

Bunk! Evadne in Green Dimension

c. 1952

Collage on paper

32.5 × 24.5 cm [13 × 9.5 in]

Collection, Victoria & Albert Museum, London

This became the signature collage in the *Bunk* series described above. The figure
of the man and the slogan 'Bunk!' are taken from a 1936 version of the long-running
advertisement for Charles Atlas's body-building technique, which Paolozzi found in
the December issue of the *Mechanics and Handicrafts* magazine of that year. 'Bunk!'
also implicitly alludes to the famous statement made to the *Chicago Tribune* in 1916
by Henry Ford, founder of the Ford Motor Company: 'History is more or less bunk …
We want to live in the present.' In the spring of 1952, Paolozzi presented his scrapbook
collages, derived from popular magazines, comics, science fiction and pulp fiction
book covers, as a rapid-fire sequence of projections from an epidiascope, at one of the
first meetings of the Independent Group in the Institute of Contemporary Arts, Dover
Street, London. Due to the projector's limitations, only a section of each page could be
shown at one time. What was crucial was the presentation of mass-media imagery for
serious consideration.

Robert RAUSCHENBERG
Bed
1955
Combine painting; oil and pencil
on pillow, sheet and patchwork
quilt on wood supports
191 × 80 × 20.5 cm
[75 × 31.5 × 8 in]
Collection, The Museum of Modern
Art, New York

From 1948 to 1950 Rauschenberg studied at Black Mountain College, North Carolina, returning to teach there in 1952, where he collaborated with the choreographer Merce Cunningham, the composer John Cage and others on the first attempt to fuse painting, dance, poetry and real-life chance events – a prototype 'happening'. Otherwise based in New York from 1949 onwards, Rauschenberg continued to question the aesthetics underlying contemporary critics' espousal of geometric and gestural abstract painting, and to explore the possibility of acting 'in the gap' between art and life. By 1955 he had devised a new type of artefact which he named a Combine, arrived at by the combination of traditional supports and areas of gestural painting with everyday objects of use or discarded found materials. *Rebus*, *Monogram* and this work, *Bed*, are among the foundational works, all produced in that year. Here the pillow, sheet and quilt are positioned as they would be in a functioning bed, retaining all the associations that a bed might evoke, yet these materials are overlaid with daubs and drips of coloured paints, hovering between the expressive and the 'artless'. The whole ensemble is brought, uncomfortably, into the traditional art arena by being mounted on a wall.

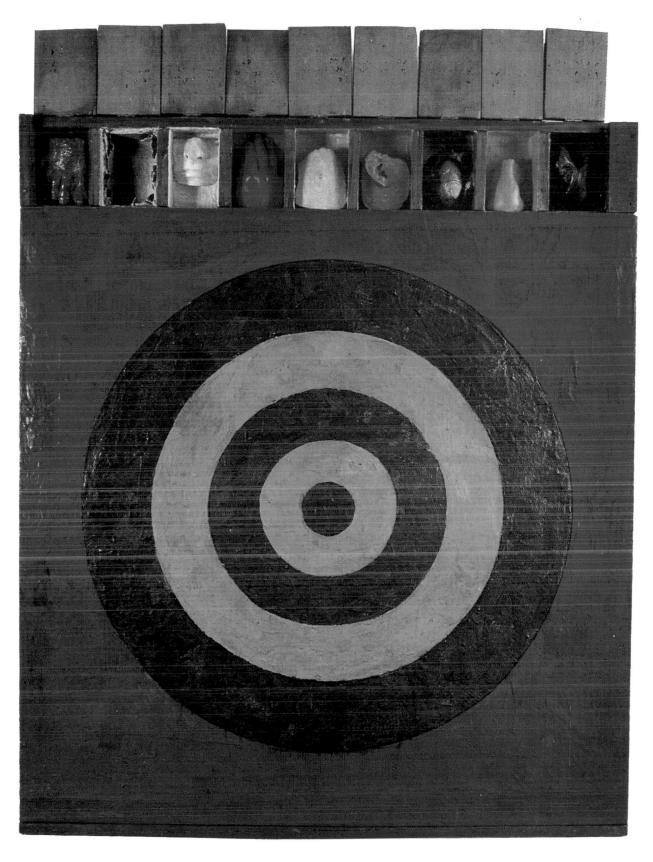

Target with Plaster Casts
1955
Encaustic and collage on canvas;
wood compartments and hinged
lids, painted plaster casts
129.5 × 112 × 6.5 cm
[51 × 44 × 2.5 in]

Johns had begun working with encaustic
and making plaster casts of his and
friends' heads and body parts in 1954.
Encaustic was a rarely used technique in
which pigment is combined with hot wax
and applied to a surface. Johns wished
to leave a material trace of the process
of building up the image, brushstroke by
brushstroke, and encaustic enabled this.
He also often incorporated collage
elements, usually from newspapers.
By early 1955 he had begun his Flag and,
slightly later, Target paintings, realizing
that such generic designs are 'ready-
made' and familiar, instantly recognized
but at the same time no longer looked at
with any attention. By making a painting
which was unusually similar to yet
significantly different from the real thing,
Johns raised questions about the
boundaries between art and the visual
signs and objects found in the common
culture. More than flags, which usually
have specific referents, the target is
a universal sign. It also focuses the
attention of the viewer on the act of
vision, since that is a target's function
In this work, above the target painting
a series of plaster casts of body parts are
painted various colours and set into little
hinged wooden compartments.
Originally intended to spring open when
pressed and trigger sounds from behind
the target, the compartments were
retained after Johns abandoned this
idea. After he coloured the casts and
their surrounds, they reminded him of
watercolour paint dishes, an association
he recalled in a small-scale work in
the series (1960) which has three paint
dishes and a brush beneath the target.

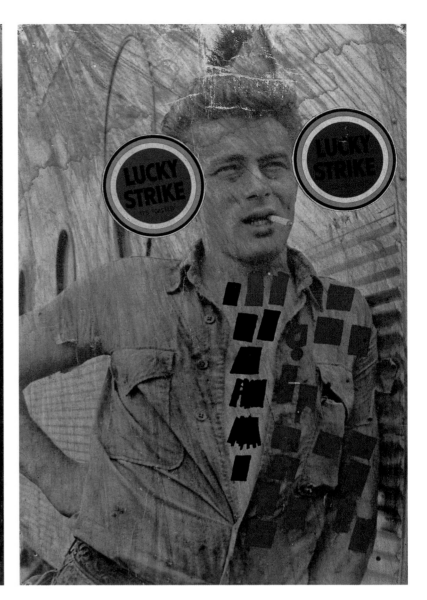

Ray <u>JOHNSON</u>

Elvis Presley # 2

1956-57

Ink, collage, paper on cardboard

23.7 × 19 cm [9.5 × 7.5 in]

Ray <u>JOHNSON</u>

James Dean

1957

Tempera, ink and collage on photograph

30 × 24 cm [12 × 9 in]

In his artworks of the mid 1950s, Johnson was ahead of his time in the use of photocopying techniques and content based on publicity stills of screen icons such as Marilyn Monroe and James Dean, or rock and roll idols such as Elvis Presley. A number of the collages were made in series, and involved cutting up pieces of paper painted black or red into small, irregularly shaped pieces which were then glued on to photocopied images. Other areas were painted with washes of colour and sometimes other elements were added, such as the trademark target logos from Lucky Strike cigarette packets, in the James Dean collage. Johnson's use of low-tech photocopying is indicative of his celebration of mechanical reproduction and democratic techniques for the production and distribution of his work. He distributed much of his work through the mail, and established the New York Correspondence School to do so. He called the collages 'moticos', a word coined by a chance method when asking his friend Norman Solomon the word he was reading. His answer: 'osmotic'. Johnson stored the moticos in cardboard boxes and showed them on the New York streets and in Grand Central Station.

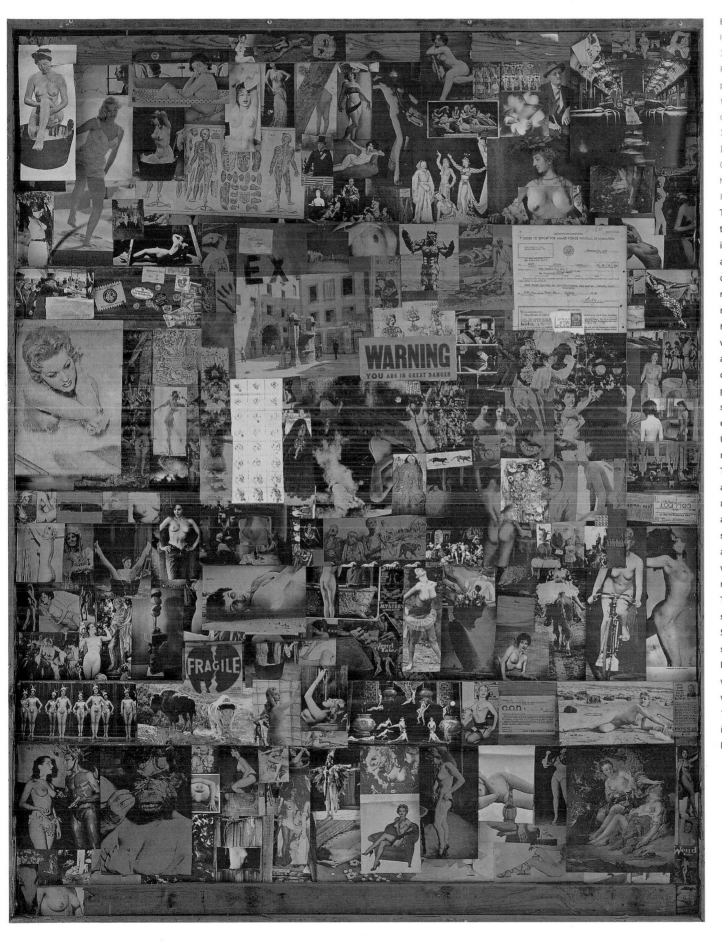

Bruce <u>CONNER</u>
UNTITLED [detail]
1954-61
Paper collage, wood, glue, nails,
paint, staples, metal, tar,
feathers, plastic, etc.,
on Masonite
162 × 126 × 10.5 cm
[64 × 49.5 × 4 in] framed
Collection, Walker Art Center,
Minneapolis
Reverse panel of two-sided work

This early, two-sided work, of which the reverse is shown here, was first intended to be one-sided only. Conner assembled distressed cardboard circles, one dark, the other light, and two rectangles, one made from a flattened metal can, the other from a piece of metal screening, surrounded by a wooden frame with visible screws attaching it to the board on which the other elements are fixed. Having seen paintings with museum seals and stickers from various collections and exhibitions attached to them, Conner then decided to attach 'seals' from magazines such as *Good Housekeeping*. This led to the decision to fill the entire area with a collage of material from many different sources in commonly available ephemera, ranging from the sexy pictures that soldiers, prisoners and others would collage in a similar way inside lockers, to postcard reproductions, postage stamps, etc. The semi-pornographic images contrast sharply with the accomplished, Kurt Schwitters-like assemblage on the other side. Initially the back, which Conner likened to the 'unconscious' of the front, was intended to be seen only by those who handled the work. From around 1960 he suggested a free-standing installation so that both sides could be viewed.

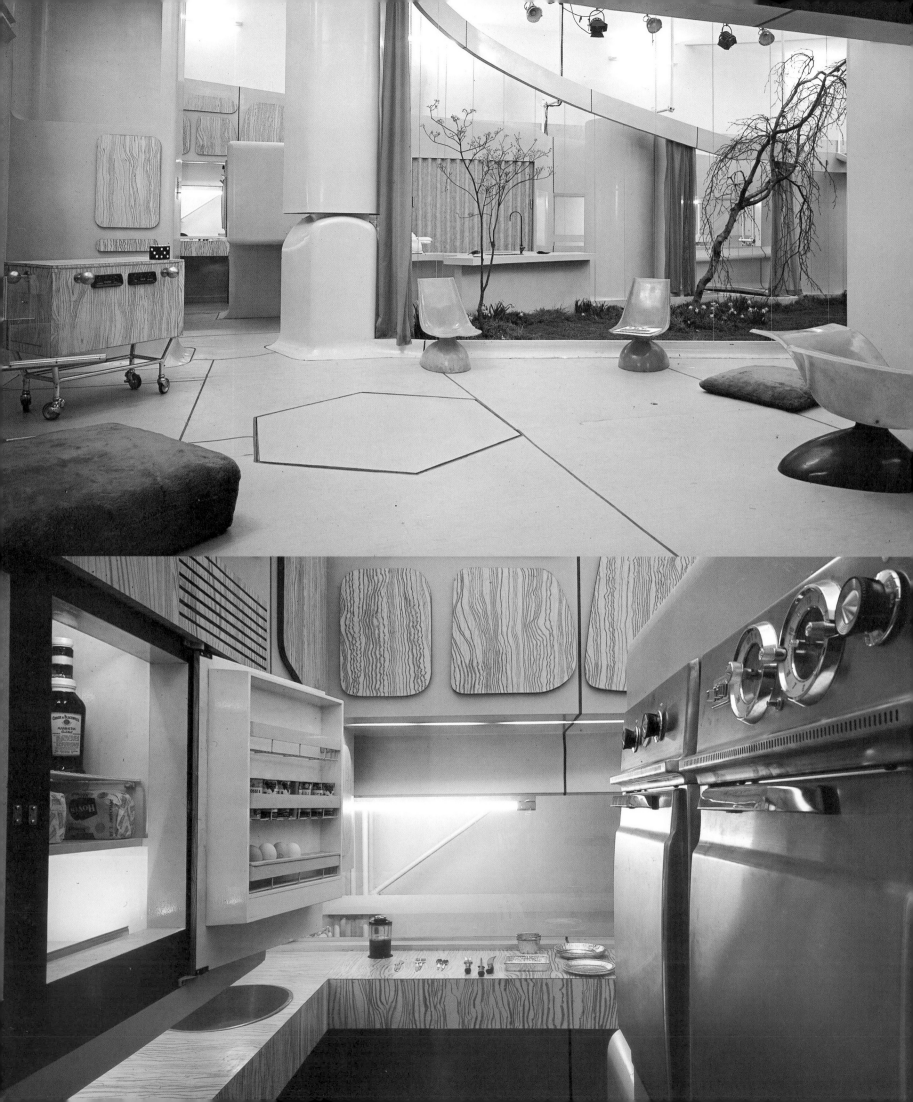

opposite

Alison and Peter SMITHSON

House of the Future

1956

Prototype realized for the Daily Mail Ideal Home Exhibition, London,
March 1956

top, Central living room with Tulip chairs and adjustable height
hexagonal table in recessed position in floor

bottom, detail of kitchen

The Smithsons developed a social housing concept based on mass-production
solutions pioneered by the motor industry in Detroit. The House of the Future had
a decentralized plan characterized by loops and bifurcations. All the rooms were to be
lit by a central oval patio, allowing three exterior walls to be without doors or windows.
The structures could thus be 'plugged in' to a system of rows, two deep and back to
back. Endless extendibility distinguished this project from other mass-produced
housing prototypes such as Buckminster Fuller's Dymaxion House (conceived in the
late 1920s and first built in 1945, this structure used tension suspension from a central
column or mast, was sold for the price of a car, and could be shipped worldwide in its
own metal tube). The Smithsons drew on both the latest sociological theories and the
most futuristic product designs of the time, such as the plastic chairs in the top
photograph, based on Eero Saarinen's designs, and the hexagonal table that recedes
into the floor when not in use. Crucially, they looked beyond their professional field to
vernacular culture and the mass media for inspiration, becoming exponents of what
would several years later emerge as the notion of Pop architecture.

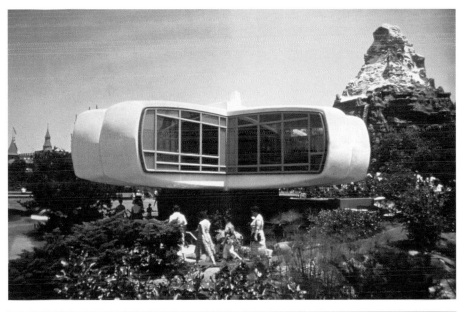

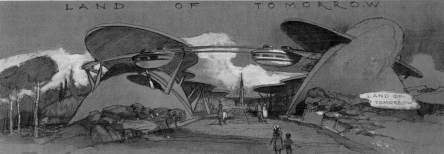

WALT DISNEY IMAGINEERING

Monsanto House of the Future [exterior view], Tomorrowland,
Disneyland, Anaheim, California

1957

Designed by Hamilton and Goody

In 1952 Walt Disney started a subsidiary which he named WED Enterprises, later
Walt Disney Imagineering, to design and develop the first theme park. This would be
clean, futuristic and utopian, in contrast to its predecessors. Disney's concept of the
'Imagineer' introduced an expanded notion of the creative team, in which architects,
designers, animators and fabricators worked together to create a total, artificial
world, based on the hyperreal realm of Disney cinema but situated in a real location.
The first Disneyland opened in July 1955, divided into four areas, one of which,
Tomorrowland, materialized popular images of a future synonymous with technical
progress. Here the visions of science fiction, such as rocket rides, were juxtaposed
with prototypes for buildings and product designs which would soon be realized
commercially, such as moulded plastic furniture and advanced kitchen appliances. To
coincide with the launch Disney promoted Tomorrowland in special TV features such
as 'Man in Space'. Over the next few years Tomorrowland was updated several times.

WALT DISNEY IMAGINEERING

Entrance of 'Land of Tomorrow', Disneyland, Anaheim, California

c. 1954

Drawing by Herbert Ryman

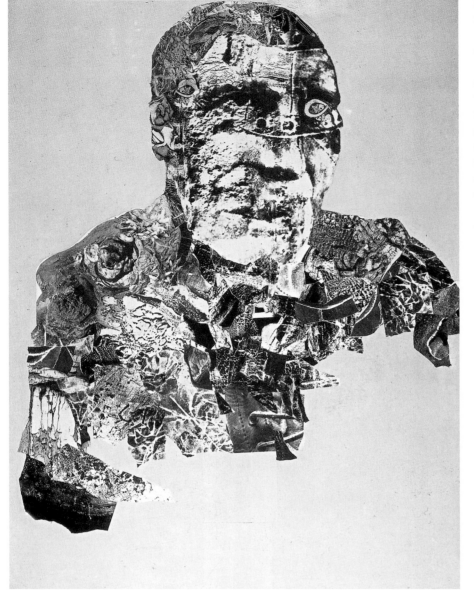

Nigel HENDERSON
Head of a Man
1956
Collage on paper
160 × 121.5 cm [63 × 48 in]
Collection, Tate, London

This work was first installed in the Patio and Pavilion conceived by Group 6 (Nigel Henderson, Eduardo Paolozzi, Alison and Peter Smithson), one of the teams of artists and architects in the group show 'This is Tomorrow' at the Whitechapel Art Gallery, London, 9 August – 9 September 1956. Seeking a visual language to convey the trauma he suffered in the Second World War, Henderson developed various experimental techniques such as a type of photogram made by placing objects, often including recuperated bombsite material, directly on light sensitive paper. He described these kinds of image as 'stressed' photographs, and this 'self-portrait' can be seen as the culmination of this body of work. Here he collaged such photograms, along with fragments of photographs he had taken of blitz damage in London's East End, into the form of his own face. The original installation – likened by the critic Reyner Banham to a garden shed excavated after an atomic holocaust – emphasized the existential pessimism of Henderson's work which, like many of Paolozzi's sculptures, used vernacular elements in a way that departed from the more progressive agendas of other Independent Group members.

opposite
Richard HAMILTON
Just what is it that makes today's homes so different, so appealing?
1956
Collage on paper
26 × 25 cm [10.5 × 10 in]
Collection, Kunsthalle Tübingen, Germany

Incorporating the word 'Pop', blazoned across the giant candy on a stick held by the muscleman, this collage has become iconic of the birth of the movement. However, the first recorded use of the term Pop art was by Hamilton in a letter to Alison and Peter Smithson on 16 January the following year. The collage (made from material largely supplied by John McHale and selected with the collaboration of Hamilton's wife Terry and the artist Magda Cordell) was originally used as artwork for a black and white poster, one of a series made for the group show 'This is Tomorrow' in the late summer of 1956. Also reproduced in black and white in the catalogue, even as a monochrome image it is likely to have given a startling impression of a future where hi-tech gadgetry, mass-media communications and images, especially the stereotyping of sex-appeal, would pervade all areas of everyday life. Partly prescient (the comic strip framed on the wall predates Roy Lichtenstein's first cartoon-based paintings by five years, and the allusion to space travel in the ceiling predates the first Sputnik rocket launch), the collage also refers to and parodies 1950s products and styles of imagery. A 'plundering' of what the Independent Group then referred to as the 'popular arts', it has been likened to an index of the themes and types of imagery that would emerge in 1960s Pop.

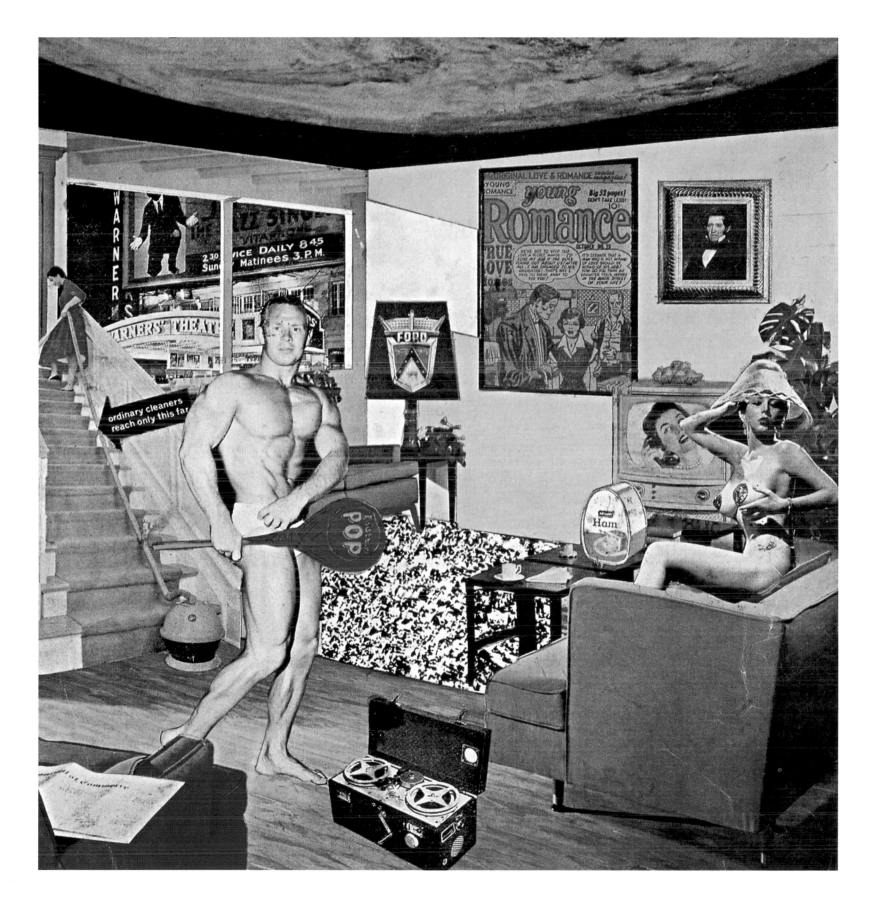

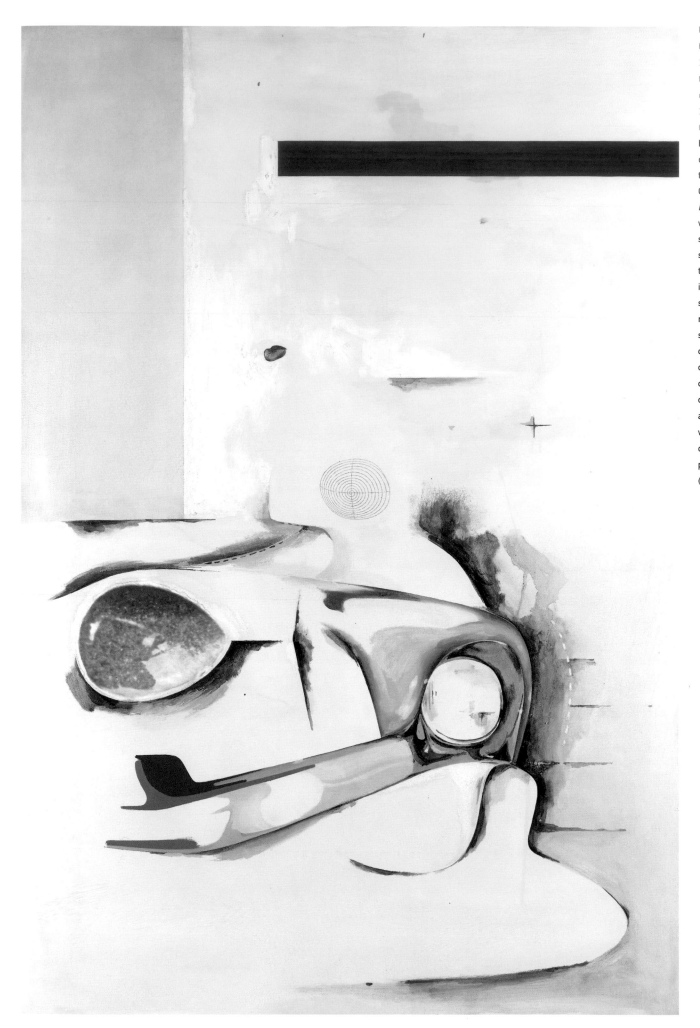

Richard **HAMILTON**
Hommage à Chrysler Corp.
1957
Oil, metal foil and collage
on panel
122 × 81 cm [48 × 32 in]
Collection, Tate, London

Both in style and theme this painting
draws upon Hamilton's close study at
the time of Marcel Duchamp's 'Large
Glass': *The Bride Stripped Bare by Her
Bachelors, Even* (1915–23). In Duchamp's
work, the 'Bachelor Machine' and the
section representing the 'Bride' inhabit
separate areas. In Hamilton's painting,
the disembodied red lips which stand
in, metonymically, for the ubiquitous
showroom girl included in car advertise-
ments, occupy the same space as the
schematic delineation of a 'latest model'
car's stylistic features. The use of pastel
colours and the allusiveness of the
curves suggest a further level of
conflation between fetishized woman
and fetishized industrial object. Hamilton
would develop these themes in a series
of texts over the next few years and in
paintings such as *Hers is a lush situation*
(1958) and *$he* (1958–61).

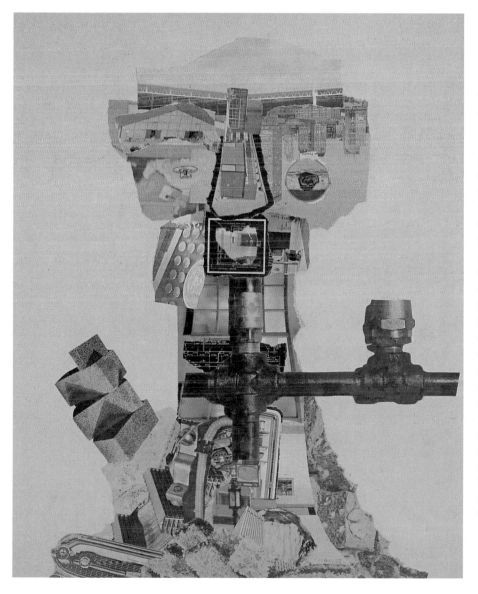

John McHALE
Machine-made America I
1956-57
Collage on paper
74 × 58.5 cm [29 × 23 in]

This is one of a series of large-scale collages McHale produced between 1956 and 1958. In each, the clusters of found material from magazines are formed into configurations which include the suggestion of a face, usually emerging from an unearthly, robotic body. The imagery here is more overtly technological than in most of the others. It includes plumbing, a car's grille, a refrigerator door, a television and various industrially produced structures and highrise buildings. Comprised of images from the 1950s present or recent past, the collage's overall form suggests an alien, futuristic presence. McHale's vision of the future oscillated between optimism and scepticism. In line with Marshall McLuhan's theory of contemporary culture's passage from the mechanical, emblematized by printing and the purely visual, to the aural and participatory, McHale emphasized mass communications both through the incorporated images such as the TV set, and the seemingly staring, gesturing forms of his composite figures.

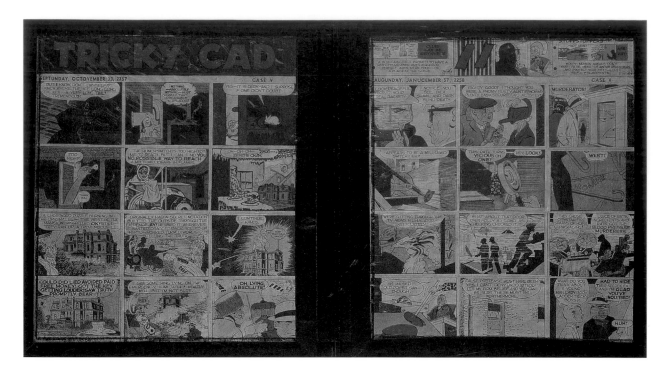

above

JESS

Tricky Cad, Case V

1958

Collage of newspaper comic
strips, cellulose acetate film,
black tape, fabric and paper
on paperboard

33.5 × 63.5 cm [13 × 25 in]

Collection, Hirshhorn Museum
and Sculpture Garden, Smithsonian
Institution, Washington, D.C.

In the late 1950s Jess began working
on a series of works he called 'paste
ups', using images from the comic strips
of American newspapers. Based on the
Dick Tracy crime detective story, Tricky
Cad is one of a number of anagrams
of the hero's name created by cutting
up and rearranging the words in the
cartoon's taglines, speech- and thought-
bubbles. While the language content is
thus subverted, the overall visual format
and elements remain largely intact.

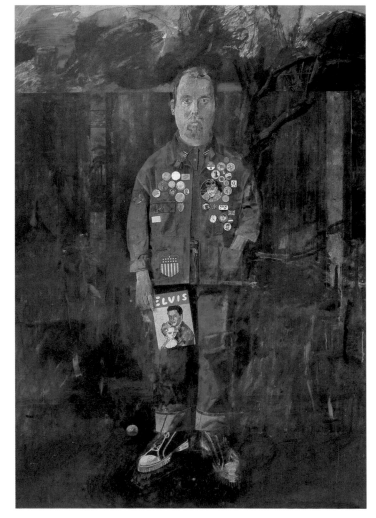

Peter BLAKE

Self-portrait with Badges

1961

Oil on board

175 × 122 cm [69 × 48 in]

Collection, Tate, London

Blake's enthusiasms for both the latest
pop phenomena from America (which
he had not yet visited) and British folk
art, such as old pub signs, are poignantly
contrasted in this naive-style painting
of the artist assuming a self-consciously
hip look while posing in a run-down
London back garden. American-style
'cuffed' jeans, baseball shoes and denim
jackets (which were only just beginning
to be distributed outside the United
States) were in fashion among a small
group of trend-setters such as London
art students. The badges, however, are
a mostly outmoded, eclectic selection
from a collection Blake started in the mid
1950s. Among other themes the badges
commemorate the Union Jack, and the
Stars and Stripes – much larger,
indicating Blake's preference; the First
World War; the Boy Scouts; Road Safety;
the British comedian Max Wall; Pepsi;
Elvis Presley (by 1961 already a bit
passé) and Dan Dare from the 1950s
children's comic *The Eagle*.

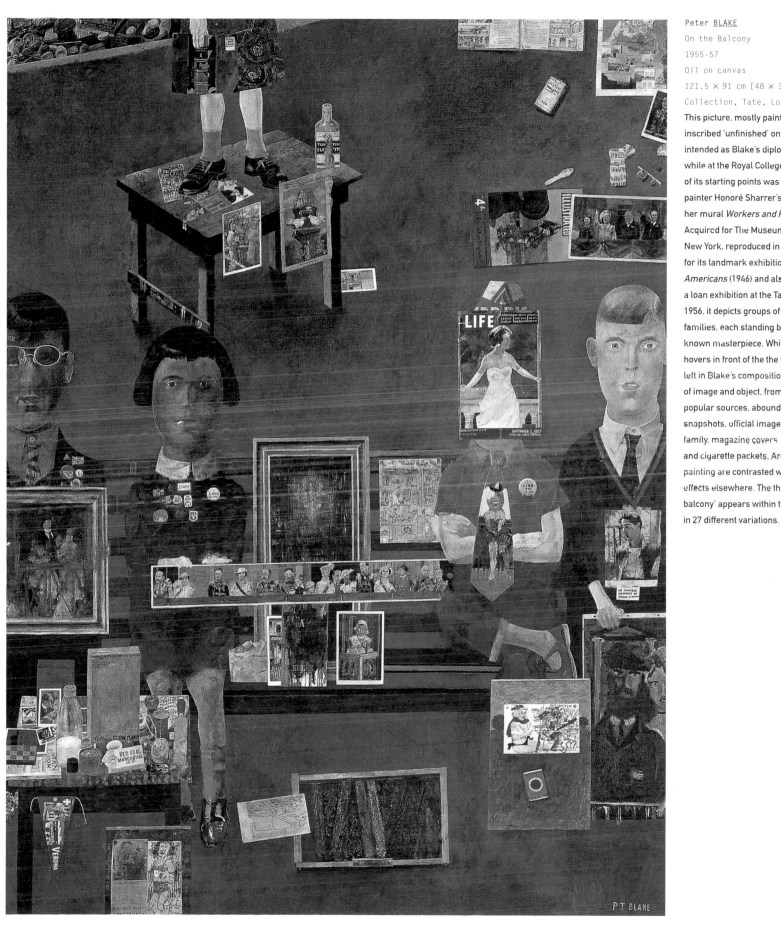

Peter BLAKE
On the Balcony
1955-57
Oil on canvas
121.5 × 91 cm [48 × 36 in]
Collection, Tate, London

This picture, mostly painted in 1955 and inscribed 'unfinished' on the back, was intended as Blake's diploma composition while at the Royal College of Art. One of its starting points was the American painter Honoré Sharrer's oil sketch for her mural *Workers and Pictures* (1943). Acquired for The Museum of Modern Art, New York, reproduced in the catalogue for its landmark exhibition *Fourteen Americans* (1946) and also displayed in a loan exhibition at the Tate Gallery in 1956, it depicts groups of working families, each standing behind a well-known masterpiece. While a Manet hovers in front of the the figure on the far left in Blake's composition, other types of image and object, from contemporary popular sources, abound. They include snapshots, official images of the Royal family, magazine covers, bottles, jars and cigarette packets. Areas of flat painting are contrasted with *trompe l'oeil* effects elsewhere. The theme 'On the balcony' appears within the painting in 27 different variations.

opposite

Jasper JOHNS

Flag above White with Collage

1955

Encaustic with collage on canvas

57 × 49 cm [22.5 × 19.5 in]

Collection, Kunstmuseum, Basel

The first of the Flag paintings was conceived of after Johns dreamed in 1954 of painting a flag, and it slightly predates the first Target paintings of 1955. As the year progressed he began to make variations on, or additions to, the representation of the flag, such as the area of white ground beneath it in this example. It was when a selection of the Flags and Targets were exhibited in Johns' first solo show at Leo Castelli Gallery, New York, in January 1958, and subsequently reproduced in various art magazines, that they attracted widespread attention among other artists and critics. While the Targets at least resembled abstract modernist painting, the Flags were more startling and confounding, some appearing at first glance to be 'artless' facsimiles of the real thing. The thick texture, built up from the layers of encaustic that bind the collaged paper and pigment together, draws attention to the painting as an object in the world, rather than as a neutral flat surface to be used for either illusionistic depiction or abstract marks. This effect is reinforced here by the uneven application of pigment, which allows fragments of the underlying newspaper pages to remain evident, in particular the four photographed faces on the right.

Jasper JOHNS

Painted Bronze

1960

Oil on bronze

14 × 20.5 × 12 cm [5.5 × 8 × 5 in]

Collection, Museum Ludwig, Cologne

During 1959 Johns made meticulously crafted bronze sculptures of commonplace objects such as flashlights and lightbulbs, continuing his investigation of objects as symbols by questioning notions of the real in relation to its representation. The following year he fabricated a realistic Savarin brand coffee can, full of paintbrushes, and these ale cans, titling both works *Painted Bronze*. The choice of Ballantine beer cans derives from an anecdotal story the artist heard of Willem de Kooning describing their dealer Leo Castelli's ability to sell virtually anything, even two beer cans. Johns literalized the notion in this work. The cans, though identical in brand and painted details, are actually of two different designs. The left can is an old-fashioned model, opened by puncturing the surface (as seen in the two perforations), whereas the other is a newer version with a ring-pull. This consideration of minor product development demonstrates the subtle manner in which, through repetition, Johns attempted to address a mundane sameness through an almost unnoticeable difference.

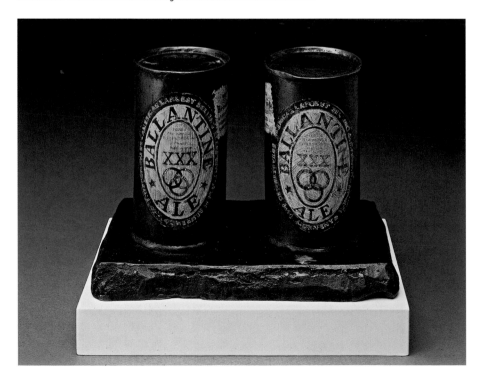

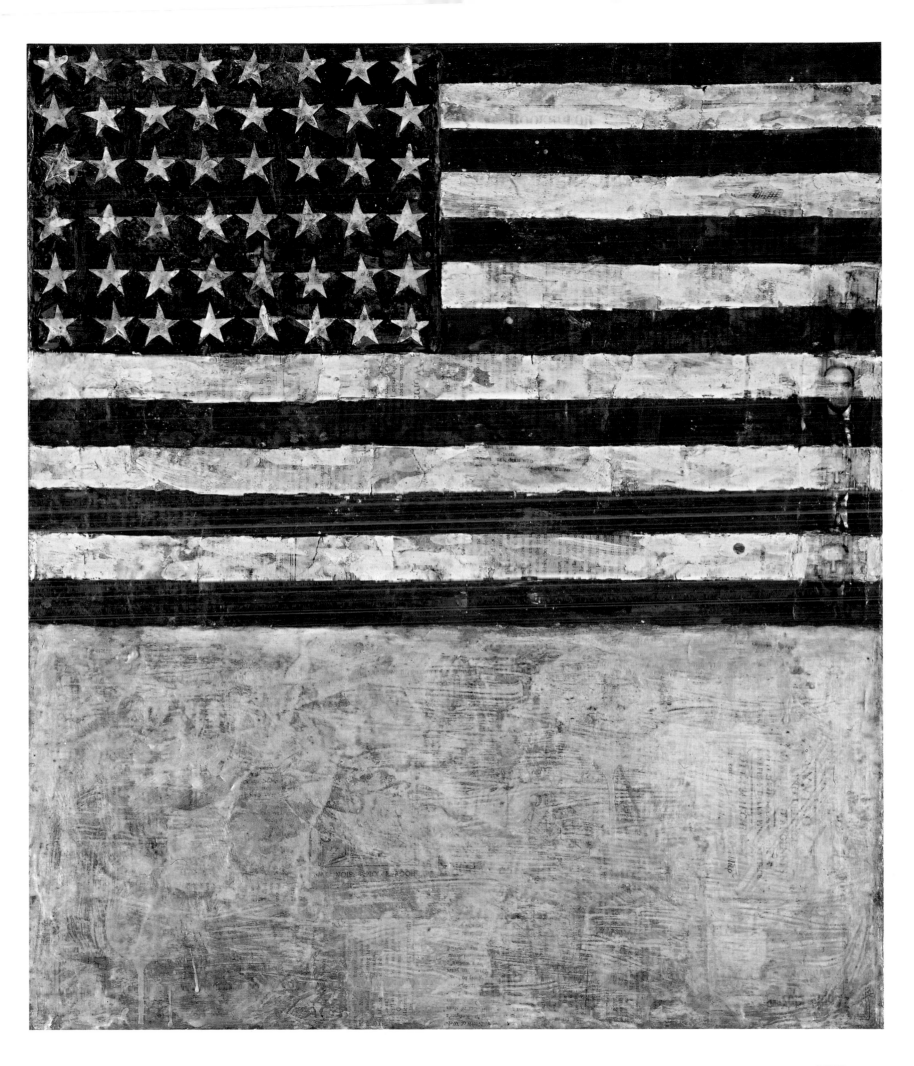

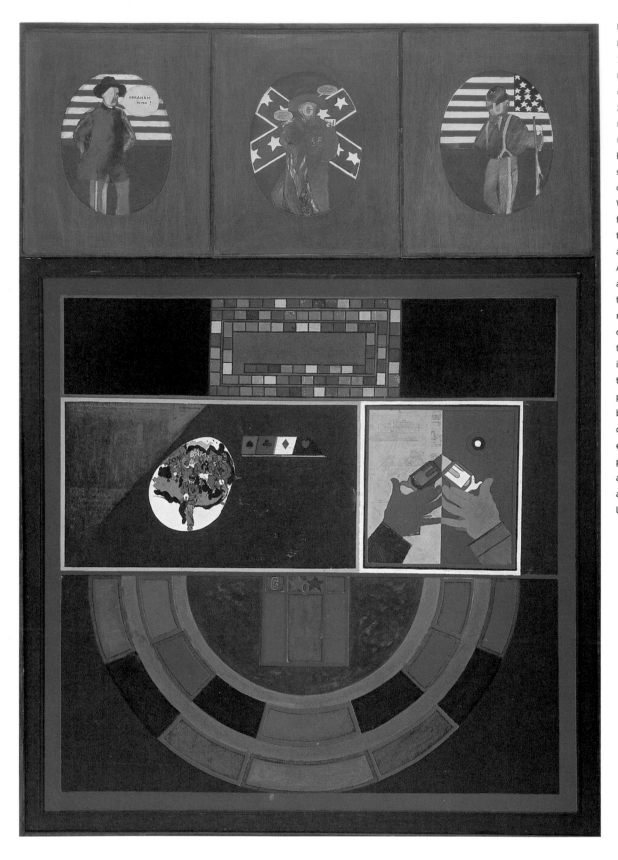

Peter PHILLIPS
War/Game
1961
Oil, enamel and newspaper on four
canvases with wood
217 × 156.5 cm [85.5 × 61.5 in]
Collection, Albright-Knox Art
Gallery, Buffalo, New York

In one of his rare paintings with a
specific theme – the contemporaneous
commemoration of the American Civil
War – Phillips combined figures derived
from American comic strips with devices
that echo heraldic forms (he had taken
a course on the subject at art school).
All is framed within what he called
a 'game format', recalling elements of
the layouts of board games and pinball
machines. The work's techniques and
construction are quite elaborate. The
three figures at the top were painted on
individual canvases and are united with
the rest of the composition by their
polished wood frames. The 'game' area
below combines areas of matt, polished
or waxed oil paint as well as black gloss
enamel sanded to a smooth finish with a
pumice stone. The stars, the small target
and the two hands holding the gun form
a bridge between heraldry, the corporate
logo and the everyday painted sign.

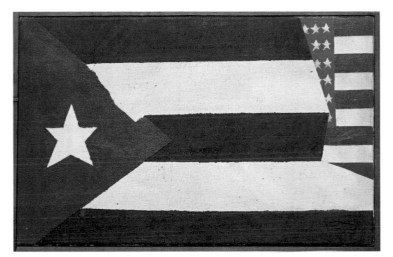

Derek BOSHIER
Situation in Cuba
1961
Oil on canvas with wood frame
33 × 51 cm [13 × 20 in]

Jasper Johns' Flag paintings – often seen in reproductions – were a source of stylistic inspiration to young British Pop artists in the early 1960s, a group that included Derek Boshier for a short period (1960–62). An avid reader of American social commentators on the consumer society such as Marshall McLuhan, Vance Packard and J.K. Galbraith, Boshier expressed a political stance rare in the work of his generation. This painting refers to the United States' attempt to regain control of Cuba after the 1959 socialist revolution led by Fidel Castro, when the US unsuccessfully invaded the Bay of Pigs on 17 April 1961. In the neat conceit of this painting the American and Cuban flags appear to encroach upon and retaliate towards one another.

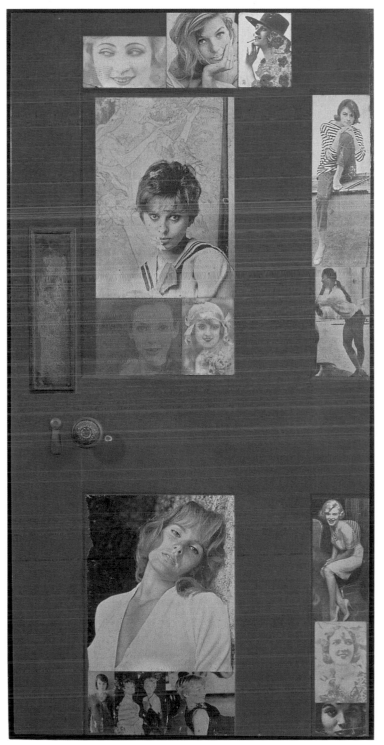

Peter BLAKE
Girlie Door
1959
Collage and objects on hardboard
122 × 59 cm [48 × 24 in]

At the end of the 1950s Blake extended the notion of collage-type painting that he had explored in *On the Balcony* (1955–57), to include real or constructed doors, lockers and other everyday objects covered with pasted-on pictures from magazines and other sources. He also placed toys, ephemera and found objects in box-like constructions, sometimes resembling windows or shop displays. *Girlie Door* is more demure than a similar work of the same year, *Locker*, on which Brigitte Bardot and other pin-up girls cover all the panels of Blake's Royal Air Force locker from his national service years (1951–53). For Blake personal associations and enthusiasm for the popular culture around him took the place of any studied theoretical position, for which another artist might have felt the need, to justify such artefacts in relation to artistic precedents.

CONSUMER CULTURE While in Europe related

tendencies such as 'new realism' emerged at the start of the decade, by the early

1960s New York had become the centre of an art world in which Pop's identity was

at first derided, then quite quickly established. Strands of derivation and influence

drawn from Dada and Surrealism were traced by museum exhibitions and the

mass media. The lasting value of works by artists such as Warhol, Lichtenstein

and Oldenburg, underlying their apparently ephemeral and trivial appeal, lay

in the artists' complex, yet deadpan, attitude to their subjects, which viewers

could not easily establish as celebratory, accepting or critical. While early Pop

seemed to conflate and revel in sensual images of food and sex, a darker note

became apparent after the deaths of Marilyn Monroe and the young President

Kennedy provided artists with indelible visual evidence of the violence, corruption

and injustice of contemporary life.

opposite

ARMAN

'Le Plein' exhibition, Galerie Iris Clert, Paris, October 1960
Detail of accumulated objects in gallery window

Arman presented 'Le Plein' ('Full') at the gallery of Iris Clert in Paris two years after she hosted Yves Klein's exhibition of 1958 that became known afterwards by the title he gave to the installation inside: 'Le Vide' ('The Void'). Klein had removed everything from the gallery space except an empty vitrine, and painted all the surfaces white. This 'dematerialization' allowed the possibility of pure sensibility becoming the subject of the work. Arman's gesture presented the exact opposite: he filled the gallery from floor to ceiling with as much junk as he could fit in. On 27 October 1960, four days after 'Le Plein' opened, the critic Pierre Restany launched the manifesto of the Nouveaux Réalistes ('new realists'), embracing the qualities of mass-produced objects, whether new or discarded: 'the real perceived in itself and not through the prism of conceptual or imaginative transcription'. The pile of lightbulbs seen in this view of the gallery window signals the emergence in this period of Arman's practice of accumulation: assembling together, usually in a box frame construction under perspex, a mass of everyday objects of the same type.

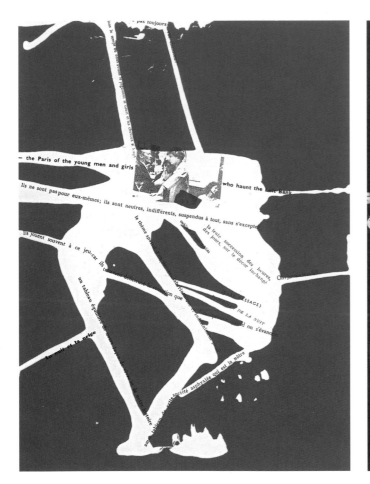

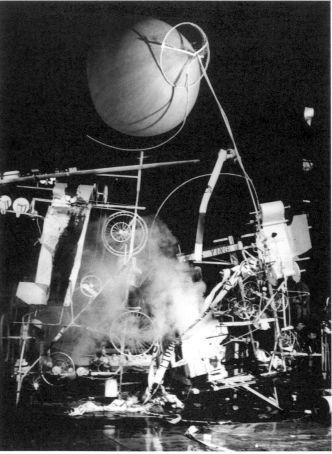

Guy DEBORD and Asger JORN
Mémoires
1959
Sample page from colour and black and white litho printed artist's
book, unpaginated, sandpaper binding. Printed by Verner Permild,
Copenhagen, published by L'Internationale situationniste, Paris
Bound in a disruptive, erasive material – sandpaper – this experimental book
presents fragments of text and sometimes images culled from printed ephemera,
within formless areas of colour evoking Debord's notion of 'psychogeography'.
Emerging from the Lettrist movement around 1957, the Situationists criticized the
capitalist system for dividing society into actors and spectators, producers and
consumers, thus diverting and stifling imaginative and creative freedom. They
proposed counter-diversions, through which these patterns would be undermined.

Jean TINGUELY
Hommage à New York
Autodestructive work presented at the Museum of Modern Art, New York,
17 March 1960
Tinguely's late 1950s experiments with kinetic art-machines were brought to a new
level with this ambitious self-destructive construction. Made from urban detritus,
it was commissioned to be sited in a dome designed by R. Buckminster Fuller,
displayed in the courtyard area at the Museum of Modern Art, New York. Some of its
intended features, such as the discharge of various odours, failed to materialize at
its public unveiling; it also failed to self-destruct completely before being extinguished
by the Fire Department. It was nevertheless a landmark, both as a fusion of the fields
of art and technology and as a statement about industrialized society's cycles of
production, consumption, waste and destruction.

Wolf VOSTELL

Coca-Cola

1961

Dè-coll/age: peeled posters on paper, mounted on hardboard

2 panels, 210 × 310 cm [83 × 122 in] overall

Collection, Museum Ludwig, Cologne

Behind an advertising poster for a family-sized Coca-Cola bottle Vostell revealed underlying posters of Cowboy shoot-outs and the toothy smiles of bucolic youth. The Coca-Cola brand had already become synonymous with exported American value systems. Vostell used such associations with a critical perspective. His version of the practice of décollage, which he spelled 'dè-coll/age', was inspired by a front-page headline in the newspaper *Le Figaro*, describing a plane crash. Vostell's works draw attention to social detachment and disintegration in post-war industrialized societies. As well as making wall-based and sculptural works, he orchestrated performance actions which referred to everyday tragedies.

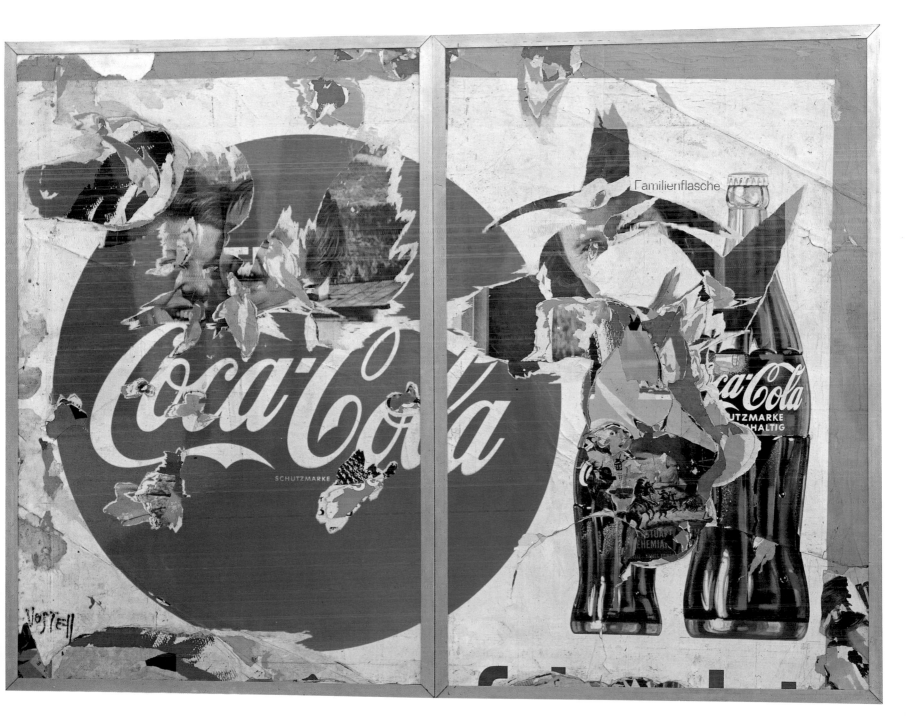

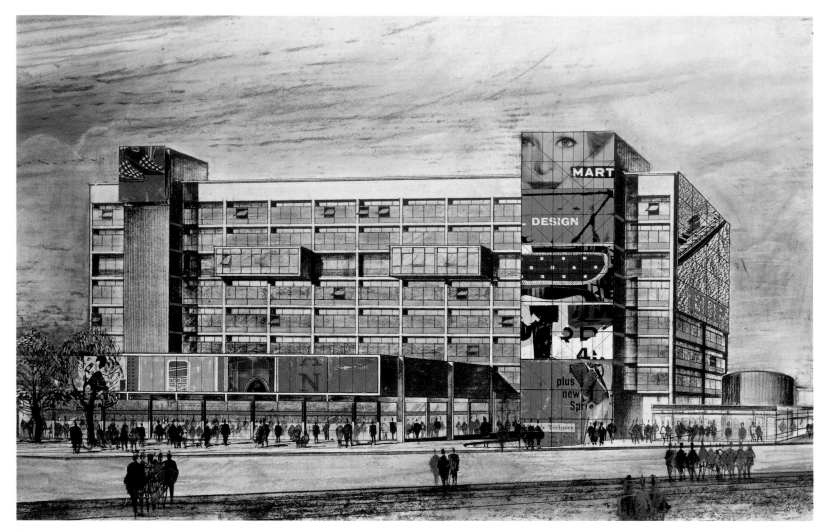

Ernö GOLDFINGER
Project for commercial centre at Elephant and Castle, London
1960
Mixed media on panel
58.5 × 122 cm [23 × 48 in]
Perspective elevation drawing by Hugh Cannings
RIBA Drawings Collection, Victoria & Albert Museum, London

With the adoption of high-rise buildings to meet the post-war housing shortage in Britain, Goldfinger began designing monumental structures that became icons of Brutalism – for a short time considered by the critic Reyner Banham as the leading style of Pop architecture. His proposal for one of Britain's first shopping and cinema complexes revealed its construction through the exposure of elements and structural systems. Panels set on the external surfaces of the building would fuse advertising with the fabric of the architecture. Mass communications such as changing signs and billboards would engage the people on the external plaza of the building as well as those who entered the structure.

opposite
Cedric PRICE [with Joan Littlewood]
Fun Palace
1959-61
from top, Photomontage perspective drawing, second proposal for Lea River site; Elevation cross-section drawing, second proposal; Perspective drawing, first proposal for Camden Town site
Collection, Centre Canadien d'Architecture, Montréal

The Fun Palace was an unrealized project commissioned specifically for London but designed to be located anywhere for any amount of time. It would have non-committal structuring, making it flexible enough for its exterior, interior and individual components to be rearranged as needed. Unlike other public amenities, it would always be open and would provide limitless possibilities of experience on active and passive levels of engagement. Joan Littlewood, a prominent director of avant-garde theatre, promoted the notion of a theme park based on everyday life, a laboratory for educational and experiential play that would synthesize popular culture, fine art and common urges in one locale. In collaboration with Littlewood and the cybernetic theorist Gordon Pask, Price brought form to these ideas by designing a ten-storey structure that could be assembled and dismantled at short notice. The Fun Palace was a key influence on later projects such as Archigram's Plug-in City (1964) and Renzo Piano and Richard Rogers' Centre Georges Pompidou (1972–76).

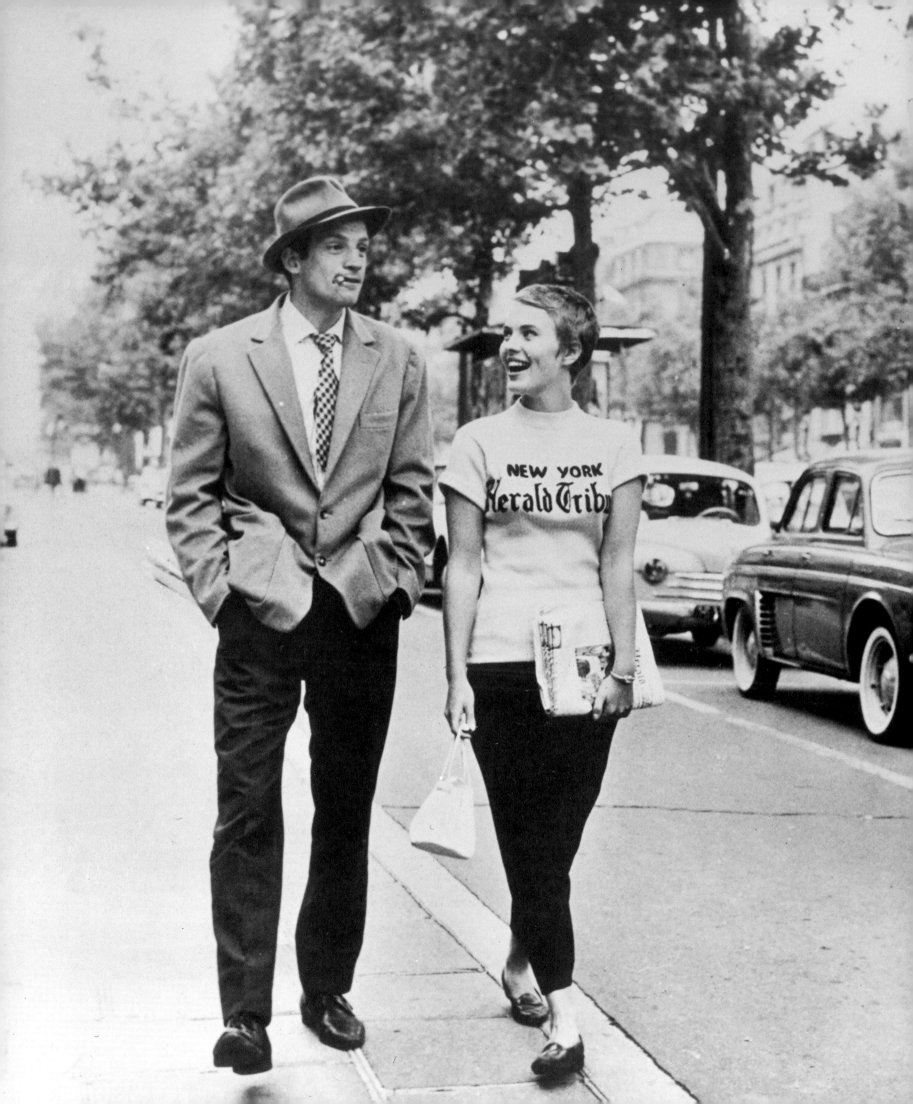

opposite
Jean-Luc <u>GODARD</u>
À bout de souffle
Breathless
1960
35mm film, 90 min., black and white, sound
With Jean-Paul Belmondo, Jean Seberg

Godard's first feature-length film was formative in the development of New Wave filmmaking, which asserted a radical freedom from mainstream cinema's established narrative and aesthetic conventions. Michel (played by Belmondo) is a hapless hoodlum who models himself on the gangsters in Hollywood films. He shoots a policeman, almost accidentally, then turns to his American student girlfriend Patricia (played by Seberg) for protection. The film follows their time together on the run, ending with Michel being shot dead by police on the street. Godard's cinematographer, Raoul Coutard, disrupted contemporary viewers' expectations by shooting the Paris streets from rooftops or pedestrian vantage points, as in Russian Constructivist films of the 1920s, or bringing them close up to the actors inside a moving car. More radical than this, however, is the extensive use of jump-cuts – the narrative 'jerk' effected by deleting consecutive sections from the filming of a continuous action within the same shot and the same scene. This technique, close to that of comic strips, formally reinforces Godard's exploration of the gap between real-life action and popular culture; between Michel and the cinematic figures he tries to imitate; between the film's artifice and viewers' conditioned responses. Godard's films, continually radical and political, but also funny and popular, and also his writings in *Cahiers du Cinema*, formed a major influence on both New Wave filmmakers and artists during the 1960s.

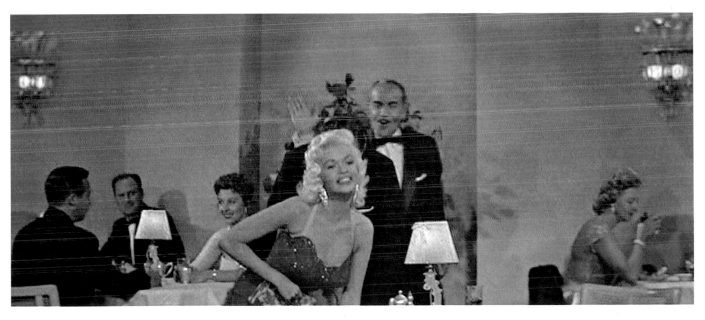

Frank <u>TASHLIN</u>
The Girl Can't Help It
1956
Eastmancolor Cinemascope, 97 min., sound
With Jayne Mansfield, Tom Ewell

In the 1930s Tashlin directed a number of Warner Brothers' 'Looney Tunes' animated cartoons. Jean-Luc Godard admired the way Tashlin adapted elements of plot construction and comic timing from the cartoon strip to the feature film to create skilful, humorous satires on the icons and obsessions of 1950s American society. This transposition might be seen as a parallel development in cinema to the adoption of comic strip material and Hollywood iconography by Pop artists in the early 1960s. In addition to Jayne Mansfield's famous role as the stereotypically voluptuous girlfriend of a gangster who wants her to become a pop star despite her inability to sing, the film showcases real rock 'n' roll, rhythm and blues, and jazz musicians, including Eddie Cochran, Fats Domino, Little Richard and Gene Vincent.

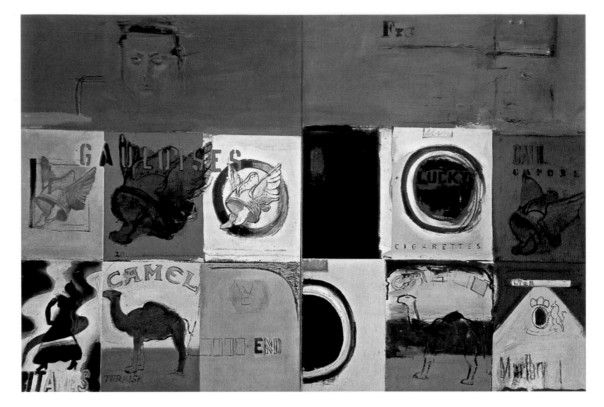

Larry <u>RIVERS</u>
Friendship of America and France [Kennedy and de Gaulle]
1961-62
Oil on canvas
130 × 194.5 × 11 cm [51 × 76.5 × 4.5 in]

Rivers' assessment of popular culture began in the 1950s, when he addressed history painting through a vernacular of commercial symbols he referred to as 'common references'. His early subjects revolved around his Jewish immigrant family background and an American folk history of myths and heroes that became whimsical in his renderings. This painting, based on John F. Kennedy and Charles de Gaulle's meetings over the Cuban crisis in 1962, is one of two works the artist made referring to the event. It was painted shortly after Rivers moved to Paris, and shows how he synthesized cultural moments and figureheads with popular iconography, such as the juxtaposed American and French cigarette brand icons. Sharing some characteristics with the work of Rauschenberg and Johns, the canvas stands out from the wall due to the depth of its support, emphasizing its presence as an object.

opposite
Daniel <u>SPOERRI</u>
Lieu de repos de la famille Delbeck
Resting Place of the Delbeck Family
1960
Table-top with preserved remains of meal; enamel plaques on reverse [not shown]
57 × 55 × 20 cm [22.5 × 22 × 8 in]

Here the residue on the table after a meal is transformed into a readymade still life. The assemblage appears to have been constructed at random by someone else – the 'Delbeck family' – the objects glued into place exactly as discarded, rather than placed in a composition by the artist. This impression is reinforced by the plaques on the underside of the table-top, each commemorating the name of a member of the family. Preserving the evidence of banal domestic scenes, Spoerri conceived his *tableaux-pièges* (snare pictures) as a medium to highlight grim living conditions, his social commentary setting the work aside from the more formally structured objects of his Nouveau Réaliste contemporaries.

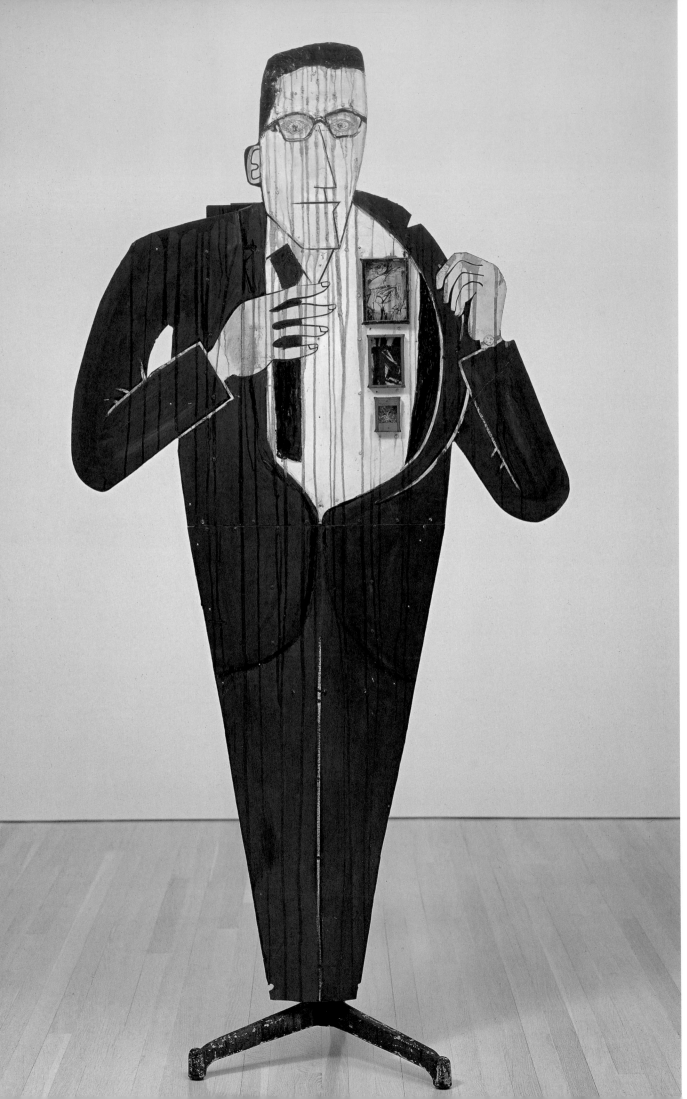

Edward <u>KIENHOLZ</u>
Walter Hopps Hopps Hopps
1959
Paint and resin on wood, printed
colour reproductions, ink on
paper, vertebrae, telephone
parts, sweets, dental moulds,
metal, pencil and leather
221 × 106.5 × 53 cm
[87 × 42 × 12 in]
The Menil Collection, Houston

Kienholz created this life-sized sculpture of his friend and associate using a free-standing gasoline station advertisement (the Bardhal Man, a cartoon detective). The title is a play on Hopps' name, Walter Hopps III. Kienholz portrays the gallerist and critic, wearing his characteristic thin tie and horn-rimmed glasses, as a street hustler, opening his jacket to reveal miniature replicas of paintings by Willem de Kooning, Jackson Pollock and Franz Kline. At the back of the figure, in several compartments, Kienholz placed phony art documentation and assorted lists he had dictated to Hopps. Walter Hopps was later director of the Pasadena Museum of Art, where in 1962 he presented 'New Painting of Common Objects', an exhibition that signalled the rise of American Pop art.

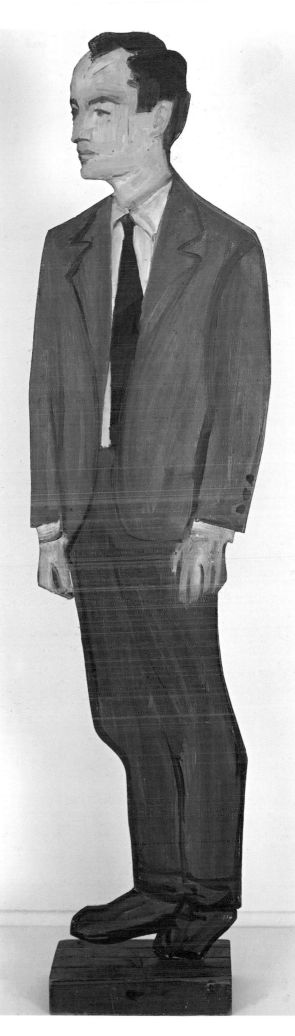

Alex <u>KATZ</u>
Frank O'Hara
1959-60
Oil on wood
152.5 × 38 cm [60 × 15 in]

Working on a large scale, Katz's realist images were transformed, developing into a 'synthetic' painting style, formally rigourous and iconic, while retaining a fidelity to appearance. *Frank O'Hara* is one of the earliest examples of his 'cut-out' series of portraits – freestanding, flat paintings of both front and back – often depicting art-world figures. O'Hara, a poet and curator at the Museum of Modern Art, used pop imagery in his poetry, incorporating everyday sights and experiences he encountered while walking around New York. Investigating the established boundaries of form in a similar way to Rauschenberg's combines, Katz's cut-outs mixed flat painting and sculpture.

Jim DINE
Car Crash
1960
Happening, Reuben Gallery, New York
centre left, Jim Dine with Judy Tersch

Dine had experienced a car crash in 1959. This work raised the question of the difference between real and imagined experience. The gallery was lined with his drawings and paintings. 'All of the works contained crosses – usually the blocky symbol of the Red Cross – and some had tyre-like circles. The white, freshly painted display room was simple, neat and clean … several large cardboard crosses hung from the ceiling' (Michael Kirby, *Happenings*, 1966). Dressed in silver, with silver face paint and red lipstick, Dine repeatedly drew anthropomorphic cars on a blackboard. He grunted, communicating only through drawing. The performance engaged with the daily spectre of reported accidents and deaths, a theme that Andy Warhol would also explore from 1963 with his series of paintings and screenprints based on disasters.

right
Red GROOMS
The Magic Train Ride
1960
Happening, Reuben Gallery, New York, part of 'Four Happenings', 8–11 January 1960

Before meeting Allan Kaprow, whose *Untitled* event in New Brunswick in April 1958 is considered the first Happening, Grooms had staged *A Play Called Fire* at the Sun Gallery, Provincetown, Massachusetts, during August and September of the same year. There he made an 'action' painting as a public performance. After meeting Kaprow in the summer of 1959 and seeing the exhibition of the Japanese Gutai group, who explored similar ideas, at the Martha Jackson Gallery in September, Grooms moved away from painting towards non-narrative based, improvisatory events such as *The Magic Train Ride*. These lasted around ten minutes and were performed by non-actors. Spoken references to New York city landmarks and comic strip characters such as Dick Tracy grounded these events in popular culture. Bob Dylan later wrote of the connection he felt with Grooms' work: 'It seemed to be on the same stage. What the folk songs were lyrically, Red's songs [*sic*] were visually – all the bums and cops, the lunatic bustle, the claustrophobic alleys …'
– Bob Dylan, *Chronicles*, 1, 2004

opposite
Claes OLDENBURG
Snapshots from the City
1960
Happening, Judson Gallery, Judson Memorial Church, New York, 29 February and 1–2 March 1960

This was Oldenburg's first Happening: a performance enacted in an environment he created, called The Street. It represented the culmination of his urban investigations, developed through his work as a street reporter and sketch artist in Chicago before moving to New York in 1956. He produced objects made from cardboard and burlap – cars, signs, figures – and painted them in a rough, cast-off style. These were then torn and tattered to evoke the chaos and aggression of city life. The performance engaged the audience in the mundane, involving them in their environment. Through his persona Ray Gun, he explored the possibility of making 'hostile objects human'.
– Claes Oldenburg quoted in Barbara Rose, *Claes Oldenburg*, 1970

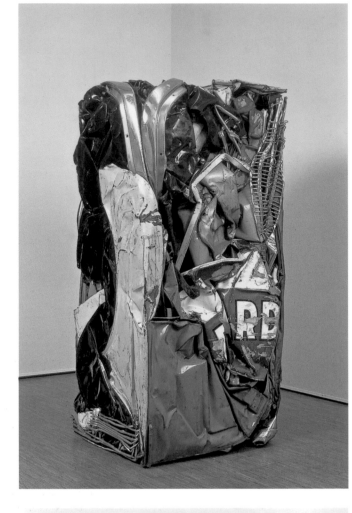

CÉSAR

Compression 'Ricard'

1962

Directed compression of car

153 × 73 × 65 cm [60.5 × 29 × 25.5 in]

Collection, Musée national d'art moderne, Centre Georges
Pompidou, Paris

In the spring of 1960 a scrap-iron facility near Paris installed the latest American technology for compressing scrap metal. The machine produced bales of different weights and sizes, fed by a system of cranes and magnetic winches. César believed this operation created a new form of visual metamorphosis, emerging from an industrial process. He directed the car compression workers to produce individual units like this one branded with a Ricard logo, and presented them as readymades. The critic Pierre Restany saw these *Compressions* as a major transitional development in the appropriation of the real into the sphere of art.

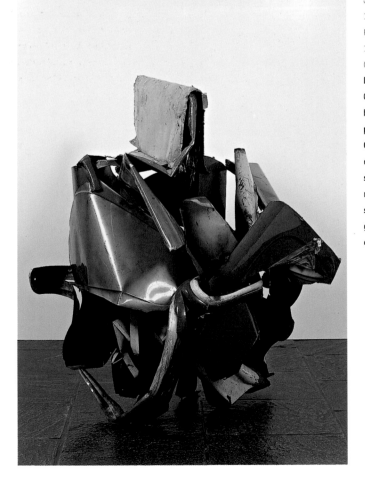

John CHAMBERLAIN

Jackpot

1962

Painted steel and gold paper

152.5 × 132 × 117 cm [60 × 52 × 46 in]

Collection, Whitney Museum of American Art, New York

Influenced by David Smith, whose welded steel sculptures he saw in the early 1950s, Chamberlain began incorporating crumpled automobile parts into his work. By 1959 he was using these parts exclusively, in sculptures that he presented without pedestals or stands. Unlike César, who made use of mechanical crushing techniques, Chamberlain assembled the components himself, based on shape and colour (often dictated by the Detroit manufacturers, although frequently the overall structure was sprayed with additional colours). The appropriation of the automobile as a source material makes reference to American consumerist culture, with its power and symbolic freedom subjected to the violence of Chamberlain's process. Chamberlain's gesture has been interpreted as an ironic comment on an industrial culture of expendability.

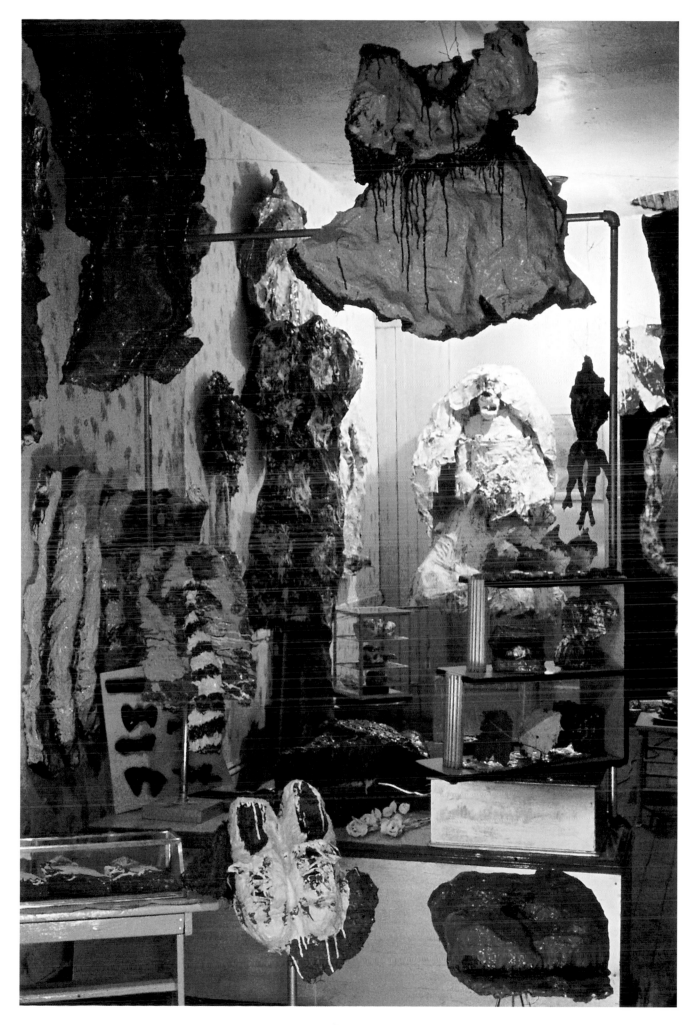

Claes OLDENBURG
The Store
1961
Ray Gun Mfg. Co., 107 East 2nd
Street, New York

Oldenburg's sense of what constituted an art object began to change as he looked towards commercial spaces. 'I saw, in my mind's eye, a complete environment based on this theme ... I began wandering through stores – all kinds and all over – as though they were museums. I saw the objects displayed in windows and on counters as previous works of art.' (Claes Oldenburg quoted in John Rublowsky, *Pop Art*, 1965). He discovered a line of paints, Frisco Enamel, that came in seven bright colours that he felt symbolized the idea of The Store. Parodying the tastes of a materialist society he created objects (such as a wedge of pie, dresses, a shirt and tie) from burlap or muslin dipped in plaster and bound with chicken-wire, then painted them with Frisco Enamel straight from the can. Oldenburg first showed these works in 'Environments, Situations, and Spaces' (Martha Jackson Gallery, New York, March 1961). However, he was dissatisfied with the installation and made a more complete environment in his own studio, a storefront called the Ray Gun Manufacturing Company, which he opened in December 1961. The Store was both a commercial and an artistic success. He changed the name of his studio to the Ray Gun Theater and became a fixture on the Lower East Side.

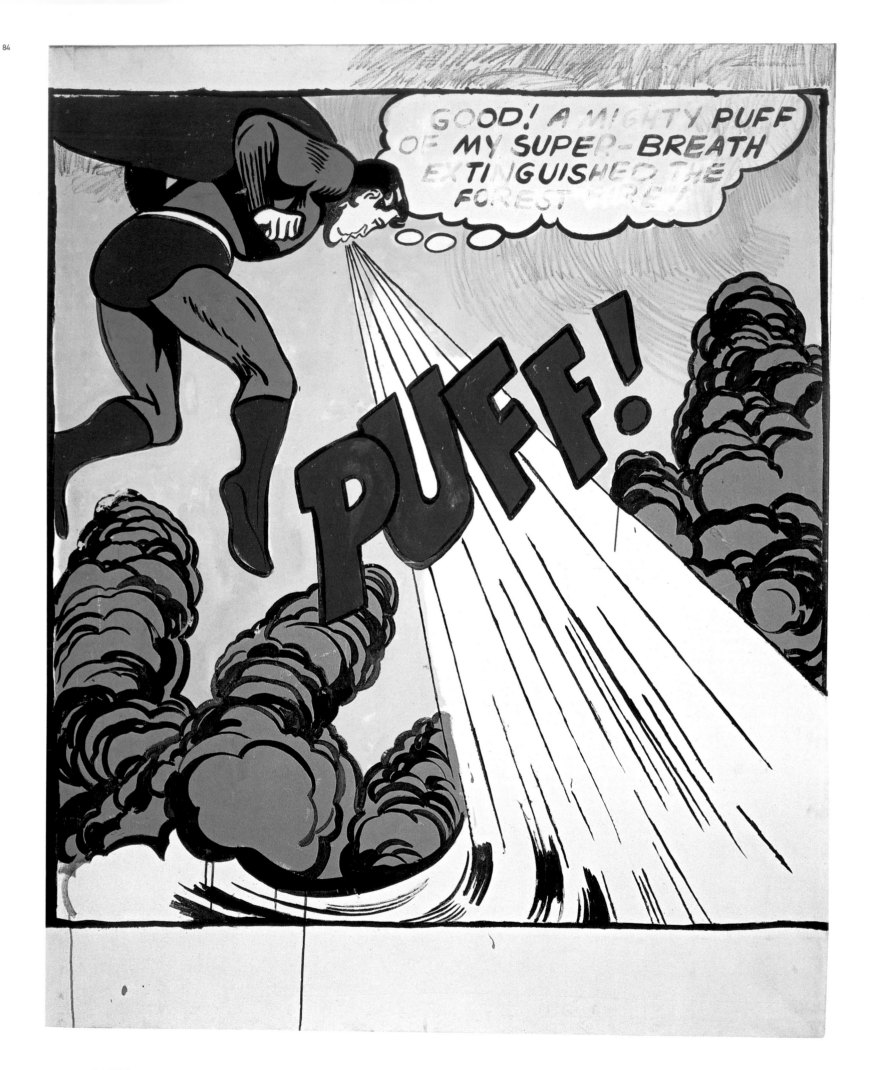

opposite

Andy WARHOL

Superman

1961

Casein and wax crayon on cotton duck

170 × 132 cm [67 × 52 in]

Warhol's *Superman* and a small group of other paintings such as *Dick Tracy* (c. 1961) are among the first to use comic-strip material as primary subject matter. They were made in tandem with his works based on newspaper small ads. *Superman* is based on a panel from *Superman's Girl Friend, Lois Lane* (24, DC/National Comics, April 1961); Warhol's archives show that he used two frames from this strip for reference. He painted the contours over the colours, reversing the accepted norm of colour following line. The monumental scale and traces of painterliness, such as the self-conscious drips, have been viewed as placing the work in a dialogue with the predominant style of gestural painting that prevailed until the end of the 1950s. This was one of the paintings displayed at the Bonwit Teller department store, shown below. Some of the crayon drawing in the work was added after that date.

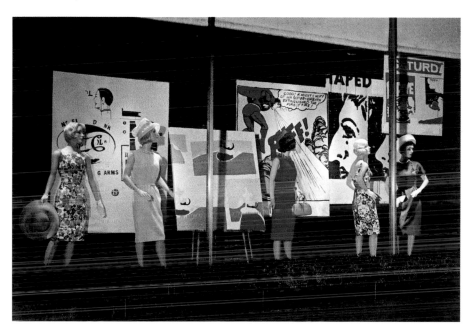

Andy WARHOL

Five paintings in display window at Bonwit Teller, New York, April 1961. *left to right*, Advertisement, 1961; Little King, 1961; Superman, 1961; Before and After [1], 1961; Saturday's Popeye, 1961

By the late 1950s Warhol was already well known in the advertising world as a commercial artist, specializing in promotions for fashionable women's shoes. His success enabled him to employ assistants and collect works of modern art. A number of prominent artists, from Salvador Dalí in the late 1930s to Jasper Johns and Robert Rauschenberg not long before Warhol, had been invited to style window displays in Manhattan's most exclusive department stores. Unlike his predecessors Warhol did not lose the opportunity to combine this commission with an exhibition of his latest paintings, presented to thousands of onlookers near the fashionable intersection of Fifth Avenue and 57th Street. This presentation by the as yet unknown artist preceded his first contact with an art dealer. Later that spring when visiting the Castelli Gallery he encountered Roy Lichtenstein's work for the first time. The realization that they were both making paintings, albeit very different kinds, based on comic strip figures, influenced Warhol to move on to different subjects by 1962.

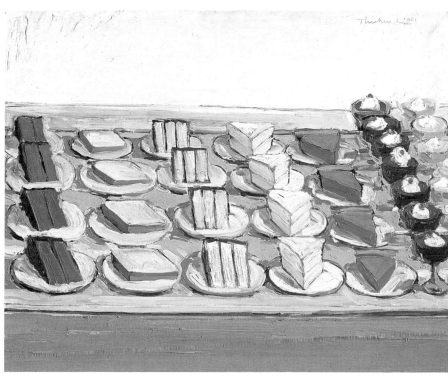

Wayne THIEBAUD

Desserts

1961

Oil on canvas

61 × 76 cm [24 × 30 in]

A West Coast painter who described himself as a 'realist', Thiebaud was co-opted by some critics as a Pop artist after his work began to be shown in New York in 1962. This was due to his typical subject matter – pinball machines, window or counter displays of rows of products – as well as the merging of sign and referent: 'I like to see what happens when the relationship between paint and subject-matter comes as close as I can get it – white, gooey, shiny, sticky oil paint [spread] out on top of a painted cake to "become" frosting. It is playing with reality – making an illusion which grows out of an exploration of the properties of materials.'

– Wayne Thiebaud, quoted in Lucy R. Lippard, *Pop Art*, 1966

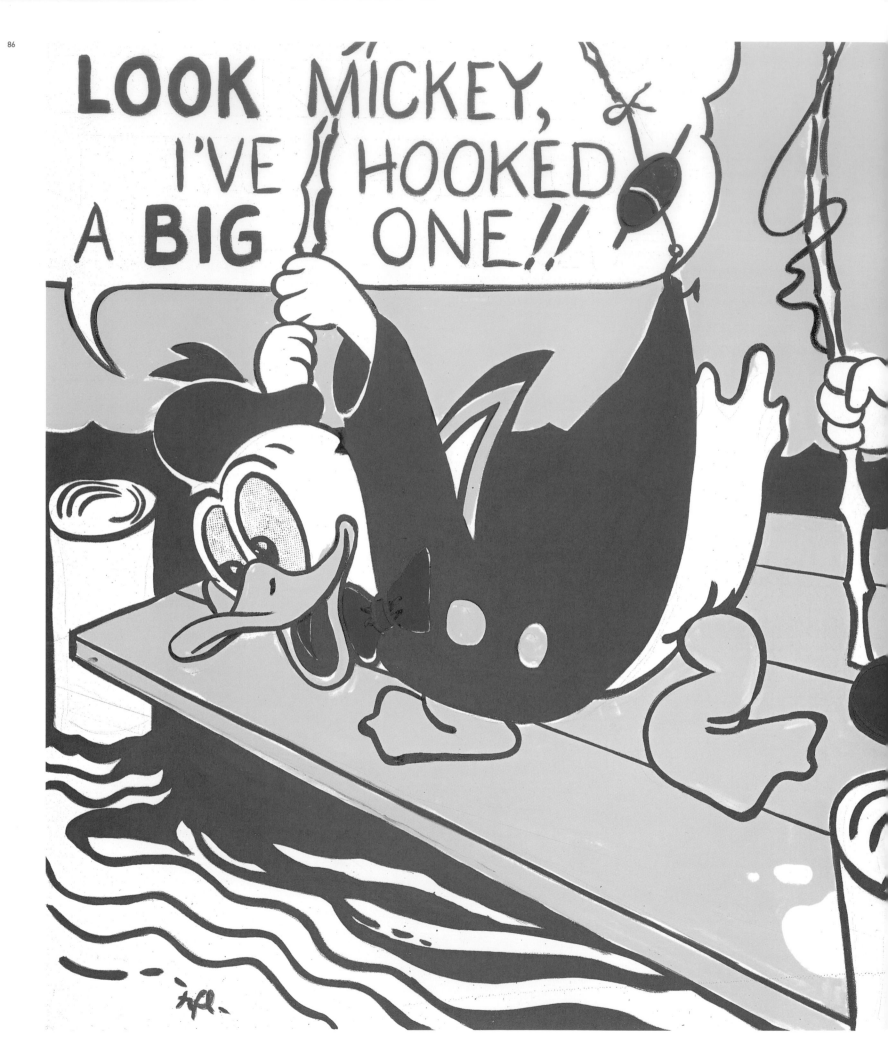

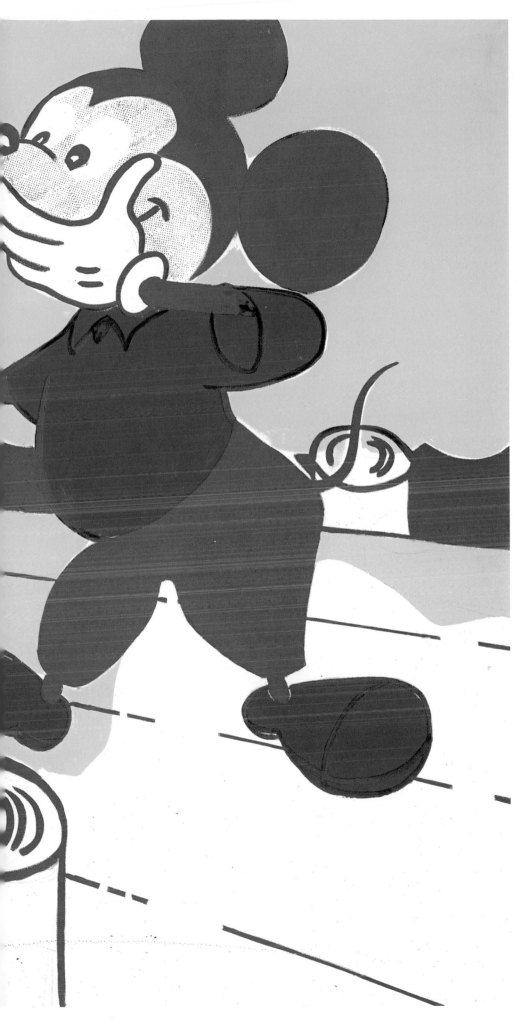

Roy <u>LICHTENSTEIN</u>

Look Mickey

1961

Oil on canvas

122 × 175 cm [48 × 69 in]

Collection, National Gallery of Art, Washington, D.C.

Painted in the summer of 1961, this was the first work in which Lichtenstein derived a subject directly from a printed comic strip. Featuring the Disney characters Donald Duck and Mickey Mouse, it shows the artist's first use of dialogue balloons and his first painted rendering of the dot patterns created by printers' halftone plates for colour separations (known as Ben Day dots). This was achieved on this occasion by applying them with a plastic-bristle dog-grooming brush dipped in oil paint. Lichtenstein would later refine his techniques for reproducing these dots, which became, ironically given their mechanical origin, a signature of his style. Although cartoon figures had started to appear in earlier works, such as a group of 1958 ink drawings, he now embarked on a radical departure from the abstract painterly style he had employed for over a decade, making paintings that many viewers at first took to be magnified facsimiles of the original sources. The large canvases in fact differed in a number of ways from the original pictures and texts, usually taken from segments of comic strips in newspapers, or other small-scale printed ephemera. This tension between the traces of the artist's hand, and creative intelligence, and his mimicking of the mechanically reproduced nature of the original sparked a heated debate among critics as to the status of these images as fine art. During this period most critics and curators would not have considered the possibility of acknowledging the original creators of cartoon strips as artists. By late 1963 the artist and critic Brian O'Doherty coined the term 'handmade readymade' to describe Lichtenstein's work

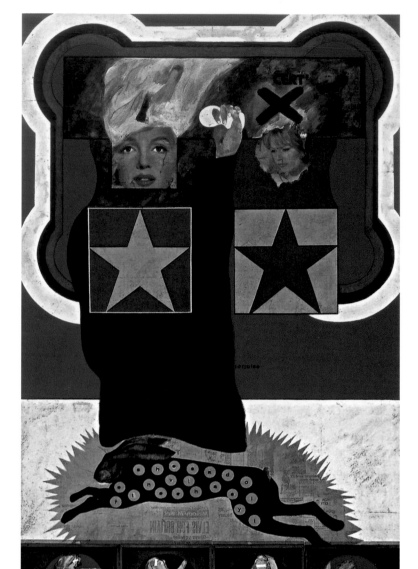

Peter <u>PHILLIPS</u>
For Men Only - starring MM and BB
1961
Oil, wood and collage on canvas
274.5 × 142.5 cm [108 × 56 in]
Collection, Centro de Arte Moderna, Fundação Calouste
Gulbenkian, Lisbon

This is one of a number of paintings in which screen icons such as Marilyn Monroe and Bridget Bardot (the MM and BB of the title) become the focal point of a composition with a structure derived from sources such as heraldry and the layout of board games or amusement arcade machines. Collaged photographs are combined with both 'hard-edge' and gestural areas of painting. In the lower section views of a painted erotic figure in a bikini are framed by realistic wooden 'peep-holes'. 'I look on what I am trying to do now as a multi-assemblage of ideas inside one format … my awareness of machines, advertising, and mass communications is not probably in the same sense as an older generation that's been wihout these factors; I've been conditioned by them and grew up with it all and use it without a second thought.'
– Peter Phillips, statement, *The New Generation*, 1964

right

David <u>HOCKNEY</u>

Tea Painting in an Illusionistic Style

1961

Oil on canvas

185 × 76 cm [73 × 30 in]

Collection, Tate, London

This is one of the few paintings by Hockney that could be described as in a pure Pop idiom. The canvas is shaped to the everyday object depicted – the box of a brand of tea which is a British 'household name'. Hockney's title, however, describes the painting as 'in an illusionistic style' rather than purely illusory. The presence of a ghostly figure (apparently seated in the box), the misspelling of the word 'tea' on one side, and Hockney's loose, painterly style make the illusion obvious in its falsity. His exploration of process connected Hockney with the ideas of Johns and Rauschenberg, and he has cited as an influence Larry Rivers, who in 1961 visited the painting studios at the Royal College of Art where he was studying. 'This is as close to Pop art as I ever came. But I didn't use it because I was interested in the design of the packet or anything; it was just that it was a very common design, a very common packet, lying around … To make a painting of a packet of tea more illusionistic, I hit on the idea of "drawing" it with the shape of the canvas. It meant that the blank canvas was itself already illusionistic and I could ignore the concept of illusionistic space and paint merrily in a flat style – people were always talking about flatness in painting.'
– David Hockney, 'The Tea Paintings', *David Hockney by David Hockney*, 1976

opposite

Derek <u>BOSHIER</u>

Special K

1961

Oil, collage, pencil on canvas

121.5 × 120.5 × 2.5 cm [48 × 47 × 1 in]

Boshier was unusual among the British Pop artists of the 1960s in presenting an overt critique of the accelerated and globally spreading capitalism emanating from the United States. In a number of paintings of this period there is a suggestion that people are becoming like their products and imprisoned by brand logos. America's provisional control over import/export economies, ranging from the crisis in Cuba to the food products in the average urban household, gave rise to the notion of the consumed consumer. For Boshier, Americanization was being sold through the basic choices of branded nourishment: 'You are what you eat'.

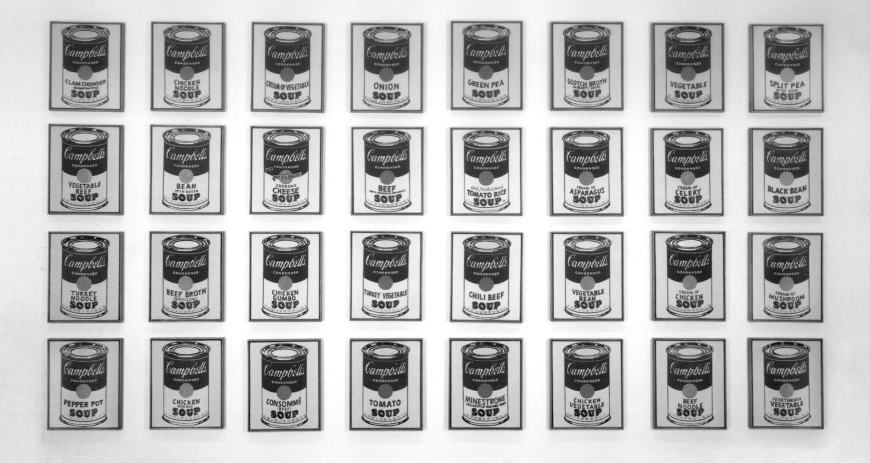

Andy WARHOL
32 Campbell's Soup Cans
1962
Casein, metallic paint and pencil on linen
51 × 40.5 cm [20 × 16 in] each
Collection, The Museum of Modern Art, New York

From 1961 Warhol made images of Campbell's Soup cans repeatedly, with variations –
open, crushed or pristine; realistic in colour and not; standing alone or in groups;
large and small; sketchy or precise – and in different media. The paintings of *32
Campbell's Soup Cans* (first exhibited at the Ferus Gallery, Los Angeles, in July 1962)
echo the image that appeared as a logo on the company's envelopes. Warhol referred
to their product list, adding 'Turkey Vegetable', which had been omitted. The name
of each variety is the only feature that distinguishes each painting from its neighbour.
Conceived as related compositions but not necessarily a single work, it was Irving
Blum's acquisition of the whole set that led to them being considered a series.
For their first showing Blum, co-director of the Ferus Gallery, devised a narrow ledge
on which they rested, which critics have compared with a supermarket shelf. These
are among the last of Warhol's handmade paintings and were assisted by the use of
stencils, a precursor of the silkscreens he began to use shortly afterwards.

opposite
Ed RUSCHA
Actual Size
1962
Oil on canvas
183 × 170 cm [72 × 67 in]
Collection, Los Angeles County Museum of Art

Twenty-four years old and as yet unknown, Ruscha was invited to participate in the
group show 'New Paintings of Common Objects' (Pasadena Museum of Art,
September–October 1962) which presented New York artists such as Dine,
Lichtenstein and Warhol alongside West Coast contemporaries. He submitted this
painting. Warhol's *32 Campbell's Soup Cans* had been on show in the local Ferus
Gallery during July and August, but the precedent for *Actual Size* goes back to 1961
when Ruscha made a series of objective-style, frontal view, centred black and white
photographic studies of household items he later titled *Product Still Lifes* (1961/99).
Subjects included a Sun Maid raisins packet, a tin of Wax Seal car polish and a Spam
can. In *Actual Size* Ruscha depicts the Spam brand logo from the top of the can's
design and presents it as a monumentally enlarged text in the upper part of the
painting, underneath which is an exact painted rendition of the product – to actual
scale. This is portrayed 'flying' across the white canvas with a fiery trail of 'Spam logo'
yellow, surrounded by paint marks which seem less like an index of painterliness
than sign-painter's drips which have not been cleaned up or overpainted. The title
invites speculation on the different relations between iconographic or textual signs
and their referents.

Tom <u>WESSELMANN</u>

Still Life # 21

1962

Acrylic and collage on board, with recorded pouring sound

122 × 152.5 cm [48 × 60 in]

The billboard size Wesselmann adopted in both the *Still Life* and *Great American Nude* series brought about a change in materials, as he painted directly on to the canvas, as well as affixing found imagery from advertising and posters. He spoke of 'assembling a situation resembling a painting, rather than painting' (*ARTnews*, 1964). Wesselmann later incorporated actual objects, including radios and fans, into his works, moving into the viewer's space. Here he added a recorded sound to accompany the image of the drink being poured into a glass. The direct lifting of imagery meant that Wesselmann's intervention was reliant on composition, as the objects retain their original forms and associations. As here, there is usually no central focal point; images are distributed evenly across the picture plane.

James <u>ROSENQUIST</u>
President Elect
1960-61/64
Oil on masonite
213.5 × 365.5 cm [84 × 144 in]
Collection, Musée national d'art moderne, Centre Georges
Pompidou, Paris

Rosenquist's billboard-sized paintings are based on pictures he cut out from magazines and other ephemera and collaged into working drawings. In this case, a campaign poster for John F. Kennedy, an automobile advertisement and another for cake merge into one another in what seems to be a political statement. Even here, however, as in Rosenquist's other works, the possible significance of the juxtapositions remains open to the viewer. *President Elect* is the first studio painting in which he translated the techniques he had learned as a billboard painter. He had continued to work commercially when he moved from Minnesota to New York in 1957 to attend art school, and now used the hyperrealism and vast scale of the cinema or advertising poster, but combined these qualities with a frozen approximation of cinematic montage that marks the point of transition from one subject-area to another. 'Painting is probably more exciting than advertising – so why shouldn't it be done with that power and gusto, that impact ... When I use a combination of fragments of things, the fragments or objects or real things are caustic to one another, and the title is also caustic to the fragments ... The images are expendable, and the images are in the painting and therefore the painting is also expendable.'
– James Rosenquist, statement, *ARTnews*, 1964

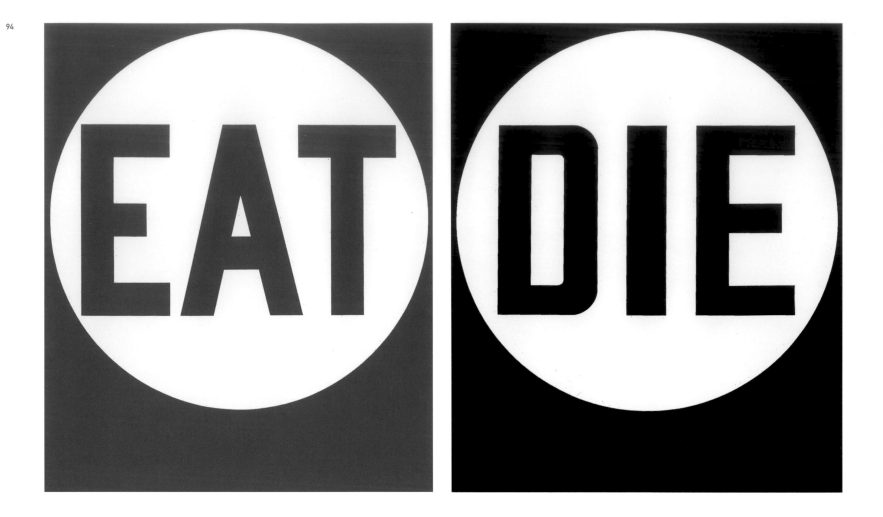

Robert INDIANA
EAT/DIE
1962
Oil on canvas
2 panels, 183 × 152.5 cm [72 × 60 in] each

Using words and numbers as images, Indiana often adapted formats derived from
signage. Using a hard-edged painting style and flat areas of pure, unvaried colour,
the work brings together the formally abstract and impersonal with the symbolically
redolent. The sign-like impact of the visual field in this diptych recalls the illuminated
signs for roadside diners that were a feature of the American landscape in the 1950s
and early 1960s. The word 'eat' was loaded with personal significance for Indiana:
his mother ran a dinner service for travellers and she referred to eating in the last
words she spoke to him at her death in 1949. 'Eat' appears both singly and combined
with other charged words in a number of works. The electric sign he made for Philip
Johnson's building at the 1964 New York World's Fair comprised the word 'eat'
twice, crossing in an X form at the central letter. Indiana was the subject (eating a
mushroom) in Andy Warhol's 45-minute film *Eat* (1963).

Richard SMITH
Staggerly
1963
Oil on canvas
226 × 226 cm [89 × 89 in]
Collection, National Museum of Wales, Cardiff

The title is a modified spelling of the traditional blues song *Staggerlee*. Smith's paintings of this period filter everyday forms, such as branded box packaging, into his own pictorial language of abstraction. Here a form based on a Lucky Strike cigarette packet is abstracted and tripled in a rhythm that derives from observations Smith made in his experimental films, in particular *Trailer* (1962), a perspectival study of a cigarette box. Only the basic shapes of the brand logo have been retained, making the reference subliminal and at the same time close to the use of generic abstract forms such as stripes and chevrons by 'hard-edge' painters such as Kenneth Noland. The canvas was designed around the shape of the composition, an approach that eventually led Smith to make relief-paintings that project areas of the work into the space around the viewer.

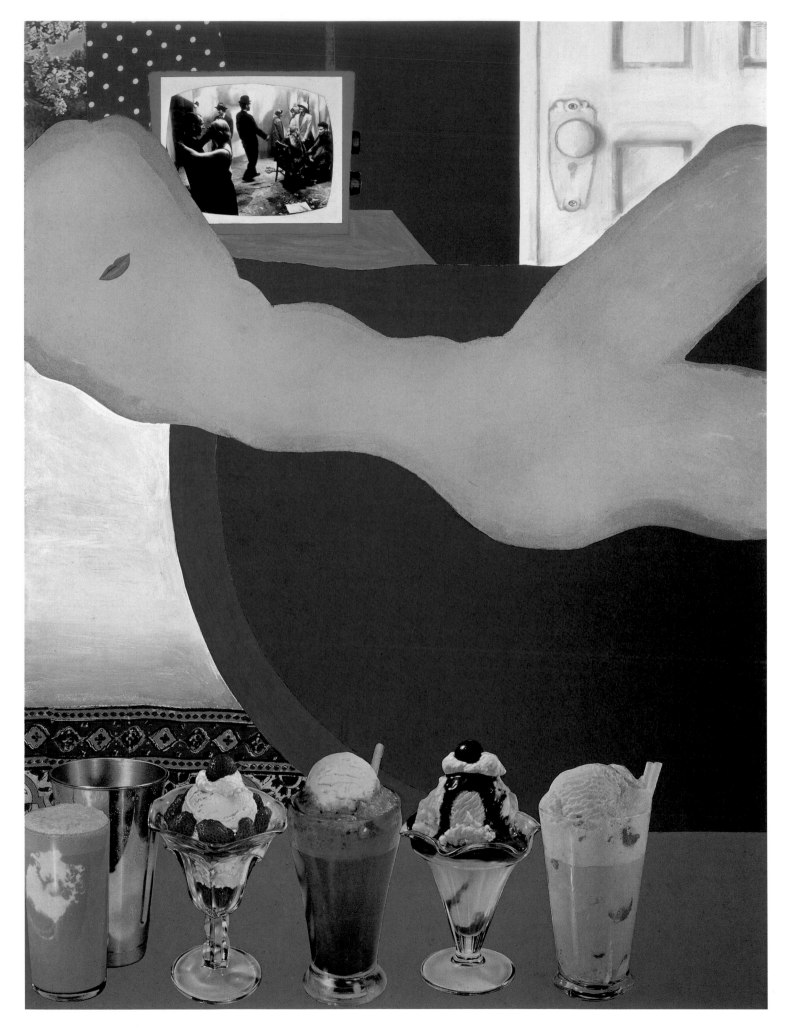

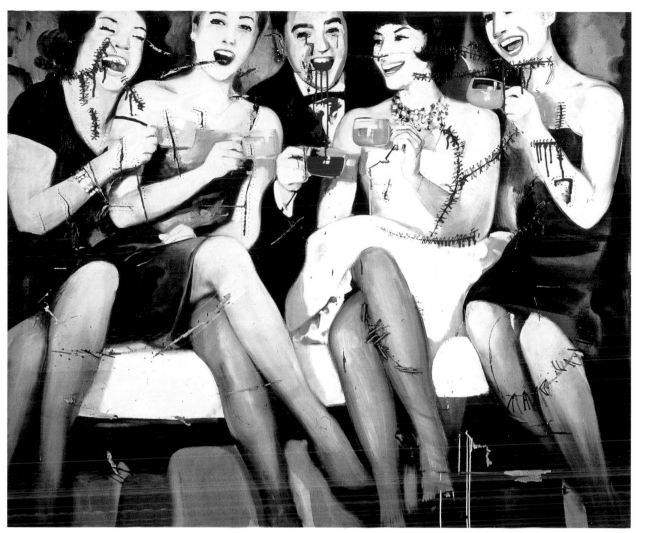

Gerhard <u>RICHTER</u>
Party
1962
Tacks, cord, oil on canvas
and newspaper
150 × 182 cm [59 × 72 in]

Rather than the advertisements and cartoons referenced by the American Pop artists, Richter used found photographs. Having worked through the canon of Western art-historical styles on his arrival at the Dusseldorf academy, he developed a photorealistic style that for a time he identified with the term 'Capitalist Realism'. This painting is derived from a photograph included in sheet 9 of the artist's extensive image archive begun in 1962: *Atlas*. Both comical and disturbing, this particular work is distinctive for being treated as an object. Richter splattered the image with drips of paint and slashed the canvas, then stitched it, repairing the painting after the brutalizing, as it were, that it had undergone. Realism is unsettled by the gothic transformation of the drinking man into a ghoulish figure by the use of red paint, and the appearance of one of the women's legs 'in colour', when all else is 'in black and white'.

opposite
Tom <u>WESSELMANN</u>
Great American Nude # 27
1962
Enamel, casein and collage on panel
122 × 91.5 cm [48 × 36 in]

Painted in a flat and schematic manner, a female nude lounges in a domestic setting, her mouth the only discernable feature, with an ensemble of ice-cream sundaes and other drinks in the foreground. The figure is composed in a style that distantly echoes the early modern painters, such as Matisse, whom Wesselmann admired. The use of collage material in the canvas was, he stated, a practical solution to being unable to paint certain objects with the accuracy he required. Raising questions of authorship and originality, this approach became a feature of much work in the Pop idiom. Wesselmann's later nudes in the series included three-dimensional objects, such as furniture and bathroom fittings. 'I refuse to draw the line betweeen flat paintings and three-dimensional structures. I'm aware of the differences between real and imitation but I don't attach much significance to the distinction.'
– Tom Wesselmann, interview, *Time* magazine, 1966

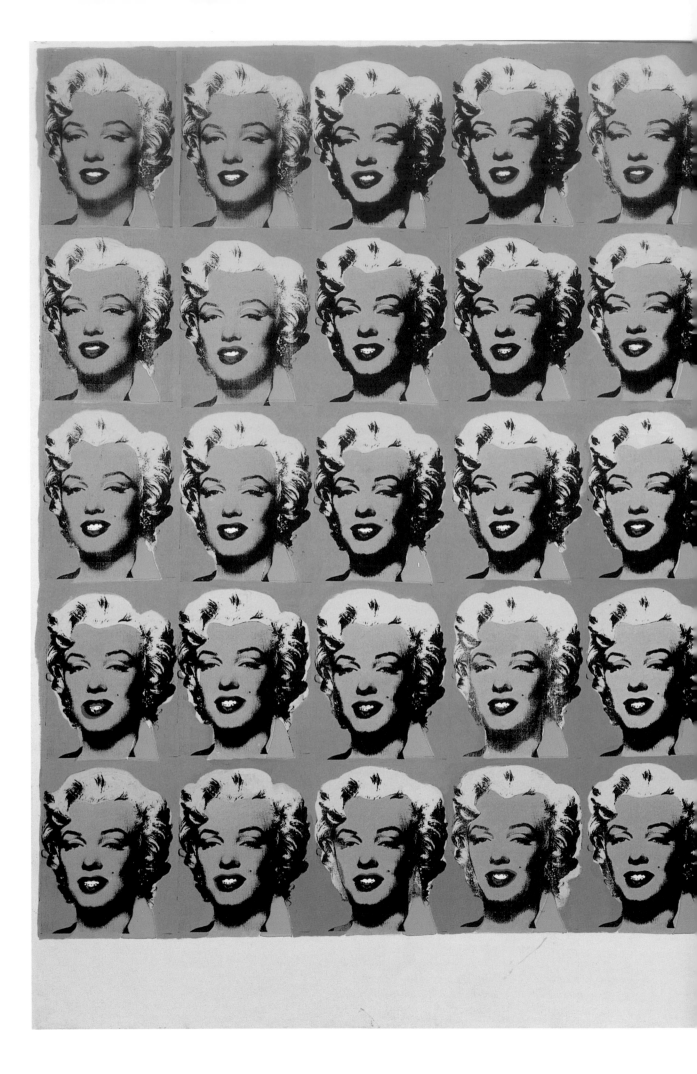

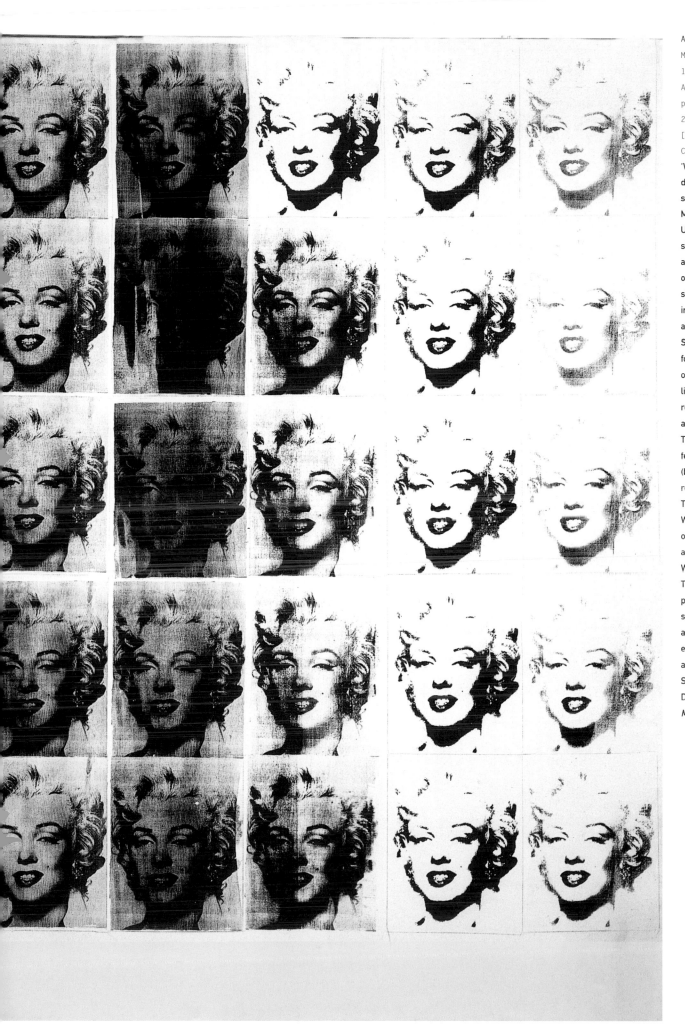

Marilyn Diptych
1962
Acrylic, silkscreen,
pencil on canvas
2 panels, 205.5 × 145 cm
[81 × 57 in] each
Collection, Tate, London

'When Marilyn Monroe happened to die that month, I got the idea to make screens of her beautiful face – the first Marilyns' (Andy Warhol, *Popism*, 1980). Using a found image – a standard-sized (8 x 10 in) photograph, possibly a publicity still – Warhol had two sizes of silkscreen made (his first use of silkscreening), for 20 x 16 and 15 x 11 inch canvases, and from these he made all his serial *Marilyn* compositions. Separate screens were used for the formal elements in the coloured works, over a base screen of black. The hair, lips and eyeshadow, in intense colour relationships with very little overlap, are fitted together like a jigsaw. Their separation draws attention to each feature and its treatment and artificiality (bleached hair, plucked eyebrows, reddened lips, garish eyeshadow). This diptych is the canonical example of Warhol's *Marilyns*, though the treatment of the two panels as a whole was, according to her account, suggested to Warhol by the collector Emily Tremaine. The right-hand panel, in black and white, placed next to the coloured panel suggests the division between drawing and painting. *Marilyn Diptych* was first exhibited in New York in November 1961, as one of ten Marilyn images at the Stable Gallery, while simultaneously the Dwan Gallery was showing *25 Colored Marilyns*.

Roy <u>LICHTENSTEIN</u>

The Kiss

1962

Oil on canvas

203 × 173 cm [80 × 68 in]

From 1961 onwards, Lichtenstein showed a sustained interest in the typologies
of comic books and their genres, such as combat or romance. *The Kiss* combines
the two in a large-scale representation of a romantic encounter that appears at first
sight to be a replica of a single comic-strip cell. Lichtenstein borrowed the basic
composition and style from the original, and approximated the dots of the printing
process. However, despite the implied removal of artistry, there are numerous
modifications in positioning, scale and emphasis, and in the use of different
thicknesses of line and areas of pure colour to activate positive and negative space.

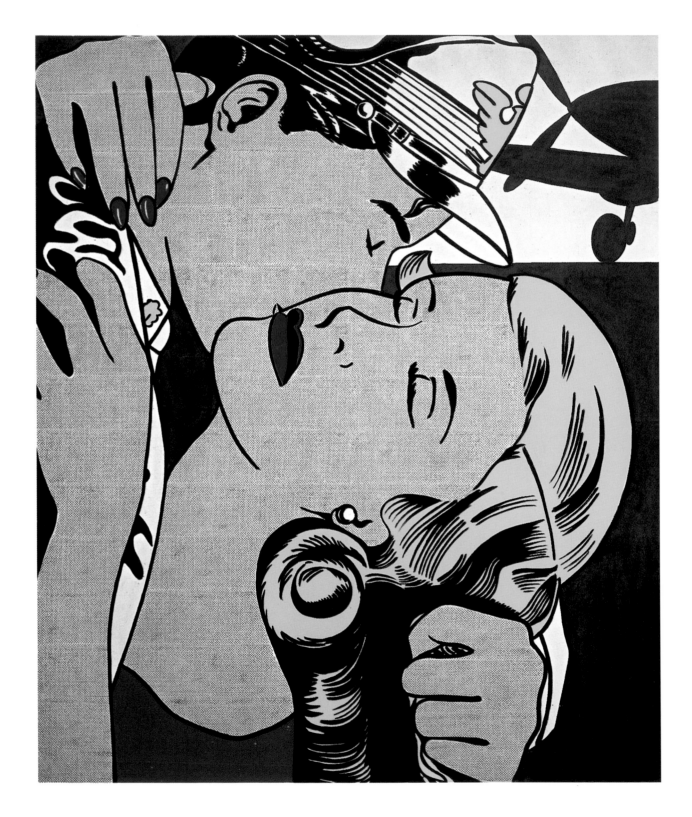

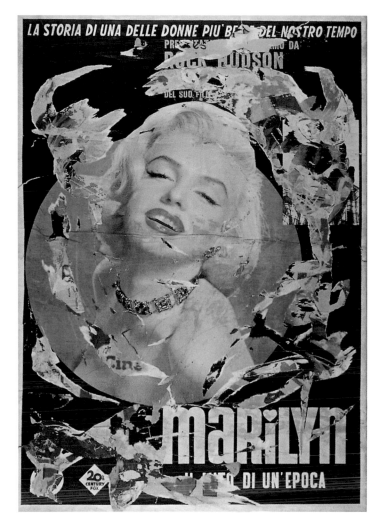

Mimmo ROTELLA
Marilyn
1962
Décollage: peeled posters on paper mounted on canvas
133 × 94 cm [52.5 × 37 in]

First presented at the Galerie J, Paris, in 1962, Rotella's décollages featuring posters of Marilyn Monroe became a substantial body of work. One of the early pioneers of this technique, he differed from the French artists Hains and Villeglé in his retention of more of the poster's composition and much of its informational content. The cinema posters he used were mostly produced by the Cinecittà feature film studios, located in Rome where he lived. Rotella's use of film posters was based on their prevalence in society as an integral part of the metropolitan fabric. Taking advantage of their availability, and fascinated by their natural evolution on the street, becoming torn, covered over and defaced, he preserved the way in which they extend cinematic fantasy and also act as a marker for collective memory.

Wolf VOSTELL
Marilyn Monroe
1962
Dè-coll/age and collage
157 × 122 cm [62 × 48 in]
Collection, Museum Moderner Kunst, Vienna

Vostell's 'dè-coll/age' works conveyed his view of art and life as inextricably linked. His imagery was taken from a wide range of sources, as likely to feature serious reportage as advertising for consumer products or paparazzi photography. The use of Marilyn Monroe iconography by artists proliferated in quick succession around the world, as artists such as Mimmo Rotella in Italy and Vostell in West Germany explored her manufactured image, like Warhol, soon after her death in 1962. Here the obsessive arrangement of publicity photos, magazine covers and news cuttings follows a 'pin-board aesthetic', fetishizing the model; their partial obliteration and over-painting might suggest the eliminative process of marking up a contact sheet, or vandalism and the gradual entropy of printed images decaying in the streets.

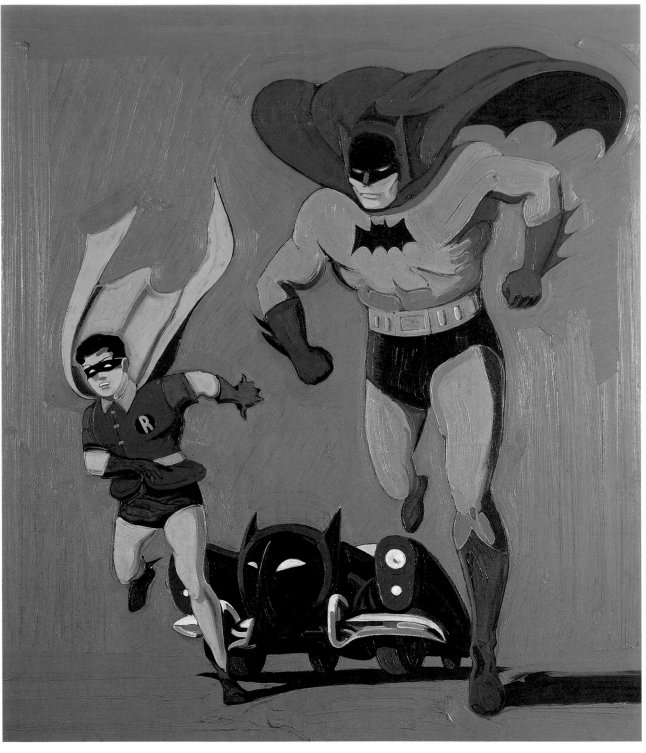

Mel RAMOS
Batmobile
1962
Oil on canvas
127.5 × 112 cm [50 × 44 in]
Collection, Museum Moderner Kunst Stiftung Ludwig, Vienna

At the end of 1961, Ramos began painting comic-book figures inspired by childhood memories and his enduring admiration for the form. With *Batmobile* he established a style of composition in which these figures are placed in a brightly coloured background. Here Batman and Robin are running directly towards the viewer, the batmobile behind them establishing a point of diminishing and dynamic perspective. Ramos uses this action and depth of field to assert the picture surface. However, he used comic-strip imagery less for its formal potential than for the values embodied by the particular figures he selected. In contrast to Lichtenstein's use of a single, recognizable frame, Ramos presents his heroes in situations of his own devising.

Öyvind FAHLSTRÖM

Sitting …

1962

Tempera on paper mounted on canvas

159 × 201 cm [62.5 × 79 in]

Collection, Moderna Museet, Stockholm

This was the first large-scale work the artist made after arriving in New York from Sweden in 1961. Since the early 1950s he had developed a form of representation he called *signifiguration*. This was characterized by forms that are between the figurative and non-figurative, hinting at meaning. Their meaning was affected by being placed in a new position and by their relationship to the whole picture. This process could be compared to a game-structure. Fahlström devised an equivalent of narrative by using 'time phases' similar to the frames in comic strips. The narrative scheme of *Sitting …* is based on a section drawing of a house, with progressions from room to room. He also introduces figurative elements, such as Batman's cape, marking a departure from *signifiguration* and a new stage in his work. The title came from wordplay: 'Sitting like Pat [Oldenburg] with a bat in her hat'. The *character-forms* in the painting are divided into different 'families' according to various characteristics. *Sitting …* initiated a series of paintings and drawings and an unfinished *Sitting … Directory* of drawings for each *character-form*.

Joe GOODE
Happy Birthday
1962
Oil and pencil on canvas with oil on glass milk bottle
170.5 × 170 × 7.5 cm [67 × 70 × 3 in]
Collection, San Francisco Museum of Modern Art

Goode produced 13 milk bottle paintings, varied in palette, starting in 1961 and culminating in his first solo exhibition, at Dilexi Gallery, Los Angeles, in 1962. Two of the series were dedicated to his daughter: *Happy Birthday*, in pale pink and dark red, celebrated her second birthday, and *One Year Old* (1962), with both canvas and bottle painted a pale cream, her first. Emptied of one liquid, then coated with another (paint) the bottles stand in front of a colour field that invites contemplation of the relationship between the physical and spiritual. Goode's concern was less with consumerism than with the everyday object. The bottles came from the Alta-Dena Dairy Company, which delivered milk to doorsteps across California. *Happy Birthday* was used on the cover of *Artforum* (August 1962), in the issue that included John Coplans' review of the Pasadena Art Museum's 'New Painting of Common Objects'.

opposite
Jim DINE
3 Panel Study for Child's Room
1962
Oil, charcoal, child's rubber raincoat, plastic toys [train, Popeye,
car, gun], metal coat hanger, metal hook, wood, on 3 joined canvases
213.5 × 184 cm [84 × 73 in]
The Menil Collection, Houston

The collection of objects in this study of a domestic interior belonged to Dine's sons Jeremy and Matthew. It was included in Dine's solo exhibition at the Sidney Janis Gallery, New York, in early 1963. Dine was interested in objects as signs of possession, in the traces left by human interaction, and in presenting the objects themselves as part of the work rather than describing them with paint. The inclusion of his children's handprints, stencilled on to the canvas, raised questions about the status of types of painting: 'Is it an "event"? Is it a "popular" or "vulgar" way of painting?' (Öyvind Fahlström, *New Paintings by Jim Dine*, 1963) Dine's use of objects with intimate, personal associations and the 'homemade look' of his works distanced him from mainstream Pop art's engagement with mass-media images and serial production, although they shared a common concern with the everyday.

Peter SAUL
Ducks in Bed
1962
Acrylic on canvas
188 × 219 cm [74 × 86 in]
Collection, Sintra Museu de Arte Moderna, Sintra, Portugal

Born and educated in California, Saul lived and worked in Europe from 1956 to 1964, but was exhibited in New York as a West Coast Pop artist from 1962. His fusion of a gestural painterly approach with cartoon-style imagery during this period has been compared with the later work of Philip Guston. A number of contemporaneous paintings convey a sense of violent out-of control frenzy, with titles such as *Bathroom Sex Murder* or *Super Crime Team*. *Ducks in Bed* is lighter and more hilarious, although all of Saul's work has a basis in serious social satire and dissent. The use of 'bad taste' colour combinations is part of the artist's sustained repudiation of high culture in favour of the directness of material connected to the everyday.

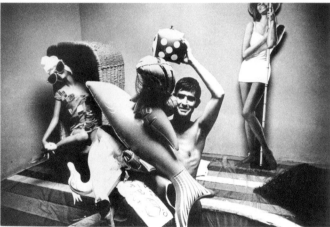

Martial RAYSSE
Raysse Beach
1962
Detail of installation, 'Dylaby', Stedelijk Museum, Amsterdam, 1962
Photograph by Ed Van der Elsken, with the artist in the foreground

Shown at the group exhibition 'Dylaby' at the Stedelijk Museum, Amsterdam, where it was inaugurated by a performance, this installation included a paddling pool, plastic flowers, inflatable toys, towels, dressed-up mannequins and life-sized photographs of women in bathing suits, enlarged from advertising images. Everything was brightly, synthetically coloured. Lamps simulated Mediterranean light and radiators produced torrid blasts of heat. A neon sign, the artist's first use of the medium (later incorporated into paintings to highlight a feature or line), declares the work 'Raysse Beach' – a world composed almost entirely of synthetic manufactured products designed for the leisure industry.

opposite
BEN
Le magasin de Ben
Ben's Boutique
1958-73
Wood, board, paint, found objects
350 × 500 × 350 cm [138 × 197 × 138 in]
Collection, Musée national d'art moderne, Centre Georges Pompidou, Paris

The Fluxus artist Ben Vautier, known from this period onwards simply as Ben, conceived this project in the late 1950s but did not present it as art until 1960, when its connection with Pop began to become apparent. The boutique, set up in various real shopfronts, the first of which was in his home town of Nice, was a place where he could freely nominate every object to hand as art. He made it evident that he was a mediating filter through which the object was transformed. The process simply involved the signing of his name or cheerful witticisms on to the objects, in his recognizably cursive handwriting. Ben's presence, living in the shop, added to the acceptance of the common object as art and generated public interest in the work.

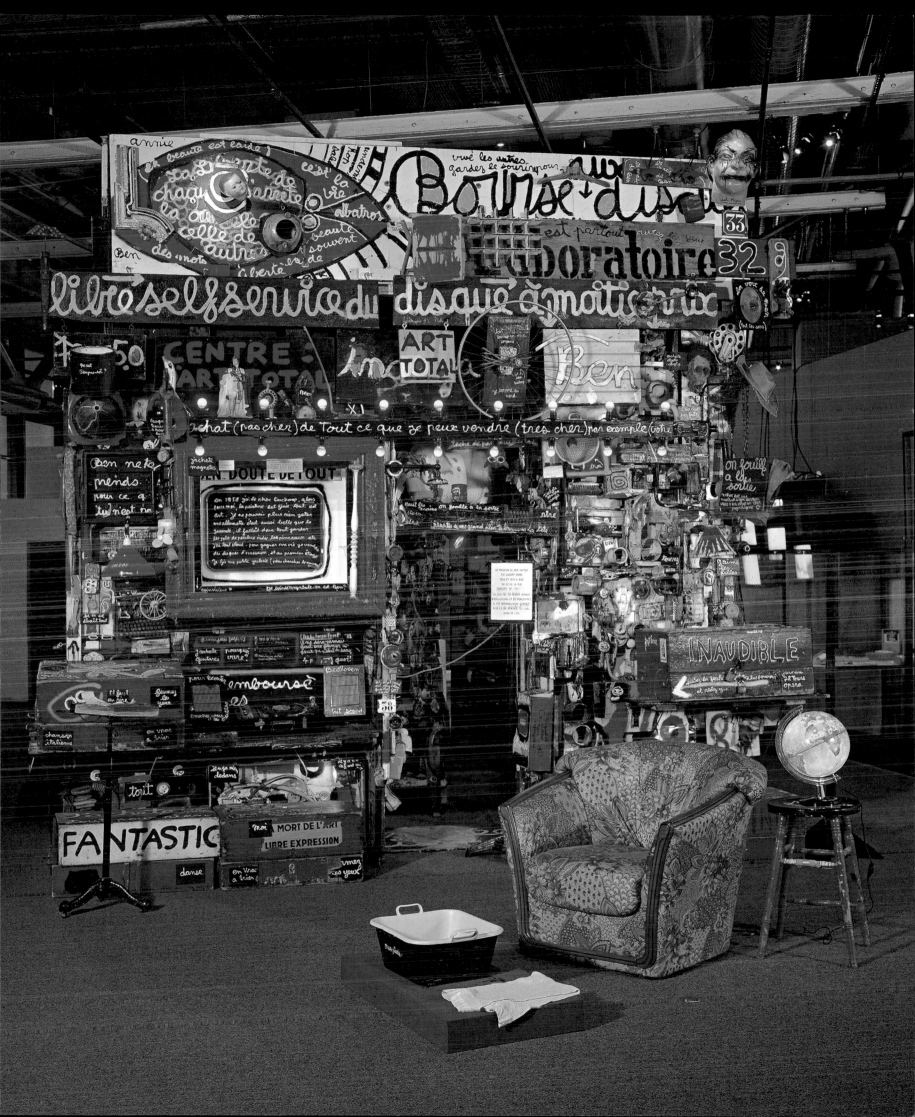

'The Store'

Environment at Green Gallery, New York, 24 September-20 October 1962

Towards the end of his Store project that had begun in 1961, Oldenburg began to produce work in softer materials, such as canvas or vinyl, stuffed with filling material. Monumental in scale, the pieces were made with the collaboration of his first wife, Pat Oldenburg. They included a giant slice of chocolate cake, a giant hamburger and various giant ice-cream cones, one lying on the floor, another suspended from the ceiling. With the earlier, painted plaster works such as a series of pies and tarts displayed in a vitrine, a large selection of Oldenburg's objects was displayed in this environment at the Green Gallery in the autumn of 1962. The objects were set out informally as if in the room of a house, some draped over chairs, scattered on a table or perched on a radiator. There the resemblance to reality ended. Ranging across widely divergent scales, the works activate the physical and associational responses to objects of those who encounter them. 'You might ask what is it that has made me make cakes and pastries and all those other things. I would say that one reason has been to give a concrete statement to my fantasy. In other words, instead of painting it, to make it touchable, to translate the eye into the fingers.'
– Claes Oldenburg, 'Oldenburg, Lichtenstein, Warhol: A Discussion', *Artforum*, 1966

Lee <u>FRIEDLANDER</u>
Newark, N.J.
1962
Gelatin silver print
31.5 × 47 cm [12.5 × 18.5 in]

In 1962 Friedlander began documenting the American urban landscape, several years after Robert Frank's *The Americans*. Capturing the increasing dominance of products and brands in everyday life, one of the features of a number of his compositions is the store or café window, both revealing the interior and fusing it, through its reflective surface, with impressions from the street outside, including the reflection of the photographer himself. Here advertising signs across the busy street outside compete with the Coca-Cola-with-fries and ice cream promotional signs inside. The human subjects seem to be framed between these references, which exert a stronger impression than the occasion for their standing to attention at the window and the boy's clutching of the American flag.

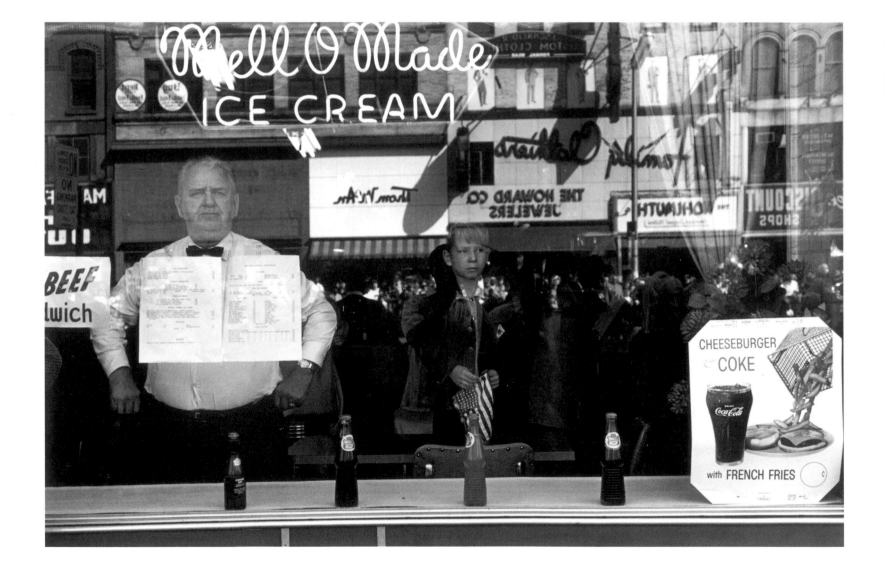

CONSUMER CULTURE

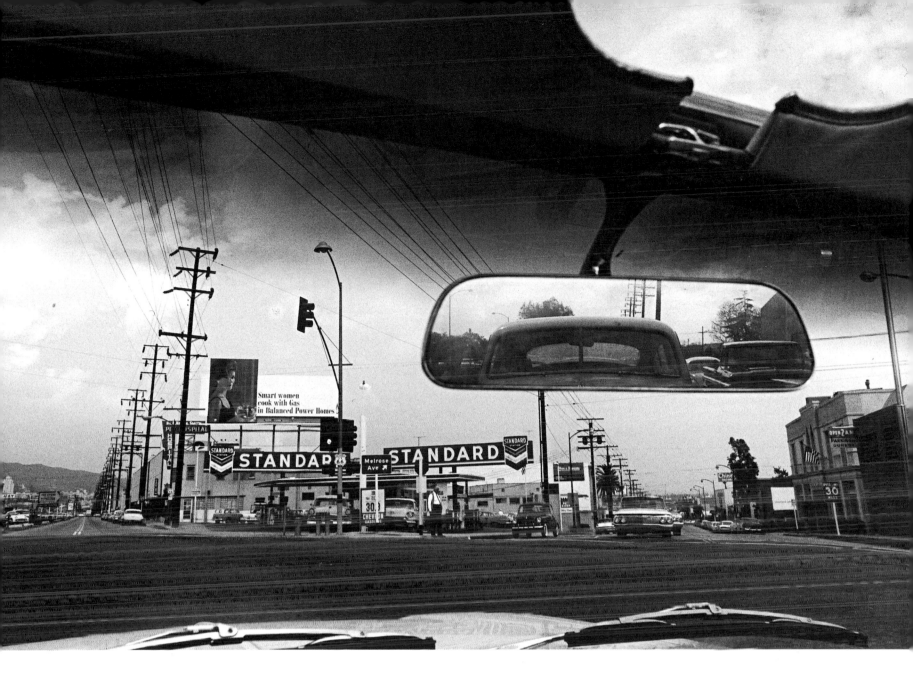

Dennis HOPPER
Double Standard
1961
Gelatin silver print
40.5 × 61 cm [16 × 24 in]

This photograph of a street junction in Los Angeles situates the photographer and the viewer in the driver's seat. The gasoline station at the intersection of Melrose Avenue and Route 66 is the focal point, underlining the expansion of consumerism into the architectural environment. The station doubles its exposure with two large signs, but the photographer's title also suggests a social comment. Hopper was closely involved with the American Pop scene in the 1960s, photographing Rosenquist, Ruscha and Lichtenstein. This photograph was reproduced on the poster for Ruscha's second solo exhibition at the Ferus Gallery, Los Angeles, in 1964, where he showed his paintings with gasoline stations as subjects.

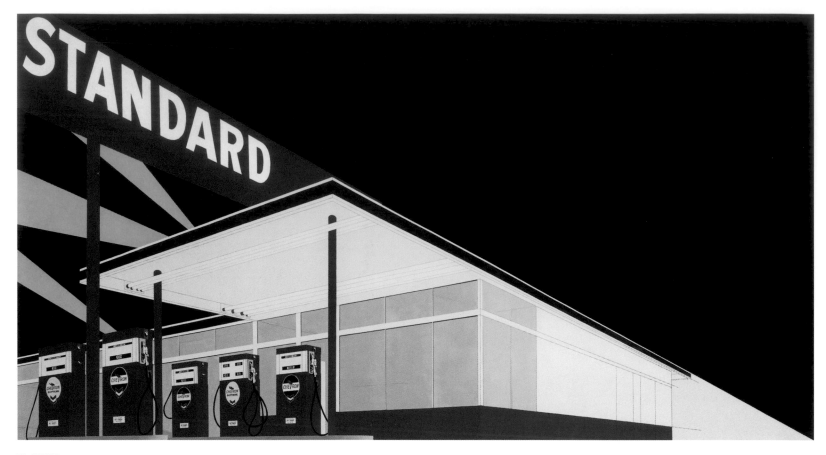

Ed RUSCHA

Standard Station, Amarillo, Texas

1963

Oil on canvas

164 × 309 cm [64.5 × 122 in]

Collection, Hood Museum of Art, Dartmouth College, Hanover,

New Hampshire

Ruscha's graphic style of painting partly arose through his training, like a number of Walt Disney's animators, at the Chouinard Art Institute, Los Angeles. In paintings such as *Large Trademark with Spotlights* (1962), portraying the Twentieth Century Fox logo, and the gasoline station paintings of the following year, he introduced an elongated format and an exaggerated single-point perspective. The cinematically derived stylization is here combined with the viewpoint of the car driver traversing the suburban landscape. Ruscha's paintings were often based on his own photographs. Also in 1963 he produced his artist's book of photos taken in 1962 along Route 66, *Twentysix Gasoline Stations*.

opposite

Allan D'ARCANGELO

Full Moon

1962

Acrylic on four canvases

166.5 × 157.5 [65.5 × 62 in]

D'Arcangelo described his canvases of the early 1960s as painted 'without gesture, without brushstroke, without colour modulation, without mysticism and without personal angst, because these qualities would have obscured the intention of the paintings. The work is pretty much preconceived, and the execution is relatively mechanical' (*Allan D'Arcangelo: Paintings of the Early Sixties*, 1978). His hard-edged aesthetic was developed to reduce and concentrate an image into its most basic recognizable form. *Full Moon* is one of a series of works that tap into the American unconscious: this road could be anywhere and nowhere; it evokes the reduction of the natural world to dark forms passing by the windows of a car; and it surrealistically conflates the moon with a petroleum company's illuminated sign. In later works he added objects to his canvases, such as a rear-view mirror.

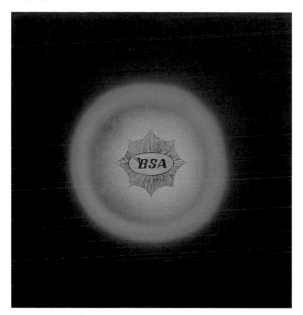

left

Billy Al BENGSTON

Birmingham Small Arms I [BSA]

1961

Oil on canvas

87.5 × 94 cm [34.5 × 37 in]

Collection, Orange County Museum of Art, Newport Beach, California

Inspired by the Flag and Target paintings by Jasper Johns that he saw in 1958, the Californian painter Bengston was associated with Pop in the early 1960s. He had several solo exhibitions at the Ferus Gallery, Los Angeles, where he showed paintings of single, centrally placed motifs – hearts, with titles such as *Grace* (Kelly) and *Kim* (Novak), or sergeants' stripes, such as *Elvis* and *Clint*. For his exhibition there in November 1961 Bengston produced a dozen works depicting motorcycle parts surrounded by glowing colours. An ex-professional motorcycle racer, he was an enthusiast of the Californian trend of customizing with spray paint, epitomized by hot-rod pinstriper Von Dutch. This influenced his move to spray lacquer paintings the following year. He began to use masonite rather than canvas to produce a harder and smoother surface, and developed abstract forms no longer linked to identifiable logos.

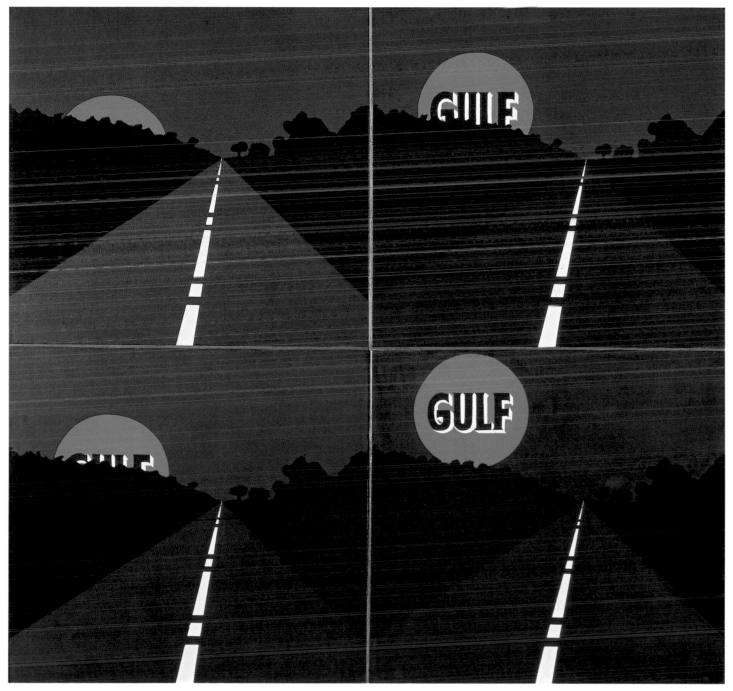

114

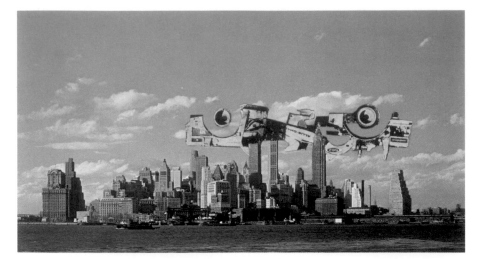

Hans HOLLEIN
Superstructure over Manhattan
1963
Coloured collage on paper
11 × 22 cm [4.5 × 9 in]

Hollein's collages took mass-produced industrial forms and incorporated them –
greatly enlarged – into urban or natural environments. In *Superstructure over
Manhattan* a form resembling a gigantic yellow mechanical vehicle is affixed to the
familiar skyline. Hollein referred to his work as creating 'urban macrostructures'.
In opposition to the functionalist conformity of the International Style he used his
structures to investigate the limits of architecture. Citing technical advancements,
Hollein advocated a pure architecture not limited by formal rationalism: 'Architecture
is without purpose. What we build will find usefulness. Form does not follow function.'
– Hans Hollein, *Arts & Architecture*, August 1963

Hans HOLLEIN
Highrise Building: Sparkplug
1964
Photomontage on paper
12 × 18 cm [5 × 7 in]
Collection, The Museum of Modern Art, New York

Highrise Building: Sparkplug is part of the *Transformation* series, a group of works
which, like the above example, propose the introduction of incongruous and
monumentally scaled forms into the environment. Hollein's work can be viewed as
a European counterpart to the later outdoor monuments of Claes Oldenburg. Here
the urbanity of a giant sparkplug is contrasted with domesticated farmland. The use
of photomontage rather than models or drawings broke from traditional architectural
precedents. The difficulty of building such a structure renders this work a theoretical
investigation into the nature of architecture. Hollein later stated: 'Everyone is an
architect. Everything is architecture.'
– Hans Hollein, 'Alles ist Architektur', *Bau*, 1968

CONSUMER CULTURE

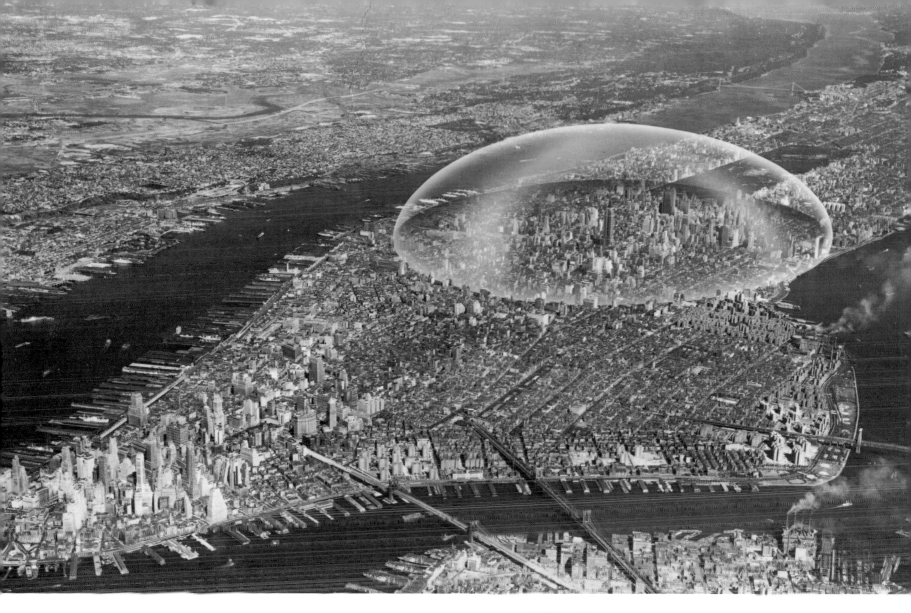

R. BUCKMINSTER FULLER
A Dome Partially Covering Manhattan
1960
Photomontage
Collection, Buckminster Fuller Institute, Santa Barbara, California

This photomontage shows a proposed giant dome designed by Fuller and his assistant Shoji Sadao. It demonstrates the endless potentials of scale and utility of Fuller's invention, the geodesic dome, which exemplified 'tensegrity' (a word he invented, combining tension and integrity). Struts and cables were set in an overlapping triangular formation, a pattern based on his early studies of structural systems found in nature. Becoming proportionately stronger and lighter the larger it is, this structure would stretch to 3.2 kilometres (2 miles) in width and a height of 1.6 kilometres (1 mile). It would be covered in a protective, translucent veil, sheltering the fifty-block area from the natural elements. No fuel-burning vehicles would be allowed inside, making the climate uncontaminated and stabilized.

opposite
Arthur QUARMBY
Corn on the Cob [Emergency Mass Housing Units No. 3]
1962
Ink on tracing paper
36.5 × 53 cm [14.5 × 21 in]
Collection, FRAC Centre, Orléans, France

Quarmby was a pioneer of the use of plastic in architecture. A flexible new material, it allowed the easy creation of structure, texture, durability and colour. For Quarmby it revolutionized design, avoiding the constraints inherent in most orthodox materials. Mass-production was possible, leading to the development of component-constructed architecture. Believing that the house could have a simple function, like the car or the refrigerator, in *Corn on the Cob* Quarmby suspended generic apartment pods from pre-stressed concrete branches. Their design satisfied the bare minimum of needs, removing the nostalgic idiosyncrasies associated with defining one's own home. From below the structure's penthouse, a twin-jab crane would reposition each unit. This idea of industrial flexibility was further developed in Archigram projects such as Plug-in City (1964).

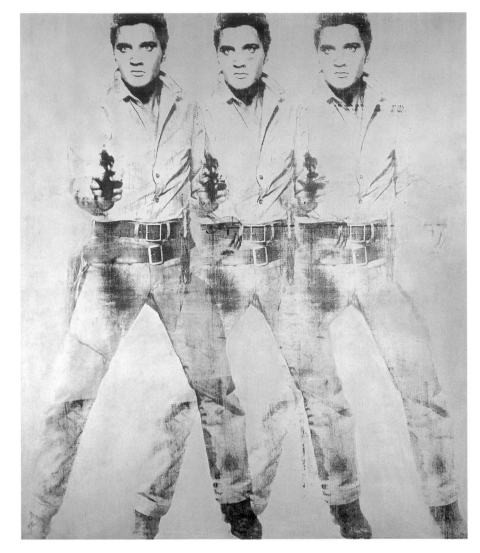

Andy <u>WARHOL</u>
Triple Elvis
1963
Aluminium paint and silkscreen ink on canvas
208.5 × 180.5 cm [82 × 71 in]
Collection, Virginia Museum of Fine Arts, Richmond

With his assistant Gerard Malanga, Warhol developed the silkscreen technique of the *Elvis* series shown at the Ferus Gallery in 1963. The effect was one of blur or 'strobe', suggesting a stop-motion image and the passage of time. Unlike Warhol's previous method of overlapping that required masking, the figure itself could be moved independently once the rectangular background had been dropped out. He began to use silver spray paint in May or June to achieve an opaque, unmodulated and reflective surface. Warhol did not always cut the canvases in the studio, leaving Irving Blum to prepare them for the Ferus exhibition, where a single 11-metre (37-ft) canvas with sixteen figures of Elvis was shown along one wall. This was later divided into five paintings. The actual photo source for the *Elvis* series has not been identified, although the Warhol archive contains a postcard of Elvis Presley in this pose, as a gunslinger in Don Siegel's Western *Flaming Star* (1960).

opposite
Andy <u>WARHOL</u>
Silver Liz
1963
Silkscreen, acrylic and spray paint on canvas
101.5 × 101.5 cm [40 × 40 in]

Using different coloured backgrounds, Warhol made several versions of this image based on a publicity photograph of Elizabeth Taylor. The silver paintings, in what became his preferred square format, were probably made first, with the exhibition at the Ferus Gallery in mind, and were the first project on which Malanga worked with Warhol as his assistant. At the exhibition in October 1963 the *Silver Liz* series was shown in the back space, with the *Elvis* series in the main gallery. Warhol first used silver in early 1963 for some of the *Electric Chairs* and the *Tunafish Disasters*. With *Elvis* and *Silver Liz*, this implicit connection between silver and death was replaced with an evocation of 'silver screen' glamour.

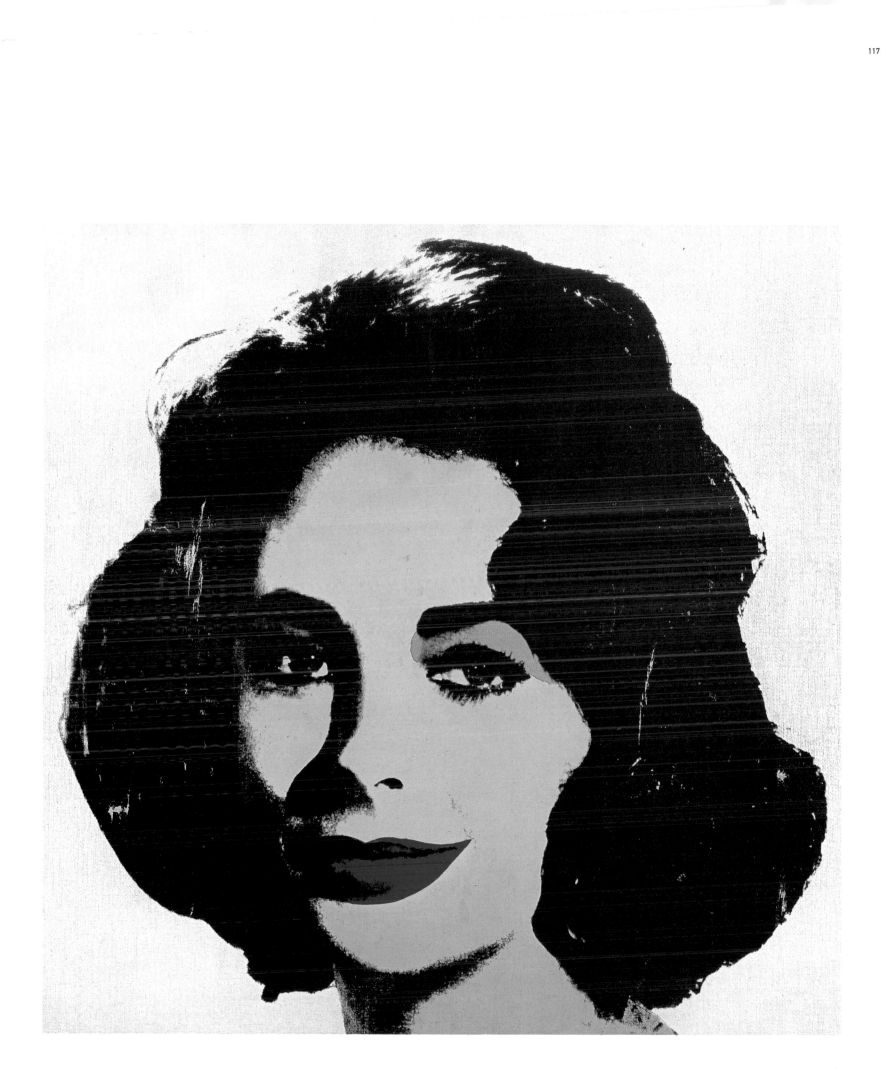

COLONIZATION OF THE MIND The cultural

impact of American films and music, spread by merchant seamen and by the presence of American troops, was pervasive and widespread, especially so in Europe, where artists reacted in appreciation or in parody. Artists from East Germany, such as Gerhard Richter and Sigmar Polke, who had moved to the more prosperous 'economic miracle' of the West, and in Britain Richard Hamilton, Colin Self and others, reacted with a sharply caustic wit to the promises of capitalism and the tensions of the Cold War. Some of the earliest supporters of Pop art were European collectors, gallerists and museum curators. There were close, if uneasy, relationships with other developments like Fluxus and Happenings, and avant-garde film established an international network. Jean-Luc Godard and Michelangelo Antonioni made films in a European language and landscape, but which referred to Hollywood genres and narrative structures. By the mid 1960s the universal appeal of American glamour was countered with a wide range of local variants which took issue with the hegemony and uniformity of mainstream culture.

opposite
George SEGAL
Cinema
1963
Plaster, illuminated Plexiglas, metal
300 × 244 × 76 cm [118 × 96 × 30 in]
Collection, Albright-Knox Art Gallery, Buffalo, New York

The monochrome, white plaster figures of Segal's early work are placed in ordinary, mundane scenes. Made using plaster bandages applied directly to a live model, the resulting works are an index of the surface of public life. In *Cinema* Segal uses an illuminated cinema display board, emblazoned self-referentially with 'CINEMA' in place of a film title. The anonymous, mummy-like figure is frozen in motion as he places the letter 'R' at the far right of the listings board. This active stance is unusual in Segal's work; his figures are most often at rest, in poses that suggest lassitude or withdrawal, such as *Bus Riders* (1962) and *Woman on a Chicken Crate* (1958). Segal arrests a 'real' moment with vivid directness. ' … daily life has a reputation for being banal, uninteresting, boring somehow. And somehow it still strikes me that daily life is baffling, mysterious and unfathomable.'
– George Segal, interview with Amber Edwards for the documentary *George Segal: American Still Life*, June 1998 – August 1999

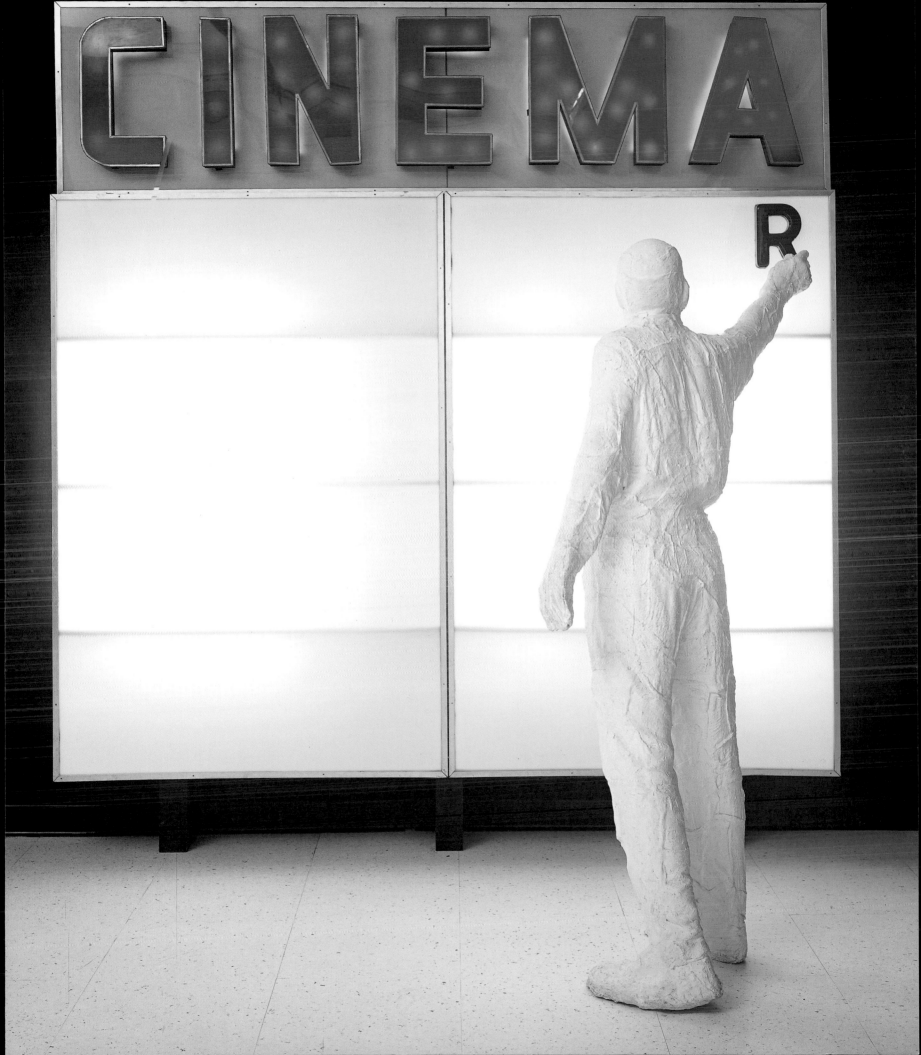

Jack SMITH
Flaming Creatures
1963
16mm film, 41 min., black and
white, silent
With Francis Francine
[in foreground]

Flaming Creatures stars Francis
Francine, later the drag-queen sheriff
of Warhol's *Lonesome Cowboys* (1968).
Smith used out-of-date film, resulting
in faded and overexposed imagery.
Ornamentally framed silent-movie
credits are interrupted by posturing
'creatures' (drag queens, mermaids,
vampires and naked poets) and an
eclectic soundtrack selected by
composer Tony Conrad, which includes
Latin pop, rock 'n' roll, bullfighting music
and a Chinese song. Fetishized lipstick
application is performed by the entire
cast to a litany of cosmetic products;
a boisterous orgy follows, in which male
and female become indistinguishable.
Smith's censored 'underground' film
was compared by the critic Susan Sontag
to 'the casualness, the arbitrariness and
the unrestrainedness of Pop art'.
(*The Nation*, 1964)

Kenneth ANGER
Scorpio Rising
1963
16mm film, 29 min., colour, sound
With Victor Childe [pictured] and Bruce Byron

A film with no dialogue and rapidly intercut scenes, *Scorpio Rising* begins with young
men polishing and fixing their motorcycles to a pop music soundtrack. It was one
of the first avant-garde films to use popular music, ranging from Elvis Presley to Ray
Charles, as a counter-cultural medium. Anger also refers to B-movies (particularly
the 'criminal youth' subgenre and László Benedek's motorcycle movie *The Wild One*
[1954]); Hollywood myths; the occult works of Aleister Crowley; and male homoerotic
photography, as popularized during the 1950s by Bob Mizer's *Physique Pictorial*.
The story climaxes at a Hallowe'en party where masked gang members subject
a guest to a ritual sexual initiation, after which Scorpio (Byron) desecrates a local
church with Hell's Angels' adopted symbols: swastikas and skull-and-crossbones.
Finally there is a motorcycle race in which the death of the hero is implied.

Ron RICE
The Queen of Sheba Meets the Atom Man
1963/82
16mm film, 109 min., black and white, sound
With Taylor Mead

Rice's films are characterized by improvisation and collaboration with his actors. Here
Mead plays a child-like beatnik clown. Attracted to products by advertisements, yet
not understanding their functions, he rubs a box of cereal over his clothes and inserts
the prongs of an electric plug into his nose. Winifred Bryan plays an alcoholic who
fights affectionately with him; later the two embrace and collapse amidst the disorder
of her apartment. Rice had intended his film to be a three-hour epic protest against
industrialization and Hollywood values. His unsophisticated style attempted to reflect
life on the streets. He died before editing a final version; between 1979 and 1982 Mead
restored and completed the 109-minute version, adding a soundtrack.

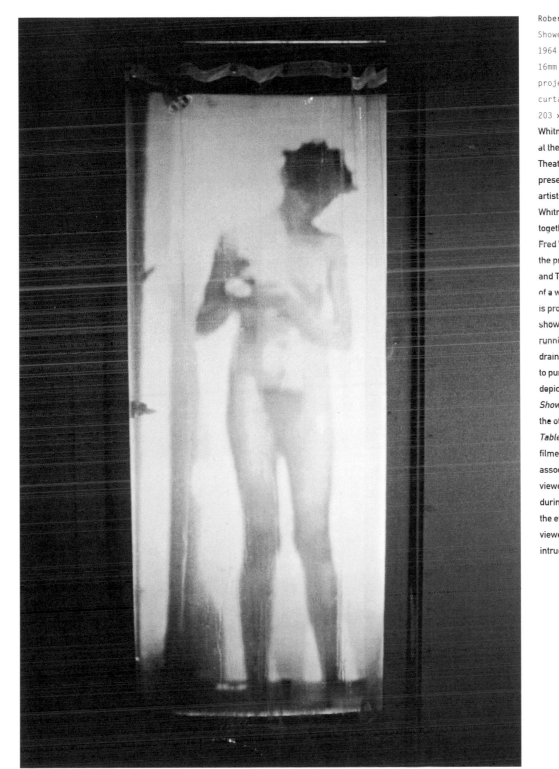

Robert WHITMAN
Shower
1964
16mm film loop, colour, silent;
projector, shower stall and
curtain, water, water pump
203 × 76 × 76 cm [80 × 30 × 30 in]
Whitman first exhibited *Shower* in 1966
at the New York event '9 Evenings of
Theater and Engineering', which
presented new uses of technology by
artists in music, dance and Happenings.
Whitman and Robert Rauschenberg,
together with engineers Billy Klüver and
Fred Waldhauer, subsequently founded
the project E.A.T. (Experiments in Art
and Technology). The life-sized image
of a woman (Mimi Stark) taking a shower
is projected on to the back wall of a real
shower cubicle. Behind a plastic curtain
running water flows from the nozzle and
drains away, turning from clear to green
to purple, in a nod to the traditional
depiction of the bathing nude in painting.
Shower is one of a series of four films;
the others are *Window* (1963), *Dressing
Table* (1964) and *Sink* (1964). They project
filmed everyday actions on to the objects
associated with them. Whitman involved
viewers directly in these environments:
during the first presentation of *Shower*,
the effect was so convincing that some
viewers momentarily believed they were
intruding on a real person's privacy.

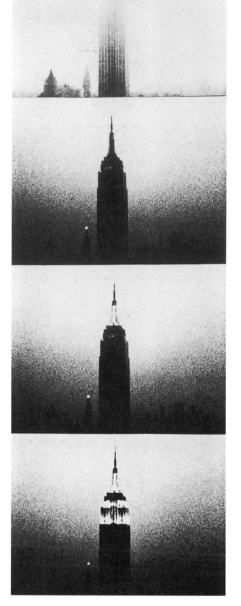

Andy <u>WARHOL</u>

Empire

1964

16mm film, 8 hours, 16 frames per second, black and white, silent

Between 8 p.m. and 3 a.m. during the night of 25–26 July 1964, *Empire* was filmed
in New York from the window of an office high up in the Time–Life Building that offered
an unobstructed view of the Empire State Building. It begins with a white screen. As
the sun sets, the haze clears and the building emerges. Its exterior floodlights are
switched on, then over the next six and a half hours its interior lights flicker on and off
until the floodlights switch off. It remains shrouded in darkness for the remainder of
the film. *Empire* was produced with a team: the young filmmaker John Palmer, Gerard
Malanga, Marie Desert and the filmmaker and critic Jonas Mekas. The one-to-one
principle of real-time recording was first established by Warhol in *Sleep* (1963), a
continuous shot of the poet John Giorno sleeping. In *Empire* editing was rejected
completely. Screening at the silent-film speed of 16 frames per second (they were
shot at 24 f.p.s.) further slowed down Warhol's already 'narrative-free' films and
added an uncanny quality of dreamlike time.

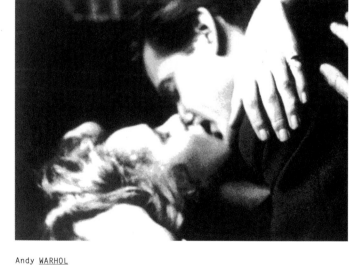

Andy <u>WARHOL</u>

Kiss

1963-64

16mm films, approx. 50 min. in total, 16 frames per second, black
and white, silent

Warhol began shooting the *Kiss* films in the autumn of 1963. They were first screened
at the Gramercy Arts Theater on West 27th Street, New York, where they were titled
The Andy Warhol Serial, as they were shown in weekly four-minute instalments.
Warhol's idea for *Kiss* – close-ups of male and female or same gender couples
kissing each other for approximately three minutes each – is believed to come from
cinema studio regulations forbidding actors to touch lips for more than three seconds.

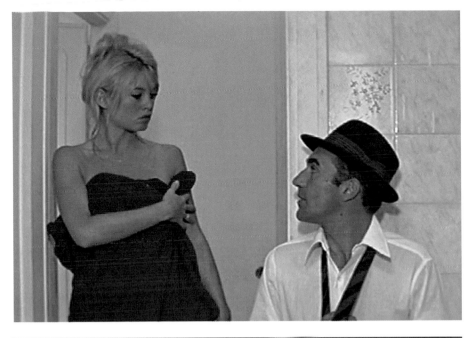

Jean-Luc GODARD
Le Mépris
Contempt
1963
35mm film, 103 min., colour, sound
With Brigitte Bardot, Michel Piccoli [*in film still*] and Fritz Lang,
Jack Palance

Le Mépris is a film about personal integrity in the face of monoculture and the mass-produced imagery of advertising and television. A writer is hired by a business-like producer (Palance) to 'sex-up' a script based on Homer's *Odyssey* and increase its popular appeal, against the wishes of the film director (Fritz Lang, who plays himself), who wants to produce an art film true to the original Greek setting and story. The writer's wife finds the producer's ideas distasteful, and he must learn to balance her ideals against commercial demands. A central motif of *Le Mépris* is the adoption of parallel characteristics in the leading players of those portrayed in the film-within-a-film: the writer, Paul (Piccoli) becomes Odysseus, Camille (Bardot) his wife Penelope. This device highlights the artificiality of film itself. *Le Mépris* has been seen as an ambivalent satire on Hollywood-style values.

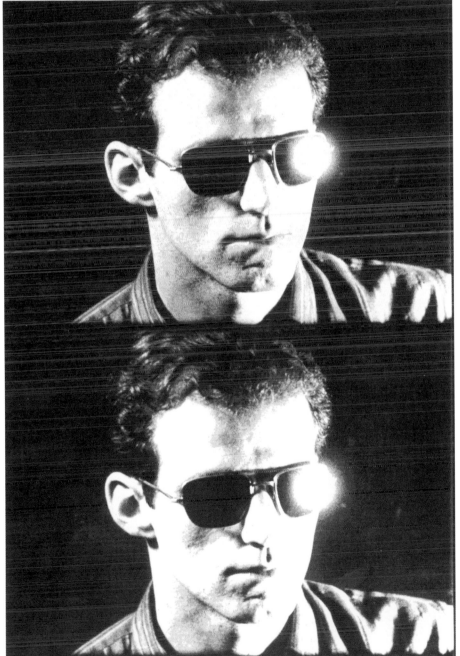

Andy WARHOL
Screen Test [Billy Name]
1964
16mm film, 4 min., 16 frames per second, black and white, silent

Warhol's *Screen Tests* were filmed from early 1964 to November 1966. The 'star' subjects included visiting filmmakers, fashion models and members of the Factory entourage such as Gerard Malanga, Edie Sedgwick and the photographer Billy Name, who features in this film strip. They were seated in front of a tripod mounted camera and usually asked to be as still as possible and not to blink while the camera was running. There were exceptions, such as the *Screen Test* of the drag actor Mario Montez in February 1965, in hilarious dialogue with the scriptwriter for many of Warhol's films, Ronald Tavel. More than 500 *Screen Tests* were made. Some of them were incorporated into longer films such as *13 Most Beautiful Boys* and *13 Most Beautiful Women* (both 1964).

George BRECHT
Repository
1961
Assemblage; storage unit containing watch, tennis ball, thermometer,
India rubber and plastic balls, baseball, piece of ebony, statuette,
wooden jigsaw pieces, toothbrushes, phial, crayons, glass, pocket
mirror, bottle caps, keys, fabric, coins, photographs, playing cards,
postcards, dollar, page of thesaurus, plastic tomato, painted wooden
beads, blue lightbulb, ball of string, painted metal toy motorbike
102.5 × 26.5 × 7.5 cm [40.5 × 10.5 × 3 in]
Collection, The Museum of Modern Art, New York

This assemblage comprises everyday objects placed in the compartments of a wall
cabinet according to size. Brecht narrowed the intervention of the artist to the
selection and arrangement of these mass-produced items in a work that evokes the
legacies of Marcel Duchamp's readymades and Joseph Cornell's box-sculptures.
Brecht studied under John Cage with fellow Fluxus artists such as George Maciunas.
The group experimented with the involvement of chance in composition. Brecht
moved from paint splashes, folds and blots on canvas during the 1950s via
assemblages to scripted events, such as *Exit* (1961), performed any time anyone
walked out of any place. He believed that the task of the artist was to stimulate the
imagination of the viewer.

opposite
Joe TILSON
A-Z Box of Friends and Family
1963
Mixed media on wood
233 × 152 cm [92 × 60 in]

A–Z Box of Friends and Family has become emblematic of the British Pop scene
in the early 1960s. It is both a personal memento of the friends who enjoyed the
hospitality of Tilson and his artist wife Jos, and the demonstration of a collaborative
way of making art in which all could share, including the couple's young children.
Its varied contents are unified by the tabular, compartmented wooden structure,
reminiscent of a printer's tray for holding metal type. This was a format that Tilson,
originally trained as a carpenter, had developed in a series of works that juxtapose
words and images as elements. He positioned the participants' contributions in an
alphabetical scheme using the initial letter of either their first or last name: Richard
Hamilton in the 'R' compartment, Allen Jones in 'J', Ronald Kitaj in 'K'. Other Pop
artists who contributed include Peter Blake (B), David Hockney (D) and Peter Phillips
(P). Artists working outside of Pop also appear – such as the painter Frank Auerbach,
the sculptor Anthony Caro and the experimental artist John Latham. Tilson himself
contributes the ziggurat in 'Z', one of the archetypal forms that would become central
in his later practice as he moved away from Pop. The key to all the works and their
creators is concealed behind the question mark.

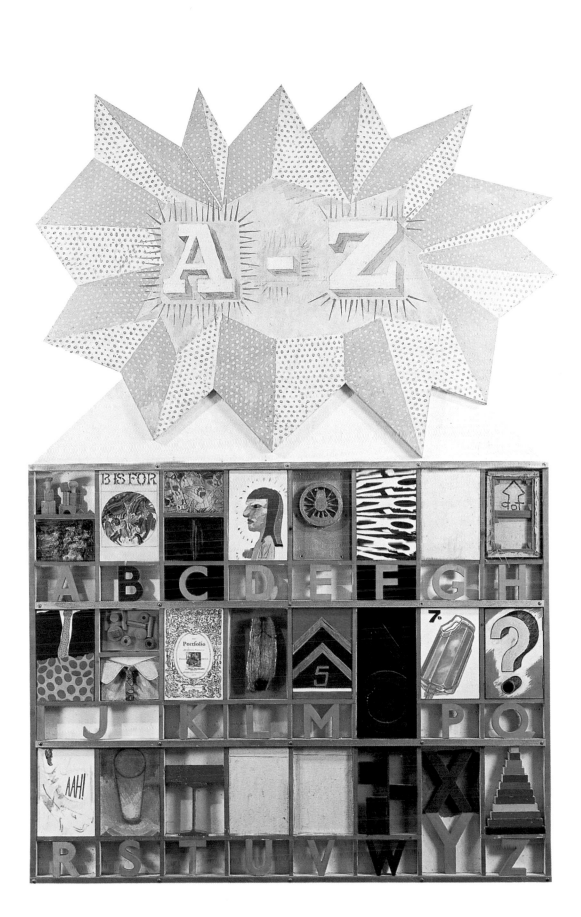

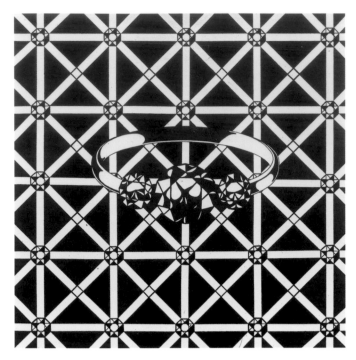

Patrick CAULFIELD
Engagement Ring
1963
Oil on panel
122 × 122 cm [48 × 48 in]

Caulfield was one of the young Pop artists from the Royal College of Art to attract attention at the 'Young Contemporaries' exhibition (RBA Galleries, London, 1963). He painted apparently trivial subject matter in a flat graphic style, investigating cliché in subjects familiar to the viewer. The ring here is presented as a symbol, placed centrally on a grid background. There is an absence of visible brushwork and painterly intervention; the starkly monochrome, hard-edged composition recalls painted advertising signs. In other works he depicted various objects on backgrounds of unmodulated colour. ' ... it was a reaction which I shared with other people against academic work, the idea of English painting in muted tones where marks were never quite finished. It seemed a reason to use very crisp black lines.' – Patrick Caulfield, interview with Marco Livingstone, *Aspects*, 15, 1981

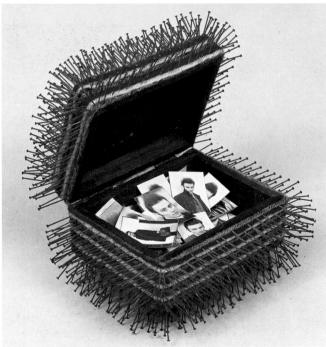

Lucas SAMARAS
Self-portrait Box
1963
Construction in wood, red, white and blue woollen thread, nails,
50 photographic portraits of the artist
Closed box, 9.5 × 15 × 11.5 cm [4 × 6 × 4.5 in]

The first period during which boxes appeared in Samaras' work began in 1962 and lasted until 1967, by which point sixty had been made. He ceased making them again until much later in his career. Typically he found or purchased a nineteenth-century box and covered the surface entirely with materials such as the pins and coloured threads in this example. These cheap and visually arresting materials sometimes spew from the inside out, transforming the container into a rebarbative object: repellent to touch. He referred to the boxes anthropomorphically, as mouths. Here Samaras introduced his self-portrait, which became the central subject of his oeuvre.

Robert WATTS
Plate of Shrimps and Clams
1963-64
Chrome-plated metal on ceramic plate
h. 7 cm [3 in] ø 14.5 cm [6 in]

Like his fellow artists from the Fluxus group, George Brecht and Ben Vautier, in the early 1960s Watts began to make works that crossed over with the concerns of Pop art. His lifesize objects drew on his background in engineering, applying a scientific approach to questions of the effect and processes of naming an object as art. His investigations led to such projects as casting everyday items and foodstuffs in metal, which he then plated in chrome, and the creation of his own postage stamps that could actually be used.

Colin SELF
Leopardskin Nuclear Bomb No. 2
1963
Painted wood, aluminium, steel, fabric
95 × 80 × 42 cm [37.5 × 31.5 × 16.5 in]
Collection, Tate, London

Self depicted animals or animal characteristics as a metaphor for the aggression of human behaviour, convinced of the apocalyptic implications of the nuclear age. *Leopardskin Nuclear Bomb No. 2* combines both of these concerns. In 1963 he also began a series of drawings of metamorphic creatures, called *Mortal Combat*. Self's work of this period was overtly political, at variance with the seemingly dispassionate nature of most Pop art. He recognized that the artists of his generation were from outside the traditional art world, being both left-wing and from working-class backgrounds, and saw their role as revolutionary. 'Pop art was the first art movement for goodness knows how long to accept and reflect the world in which it lives ... Art still seemed to be hoping cars and aeroplanes "went away" and horses made a comeback so they could re-do *The Haywain*.'
– Colin Self, from an unpublished letter to Marco Livingstone, 1 December 1987

COLIN SELF HOT DOG 10.

Colin SELF
Hot Dog 10
1965
Pencil and watercolour on paper
45 × 58.5 cm [18 × 23 in]

In 1965 Self began to concentrate on the sausage in a bun as one of his subjects, initiating a series of drawings and paintings in which they feature, as well as several sculptures. It is likely that his travels in the United States during that year, following an earlier trip in 1962, reinvigorated his awareness of the ubiquitous fast-food staple. Since 1961, hot dogs had featured in the paintings of American artists such as Wayne Thiebaud and Roy Lichtenstein; and Claes Oldenburg had produced his giant hamburger sculpture. Self adds an almost surrealist dimension to this Pop subject. His depiction of the enveloped sausage infuses it with connotations that are by turns erotic, comical and menacing.

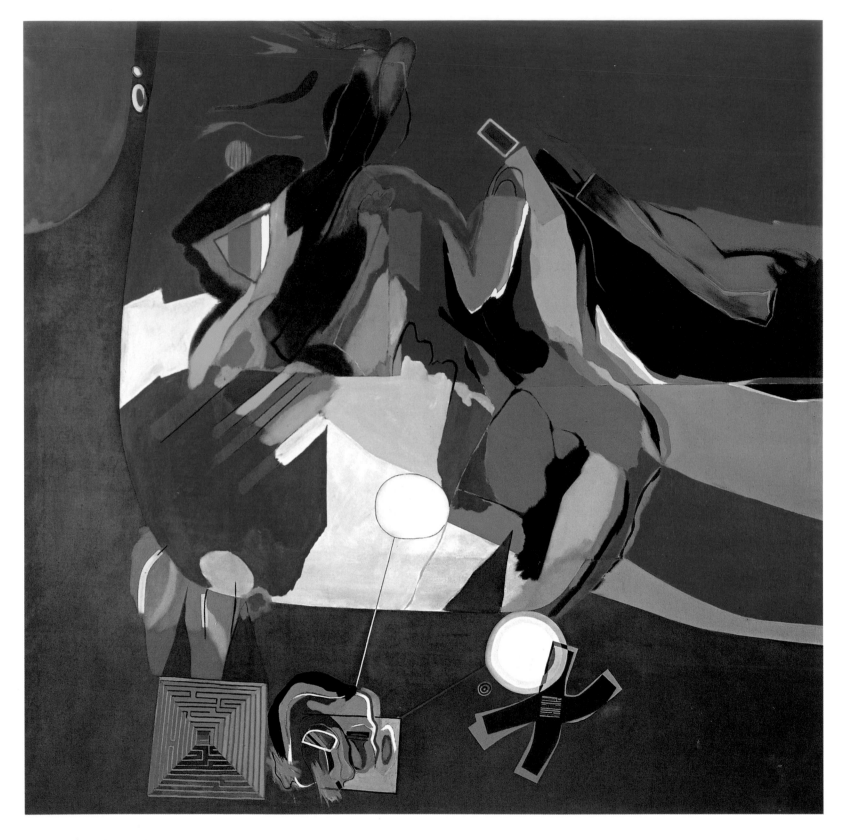

COLONIZATION OF THE MIND

opposite

Allen JONES

Thinking about Women

1961

Oil on canvas

152 × 152 cm [60 × 60 in]

Collection, Norfolk Art Society, Norwich, England

Associated with the rising Pop generation through his brief time at the Royal College of Art, London (1959–60) Jones adapted the ideas and formal language of early modern painters such as Kandinsky and Klee to develop a vividly contemporary synthesis of figuration and abstraction. This painting is as large as a billboard, its striking hues as intense as those used by contemporary colour field painters, optical artists and graphic designers. The sense of blurred, rapid movement is reminiscent of cinematic effects. The white circles linked by lines to the head in the foreground suggest the 'thought balloons' of cartoons. Other features, such as the square partially enclosing the head in the foreground, and the indeterminate, androgynous appearance of the right-hand figure, recur in a number of Jones's paintings of the 1960s, where he drew on Jungian and Nietzschian ideas about the merging of male and female characteristics as a metaphorical element in his work.

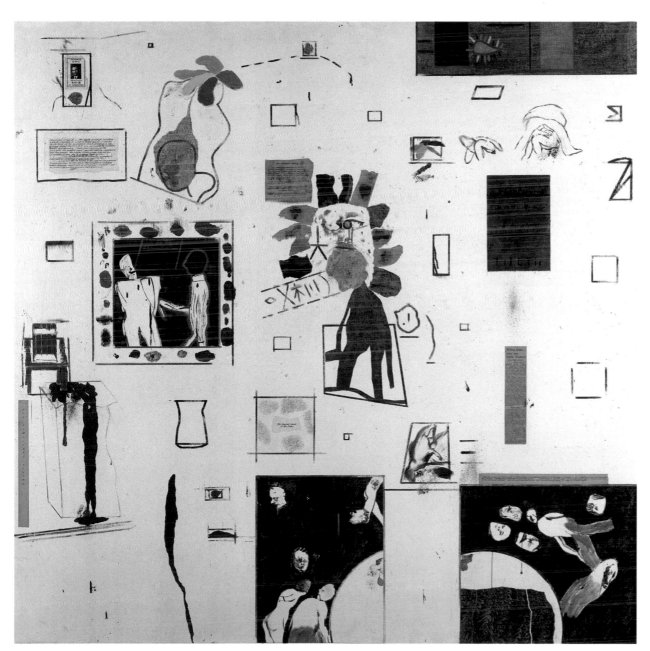

R.B. KITAJ

Reflections on Violence

1962

Oil and collage on canvas

152.5 × 152.5 cm [60 × 60 in]

Collection, Hamburger Kunsthalle, Hamburg

Georges Sorel's book *Reflections on Violence* (1908) suggested this work's title and many of its themes, such as 'another victim of communism'; 'the homicidal throne'; 'the lunacy doctor'. The French philosopher developed the notion of anarcho-syndicalism and set out his theory of 'violence' as the power of the proletariat to seize the means of production from the bourgeoisie through direct action. Kitaj explicitly noted his source in early exhibition catalogues. Discrete images are loosely dispersed around the canvas, without emphasis on one particular element, highlighting Kitaj's intention of equality in these interrelationships. He referred to pictorial languages and iconography, as well as literary texts. In the pinboard-like composition of *Reflections on Violence* Kitaj included representations of Native American pictographs (and a citation of his source, a Smithsonian Institution study from 1893), interspersed with doodles and textual material, including a newspaper clipping with the headline 'When nuns may use birth control'. Kitaj's detailed allusions to literature and politics separated him from mainstream Pop art, although he also drew on similar visual sources.

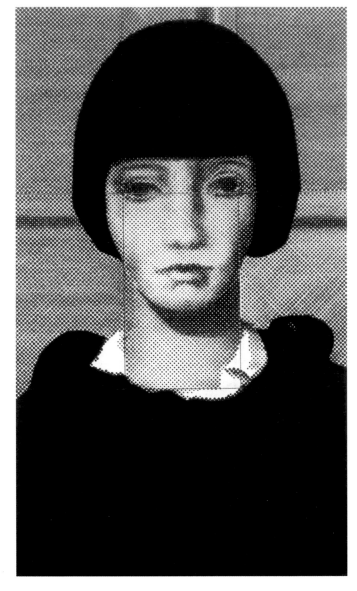

Gerald <u>LAING</u>

Anna Karina

1963

Oil on canvas

366 × 213.5 cm [144 × 84 in]

This vast painting was the centrepiece of Laing's student solo exhibition, 'Paintings from Photographs/Photographs from Paintings', at St Martin's School of Art, London, in March 1963. Its source is a tiny newspaper photo of the French film actress who worked with Jean-Luc Godard, in her role as a prostitute in Godard's film *Vivre sa vie* (1962, released in Britain as *It's My Life*). In related works Laing portrayed other subjects from independent European cinema, such as Brigitte Bardot, in contrast to the Hollywood icons of American Pop. Rather than using silkscreen techniques like Warhol, or replicating the basic form of printers' colour half-tone dots that Lichtenstein found in cartoon strips, Laing both reduced (to black and white only) and complicated his hand-painted dot-screen patterns. These were based on the many variations of screen angle and corresponding effects – such as 'square' or 'diamond'-shaped dots – available to printers. Made up of separate panels, the painting is both like and very unlike a huge film poster: the mesmerizing optical effects of the screen pattern have become central.

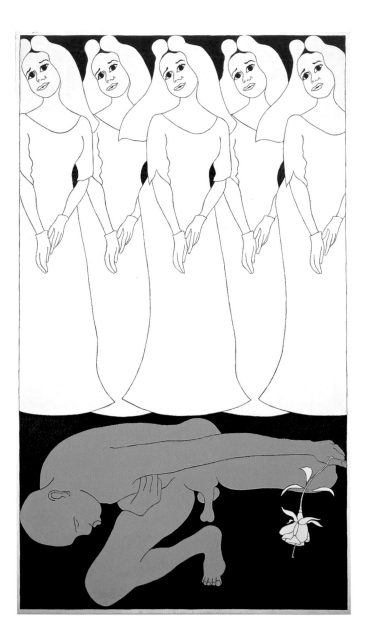

John <u>WESLEY</u>

Brides

1966

Acrylic on canvas

167 x 94 cm [65 x 37 in]

Brides has a fairy tale or fantasy atmosphere reminiscent of the erotic, 'decadent' work of the Art Nouveau artist Aubrey Beardsley. Wesley's invented imagery and mannered style also allude to the graphic characteristics of cartoon strips. His paintings are flat compositions of minimal lines and uniform surfaces, avoiding gradations of tone and illusionistic space. Often Wesley's black outlines surround areas of either monotone shades or a limited palette of bubble-gum pink and sky blue. Many of his paintings employ repetition as a means of testing the viewer's attention to inconspicuous differences in detail. The roots of his interest in industrialized sameness grew from his work as an illustrator for the engineering corps. Repetition was also a device for his surrealist humour, as recorded by his wife, author Hannah Green: '"It better be funny" Jack says […] meaning life, the human predicament … repetition makes things funny and it puts things in their proper perspective. "If you say foot foot foot foot foot foot foot foot foot long enough, then foot becomes hilarious", Jack says. "If you paint forty Nixons, it puts Nixon in his place."'
– Hannah Green, *Unmuzzled Ox*, 1974

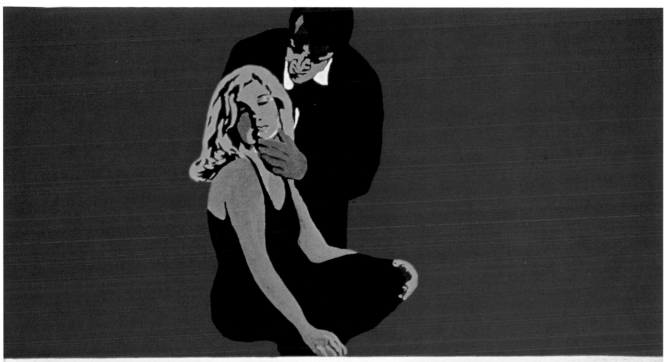

Rosalyn <u>DREXLER</u>
Love & Violence
1964
Oil over paper collage on canvas
173 × 155 cm [68 × 61 in]

Drexler's work offers a caustic angle on the otherwise male-dominated perspective of Pop. Her paintings make direct references to film noir and tabloid reporting, assembling scenes that emphasize female subjugation in social situations as depicted in the media, underlined by her loaded titles such as *Love and Violence* and *I Won't Hurt You*. Drexler cut images from selected sources, attaching them to the canvas and then painting over them. Underlying their reductive, almost cartoon-like figuration, most of the early works include the original collaged images beneath, just visible at the edges of the painted field. The palette is limited to primary and secondary colours, with the subjects rendered in gradations using black and white. Drexler was among the first Pop artists to use the sequential imagery of film and television, quoting and translating the image in motion on to the canvas

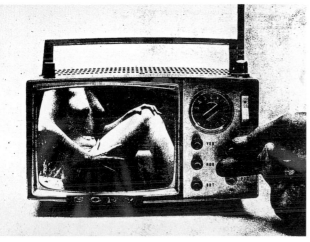

Wallace <u>BERMAN</u>
Untitled
1964
Verifax collage on paper
18 × 25 cm [7 × 10 in]

This is one of a series of collages Berman made using an outmoded Verifax photocopier. Each work contains single or multiple repetitions of the same visual frame: a portable radio, with a hand in the foreground. In place of the radio speaker is a TV screen (originally Berman used an image of a TV set but preferred the radio's fusion of language and sound associations with the visual). Forging an implicit connection between global communications and the free association of the unconscious mind, in each collage a different image appears on the screen, ranging from the esoteric (magic mushrooms, Hebrew symbols, the Buddha) to the mass-mediatized (astronauts, film stars, naked women).

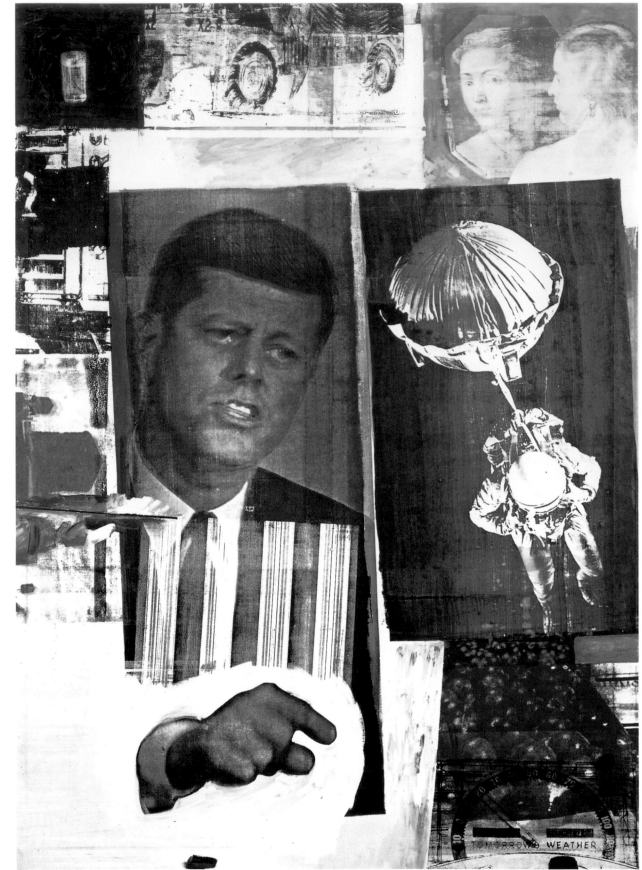

Robert RAUSCHENBERG
Retroactive II
1963
Oil, silkscreen and ink on canvas
203 × 152.5 cm [80 × 60 in]
Collection, Museum of
Contemporary Art, Chicago

Rauschenberg and Warhol coincidentally began using silkscreen in the same year. Rauschenberg built up his images using almost 100 re-usable screens, repeating subjects in various colours and degrees of technical refinement. Among these are reproductions of paintings by Rubens and Velázquez, charts, diagrams, dials, cityscapes, advertisements, photographs of astronauts in space and of President J.F. Kennedy. He worked with these images between the autumn of 1962 and the spring of 1964. Drag marks, caused by pulling ink across the screen, counter the illusionism of the photographic material; layered paint and printing overlaps the images. Historically specific, *Retroactive II* also makes a broader comment on information overload and image saturation.

opposite
Andy WARHOL
Orange Car Crash [5 Deaths
11 Times in Orange]
1963
Acrylic and silkscreen ink
on linen
220 × 209 cm [86.5 × 82 in]
Collection, Galleria Civica
d'Arte Moderna, Turin

Among other things, Warhol associated his 'death' and 'disaster' series with a car accident warning he heard broadcast in late 1962: 'Every time you turned on the radio they said something like "4 million are going to die". That started it. But when you see a gruesome picture over and over again, it doesn't really have any effect.' This work is among those he completed in October 1963 for his upcoming show at Ileana Sonnabend's Paris gallery: 'My show in Paris is going to be called "Death in America". I'll show the electric chair pictures [Disasters] and the dogs in Birmingham [Race Riots] and car wrecks and some suicide pictures.' Their often sublime scale and horrifying subject matter is poignantly and ironically counterposed with the offering of the same image in various colours, such as red, orange, white or silver.
– quotes from Andy Warhol, interview with Gene Swenson, 1963

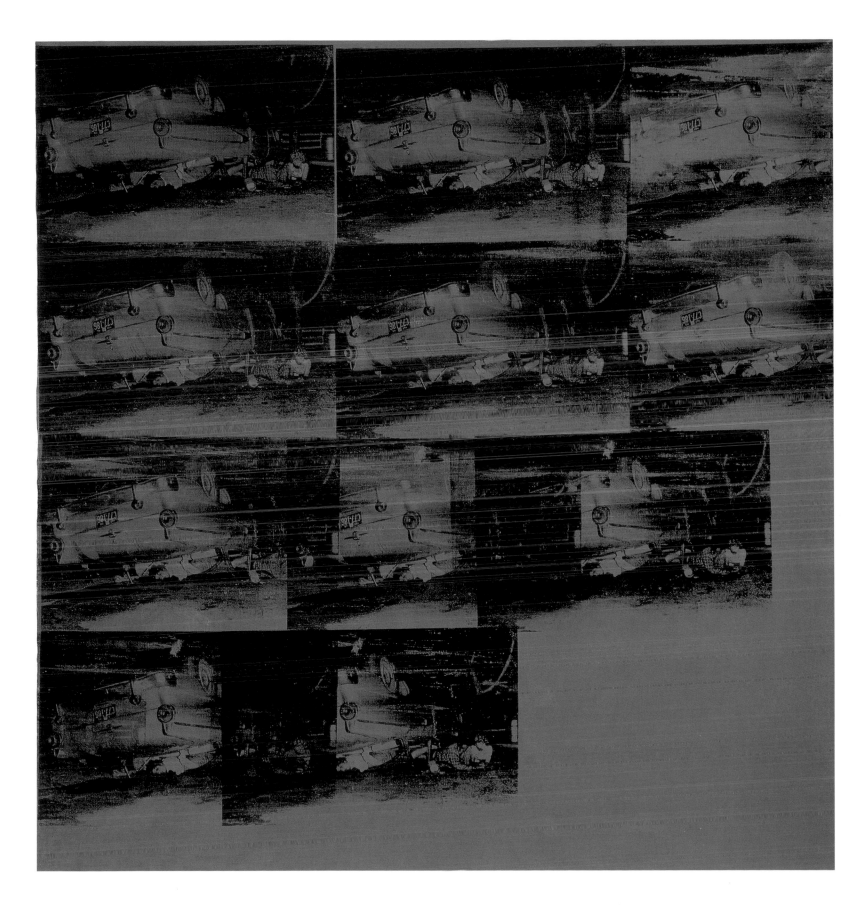

Öyvind <u>FAHLSTRÖM</u>
Performing KK, No. 2 [Sunday Edition]
1964
Tempera on paper mounted on canvas
132 × 86.5 cm [52 × 34 in]

During 1963–64, Fahlström continued to develop a relationship between his system of *character-forms* (see *Sitting . . .* , 1962, page 103) and more immediately recognizable figurative forms taken from sources such as comic strips. This painting appropriates a panel from George Herriman's comic *Krazy Kat*. The idea of the 'cat and mouse' game has become the basis of a pictorial game with many elements and allusions.

'… The association of disparate elements to each other thus makes game rules, and the work of art will be a game structure.

This, among other things, leads to presupposing an active, participating spectator who – whether he is confronted with a static or variable work of art – will find relationships which will make him able to "play" the work …'
– Öyvind Fahlström, 'A Game of Character', *Art and Literature*, 3, New York, 1964

Konrad <u>LUEG</u> and Gerhard <u>RICHTER</u>
Leben mit Pop. Eine Demonstration für kapitalistischen Realismus
[Living with Pop. A Demonstration for Capitalist Realism]
View of installation and event at Möbelhaus Berges furniture store,
Dusseldorf, 11 October 1963

Living with Pop was an exhibition that positioned certain German artists within the discourse of Pop art. Lueg and Richter organized the event at the Möbelhaus Berges, a famous furniture store in Dusseldorf. Attached to each invitation was a green balloon that bore the exhibition's title and, if inflated beyond capacity, would make the onomatopoeic sound 'pop'. The visitors were given numbered programmes that instructed them to move through an ordered succession of exhibition spaces, which were themed around the showroom displays. Artworks, including a crude *papier mâché* sculpture of John F. Kennedy by Richter, were integrated throughout the multi-storey establishment as a way of contextualizing generic images into simulated arrangements of the modern home, in effect putting the entire store and its aesthetics of standardized living on display. The image shows, left to right, Lueg and Richter in Exhibition Room 1, seated within the showroom setting, unengaged with the viewer, just another fixture, a living piece of furniture.

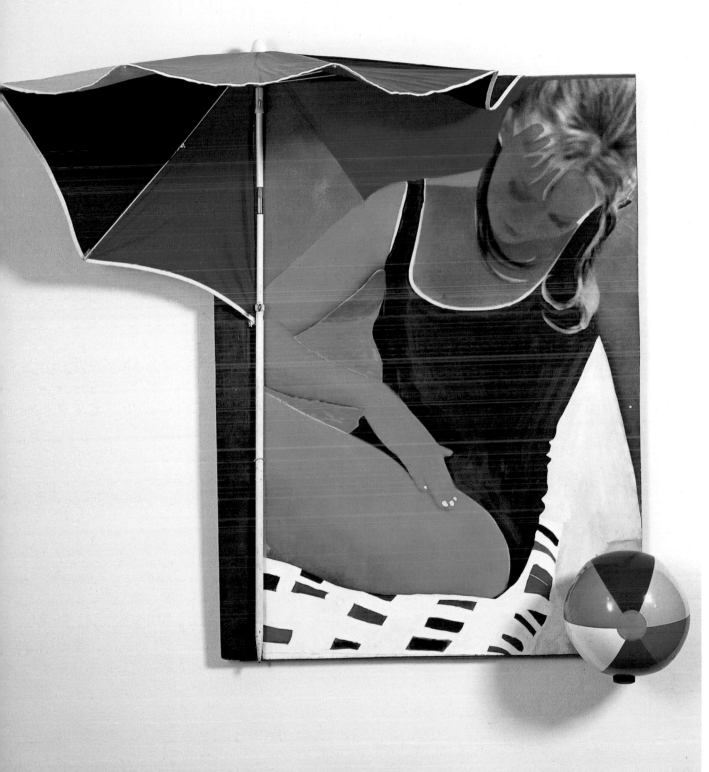

Martial <u>RAYSSE</u>
Souviens-toi de Tahiti en
septembre 61
[Remember Tahiti in September 61]
1963
Photograph, acrylic and
silkscreen on canvas, with
parasol and beach ball
180 × 170 × 45 cm
[71 × 67 × 18 in]
Collection, Louisiana Museum of
Modern Art, Humlebaek, Denmark

By 1962 Raysse had moved on from environmental assemblages to the pictorial, although he still included three-dimensional elements. Rather than representing a parasol and a beach ball, like the American artist Jim Dine he added these objects to the canvas. The source image for this work is a photograph of a woman on a beach, which has been screenprinted and then painted in flat areas of exceptionally bright, synthetic colour. The sunbather is shown applying suntan lotion, her right arm and left leg coloured bright green, the rest of her body coloured amber-orange. The work emphasizes the artificiality and synthetic glamour of consumer culture and the anonymous women used to represent it. The young woman's green arm and leg fuse her image with the corresponding colour in the ball and sun shade. Raysse was one of Pop's chief exponents and critics in France during the 1960s.

ARCHIGRAM
Plug-In City
1964
Axonometric drawing; mixed media on card
76 × 69.5 cm [30 × 27.5 in]
Collection, The Museum of Modern Art, New York

This project was the culmination of ideas the group was exploring from 1962 onwards, from capsule homes to philosophies for a living city. The master plan transformed the city into a system that could be configured flexibly to fit the needs of civic development. It replaced the static structuring of traditional urban planning with architecture that was mass-produced and expendable, free from the nostalgic inhibitions that hindered active changes within the built environment. The mainframe of the structure would have a lifespan of forty years and provide conduits for the transportation of goods and services to the standardized office and living units. The whole arrangement divided the functions of the citizen's life into zones that were easily updated and relocated. Restructuring would be undertaken using an elaborate crane system, moving individual units within the network. This flexible and temporary configuration led to the development of the Walking City project.

Ken ADAM
War Room
1962-63
Preparatory drawing for set in Stanley Kubrick's film *Dr Strangelove*

Creating film sets for the *James Bond* series, *Star Trek* and *Dr Strangelove*, Adam contributed to a new consciousness of architectural symbolism, disseminated through cinema. This imaginary War Room evoked a widely recognized collective notion of the place where the fantastical paranoia of a looming nuclear holocaust might be orchestrated. The triangular construction is reminiscent of bomb shelters of the era. Adam's use of architectural forms to express psychological states anticipated later projects by architects such as Frank Gehry and Daniel Libeskind.

Arthur QUARMBY
Pneumatic Paraboloid
1963
Inflatable dome realized with students at Bradford College
of Art, England

The *Pneumatic Paraboloid* was a plastic dome inflated using low-pressure air compression. Quarmby's pneumatic structures could potentially occupy any amount of space, even on the grandest of scales. The use of air as a constructive component moved architecture in an organic direction: these forms could take on a variety of shapes, flexible enough to fit into complex spaces within the built environment. The dome's resemblance to a woman's breast is a rare example of humour in architecture. Quarmby later made transparent plastic sets for Robert Freeman's film *The Touchables* (1966).

ARCHIGRAM [Ron HERRON]
Cities: Moving [detail]
1964/73
Collage and airbrush painting on paper mounted on card
Left panel of two-panel work, 88 × 182 cm [34.5 × 72 in] overall

The Walking City proposal envisioned the geographical and constructional fixity of cities being superseded by nomadic, articulated structures. The structure was envisioned as capable of hovering around the globe freely. It would connect with energy and data ports or other moving city structures, for social and commercial exchange. The overall appearance of the Walking City was inspired by the fantasies of science fiction, and in this case is a hybrid of insect and UFO. Meticulously organized, it would house everything needed to sustain a society. The leg extensions would function as supports, engaged when the metropolis was stationary.

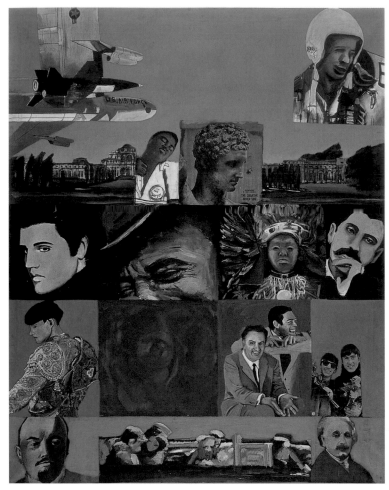

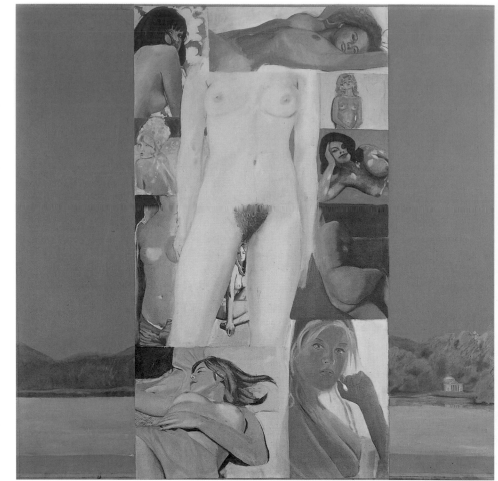

left to right
Pauline <u>BOTY</u>
It's a Man's World I
1964
Oil on canvas
153 × 122 cm [60 × 48 in]
Pauline <u>BOTY</u>
It's a Man's World II
1965
Oil on canvas
125 × 125 cm [49 × 49 in]

Boty often painted representations of collaged material from mass-media sources within her pictures, establishing relationships between mediated images of glamour, power or eroticism, and a more local background context. Here in the left-hand painting of what eventually became a diptych [not shown to relative scale], the background shows an English 'stately home', over which are superimposed images of male figures symbolic of achievement in all active spheres of public life, from literature and politics to sport and pop music. The only female presence is Jacqueline Kennedy, the glamorous First Lady, shown at Kennedy's side in the fatal Dallas motorcade. In the right-hand painting (seen in an earlier stage in Bailey's photograph opposite), the view from the house is interrupted by a similar montage arrangement, except that this time it portrays women in passive poses typical of sex magazines. Boty was more critical of sexist attitudes of the time than most male Pop artists, although she was herself glamorized by photographers and filmmakers such as Ken Russell, in his television documentary on the London Pop scene, *Pop Goes the Easel* (1962).

opposite
David <u>BAILEY</u>
Pauline Boty
1964
Gelatin silver print
30.5 × 25.5 cm [12 × 10 in]
Photograph published in *Vogue* magazine, September 1964

Bailey's arresting portrait of the artist and London icon of glamour is artificially lit by cold, hard light and presented at an oblique angle, like an updated form of Russian constructivist photography. He used a single-kilowatt Mole-Richardson Scoop lamp, mirroring the use of high-contrast effects in television and film lighting. Bailey's original portraits of iconic figures were central to the mediation of British Pop style. An early version of *It's a Man's World II* is shown in the background.

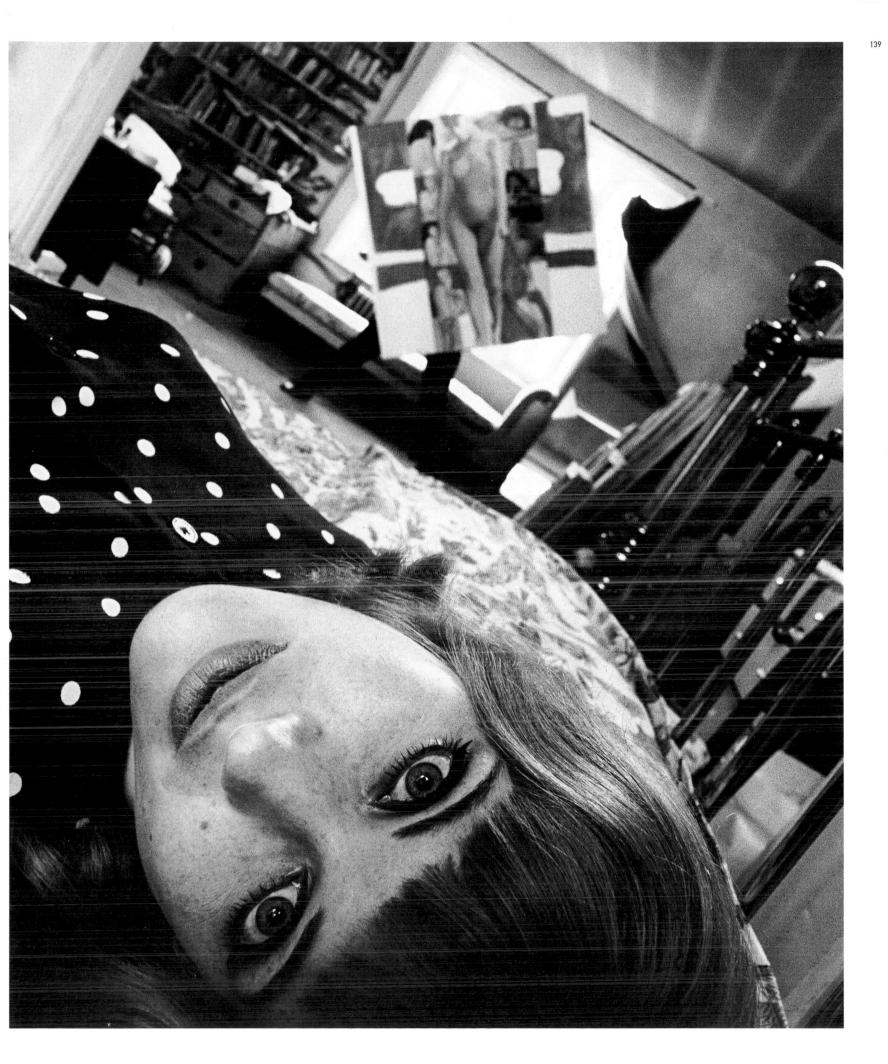

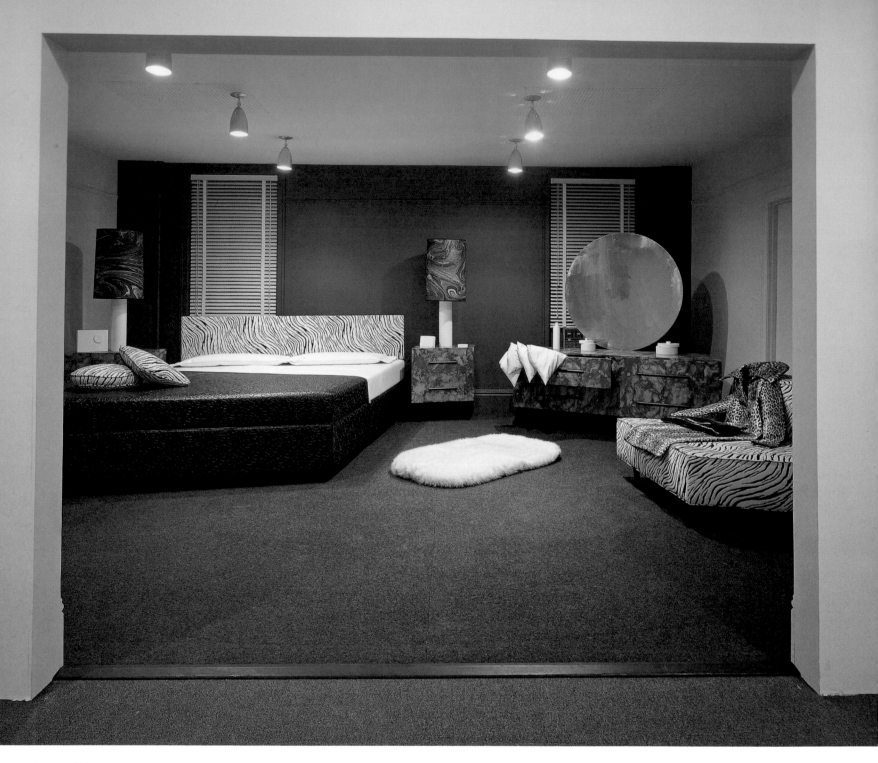

Claes OLDENBURG

Bedroom Ensemble 1

1963

Wood, vinyl, metal, fake fur, other media

305 × 518 × 609.5 cm [120 × 204 × 240 in]

Collection, National Gallery of Canada, Ottawa

Bedroom Ensemble was first installed as one of 'Four Environments' at the Sidney
Janis Gallery, New York, in January 1964 (the other artists were James Rosenquist,
George Segal and Jim Dine). It replicates a kitsch version of a bedroom complete
with dressing table, mirror and an air-conditioner that cooled the room throughout
the exhibition. Like a stage set, the false perspective of the environment alters the
viewer's perception of what at first appears as a real domestic space. The apparent
functionality of the objects is also misleading – the vanity mirror distorts, the
drawers do not open and the bed is hard. Oldenburg's use of fake pelts and synthetic,
easy-clean materials popular at the time highlights the ensemble's artifice.

Richard <u>ARTSCHWAGER</u>
Description of a Table
1964
Formica
66.5 × 81 × 81 cm [26 × 32 × 32 in]
Collection, Whitney Museum of American Art, New York

Artschwager trained as a fine artist under Amédée Ozenfant and then worked as a commercial furniture-maker in the 1950s, combining his creative and industrial skills to create his first sculptures in the early 1960s. *Description of a Table* focuses on surface, creating a table-sculpture in the form of a cube. It is covered in formica, a standard material found in many American homes and with its own connotations of illusion – the 'wood effect' used to create an impression of luxury and wealth – and inferences of mass-production. Over this, Artschwager painted the tablecloth in white and the negative spaces in black. He referred to it as 'three-dimensional still life'. Like Oldenburg, with whom he collaborated, Artschwager used simulation and obvious artificiality to reassess common objects. 'By killing off the use part, non-use aspects are allowed living space, breathing space. Things in a still-life painting can have monumentality – and I don't think their monumentality has been lessened because their ediblity or other use has been either taken away or not put into them.'
– Richard Artschwager quoted in Jan McDevitt, *Craft Horizons*, 1965

Andy WARHOL

Brillo Box [3 ¢ off]

c. 1963-64

Silkscreen and house paint on plywood

33.5 × 40.5 × 29 cm [13 × 16 × 11.5 in]

Collection, The Andy Warhol Museum, Pittsburg

In the winter of 1963–64, after experimenting with a prototype of a Campbell's Soup can, Warhol embarked on his first sculptures. He began to replicate cardboard boxes for products such as Brillo soap pads, Campbell's tomato juice and Del Monte peach halves. The yellow versions of the *Brillo Box* were among the first. Invoices from this period indicate that initially 50 examples were made. Warhol instructed a cabinet maker to construct the boxes out of plywood to the exact dimensions of the originals. Then they were painted to simulate either the cardboard or the printed background colours, over which the relevant brand label was silkscreened on all sides. The boxes were assembled in Warhol's studio in production lines (likely to be the context for the adoption of the Factory as the studio's name). A selection of the sculptures was exhibited at the Dwan Gallery, Los Angeles, in February 1964 and the Stable Gallery, New York, in April. They were stacked up or laid along the gallery floors, making the experience of being in the space similar to navigating through a grocery warehouse. These serial accumulations of identical objects, which were indistinguishable from their non-art counterparts, went further than Warhol's two-dimensional work in questioning traditional notions of artistic status and value.

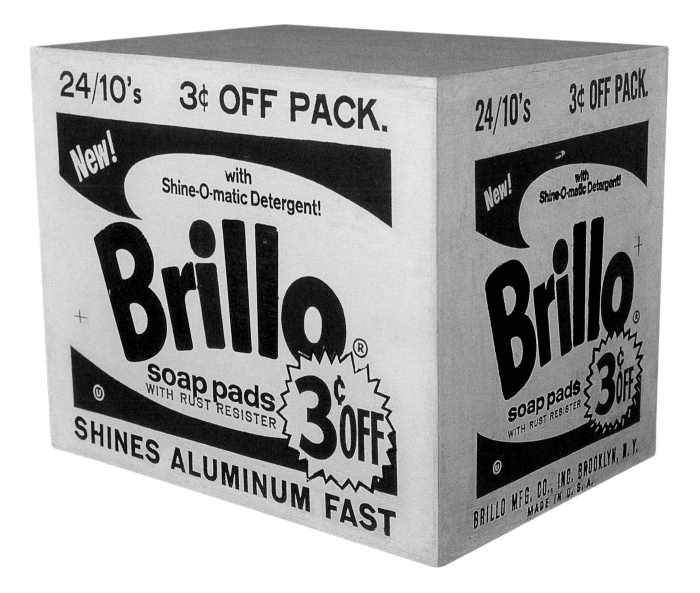

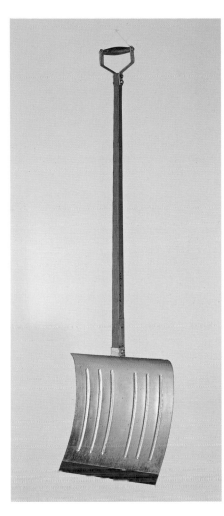

Marcel <u>DUCHAMP</u>
En prévision du bras cassé
[In Advance of the Broken Arm]
1915/64
Readymade: snow shovel; wood and galvanized iron
132 × 35 cm [52 × 14 in]
Replica of original lost in 1915
Collection, Musée national d'art moderne, Centre Georges
Pompidou, Paris

With his readymades, Duchamp removed objects from their ordinary context and re-presented them as art. He considered *In Advance of the Broken Arm* to be one of the most important of his 'unassisted' readymade objects, such as *Bottle Rack* (*Sèche-bouteilles*, 1914). Although the object was presented unaltered, like the bottle rack, Duchamp substituted a factually descriptive title with a phrase that invites speculation on the object's possible symbolic meaning. After a long period when Duchamp's work was known only to a relatively small group of artists and their circle, he became widely recognized in the mid 1960s. In 1964 he collaborated with the scholar and dealer Arturo Schwarz on new editions of eight of his readymades, which gave them new currency. The legacy of Duchamp apparent in the work of a number of American artists such as Dine and Warhol led to the term 'Neo-Dada' sometimes being applied to their work before 1962 when the term Pop art became predominant. The Nouveaux Réalistes also alluded to this legacy in their manifesto produced to accompany their second Paris group show in 1961, entitled '*À 40° au-dessus de Dada*' ('At 40 degrees above Dada').

Jim <u>DINE</u>
Black Shovel, No. 2
1962
Oil on canvas and shovel
214.5 × 91.5 cm [84.5 × 36 in]
Collection, Whitney Museum of American Art, New York

Dine's early paintings refer to the human body through subjects such as clothing, hair and skin. This developed into the use of common associative objects such as soap, garden implements and household appliances, investigating bodily surrogates through absence and appendage. He referred to tools as 'an extension of one's own hand'. Dine frequented hardware shops, studying the design of tools and the latent notion that their evolution was an anecdote in the history of civilized man. Unlike his contemporaries, Dine did not use simulation or manipulation of scale and proportion, but rather a straightforward placement of objects on the canvas by hanging or attachment, treating them as relics. In *Black Shovel, No. 2*, the artist unifies the shovel with the canvas by covering them both with black paint. This integrated the object into a visual field, transfiguring form into texture and colour.

　Alain JACQUET

Le Déjeuner sur l'herbe
1964
Quadrochrome silkscreen and celluloid varnish on canvas
175 × 197 × 2 cm [69 × 77.5 × 1 in]
Collection, Musée d'art contemporain, Val de Marne/Vitry, France

Silkscreening a greatly magnified photographic image, Jacquet produced a figurative representation verging on abstraction. Based on a snapshot-type photo and mimicking printers' reproduction processes, the painting updates Manet's *Le Déjeuner sur l'herbe* (1863), a turning point in the emergence of modern art, which was itself based on a 1510 engraving by Marcantonio Raimondi after Raphael's *Judgement of Paris*. Jacquet's use of mechanical processes (the critic Pierre Restany called his work 'Mec Art') was motivated by the visual effects they made possible. Distortion, disintegration and the slight variation with repetition characteristic of silkscreening allowed him to investigate the extent to which an everyday image would remain recognizable after undergoing, or despite, these interferences.

r als sein Vor-
n Stelle er ge-
iat die Zeichen
n bis 1500 ccm
jesenkt, dabei
auf 12 Monate

m 1100 D der
, England und
Einliter-Wagen
Cardinal, Mor-
M) begegnen.
für die Neu-
Fiat hat allen
n ausgereiftes,
)laren zur Zu-
ιufendes Auto-

generellen Ex-
orgesehen und

Gerhard RICHTER

Alfa Romeo [mit Text]

1965

Oil on canvas

150 × 155 cm [59 × 61 in]

This is one of several paintings that derive from a found picture on a printed page,
with the residual details of surrounding text included in the image. A number of these
works depict cars: a speeding pair of Fiats, a Ferrari and, here, the rear view of an Alfa
Romeo SZ 2600. Meticulously executed in graduated greyish tones, the painting
appears to replicate its source almost mechanically. The crop of the image and text
reduces their meaning content, foregrounding graphic composition and tonal effects.
This simulation of a mechanistic form of reproduction, with minimal traces of the
artist's hand, allies Richter's painting with the objective filter of photography.

William <u>EGGLESTON</u>
Webb, Mississippi
1964
Dye transfer print
39.5 × 57 cm [15.5 × 22.5 in]

Colour had occasionally been employed by a few major photographers for specific subjects: in the 1930s Paul Outerbridge used a colour process for still life and nudes, and later Eliot Porter mastered the dye-transfer process introduced by Kodak in 1946 for his nature photographs. Despite this, in the mid 1960s the monochrome aesthetic was still considered essential to serious art photography and reportage. Eggleston was among the first to embrace the 'vulgar' attributes of colour, turning Kodachrome slides into dye-transfer prints to convey the particular vernacular qualities of everyday scenes and objects in the Southern states where he lived and worked. He departed from the photographers he admired, such as Walker Evans, in another respect by avoiding the carefully framed frontal composition in favour of angles reminiscent of amateur snapshots. This is one of the earliest examples of his work in colour. It was not until Eggleston's retrospective at The Museum of Modern Art, New York, in 1976 that colour photography was exhibited as art in a major museum.

Garry <u>WINOGRAND</u>
Tally Ho Motel, Lake Tahoe
1964
Cibachrome print
40 × 58 cm [16 × 23 in]
Collection, Center for Creative Photography, University
of Arizona at Tucson

Winogrand worked mainly in black and white. In this saturated colour photograph
holidaymakers are seen at a motel, relaxing by the pool. The car in the foreground and
the coach on the signpost point to two American symbols: pioneers of the old West
and the newly mobile consumers of the 1960s. Winogrand found subjects in the
everyday spaces of post-war architecture – roadsides, shopping malls, motels, airport
lounges. In 1964 he was awarded a bursary by the Guggenheim Foundation, which he
used to tour the United States taking photographs of contemporary American life one
year after the Kennedy assassination. While on the road, Winogrand took thousands
of photographs. He later submitted a selection of the prints to 'New Documents' at
The Museum of Modern Art, New York, in 1967, though only his black and white
photographs were shown. That exhibition also showed Diane Arbus and Lee
Friedlander, with whom he shared the documentary style sometimes called the
'snapshot aesthetic'.

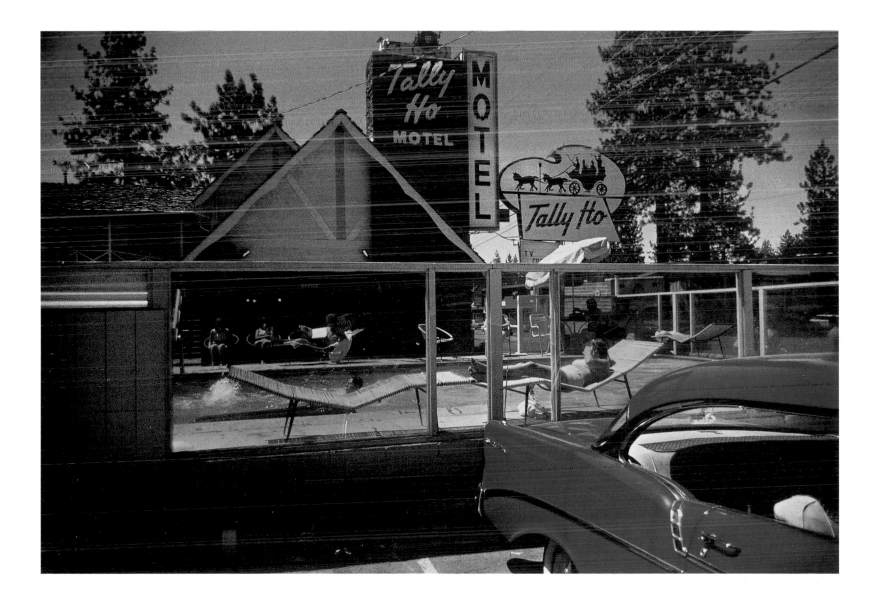

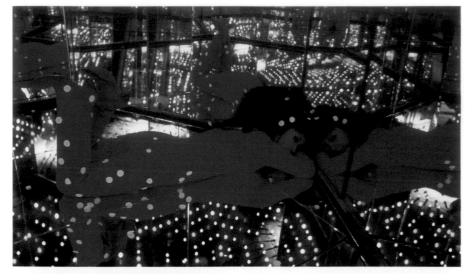

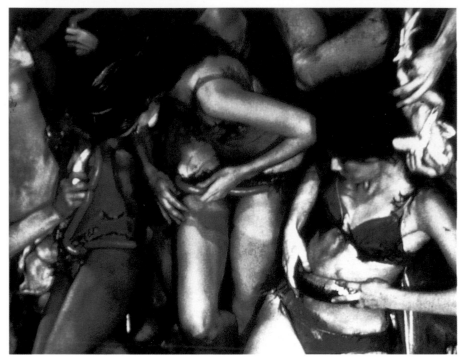

Yayoi <u>KUSAMA</u>

Kusama's Peep Show, or Endless Love Show

1966

Hexagonal room with mirrored walls, floor and ceiling, peep hole, small coloured lightbulbs in ceiling, flashing on and off in sequence

210 × 240 × 205 cm [83 × 94.5 × 81 in]

Installation view with the artist in the environment, Castellane Gallery, New York, March 1966

Since her arrival in New York in the late 1950s, Kusama had explored accumulation and serial repetition in works that paralleled the innovations of her contemporaries such as Andy Warhol and the Nouveaux Réalistes in Europe. While critically engaged with Pop, she had arrived at endless replication as the outcome of a mental condition characterized by compulsive obsession. Accompanied by loud pop music, this installation adapted the form of a peep show. Instead of a woman (Kusama's presence here was a temporary performance) the viewer peering through the peep hole would see endless patterns of coloured lights – a sublime intimation of infinity.

Carolee <u>SCHNEEMANN</u>

Meat Joy

1964

First performed at Festival de la libre expression, organized by Jean-Jacques Lebel, American Cultural Center, Paris, 25-30 May 1964

Schneemann's Happenings were structured, yet each realization of a work was spontaneous and different. Meat Joy was partially improvised by the participants. Near-naked, writhing men and women wriggled with fish, sausages, chickens, paint, plastic and each other in an 'erotic rite'. Lighting specialists and sound engineers (who played a soundscape of Parisian street noises and Motown songs) reacted to the performers and the audience, who were in close proximity. Schneemann encouraged 'a celebration of flesh as raw material … sensual, comic, joyous, repellent'. The Festival de la libre expression combined exhibitions with Happenings, performances and film screenings; other participants included Jasper Johns, Merce Cunningham and Andy Warhol. Performances of Meat Joy took place later in 1964 in London and New York.

– quotations from Carolee Schneemann, More Than Meat Joy, 1979

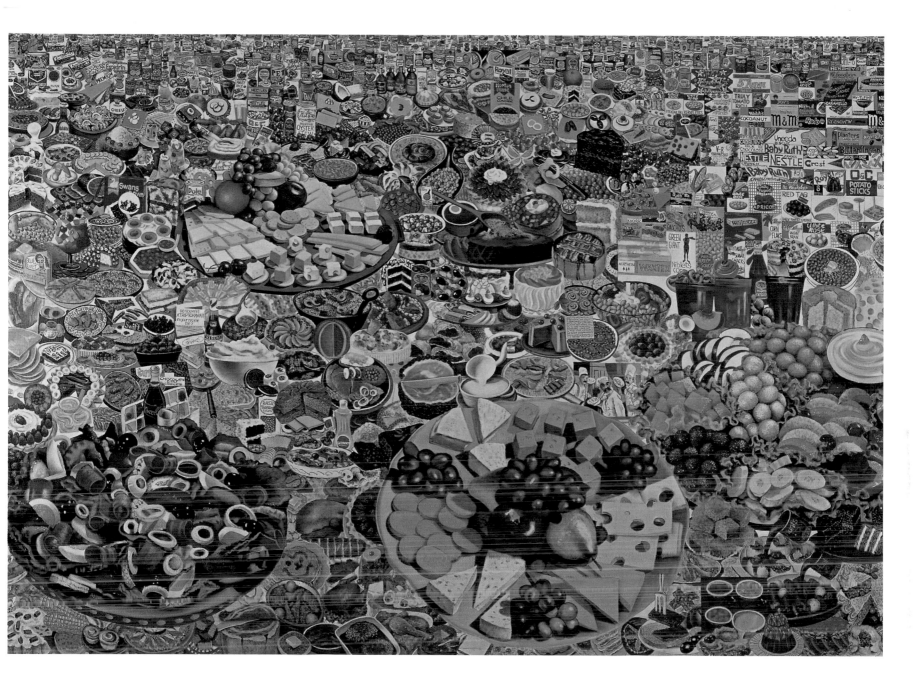

ERRÓ

Foodscape

1964

Oil on canvas

201 × 301 cm [79 × 118.5 in]

Collection, Moderna Museet, Stockholm

Erró (Gudmunder Gudmundsson) trained as a mosaic artist in Florence after studying at the Academies in Reykjavik and Oslo. In *Foodscape* his subject covers the surface of the canvas in continuous patterning. Displays of party food, of the kind sold ready-prepared, disappear into a deep recessional space. *Foodscape* is a depiction of never-ending consumption. Erró was a political Pop artist, taking as his subjects the Cold War and American consumerism. Using images of mass-produced items Erró first completed a collage, which he then projected on to canvas and painted. He took part in European Happenings including *Catastrophe* (1962) with Jean-Jacques Lebel, and recorded the work of his friend Carolee Schneemann.

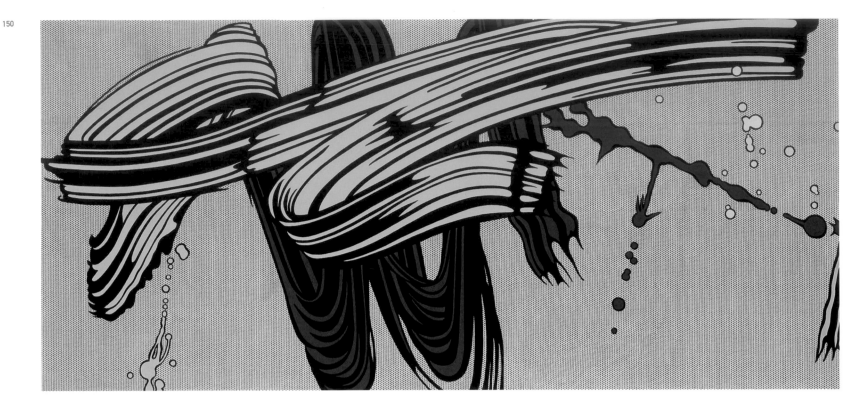

Roy <u>LICHTENSTEIN</u>

Yellow and Green Brushstrokes

1966

Oil and magna on canvas

214 × 458 cm [84.5 × 180.5 in]

Collection, Museum für Moderne Kunst, Frankfurt am Main

Begun in the autumn of 1965, Lichtenstein's series of *Brushstroke* paintings was initiated after he saw a cartoon in Charlton Comics' *Strange Suspense Stories*, 72 (October 1964). One scene shows an exhausted yet relieved artist who has just completed a painting. This depicts two massive brushstrokes that take up the entire surface area. The absurdity of using a small paintbrush to create an image of two monumental brushstrokes was explored in many different variations. Transforming an expressive act that was mythologized for its immediacy and primal origins into a cartoon-like, mechanically produced-looking image, Lichtenstein created a reflexive commentary on gestural painting.

opposite

Richard <u>HAMILTON</u>

My Marilyn

1965

Oil and collage on photographs on panel

102.5 × 122 cm [40.5 × 48 in]

Collection, Ludwig Forum für Internationale Kunst, Aachen

These images of Marilyn Monroe by the photographer George Barris were published posthumously. She had control over such publicity shots and her preferences are shown in her markings on these contact sheets – crossing through those she did not like, partially obliterating some, and ticking those she cleared. Photography became central to Hamilton's work in the mid 1960s as he investigated the line between photography and painting, and the construction of illusion. He takes the editing process of the photographer and film star a step further, collaging the photographs directly on to the canvas, defacing some discarded images and reworking others. Images are presented more than once, at different scales, and with different levels of intervention with paint. Hamilton took an intellectual approach to Pop art, analysing mass media: ' … the expression of popular culture in fine art terms is, like Futurism, fundamentally a statement of belief in the changing values of society. Pop-Fine-Art is a profession of approbation of mass culture.' – Richard Hamilton, 'For the Finest Art Try – POP', *Collected Words*, 1982

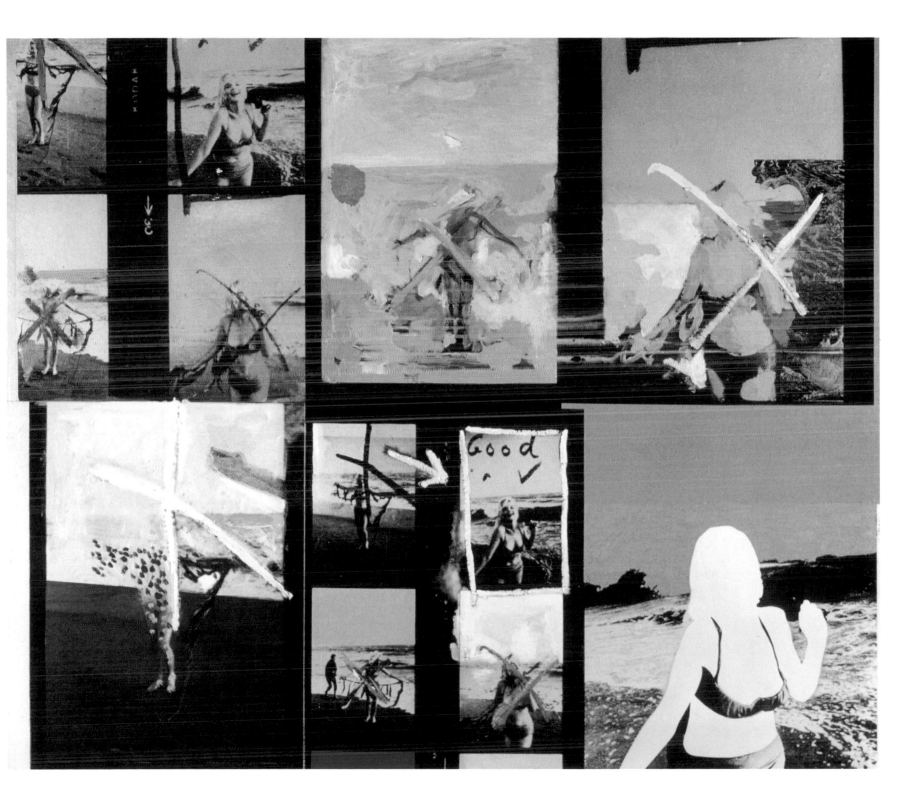

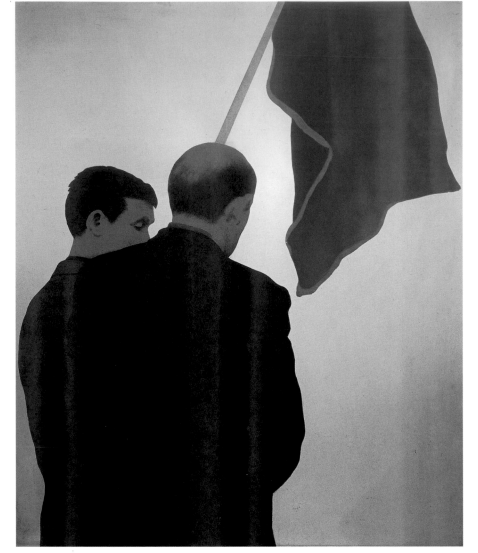

Michelangelo <u>PISTOLETTO</u>
Biandera rossa [Red Banner]
1966
Painted vellum paper on chromed
steel sheet
120 × 100 cm [47 × 39.5 in]

Pistoletto's 'mirror' works developed from a series of self-portraits made in the early 1960s. He painted figures on reflective backgrounds of black, gold or silver, positioning the figurative images within a monochrome field. This removed any temporal or spatial context from the composition and focused on the figures' existential presence. The reflective quality encapsulated Pistoletto's emerging interest in the contingencies of time and physical presence between the viewer and the artwork. The polished steel background became analogous to the doorway to a tangible space. Adhering to its surface, the figures he painted on paper are depicted lifesize. His initial subjects were scenarios of people leaning against the frame, looking into the mirror without a reciprocating reflection. *Biandera rossa* shows a fragment of a protest. Viewers reflected in the mirror background are invited to consider themselves in relation to the work's subject and the moment at which the painting has created an active register of their position in the gallery.

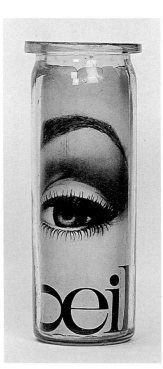

Marcel <u>BROODTHAERS</u>
L'Oeil [The Eye]
1966
Painted image on paper, glass
h. 29 cm [11.5 in] ø 9 cm [3.5 in]

Until 1964 Broodthaers had been a poet associated with a radical group of Belgian surrealist writers. In the mid 1960s he linked the questions Pop art raised with aspects of Magritte's work, such as his juxtaposition of visual and verbal signs for objects. Observing the transformation of art into merchandise, Broodthaers noted how 'this has accelerated to the point at which artistic and commercial values are super-imposed. And if we are concerned with the phenomenon of reification then art will be a particular instance of that phenomenon – a form of tautology.'
– Marcel Broodthaers, 'To be *bien-pensant*, or not to be. To be blind', 1975

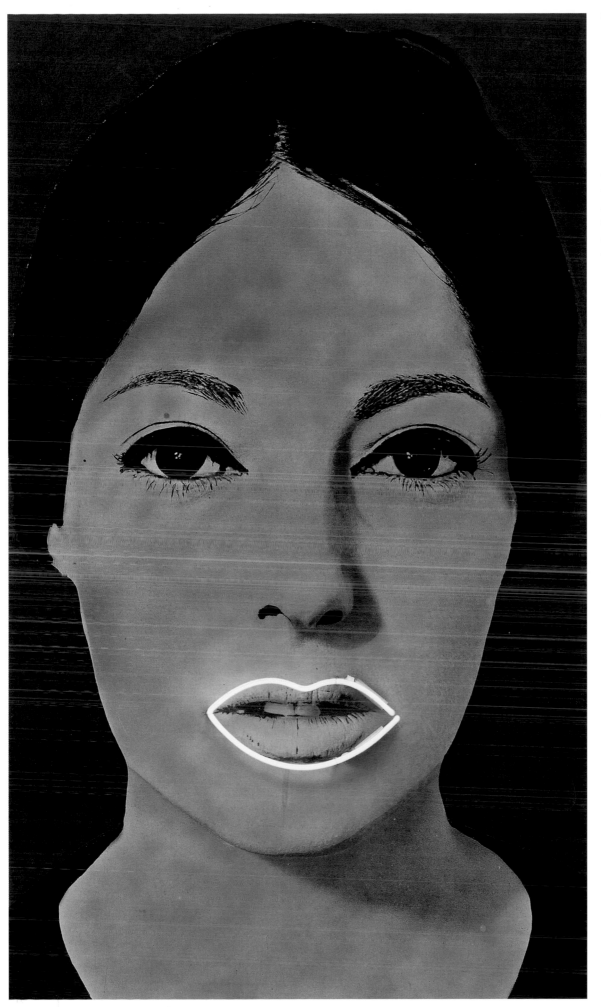

Martial <u>RAYSSE</u>
Peinture à haute tension
High Voltage Painting
1965
Photograph, oil and fluorescent
paint on canvas with neon
162.5 × 97.5 cm [64 × 38.5 in]
Collection, Stedelijk Museum,
Amsterdam

By 1965 Raysse had become critical of
the conclusive discourse around what
was nominated Pop, considering it to be
a superficial codification of beauty. He
viewed many of his contemporaries as
creating 'idols not icons'. In response to
the imagery in works such as Warhol's
Marilyn series, he formulated an
alternative kind of representation that
he referred to as 'hygiene of vision'.
In works such as *Peinture à haute
tension* he attempted to 'sanitize'
depictions of beauty, moving away from
the cult of personality to an archetypal
figure, as found in anonymous fashion
models. His use of neon to outline the
woman's lips emphasizes their
sensuality but also creates a humorous
play on the electric dangers of attraction
and contact.

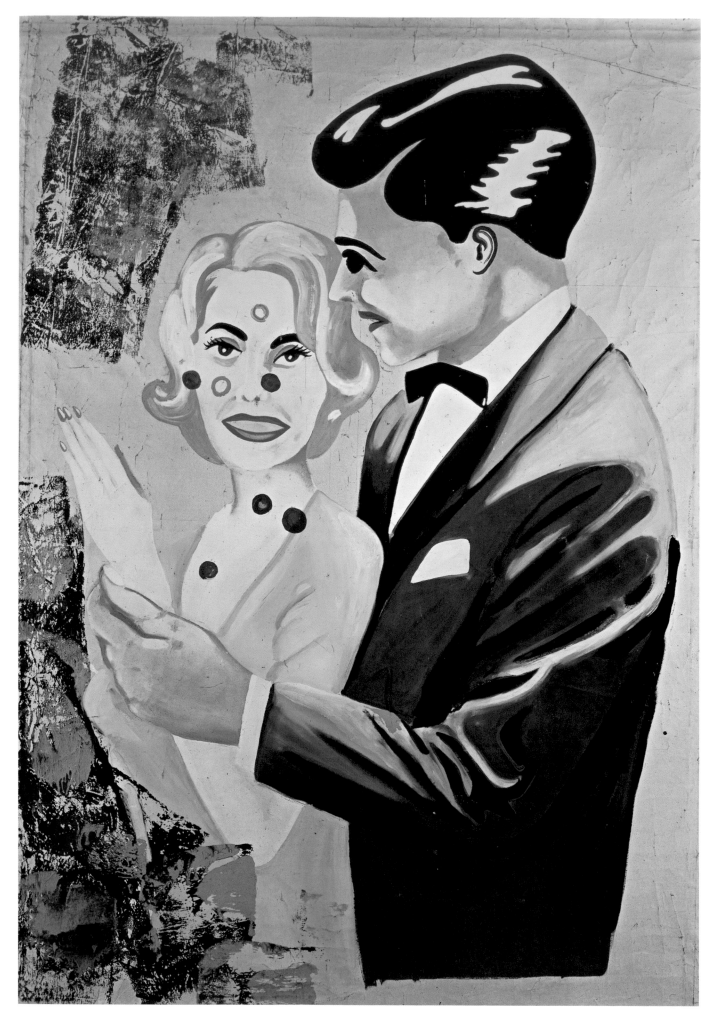

Sigmar POLKE
Liebespaar II [Lovers II]
1965
Oil and enamel on canvas
200 × 139.5 cm [79 × 55 in]
Polke originally drew on mass-media
sources as a vehicle for provocation.
He undermined painterly convention,
deliberately creating 'bad' paintings.
The evidence of compositional planning
in *Liebespaar II* makes the lack of finish,
anatomical anomalies and what look like
attacks on the surface, at the far left, all
the more disquieting. As a challenge
to 'good' taste, Polke aimed to produce
a truly ugly painting. After leaving East
Germany he trained at the Düsseldorf
Academy and became a member of the
short-lived Capitalist Realist group, with
Gerhard Richter and Konrad Lueg (later
to become the gallerist Konrad Fischer).
Polke later lived with a band of friends,
working collaboratively and delegating
the execution of work to them, in an echo
of Andy Warhol's Factory.

Sigmar POLKE
Bunnies
1966
Synthetic polymer on linen
149 × 99.5 cm [59 × 39 in]
Collection, Hirshhorn Museum and Sculpture Garden, Smithsonian
Institution, Washington, D.C.

Polke chose Playboy bunnies, hostesses at Hugh Hefner's men's clubs, as a subject symbolic of Western decadence. He mocked manufactured American Pop and the standards of consumer society in which these women are objects, setting a standard of female beauty, dressed as rabbits. In *Bunnies* he presented them through a screen of dots based, as in Lichtenstein's paintings, on the enlargement of printing screen patterns. However, unlike Lichtenstein, Polke blurred and rearranged the dots. 'I love all dots. I am married to many of them. I would like all dots to be happy. Dots are my brothers. I too am a dot. Once we all played together; now each goes his separate way. We meet only at family celebrations, and then we ask each other "How's it going?"'
– Sigmar Polke, statement in *Graphik des Kapitalistischen Realismus: Werke von 1964 bis 1971*, Galerie René Block, West Berlin, 1971

Claes OLDENBURG
Proposed Colossal Monument for Park Avenue, New York: Good Humor Bar
1965
Crayon and watercolour on paper
60.5 × 45.5 cm [24 × 18 in]
Collection, Solomon R. Guggenheim Museum, New York

In 1965 Oldenberg moved to a huge new studio space, and began to design colossal, even impossible, monumental sculpture. His drawings placed enlarged everyday objects in public spaces as civic monuments. The Good Humor Bar was a type of ice-cream on a stick. The objects he selected were often phallic, such as lipsticks, hot dogs and drill-bits, and small, playing on unexpected differences in scale. During a trip to London in 1966 he continued this theme, using collage to suggest the replacement of the statue of Eros at the centre of Piccadilly Circus with a group of towering cosmetics (*Lipsticks in Piccadilly Circus*, 1966). A combination of financial and planning constraints prevented such projects being realized until in 1969 Yale School of Architecture commissioned *Lipstick, Ascending, on Caterpillar Tracks*, on which Oldenburg supervised industrial technicians to produce his first Pop monument.

Robert INDIANA
LOVE
1966
Oil on canvas
183 × 183 cm [72 × 72 in]
Collection, Indianapolis Museum of Art

As Susan Elizabeth Ryan records (*Robert Indiana: Figures of Speech*, 2000), the composition of *LOVE* originated in some handmade Christmas cards Indiana made in 1964. He placed stencil letters to fill each of the four corners of a square so that they touched each other, tilting the 'O'. He placed paper over the top and made rubbings in coloured crayon. Then in 1965 he responded to an invitation from The Museum of Modern Art for an artist-designed Christmas card by submitting oil on canvas paintings of the composition in a number of colour variations. The museum chose the red, green and blue version for its striking optical effect and the cards were sold widely before this painting and other variations such as the kaleidoscope-repeat *LOVE* walls were publicly exhibited at the Stable Gallery, New York, in May 1966. The colours also conveyed a personal symbolism for Indiana, the red and green evoking the logo of the gasoline company, Phillips 66, for which his father had worked, and the blue its setting against the clear Midwestern sky of his childhood. Marking a new departure in Indiana's compositions – cool and formalist yet vibrantly resonant – *LOVE* coincided with the first large New York shows of Op art ('The Responsive Eye', 1965) and Minimalism ('Primary Structures', 1966). It also resonated widely during the 'Summer of Love' period of 1966–67; due to various factors beyond the artist's control the composition has been appropriated and visually quoted extensively ever since.

Sister CORITA [Frances Kent]
Make Love not War
1965
Silkscreen on paper
Dimensions variable

Frances Elizabeth Kent, who became a nun, Sister Mary Corita, was a controversial figure during the 1960s, whose slogans for social awareness and political responsibility made her position in the church and popular culture fraught with tensions. Her artistic training was in serigraphy: through the low-tech economies of silkscreening, she made her messages colourfully present and affordably available. She used simple framing devices, from square cut-outs to the camera lens, to remove compositions from the everyday and transfer them to prints. She would often start with the logos and slogans of popular brands; she then transformed the ethos of their messages while retaining their form, challenging their ownership of language.

Richard <u>HAMILTON</u>
Epiphany
1964
Cellulose paint on panel
ø 122 cm [48 in]

Epiphany is the only work of this period in which Hamilton transliterated a mass-produced object directly, enlarged and reproduced as a painting. He bought the badge on which *Epiphany* is based from a joke shop at Pacific Ocean Park (POP), Venice Beach, California, while on his first trip to the United States to see Marcel Duchamp's retrospective exhibition at the Pasadena Art Museum in 1963. It provoked an ephiphanic moment, a sudden realization that summed up his responsiveness to American Pop and its freedom from European historical concerns. Its complementary colours also echo the optical effects of Duchamp's *Fluttering Hearts* (1936).

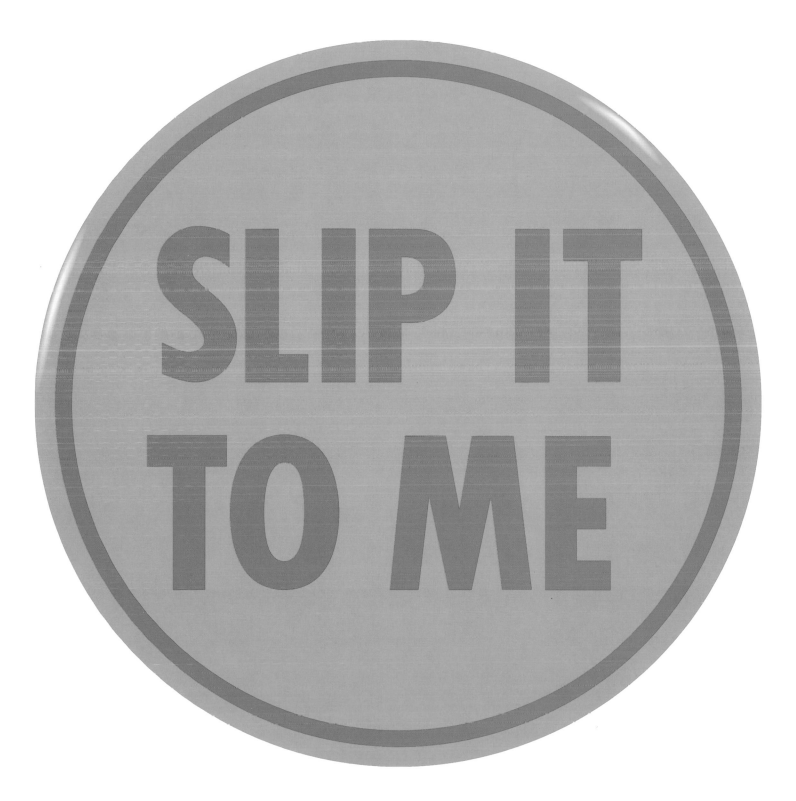

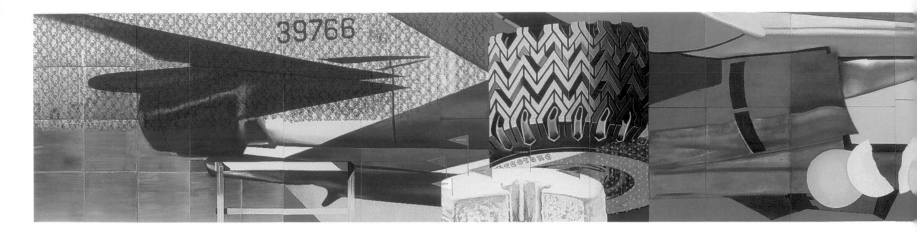

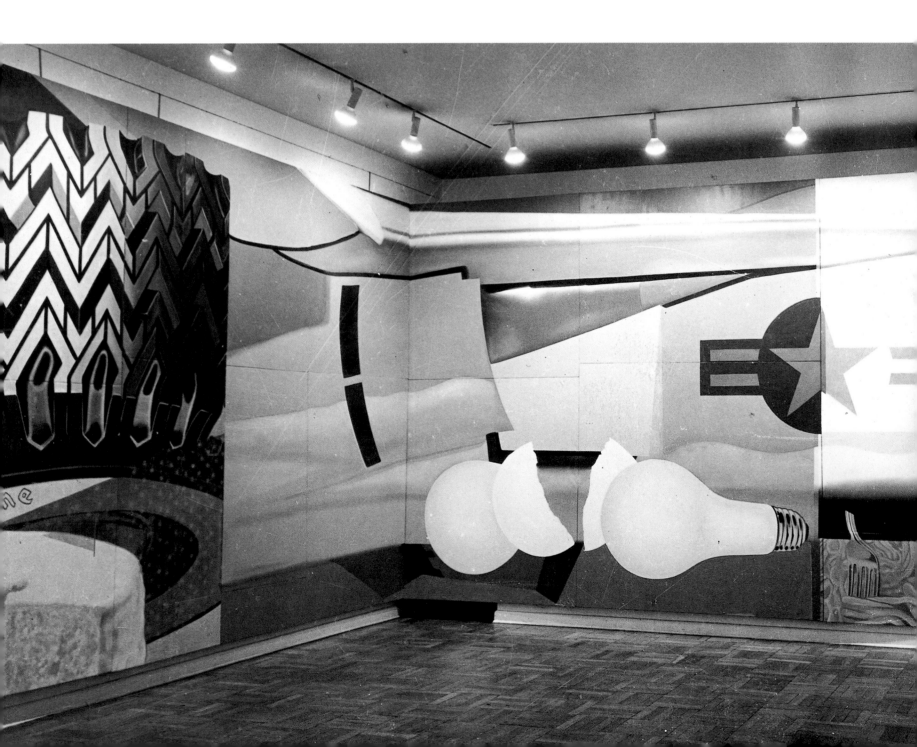

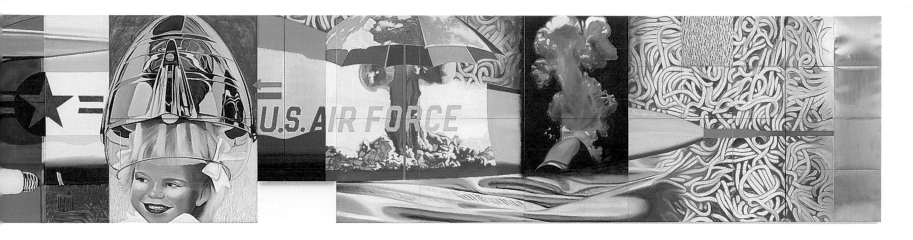

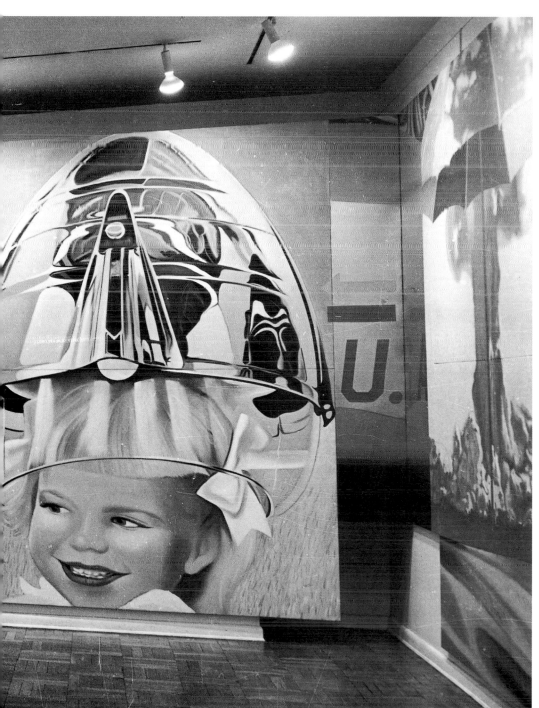

James ROSENQUIST

F-111

1964-65

Oil on canvas with aluminium

305 × 2,621.5 cm [120 × 1,032 in]

Collection, The Museum of Modern Art, New York

left, Installation view, Leo Castelli Gallery, New York, 1965

F-111 was labelled 'the world's largest pop painting' when it was first exhibited at the Leo Castelli Gallery in April 1965. It consists of fifty-one interlocking sections over 26 m (86 ft) long in total. In the Castelli Gallery it covered all four walls, surrounding the viewer. The central horizontal element running through the composition, the eponymous F-111, was a new, controversially expensive bomber; the painting was executed during the Vietnam conflict. Pictorial elements including rubber tyres, a young girl under a hairdresser's hairdryer, a bomb blast and a mass of spaghetti, combine the visual rhetoric of the military-industrial complex with consumer commodity advertising imagery. Rosenquist's sleek, polished style and billboard scale (even the aeroplane is represented larger than life) can induce claustrophobic, overwhelmed responses. It is impossible to see the entire painting at once. Although it remained complete, Rosenquist was willing to sell the painting in sections, entertaining the ideas of disintegration this would raise.

SPECTACULAR TIME

Around 1967, the 'Summer of Love', it seemed that the alternatives to corporate, industrial and imperialist America had themselves turned into a colourful, nomadic, psychedelic cliché. Artists became popular figures in unprecedented ways, and links were established between their work and fashion, film and advertising, thereby spreading their influence further. Some (Andy Warhol, Peter Blake, Richard Hamilton) even designed Pop album covers. All cultural life was increasingly co-opted into a spectacular and inescapable merger of advertising, television and consumption. This repressive tolerance of all forms of communication subsumed even marginal phenomena into the totality. The utopian freedom which seemed within reach only a short time previously now appeared to artists in different fields to be a mirage. While the spectators for art, music and film increased they also became more passive and easily manipulated. A step back to basics, and an analysis of the vernacular and the traditional, was presented in Ed Ruscha's *Every Building on the Sunset Strip* and other works, which created the conditions for a structural understanding of the world's appearance, for individual imagination, and for a recognition of the artist's more nuanced role with regard to the public sphere.

opposite
Andy WARHOL
Silver Clouds
1965-66
Helium-filled Scotchpack [silver foil-coated Mylar]
87.5 x 126.5 cm [34.5 x 50 in] each
Installation view, 'Andy Warhol. Wallpaper and Clouds',
Leo Castelli Gallery, New York, April 1966

The *Silver Clouds* were presented in a double installation at the Leo Castelli Gallery, New York, in April 1966. In the front gallery, they were intended to float between the floor and the ceiling. The walls of the adjacent gallery were papered with *Cow Wallpaper* (shown overleaf). The idea for the *Silver Clouds* dates back to 1964, when Warhol met Billy Klüver, the engineer at Bell Laboratories who had worked with artists such as Robert Rauschenberg. Originally they discussed collaborating on a floating light bulb, then on a cloud-shaped form. Neither was feasible using the silver material they located (Scotchpak, used by US Army suppliers to wrap sandwiches). It was heat-sealable and relatively impermeable to air or helium but could only be shaped to a basic geometric form. Most viewers referred to the works as 'silver pillows', missing the elemental reference that Warhol retained in his title.

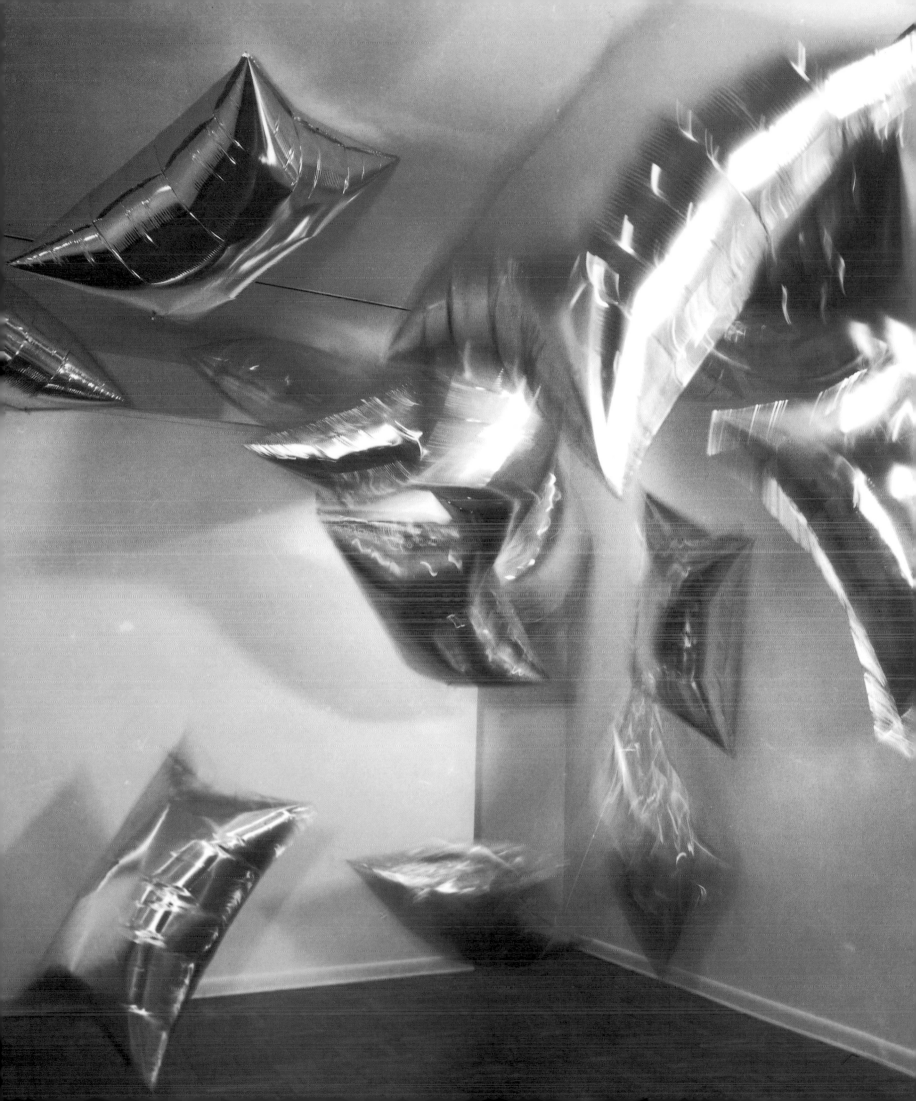

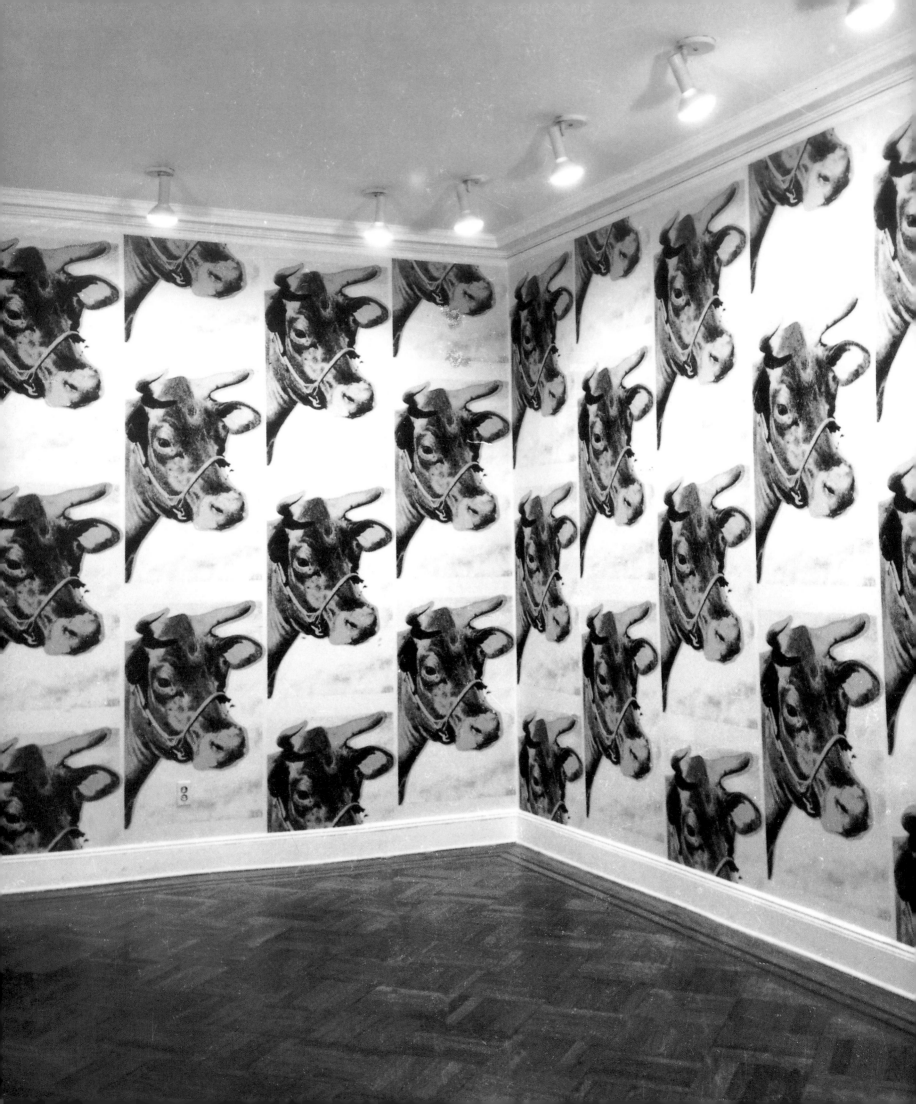

Andy WARHOL
Cow Wallpaper
1966
Silkscreen ink on wallpaper
Dimensions variable
far left, Installation view, 'Andy Warhol. Wallpaper and Clouds',
Leo Castelli Gallery, New York, April 1966
left, detail of wallpaper

The entire wall space of the second gallery at Leo Castelli was covered with this wallpaper. The *Cow Wallpaper* refers to nature but the colours could not be more unnatural. Going beyond the bright hues of the *Flowers* series, the magenta/red and gold/yellow combination produces a dazzling 'day-glo' effect. The *Silver Clouds* and the *Cow Wallpaper* could be viewed, respectively, as 'finishing off' Warhol's sculptural and painting practice to date. The *Silver Clouds* replaced the hard-edged definition, mass and presence of the box sculptures with randomness, dispersal, insubstantiality and reflectiveness. The *Cow Wallpaper* replaced the production of multiple but varied individual paintings (such as the *Flowers*, installed as a grid in the same space a year before) with a uniform, all-over wall covering. Both works were ephemeral, manufactured products that were potentially unlimited and without value (not for sale). Both replaced discrete artworks with an ambient environment.

Andy WARHOL
The Chelsea Girls
1966
16mm film, 195 min., black and white and colour, sound, double
screen projection

Apart from two scenes for which Ronald Tavel supplied scripts, *The Chelsea Girls* comprises six and a half hours of improvised, 'real' dialogue and monologue by members of Warhol's entourage, including Brigid Berlin, Susan Bottomley (International Velvet) and Nico, who lived at the Chelsea Hotel at the time the film was made. From June 1966, scenes were shot at the hotel, in the Factory and at the Velvet Underground's apartment. In August Jonas Mekas asked Warhol for a new film to screen and twelve of the scenes were assembled into *The Chelsea Girls*. The reels of film were shown on two screens. This reduced the performance duration to three and a quarter hours. Most of the film is in black and white. Occasional scenes in intense colour, created by lighting effects, appear on one screen: an echo of the contrasts in Warhol's *Silver Clouds/Cow Wallpaper* installation. The film opened at the Filmmakers' Cinematheque in September 1966. Due to its popularity it was soon transferred to larger venues in New York, becoming an art house cinema box office success and touring to other major cities across the United States.

Diane <u>ARBUS</u>
The King of Soul, backstage at the Apollo Theater in Harlem
1966
Gelatin silver print
Published to accompany 'James Brown is Out of Sight', by Doon Arbus,
The Sunday Herald Tribune Magazine, New York, 20 March 1966

Diane Arbus was commissioned, with her daughter Doon as writer, for a portrait of
James Brown by Clay Felker's New York magazine in March 1966. This image shows the
singer backstage, probably at Madison Square Garden, where he performed that month.
She transforms the flamboyant performer into a disturbing and ambiguously monstrous
figure, turning towards the camera in profile against a harshly lit wall on which his
shadow is cast. In 1967 The Museum of Modern Art, New York, included Arbus, with Lee
Friedlander and Garry Winogrand, in the influential exhibition 'New Documents'.

Lee FRIEDLANDER
Aretha Franklin
1967
Cibachrome print
38 × 38 cm [15 × 15 in]

Lee Friedlander was a regular photographer for Atlantic Records, providing images for their record covers and publicity materials. He therefore had privileged access to musicians while recording in the studio, many shot close-up and in colour. This intense image captures the great gospel and soul singer Aretha Franklin in full flow, at the time of her hit record *Respect*, which had great impact for the Civil Rights movement and for other activists. Friedlander amassed an enormous archive of his photographs of American musicians, who worked in every popular genre from jazz to country and western music.

Andy WARHOL and THE VELVET UNDERGROUND
'The Exploding Plastic Inevitable Show', The Dom, New York, 1 April 1966
Photograph by Billy Name

Warhol's *Silver Clouds/Cow Wallpaper* installation coincided with this event in which he attempted to transcend the boundaries between visual art, film, music and performance in a total art work. The Velvet Underground, whom Warhol, Gerard Malanga and Paul Morrissey had met in December 1965, performed on stage surrounded by new spectacular innovations such as a light show (so blinding at times that the band adopted sunglasses as much for eye-protection as to look cool); back projections (such as Warhol's film *Vinyl*); and choreography (Gerard Malanga and Mary Woronov's frenetic dancing). Documented by the filmmaker Ronald Nameth and the photographer Billy Name, this event was a short-lived experiment in Warhol's practice as an artist but initiated the spectacular rock events that expanded the fusion of various media with live performance in the late 1960s.

Mark BOYLE and Joan HILLS
Aldis light projection from Son et Lumière for Earth, Air, Fire and Water
1966

The *Son et Lumière for Earth, Air, Fire and Water* project used technological means to provide a sensory experience modelled on the characteristics of the natural elements. The visual component was created through physical reactions between coloured oils and water transpiring in a special compartment within a slide projector. The projection was accompanied by recorded or performed sounds of environmental reactions such as volcanic eruptions, gusting winds or falling water. The process was simple and flexible and the overall effect was the result of chance. Screened privately until the technique and desired presentation had been refined, the first major performance took place in 1966 in Liverpool. At that time Boyle also performed the 'sounds and lights' for *Bodily Fluids and Functions* using actual body substances instead of dyed surrogates. The events served as an exploration of interior and exterior relationships between visual and aural textures through their natural rhythms. Boyle staged these projections on tour with the bands Soft Machine and the Jimi Hendrix Experience. The optical effects were widely adopted and became the backdrop for many acid-rock concerts.

Richard <u>HAMILTON</u>
People
1965-66
Oil and cellulose on photograph on panel
81 × 122 cm [32 × 48 in]

Hamilton used postcards as source imagery in several works, including *People* and *Whitley Bay* (1965), both of which were based on pictures of the coastal resort in north-eastern England. For *People*, Hamilton created a 35mm negative showing a small portion of a postcard and made a standard format monochrome print from it, which he then re-photographed. He repeated the enlargement process many times until the prints had lost formative meaning. Retracing his steps he was then able to pinpoint exactly the last legible stage, which was used to construct this hybrid photograph/painting. While the image verges on abstraction the viewer can still discern individuals and groups, even ages and dynamics between people.

Michelangelo <u>ANTONIONI</u>
Blow-Up
1966
35mm film, 111 min., colour, sound
With David Hemmings

Like Hamilton's paintings of the same year, Antonioni's film examines the limits of our perception of reality as mediated through photography. Bored with the artificiality of fashion shoots, a photographer embarks on a voyeuristic form of reportage. From a distance he snaps what seems a romantic rendezvous between a middle-aged man and woman. She pursues him to try to confiscate the images. Thinking he witnessed an illicit affair he processes and enlarges the pictures to greater and greater magnifications (the prints used in the film were made by the photographer Don McCullin). He pins them on his wall in sequence, like film stills. They reveal a man with a gun in the shadows of the bushes. He speculates that he foiled a potential murder but further blow-ups reveal what could be a dead body. The photographs are then stolen. Without them he is left with nothing as evidence of what might have taken place.

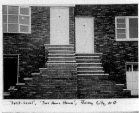
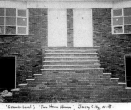

Dan GRAHAM

Homes for America

1966-67

Colour and black and white photographs, texts

2 panels, 101.5 × 84.5 cm [40 × 33.5 in] each

1970 revised version of the artist's original paste-up for

Arts Magazine, New York

Graham's essay 'Homes for America', describing new large-scale, suburban housing projects, is laid out on a double-page spread. It is illustrated with his Kodak Instamatic snapshots, which document such projects in New Jersey. The essay describes the methodology of domestic construction in terms similar to those used to describe the work of his contemporaries such as Sol LeWitt, whose work he had shown in a short-lived New York gallery just previously. The houses form repeated geometric patterns, like serial units of minimalist sculpture, which Graham designates 'serial logic'.

On first publication, in *Arts Magazine* (December 1966/January 1967), the editors substituted Graham's photos with a cropped print of a Walker Evans photograph. With this project, Graham began his engagement with vernacular architecture and the popular cultures and subcultures outside the gallery system.

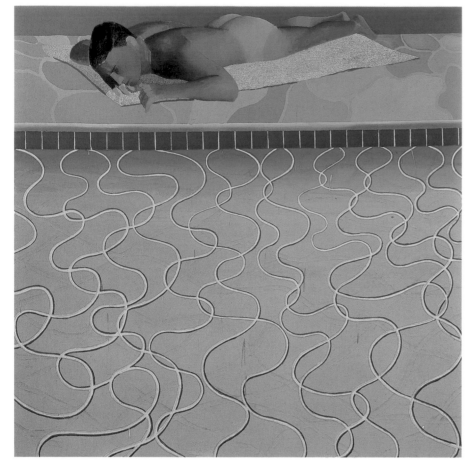

David <u>HOCKNEY</u>
Sunbather
1966
Acrylic on canvas
183 × 183 cm [72 × 72 in]
Collection, Museum Ludwig, Cologne

In *Sunbather* and related works, Hockney combines his simplified realism of depiction with features derived from modernist abstraction, such as the wavy lines signifying the pool's reflection of sunlight. Those traditional subjects of painters, bathers and reclining nudes, are here updated in several ways: they are contemporary Californian men; they are openly gay, representing the newly assertive visibility of the West Coast scene; and like their surroundings they glow with the bright hues Hockney obtained by switching from oils to synthetic polymer paints.

opposite
Malcolm <u>MORLEY</u>
Coronation and Beach Scene
1968
Acrylic on canvas
228 × 228 cm [90 × 90 in]
Collection, Hirshhorn Museum and Sculpture Garden, Smithsonian Institution, Washington, D.C.

This scene of holidaymakers at a beach café, contrasted with the pomp of Queen Elizabeth II's coronation, is founded on a lineage of subjects that Morley was exploring during the mid 1960s. The coupling of moneyed decadence with aristocratic celebrations of continued rule highlights new and old caste systems. His preoccupation with the decadent leisure class had emerged in his previous paintings of cruise liners seen from afar followed by compositions that zoomed in to close-ups of the passengers' activities on deck. This work scrutinizes social details through the generic postcard images that the artist collected. The sense of removal from his subject came from Morley's own English working-class upbringing and exile in America. His brand of Photorealism, self-dubbed 'Super-realism', came from a meticulous translation of the image on to canvas. By sectioning the postcard with a grid, Morley would render each square individually, disregarding any hierarchy of parts, as if each component were an image in itself.

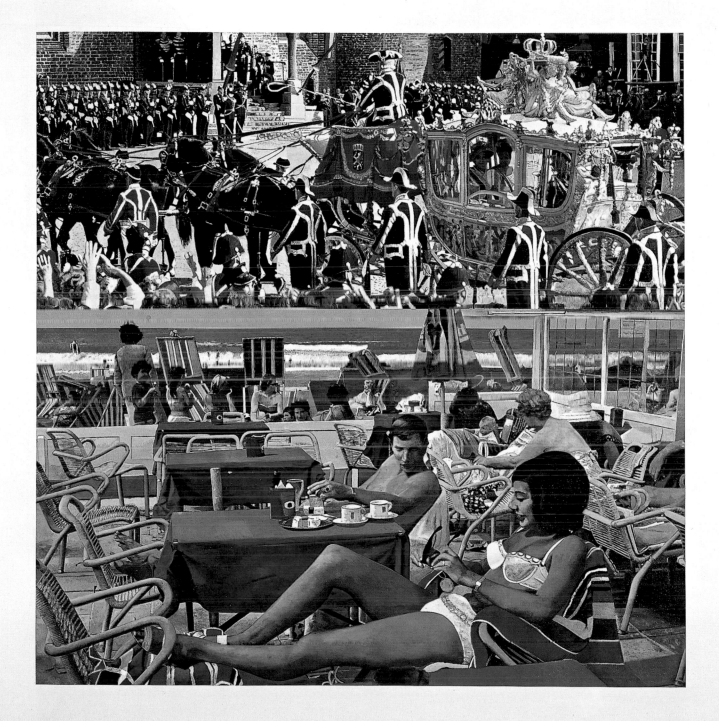

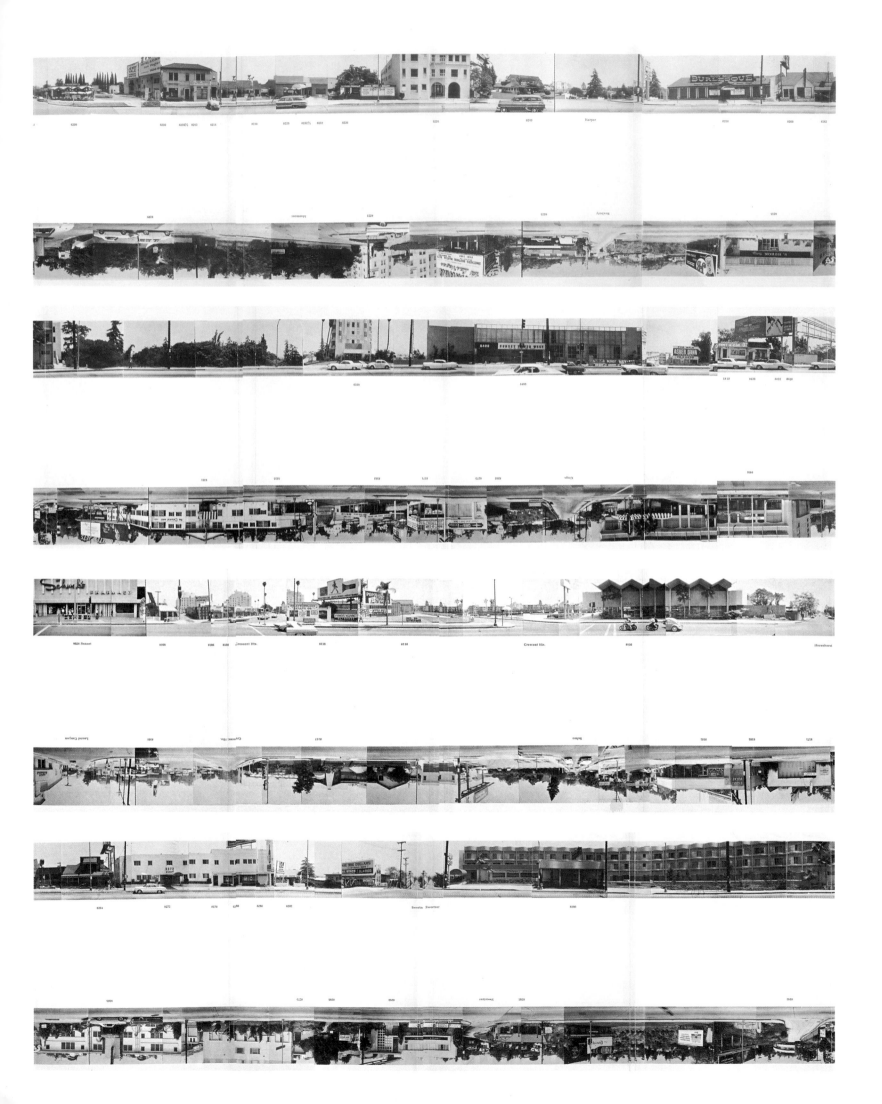

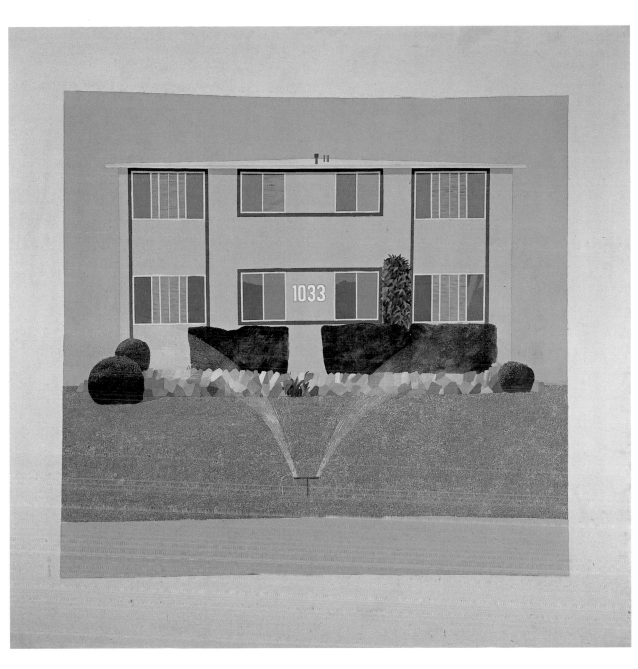

David HOCKNEY
Neat Lawn
1967
Acrylic on canvas
244 × 244 cm [96 × 96 in]

Hockney first visited Los Angeles for an extended period in 1964, returning there in the summer of 1966 for a year. After 1961 he no longer considered himself a Pop artist according to the criteria of early Pop but his Californian paintings connect with the expansion of Pop imagery by contemporaries such as Ed Ruscha and Malcolm Morley. Like Morley, Hockney draws on postcard and brochure styles of depiction as one of his many sources, and like Ruscha he focuses on the contemporary vernacular setting of Los Angeles suburban life – the neat modern architecture and manicured grounds, the ubiquitous palm trees and private swimming pools. *Neat Lawn* exemplifies the cool exoticism this environment represented to the northern English artist.

opposite
Ed RUSCHA
Every Building on the Sunset Strip
1966
Artist's book, offset litho, black and white photographs, text, accordion folded and glued, softbound
18 × 14.5 cm [7 × 5.5 in] closed, 761 cm [299.5 in] extended

Ruscha produced his first artist's book, *Twentysix Gasoline Stations*, in 1963, a meticulously produced but cheap, widely available edition comprising photographs taken along Route 66 between Los Angeles and Oklahoma City. In *Every Building on the Sunset Strip* Ruscha again explored the long, open highway and a dead-pan, serial use of images. Unstaged, the photographs have a documentary feel, presenting the street as a kind of readymade. The buildings are seemingly bland but reveal the conformity and rigid design systems of the environment. By the mid 1960s increased car ownership in America had led to expanded housing developments, freeway systems, billboards, drive-in movies, drive-in diners and even drive-in churches. Ruscha's viewpoint is from the road: he took the photographs using a motorized Nikon camera mounted on the back of a pickup truck. The concertina-folded book opens out to a 7.6 m (25 ft) strip of photographs. Each building is identified by its street number. The south side of the street from east to west runs along the top of the pages; the buildings on the opposite side of the street are printed facing the buildings across the street as they did in actuality.

Bruce CONNER
REPORT
1963-67
16mm film, 13 min., black and white, sound

These are the final images of the film. The word 'sell', prominent on the keyboard, puts the events and images in the context of a myth the viewer 'buys into'. Conner started work on the film in the immediate aftermath of Kennedy's assassination. The film deals with the media's reaction to the incident and its absorption into cultural consciousness. The soundtrack is composed of newsreaders and police radio operators reacting to the attack as it happened, in aural loops – the shooting itself is not shown. Conner collated newsreel, archival footage and his own shots. He also used intercut sequences of stroboscopic black and white frames. 'Whenever you look at any black and white or almost any contrasting image, a certain amount of that impression is kept on the retina of the eyeball' (interviewed by Peter Boswell, 11 February 1986). He was interested in this 'persistence of vision' and in the reduction of events to iconic images. Conner's use of rapid editing, inter-cutting and repeated images was intended to induce in the viewer a sense of uneasy déjà vu. These disruptions also highlighted the narrative nature of accepted film norms.

Jean-Luc GODARD
Pierrot le fou
Pierrot the Mad
1965
35mm film, 110 min., colour, sound
With Anna Karina

In *Pierrot le fou* (1965), Godard began to embark on a radical blurring of distinctions between narrative and the cinematic essay. While this was anticipated in his earlier films, they maintained a surface illusion of plot and various features of narrative construction. These were now more overtly abandoned. The characters address the audience directly. In front of a group of American sailors they improvise a Brechtian performance on the topics of Hollywood and Vietnam. Their statements and actions are interspersed with static frames showing details of advertisements, paintings or entries in journals. From this point onwards, Godard's methodology as a filmmaker moves towards Marxist social critique, particularly in *La Chinoise* (1967), centred on a group of Maoist students in Paris, which anticipates the events of 1968.

The biker epic *The Wild Angels* was
inspired by a photograph of the funeral
of Mother Miles, head of the Hell's Angels
in Sacramento, California, that was
published in *Life* magazine. Corman
takes up the case of a gang of Hell's
Angels (actual members were used
as extras) as they go on a rampage.
The film's plot is an updated Western.
Heavenly Blues (Fonda) attempts to bury
his friend Loser (Bruce Dern), who has
been shot dead by police. The town's
locals object. Realistic violence follows,
which, together with the film's depictions
of drug use and nihilism, shocked
contemporary audiences and censors.

Kenneth ANGER
Kustom Kar Kommandos
1965
16mm film, 3 min., colour, sound
With Sandy Trent

Kustom Kar Kommandos is a fragment
of an abandoned project, from which
Anger's original, comprehensive notes
survive. He made this small segment
(a single scene) as a showreel to try to
raise funds to complete his envisaged
thirty-minute film. Anger applied similar
formal techniques to those seen in his
earlier film about bikers, *Scorpio Rising*
(1964), to the theme of customization and
hot-rod fetishes among Californian
teenagers. A young man wearing tight
jeans polishes his car with a giant
powder puff, manipulates the gears and
cleans the chassis. The rock 'n' roll song
'Dream Lover' by the Parris Sisters is
played on a repeating loop.

Clive BARKER
Splash
1967
Chrome-plated steel, chrome-plated brass and painted wood
86.5 × 38 × 35.5 cm [34 × 15 × 14 in]
Collection, Tate, London

Originally a painter, from 1962 onwards the British artist Barker focused on making sculptures that further developed the dialogue between representation, replication and real objects initiated by Jasper Johns and Jim Dine. Starting with media such as leather and zips, by 1965 he had focused on the use of metals such as bronze, brass and steel, usually combined with various finishes such as chrome or gold plating. Between 1966 and 1968 he fabricated the wide range of three-dimensional objects that mark the high point of his Pop period. These included replicas of artists' palettes and boxes of paints, cigars, displays of sweets, the chair of Vincent Van Gogh, splashes and droplets of water falling into a bucket, and Coca-Cola bottles, presented singly or in groups. Barker's primary interest was in the contrast between materiality, solid and liquid, and the effects of his highly reflective surfaces. *Splash* conflates various preoccupations of art in the late 1960s: it is 'photorealistic' but monochrome and reflective; it draws on the ideas of both the readymade found object and the industrially fabricated 'specific object' of Minimalism, yet it enacts a literal demonstration of traditional representational values.

opposite
Paul THEK
Meat Piece with Brillo Box
1964-65
Silkscreen ink and household paint on plywood, beeswax and Plexiglas
43 × 43 × 35.5 cm [17 × 17 × 14 in]
Collection, Philadelphia Museum of Art
From the series *Technological Reliquaries*, 1964-67

Thek acquired one of Warhol's *Brillo Boxes*. He removed its blank bottom face and inserted one of his beeswax sculptures inside. 'Gazing into the Plexiglas bottom of the case, we are appalled. The motifs of the mouth with tongue and the television as framing device have shifted to three dimensions In order to mount a full-scale attack on consumer culture. "No ideas but in things", Warhol implied. "No ideas but in flesh", Thek countered. In the *Technological Reliquaries* series, to which this piece belongs, elaborate containers, often of coloured plastic, house lumps of what resemble raw meat. The choice of the *Brillo Box* was deliberate. Yet though Thek had visited the Factory and met Warhol, there can be little doubt that he meant this as a reproach, not only on Warhol himself but also on his particular interpretation of Pop ...
– Stuart Morgan, 'The Man Who Couldn't Get Up', *frieze*, 24, 1995

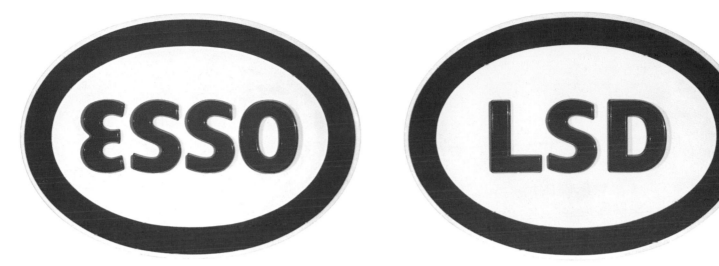

above

Öyvind FAHLSTRÖM

ESSO-LSD

1967

Plastic signs

2 panels, 89 × 127 × 15 cm [35 × 50 × 6 in] each, hung 30 cm
[12 in] apart

Edition of 5, manufactured by B. Nässil & Co. AB Skyltfabrik,
Sundbyberg, Sweden

Collection, IVAM: Instituto Valenciano de Arte Moderno, Valencia

Consistency of style, form and materials were irrelevant to Fahlström, nevertheless these paired fabricated plastic signs are distinct from his other work of the period. The left-hand component of *ESSO-LSD* is an exact replica of an existing sign for the petroleum company. Its counterpart on the right, however, has been colonized, as it were, by the acronym for the psychotropic drug. The viewer is provoked to reflect on the possible associations of these words, the combination of which is as striking as Robert Indiana's *EAT/DIE* (1962). Like Indiana, Fahlström began as a poet, but of a different kind: he pioneered concrete poetry in the early 1950s. *ESSO-LSD* draws on those precedents as well as Duchamp's readymades and word play. Fahlström's first experience with LSD in 1967 had proved a turning point. In texts such as the manifesto *Take Care of the World* (1966) he proposed alternative models of society in which new, 'good' forms of consciousness-expanding drugs would contribute to 'greater sensory experiences and ego-insight'.

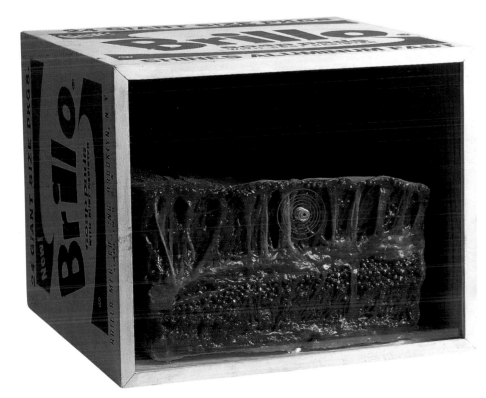

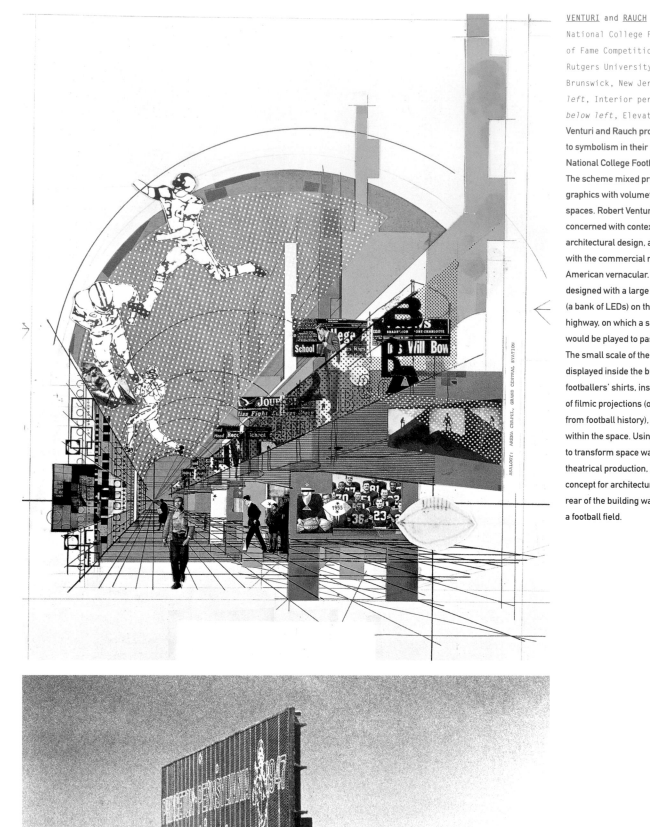

ANALOGY: ARENA CHAPEL, GRAND CENTRAL STATION

National College Football Hall
of Fame Competition
Rutgers University, New
Brunswick, New Jersey, 1967
left, Interior perspective
below left, Elevation model

Venturi and Rauch proposed a return
to symbolism in their design for the
National College Football Hall of Fame.
The scheme mixed projections and
graphics with volumetric architectural
spaces. Robert Venturi in particular was
concerned with context and meaning in
architectural design, and engagement
with the commercial realities of the
American vernacular. The exterior was
designed with a large 'Bill-Ding-Board'
(a bank of LEDs) on the side facing the
highway, on which a sequence of images
would be played to passing motorists.
The small scale of the objects to be
displayed inside the building, such as
footballers' shirts, inspired the idea
of filmic projections (of great moments
from football history), creating volume
within the space. Using light and pictures
to transform space was a staple of
theatrical production, but a relatively new
concept for architecture. A grandstand
rear of the building was to overlook
a football field.

Charles MOORE
Moore House
1966
New Haven, Connecticut

Moore moved to New Haven in 1965 after being named head of the Yale Architectural School. He was highly criticized for his eccentric designs, which parodied the formal elements of classical architecture, turning functional logic into decoration and mannerism. His assimilation of styles established the early notions of Postmodernism in the field. The renovation of this two-storey, nineteenth-century wooden house was a challenge of restructuring within limited spatial dimensions. After gutting the interior and creating a unified space, Moore designed three modest towers for bedrooms, added layers of circular plywood as connective divides and coated the entirety in apple green and lemon yellow. His interior design ran in tandem with his architectural convictions. One bedroom ensemble is entered through door panels perforated by large numbers. The walls and ceiling are adorned with white stars on a blue ground, leading up to a hemispherical recession in the ceiling, painted to suggest the cupola of the US Capitol.

ARCHIZOOM [Andrea Branzi, Gilberto Corretti, Massimo Morozzi]
and SUPERSTUDIO [Adolfo Natalini]
View of 'Superarchittetura' exhibition, Galleria Jolly 2, Pistoia,
Italy, December 1966

This exhibition introduced the radical approaches of Archizoom Associates and Superstudio, bringing the Pop sensibilities of consumer culture to the wider dialogue of architecture and urban theory. 'Superarchitecture' was based on the logic, rate and scale of modern-day consumption and production. The word 'super' carried associations of quality and possibility, ranging from Superman to the supermarket, in this case expressed in an ultra-baroque illustration of potential directions for planning. They considered the orthodox architect's role as an urban problem-solver to be too focused on serving an individual's experience within a codified environment. Through the elimination of the functional building, Archizoom and Superstudio put their efforts into a progressive master plan, updating the means of engagement to serve contemporary living standards. For these two groups, the exhibition was a way to sever ties with the past and signal the end of modernist architecture.

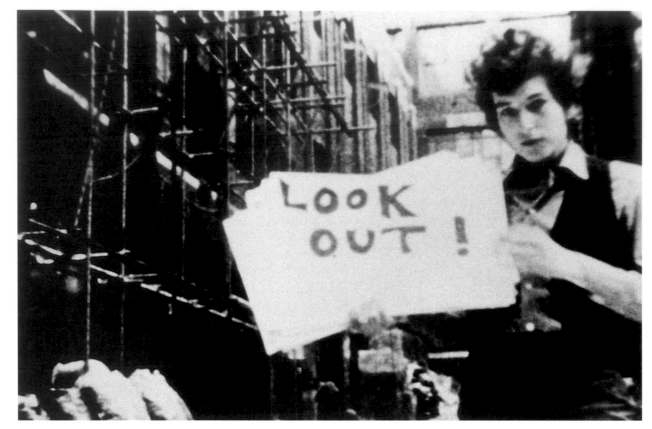

D.A. PENNEBAKER
Don't Look Back
1967
35mm film, 90 min., black and
white, sound
With Bob Dylan

In this sequence from Pennebaker's film, the singer Bob Dylan holds up cards with the lyrics of his 'Subterranean Homesick Blues' as they are simultaneously heard on the soundtrack. *Don't Look Back* was a portrait of Dylan filmed during his tour of Britain in 1965, and Pennebaker's first sustained exercise in what he called Direct Cinema. This movement, which he co-founded with Richard Leacock and Albert Maysles, allowed the subjects of documentary films to speak for themselves. Voice-over narration was avoided, and sound was held to be as important as the image. These goals were aided by the development of lightweight, professional-quality 16mm equipment during this period.

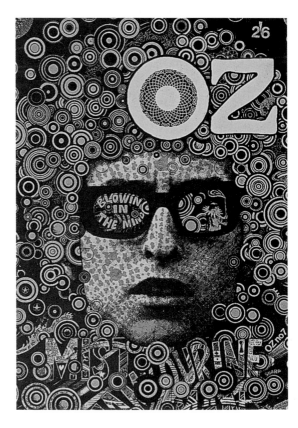

Martin SHARP
'Blowing in the Mind' cover of *Oz* magazine
1967
Offset litho magazine cover reproduction of original silkscreen print

Martin Sharp came to London from Sydney, Australia to work on the underground magazine *Oz*. Psychedelic images he designed as posters were also adapted, as here, for use on the magazine's covers. A friend of musicians such as Eric Clapton, he became an influential designer of record album covers and concert posters.
The original graphic *Blowing in the Mind* was created for Bob Dylan's record *Mister Tambourine Man*. Dylan's hair is represented by bubbling circles that disperse into the environment as a literal echoing of the song's hallucinogenic references.
Psychedelic graphics became a widespread artform in the late 1960s. Other notable artists include Rick Griffin, John Van Hammersveld, Alton Kelley, Victor Moscoso, Stanley Mouse and Wes Wilson.

Gérard JOANNÈS
Poster announcing the publication of *L'Internationale
Situationniste*, 11
1967
Offset litho printed drawing on paper
53 × 33 cm [21 × 13 in]

In 1962 the original artist members of the Situationist International had been excluded by the group in Paris, dominated by Guy Debord, Raoul Vaneigem and Michèle Bernstein, who developed it into a political organization. For them there was no situationist art, only situationist uses of art. In 1967 Vaneigem published *The Revolution of Everyday Life* to present the SI's theories to a mass audience. He collaborated with graphic artists such as Joannès, who appropriated the style of comic strips to achieve the same objectives. A further context for this poster was the collaboration in 1966 between the SI and a student union at the University of Strasbourg on a critique published as a pamphlet: 'The Poverty of Student Life'. This called for a revolt by students similar to those that had taken place at Berkeley, California, and elsewhere, and was the trigger for the 1968 student revolution in which the Situationists played a leading role.

Peter BLAKE with Jann Haworth and Michael Cooper
The Beatles: Sergeant Pepper's Lonely Hearts Club Band
1967
Assemblage and photomontage photographed and printed as colour offset
litho album cover

Blake and his collaborators, including his wife, the artist Jann Haworth, created a nostalgic montage of images of twentieth-century icons from literature, politics, Hollywood cinema and Pop music, and the band's own early 1960s incarnation in identical tailored suits stipulated by their first manager, Brian Epstein. At the centre, they have been reincarnated and even renamed in what would become the most influential 'concept album'. Outmoded, imperial-looking uniforms are transformed into other-wordly costumes, placing the band in their own self-defined realm, evoking the mystical and psychedelic transcendence that is the subject of many of the lyrics.

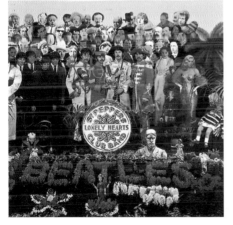

Robert CRUMB
Cover of *Zap Comix* No. 0
1968-69
Drawing printed as colour offset litho comic-book cover

After Crumb's *Zap Comix* was launched in the winter of 1968–69, Öyvind Fahlström wrote of him: 'You could say that he makes Pop art in the true sense of the word: art for the people, popular art' (*Dagens Nyheter*, 5 October 1969). One of his cartoons inspired Fahlström's 1969 installation *Meatball Curtain (for R. Crumb)*. Crumb had originally been discovered by the MAD magazine cartoonist Harvey Kurtzman in the late 1950s. With the launch of *Zap Comix* this underground tradition emerged in an influential new form: alternative magazines, posters and books produced directly by counter-cultural artists.

HELTER SKELTER

After the euphoria and fantasies of revolution that marked the high point of the 1960s, the year of 1968 offered a sharp rebuke. The events of May 1968 in Paris, Prague and elsewhere showed that the aspirations of students and workers could be ignited into action and provoke the authorities into violent suppression. Cultural and societal changes were reflected in the very title of Richard Hamilton's painting *Swingeing London*, a defining image which brought together the hedonistic worlds of art and popular music, incarcerated by the establishment. Andy Warhol was, by contrast, shot by a disaffected acolyte. The resulting paradoxes and inversions were acutely imagined in the films *Performance* and *Zabriskie Point*, which reflected the immediate futility of revolutionary action and the sterility of psychedelia. The Manson family's grotesque interpretation of the Beatles' 'White Album' was only symptomatic of the hiatus reached by the end of the decade.

opposite

Robert VENTURI, Denise SCOTT BROWN, Steven IZENOUR
Photographs of Las Vegas from 1965-66, first published in *Learning from Las Vegas*, MIT Press, Cambridge, Massachusetts, 1972
These phototgraphs echo Edward Ruscha's images of gas stations and roadside architecture, documenting the existing urban environment. Venturi, Scott Brown and Izenour's approach to architecture suggested the incorporation of elements from vernacular American style into building design. In *Learning from Las Vegas* they challenged the prevailing modernist aesthetic by presenting commercial roadside buildings and signage as inspiration for a new, symbolic architecture. Venturi responded to Mies van der Rohe's dictum 'less is more' with 'less is a bore'. The group encouraged a consideration of the practical realities of people's lives in architectural design. Scott Brown's essay 'Learning from Pop' (*Casabella*, December 1971) argued for the importance of such buildings as supermarkets and hot dog stands in informing future planning.

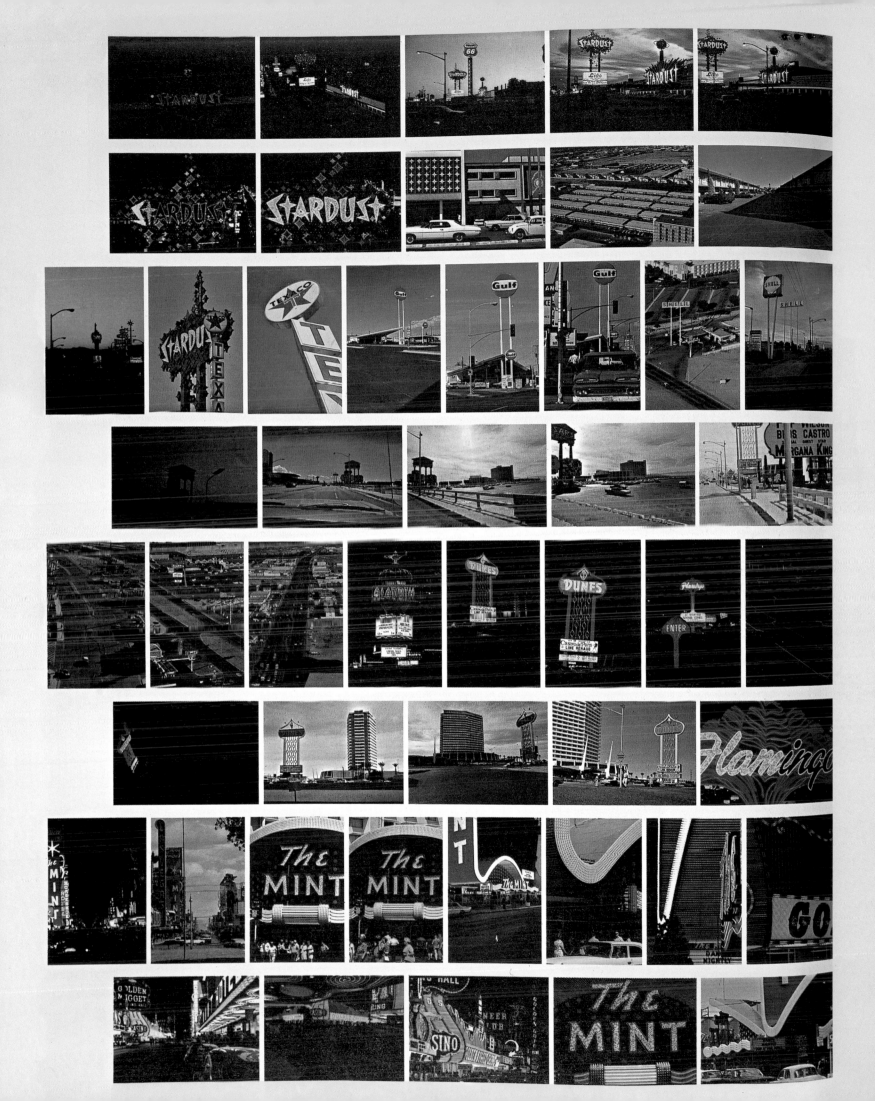

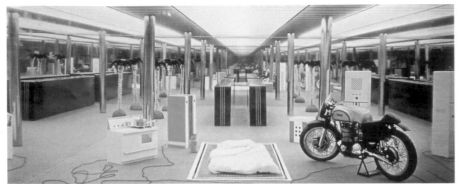

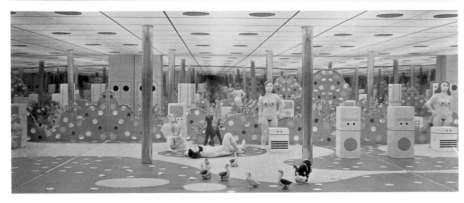

ARCHIZOOM [Andrea Branzi, Gilberto Corretti, Paolo Deganello,
Massimo Morozzi, Lucia and Dario Bartolini]
No Stop City, No Stop Theatre, Monomorphic Quarter, Internal
Landscape [details]
1968-70
Maquettes; wood, metal, board, paper, tempera, acrylic and mirrors,
with internal lighting
Collection, Centro Studi e Archivio della Communicazione,
Universita di Parma

Archizoom's *No Stop City* was a pointed comment on city planning and development. The project produced designs emphasizing dystopian possibilities. A single, unified and infinite building was shown divided into functional zones for daily behaviours including dwelling and work, leisure and consumption, removing the need for designated functional structures such as the home or office. The models were filled with representative goods for each theme and lined with mirrors, so that the viewer saw an endless repetition. This vision of an unending metropolis integrated all buildings into a single superstructure, implying infinite desire and consumption. According to Andrea Branzi, the group was inspired by repeated imagery in the work of Andy Warhol, and the music of Philip Glass and Brian Eno.

John LENNON
'You Are Here' exhibition, Robert Fraser Gallery, London, July 1968
Installation view showing charity collection boxes

Lennon and Yoko Ono, both artists as well as Pop musicians, released 365 helium balloons into the London air to begin this show. Each balloon contained a tag bearing the message 'You are here' and a request to be mailed back to the Robert Fraser Gallery with a return address. This conceptual use of language pinpointed individuals in space and time, extending the exhibition to each of their locations simultaneously. The gesture was echoed in the gallery by a display of the same text on a large circular screen and again on small buttons that visitors could take away. A collection of found charity boxes, with styles varying from homemade to mass-produced, was installed in a separate space. Towards the rear of the gallery, on a pair of plinths, was a hat bearing the text 'For the artist. Thank you.' and a jar of buttons, signalling Lennon's own appeal for alms.

opposite
Richard HAMILTON
Swingeing London 67
1968
Photo-offset lithograph poster on paper
70.5 × 50 cm [28 × 20 in]

In February 1967 Mick Jagger of the Rolling Stones and the art dealer Robert Fraser were arrested for possession of cannabis and other drugs. Fraser was given a six-month sentence and Jagger was conditionally discharged on appeal. Hamilton, who was represented by Fraser, responded to the event with this poster and a series of six mixed-media paintings of which the first is shown overleaf. From newspaper cuttings he selected the material in this collage, reproduced as a photo-offset lithograph and published by an Italian distributor of art posters. The texts present many varied accounts of the incident and descriptive details about the protagonists, their actions, statements, appearance and lifestyles, with photos presented like evidence. The title puns ironically on *Time* magazine's portrayal of London in April 1966 as 'The Swinging City', a centre of liberated permissiveness, contrasted with a statement by the judge: 'There are times when a swingeing sentence can act as a deterrent.'

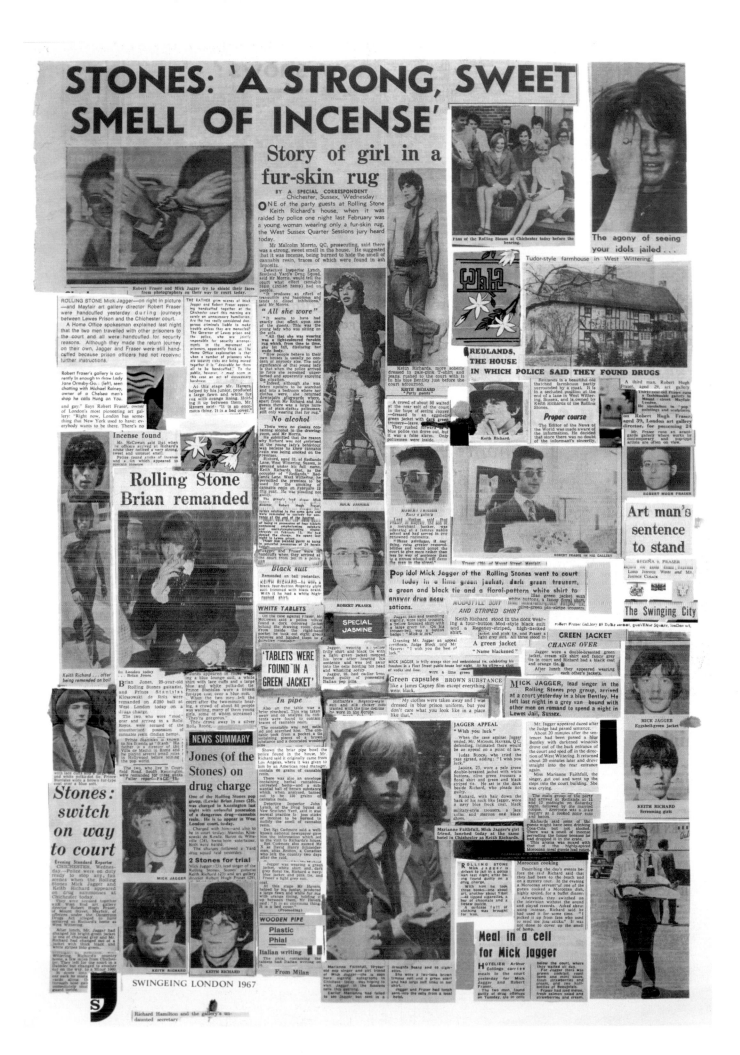

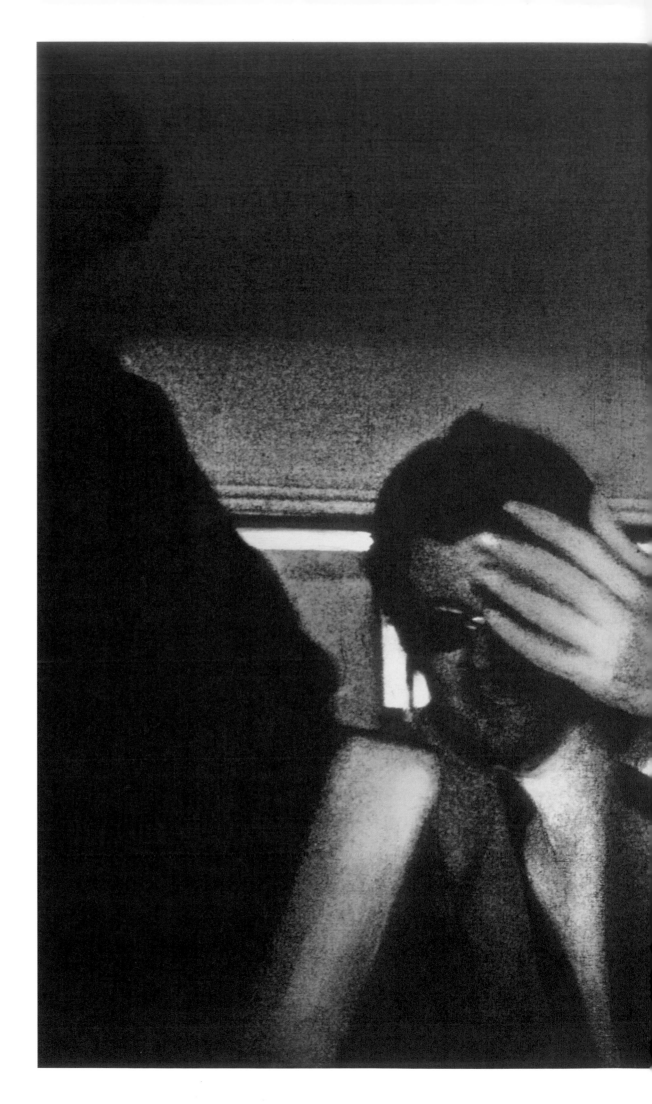

Richard HAMILTON
Swingeing London 67 [a]
1968-69
Silkscreen and oil on canvas
67 × 85 cm [26.5 × 33.5 in]

The source for this painting, the first in a series of six varied treatments of the same image, was the press photograph reproduced at the top left of the *Swingeing London 67* poster shown on the preceding page. Charged with cannabis possession, Mick Jagger and the gallery owner Robert Fraser are handcuffed together inside a police vehicle, stretching out their restrained hands in front of their faces in the glare of photographers' flashbulbs. Hamilton obtained the original photograph from the *Daily Mail*. It was enlarged and retouched to remove the outside of the police vehicle and extend the interior. The resultant image was then silk-screened in black over a coloured oil painting of the same subject. The indeterminacy of this process led Hamilton to experiment with six variations. In version (a) the painting underneath the screenprint is the most developed and self-sufficient of the series. In the others he experimented with various media, techniques and effects, such as airbrushing, replacing oils with enamel or acrylic, and increasing or reducing contrast or light and shade.

Jean Luc GODARD
One Plus One
1968
35mm film, 99 min., colour, sound
top, Keith Richard rehearsing with the Rolling Stones
below, Junkyard scene

Approached by the English producer Eleni Collard in 1968 to make a film in London, Godard originally devised a narrative scheme in which a French girl, named Eve Democracy, is seduced by a neo-fascist white Texan, then falls in love with an extreme-left Black militant. The ensuing conflicts would be framed by parallel themes of 'creation', reflected by the Rolling Stones rehearsing in their studio, and 'destruction': Eve's suicide. The more developed structure of the final film analyses the relationships between democracy and revolution, art and exploitation, rhetoric and the power of the media. Intercut with documentary-style sequences, it comprises three fictional episodes. In the first, set in a car junkyard, militants based on the Black Panthers read aloud texts, largely from Eldridge Cleaver's novel *Soul on Ice* (1968) in which he attacked white bourgeois values, in particular the appropriation and exploitation of black music. In the second, Eve Democracy is interviewed by the media in a woodland area, only permitted to answer yes or no to questions about freedom and revolution. In the third, a pornographic magazine shop is the setting for a symbolic portrayal of links between fascism and forms of visual representation. These scenes are intercut with Eve writing graffiti and the Rolling Stones rehearsing the song 'Sympathy for the Devil' in their studio. In the original cut, the final performance of the song fades out midway and the screen also fades to black: the revolution remains unfinished. For commercial reasons, the distributors added the full recording. When this version of the film premiered at the London Film Festival in November 1968 Godard attacked the producer and asked the audience to demand their money back.

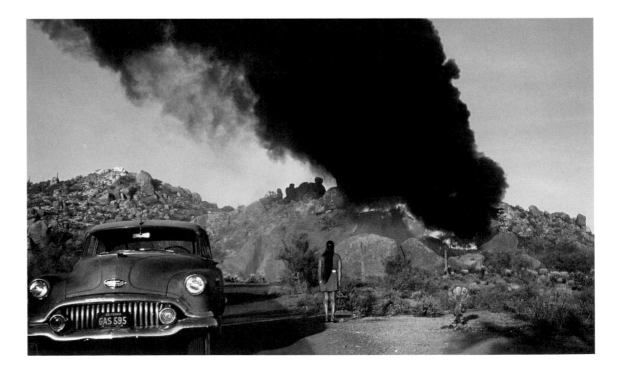

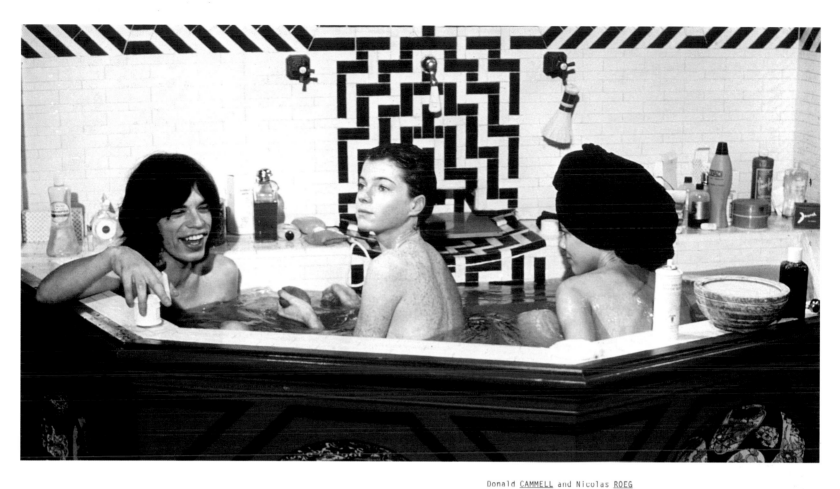

Donald CAMMELL and Nicolas ROEG
Performance
1968-69
35mm film, 96 min., colour, sound
With James Fox, Mick Jagger, Anita Pallenberg

Filmed in 1968 but not released until 1970, *Performance* brought two underworlds of 1960s London into collision. The narrative is divided into two distinct parts, an exposé of the ultraviolent gangland of London's East End, followed by the drug-fuelled counter-culture of 1960s bohemia. The main character, Chas Devlin (played by James Fox), is forced into hiding after his violent lifestyle becomes threatening. In order to escape certain peril, he must change his identity and seek refuge in a Notting Hill apartment owned by an effete rock star, Turner (played by Jagger). With Nicolas Roeg's careful editing and camera techniques, the film dissolves into a coloured tableau infused with sex and drugs, an evocation of the characters' intoxicated states. Throughout the film, Chas is continually confronted with the question of his own identity and a notion that he is always performing. Turner faces the same questions and the film eludes a definite resolution, choosing instead role reversals between the two, making each the other's doppelgänger.

opposite

Michelangelo ANTONIONI
Zabriskie Point
1969
35mm film, 110 min., colour, sound

Ironically funded by MGM studios who wished to cash in on counter-cultural youth, *Zabriskie Point* metaphorically portrayed late 1960s America, and by extension advanced industrial society, at war with itself. A white male student involved in college campus protests in Los Angeles buys a gun and fires in retaliation at the police when he sees a black student being shot. To escape capture he steals a small plane and flies to Death Valley, where he encounters another lone figure: a young woman driving around the desert in a 1950s car. From the outpost Zabriskie Point they venture to the heart of the desert, consummating their relationship in a hallucinatory, mirage-like scene, surrounded by scores of other similar couples. They paint the plane with psychedelic patterns and slogans and he flies back to LA. She returns to her employer, a property tycoon with a 'model home' overlooking the desert, who intends to build over the indigenous peoples' land. When she hears that the student was shot dead by police as he landed, she gazes towards the clifftop building and vengefully imagines it exploding in flames. The explosion is repeated again and again, first as a distant shot of the structure igniting, then moving in closer and closer to the details of shattered mass-produced items floating in the sky, accompanied by a Pink Floyd soundtrack. This climactic scene has become emblematic of anti-consumerism.

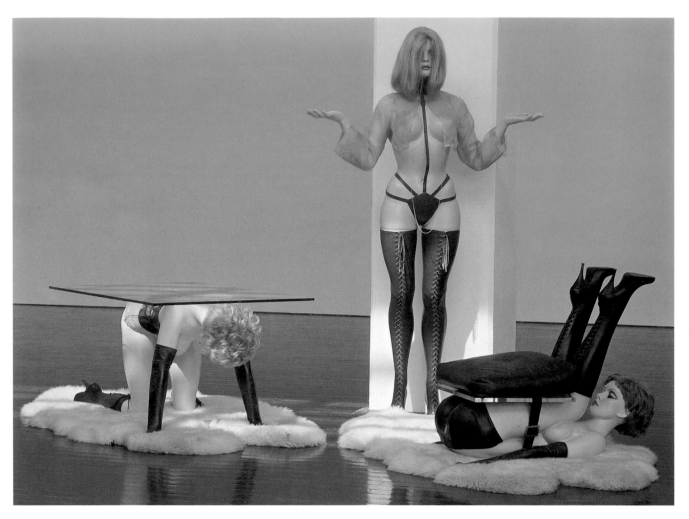

Allen JONES
Table, Hat Stand and Chair
1969
Painted fibreglass, metal, glass, leather, hair, synthetic fibre rugs
Table, 61 x 145 x 84 cm [24 x 57 x 33 in], Hat Stand, 185 x 107 x 30 cm
[73 x 42 x 12 in], Chair, 84 x 108 x 84 cm [33 x 42.5 x 33 in]
Collection, Ludwig Forum, Aachen

This ensemble of three slightly larger than lifesize figures, produced in an edition
of six, extended into three-dimensional forms the stylized and fetishistic portrayal
of women that was a principal subject in Jones's painting since the mid 1960s.
These sculptures of female figures in servile and abject positions (albeit laced with
a counter-inference of dominatrix-like irony) coincided with the rise of the second
wave of feminism in the late 1960s, engendering much debate and critique.
In subsequent statements and interviews Jones differentiated between condemning
the sculptures themselves and viewing them as a catalyst for debates about political
issues. His concern was to investigate forms of representation. One of the sources
for the imagery in these works is Roger Vadim's science fiction film *Barbarella* (1968),
an adaptation of a French S&M comic strip, in which the semi-naked Jane Fonda
inhabits futuristic environments of inflatable plastic and fur.

Duane HANSON
Riot [Policeman and Rioter]
1967
Painted fibreglass
Lifesize

The arrival of Hanson's highly realistic figure sculptures in the late 1960s aligned
him in the view of art commentators with the Photorealist painters who emerged
out of Pop during the early 1970s. As that decade progressed Hanson focused on
a meticulous, illusionistic portrayal of vernacular American scenes: the tourist
in a museum or the working woman pushing her supermarket trolley. The political
undercurrent is less immediately visible in these than in his earlier works such as
Riot (Policeman and Rioter) and *Bowery Derelicts* (1969). Hanson's deceptive realism
was achieved by departing from accepted sculptural materials and aesthetics.
The sculptures are made of synthetic substances such as fibreglass or polyvinyl
acetate and emulate the truth-to-life of figures in a waxworks museum.

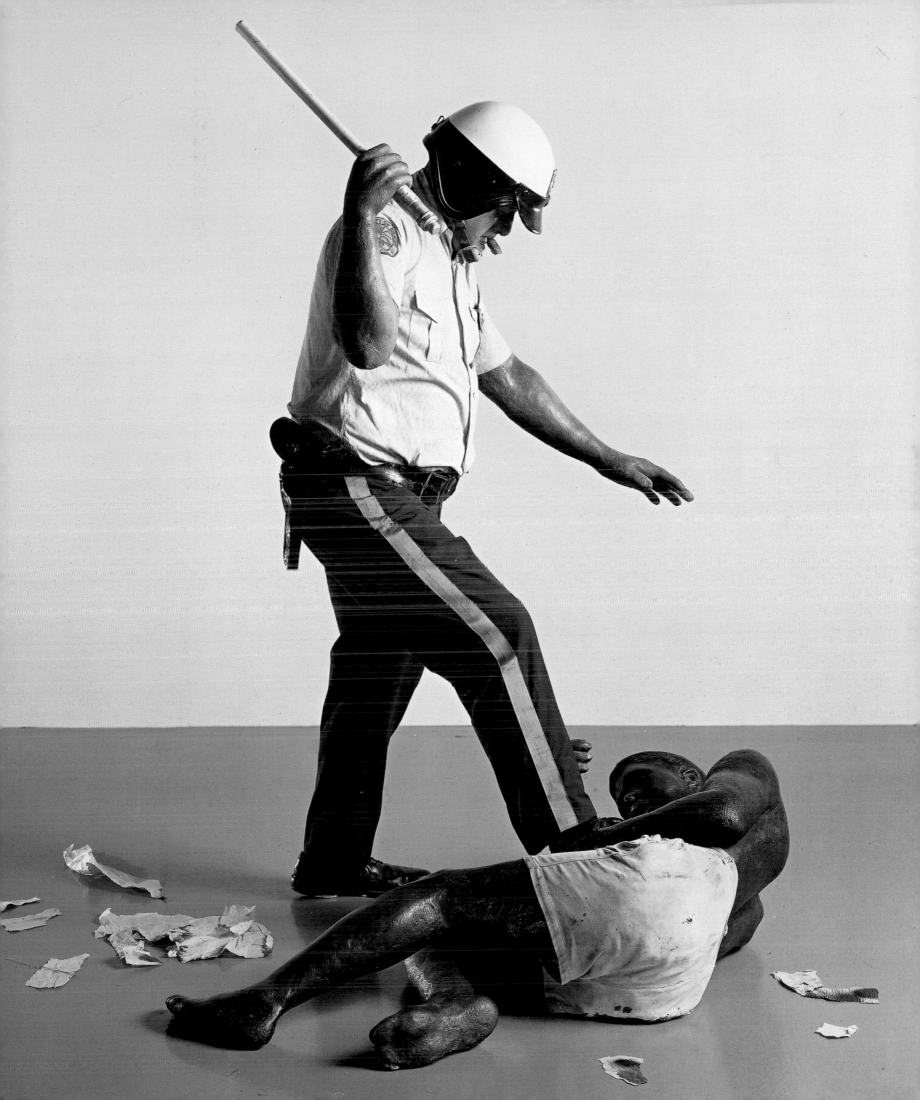

APPEN-
DICES

ARTISTS' BIOGRAPHIES

Ken **ADAM** [Klaus Adam, b. 1921, Berlin] emigrated to Britain in 1934. Trained as an architect, he began working for film studios in 1947, becoming an acclaimed art director who devised highly innovative sets for films such as the James Bond series from the early 1960s onwards, and Stanley Kubrick's *Dr Strangelove* [1964]. Retrospectives include Serpentine Gallery, London [1999].

Kenneth **ANGER** [Kenneth Wilbur Anglemyer, b. 1927, Santa Monica, California] was a founding figure in post-war American avant-garde cinema. In the late 1940s he developed an aesthetic based on the silent film era to convey fetishistic, ritual and occult messages via the iconography of popular culture, as suggested in the title of his 1959 book *Hollywood Babylon*. His films include *Fireworks* [1947], *Puce Moment* [1949], *Eaux d'Artifice* [1953], *Inauguration of the Pleasure Dome* [1954-66], *Scorpio Rising* [1963] and *Kustom Kar Kommandos* [1965].

Michelangelo **ANTONIONI** [b. 1912, Ferrara, d. 2007, Rome] began working in Rome in 1940 as a documentary filmmaker. In the 1960s he developed cinematic fictions in which narrative is displaced by enigmatic situations and visual effects which disrupt characters' and viewers' certainties about purposeful action and the representation of reality. His films include *L'Avventura* [*The Adventure*, 1960], *La Notte* [*The Night*, 1961], *L'Eclisse* [*The Eclipse*, 1962], *Il Deserto rosso* [*Red Desert*, 1964], *Blow-Up* [1966] and *Zabriskie Point* [1970].

Diane **ARBUS** [Diane Nemerov, b. 1923, New York; d. 1971, New York] was a documentary and magazine photographer based in New York, where she found most of her subjects during the 1950s and 1960s. These included marginalized groups, 'typical American citizens' and wealthy celebrities, all surveyed as intense personal encounters. Retrospectives include The Museum of Modern Art, New York [1971] and San Francisco Museum of Modern Art [2003].

Allan **D'ARCANGELO** [b. 1930, Buffalo, New York; d. 1998, New York] was a painter who in the early 1960s developed a hard-edge style with Pop affinities, portraying highway travel and road signs. Solo exhibitions include Thibaut Gallery, New York [1963]

and Neuberger Museum, State University of New York [1978].

ARCHIGRAM [Warren Chalk, 1927-88; Peter Cook, b. 1936; Dennis Crompton, b. 1933; David Greene, b. 1937; Ron Herron, 1930-94; Mike Webb, b. 1937] was the name chosen by these London-based architects to present their radical projects between 1961 and 1974. Their expanded concept of architecture included such projects as a Spray Plastic House, a Plug-in City, a Walking City and living pods and capsules. Exhibitions include 'Living City', Institute of Contemporary Arts, London [1964]. Retrospectives include Centre Georges Pompidou, Paris [1994].

ARCHIZOOM [architects Andrea Branzi, b. 1939; Gilberto Corretti, b. 1941; Paolo Deganello, b. 1940; Massimo Morozzi, b. 1941; joined in 1968 by designers Dario Bartolini, b. 1943 and Lucia Bartolini, b. 1944] were a Florence-based studio that worked under this name and with Superstudio, between 1966 and 1974. Initially influenced by Archigram, they devised radical projects for buildings, interiors and products. Exhibitions include 'Superarchittetura', Pistoia [1966] and Modena [1967] and 'Centre for Eclectic Conspiracy' at the Milan Triennale [1968].

ARMAN [Armand Fernandez, b. 1928, Nice; d. 2005, New York City], was based in New York since 1972 and met Yves Klein in 1948, collaborating with him during the 1950s. A founder-member of the Nouveaux Réalistes, in 1960 he began exhibiting *Poubelles* (transparent containers of garbage) and *Accumulations* (junk assemblages in cases). In later work he sliced, smashed and incinerated these materials. Solo exhibitions include 'Le Plein', Galerie Iris Clert [1960] and retrospective, Houston Museum of Fine Arts [1992].

Richard **ARTSCHWAGER** [b. 1924, Washington, D.C.] studied with the purist painter Amédée Ozenfant in New York in 1953, then became a furniture maker, gradually turning to art. From 1962 he has focused on grisaille paintings on Celotex, and objects, often made of such materials as formica. Solo exhibitions include Leo Castelli Gallery, New York [1965] and retrospectives, Whitney Museum of American Art, New York [1988] and Fondation Cartier pour l'art contemporain, Paris [1994].

David **BAILEY** [b. 1938, London] taught himself photography, 1948-53, by 1960 becoming a fashion photographer for *Vogue* magazine and *The Sunday Times*, the *Daily Telegraph*, and magazines such as *Elle* and *Glamour*. His *Box of Pin-ups* [1964] and *Goodbye Baby and Amen* [1969] are quintessential photographic documents of the Pop era. Retrospectives include Victoria & Albert Museum, London [1983] and Barbican Art Gallery, London [1999].

Clive **BARKER** [b. 1940, Luton, England] after art college worked in a car factory and then at a jewellery shop. He used production-line materials - leather and chrome-plated metal - in his earliest objects, from 1962. By the late 1960s he was making plated, reflective facsimiles of everyday items. Solo exhibitions include Robert Fraser Gallery, London [1968]; retrospectives include Whitford Fine Art, London [2003].

BEN [Ben Vautier, b. 1935, Naples] is based in Nice, where he first settled in 1949, opening a shop there in 1954 which he had transformed by the decade's end into a living artwork, after encountering the work of Duchamp and Daniel Spoerri. In 1962 he met George Maciunas and became a leading artist and theorist in the Fluxus movement. Retrospectives include Musée d'art moderne et contemporain, Nice [2001].

Billy Al **BENGSTON** [b. 1934, Dodge City, Kansas] radically changed his work after seeing reproductions of Jasper Johns's *Flag* and *Target* paintings. In California he adopted preconceived motifs such as hearts, chevrons and motorcycle logos. In the early 1960s he was widely exhibited as a 'West Coast Pop' painter. He was first exhibited at Ferus Gallery, Los Angeles, in 1958 and at Martha Jackson Gallery, New York, in 1962. Retrospectives include Contemporary Arts Museum, Houston [1988] and tour.

Wallace **BERMAN** [b. 1926, Staten Island, New York; d. 1976, Topanga Canyon, California] was a leading figure in the West Coast's 1950s Beat community, a pioneer of assemblage and mail art. From 1963 onwards he made verifax collages with images derived from diverse media sources. Retrospectives include University Art Museum, Berkeley, California [1979].

Peter **BLAKE** [b. 1932, Dartford, Kent] trained as a graphic artist before studying at the Royal College of Art [1953-56] after which he spent a year in Europe studying folk and popular art. From 1959 he developed a form of collage-derived painting, as well as collage works, incorporating popular iconography and ephemera. In 1967 he co-designed the cover for the Beatles' *Sgt. Pepper* album. Solo exhibitions include Portal Gallery, London [1962]. Retrospectives include Tate Gallery, London [1983] and Liverpool [2000].

Derek **BOSHIER** [b. 1937, Portsmouth, England] was briefly associated with Pop between 1959 and 1962, when he studied at the Royal College of Art with Hockney, Kitaj, Jones, Phillips and Caulfield. His paintings of the time portrayed American consumer products and symbols with an incisive, political engagement. Solo exhibitions include Robert Fraser Gallery, London [1965] and Whitechapel Art Gallery, London [1973].

Pauline **BOTY** [b. 1938, London; d. 1966, London] was the only woman painter in the British Pop art movement, introducing a female perspective into the Pop lexicon. A contemporary of Blake, Hockney, Boshier and others at the Royal College of Art, she was included in the BBC film *Pop Goes the Easel* [1962]. The first major retrospective of her work was at Whitford Fine Art and The Mayor Gallery, London [1998].

Mark **BOYLE** [b. 1934, Glasgow; d. 2005, London], his wife the artist Joan **HILLS** and later their children, collaborated on artworks as The Boyle Family. With Hills in the 1950s he conceived of a total form of art which would be an objective examination of reality. Their investigations led to the light and sound environments of the mid 1960s that initiated their collaborations with the band Soft Machine and Jimi Hendrix. Retrospectives include Hayward Gallery, London [1986] and Scottish National Gallery of Modern Art [2003].

George **BRECHT** [b. 1926, New York City; d. 2008, Cologne] studied in New York with John Cage in the late 1950s, becoming a founder-member and theorist of the Fluxus movement. As well as devising scores for 'events', he went on in the 1960s to make

assemblages of everyday objects. Solo exhibitions include Reuben Gallery, New York [1959] and retrospectives, Kunsthalle Bern [1978] and Ludwig Museum, Cologne [2005].

Marcel **BROODTHAERS** [b. 1924, Brussels; d. 1976, Cologne] first came into contact with Magritte in 1940. In the mid 1960s he progressed from poetry and critical writing to making actions, objects, images, films and installations that questioned the status of cultural media and institutions. Retrospectives include Galerie national du Jeu de Paume, Paris [1991] and tour.

R. **BUCKMINSTER FULLER** [b. 1895. Milton, Massachusetts; d. 1983, Los Angeles] was a mathematician, engineer, futuristic architect and utopian thinker who developed the concepts of 'tensegrity' and 'synergetics' in the dymaxion car and house [mid 1930s], the geodesic dome [patented in 1954] and floating cities [late 1960s]. These self-sustaining, ecologically economical structures use the most advanced technology.

Rudy **BURCKHARDT** [Rudolph Burckhardt, b. 1914, Basel; d. 1999, Maine] was a photographer, filmmaker and painter. His photographs of streets, storefronts and signs [c.1939-59] foreshadowed the work of artists such as Ed Ruscha. In the 1960s he associated with Pop artists such as James Rosenquist, photographing their work. His first photography retrospective was held at IVAM, Valencia, in 1998.

Donald **CAMMELL** [b. 1934, Edinburgh; d. 1996, Hollywood] and the cinematographer Nicolas **ROEG** [b. 1928, London] collaborated as co-directors on *Performance* [1968] starring Mick Jagger, James Fox and Anita Pallenberg. Cammell wrote the screenplay for *The Touchables* [1968], in which a male Pop star languishes in a clear plastic dome designed by Arthur Quarmby. Cammell combined study of avant-garde filmmakers such as Kenneth Anger with a home-movie approach to produce a document of self-destructiveness at the end of the 1960s.

Patrick **CAULFIELD** [b. 1936, London; d. 2005, London] studied at the Royal College of Art [1960-63] and until 1965 used household enamel paints on hardboard for his hard-edge outline paintings of mundane objects. He disavowed a Pop connection, aligning his work with Gris, Léger and Magritte, and moving on to traditional subjects - interiors, landscape and still life. Solo exhibitions include Robert Fraser Gallery, London [1965] and retrospectives, Tate Gallery, London [1981] and Hayward Gallery, London [1999].

CÉSAR [César Baldaccini, b. 1921, Marseille; d. 1998, Paris] was a sculptor who in 1958 began to produce *Compressions* of scrap iron, from 1960 directing compression of cars with a hydraulic press and participating in Nouveau Réalisme events. In 1967 he began making *Expansions* - poured coloured polyurethane fluid that rapidly expanded and solidified.. Solo exhibitions include Galerie Lucien Durand, Paris [1954] and retrospective, Galerie national du Jeu de Paume, Paris [1997].

John **CHAMBERLAIN** [b. 1927, Rochester, Indiana] studied at Black Mountain College [1955-56] where he encountered the ideas of John Cage and others. From 1958, in New York, he made welded assemblages of scrap metal, by the early 1960s using compressed car body parts. In the mid 1960s he experimented with plastics and car lacquer. Solo exhibitions include retrospective, The Museum of Contemporary Art, Los Angeles [1986].

Bruce **CONNER** [b. 1933, McPherson, Kansas; d. 2008, San Francisco] is a filmmaker, artist and photographer, based in San Francisco. A key figure in the West Coast Beat scene, with his first film, *A Movie* [1958], he pioneered the collage/ montage of B-movies, newsreels and other diverse sources. In the early 1960s he was also among the first to use Pop music for soundtracks, and to film material from a TV screen. His first retrospective was '2000 BC: The Bruce Conner Story Part II', Walker Art Center, Minneapolis [2000] and tour.

Sister **CORITA** [Frances Kent, b. 1918, Fort Dodge, Iowa; d. 1986, Boston] was a nun who taught art at the Immaculate Heart College, Los Angeles, until 1968 when she left the order and moved to Boston. Her screenprints used a Pop idiom to transform corporate-style slogans into messages for love, peace and justice. Her work is in public collections at the Corita Art Center, Los Angeles; The Museum of Modern Art, New York; Victoria & Albert Museum, London; Bibliothèque Nationale de France, Paris.

Roger **CORMAN** [b. 1926, Detroit] has produced or directed over 300 low-budget, independent 'B' movies since the 1950s, creating cult classics such as *The Wild Angels* [1966] and *Death Race 2000* [1975] through his skilful use of pop-culture formulae including gangsters, bikers, hippies or science fiction scenarios. He has worked with actors Jack Nicholson and Peter Fonda and directors Scorsese and Coppola.

Robert **CRUMB** [b. 1943, Philadelphia] is a subversive, satirical cartoon artist. Discovered by Harvey Kurtzman, formerly of *MAD* magazine, in the early 1960s, by 1967 he launched his own underground *Zap Comix* from San Francisco, with characters such as Fritz the Cat and Joe Blow embodying the anathema and repressed unconscious of puritan America. Retrospectives include Whitechapel Art Gallery, London [2005].

Guy **DEBORD** [b. 1931, Paris; d. 1994, Paris] was a French theorist and filmmaker. With Asger Jorn and others he formed the Situationist International in 1957. Their ideas, such as dérive, détournement, unitary urbanism and psychogeograhy, have influenced many artists, architects and critics of capitalism. His books include *The Society of the Spectacle* [1967].

Jim **DINE** [b. 1935, Cincinatti] was instrumental in setting up a counter-movement to gestural abstraction with his New York environments and events of the late 1950s. Events/ environments include *Car Crash*, Reuben Gallery, New York [1959] and *The House*, Judson Gallery, New York [1960]. Retrospectives include the Solomon R. Guggenheim Museum, New York [1999].

WALT DISNEY IMAGINEERING has been the name since 1984 of the creative partnership originally known as WED Enterprises, selected by Walt [Elias] Disney in the early 1950s as an integrated concept planning, design and installation team for the first Disneyland Park in Anaheim, California. It has been responsible for numerous technological innovations in areas such as special effects and interactive technology. Imagineering's headquarters are in Glendale, California.

Rosalyn **DREXLER** [b. 1925, New York] is a painter, writer and dramatist based in Newark, New Jersey. Marginalized from art history until the 1990s, she is now recognized as an innovative contemporary of the New York Pop painters, who introduced a proto-feminist critique of mass-media imagery in her paintings of the mid 1960s. Solo exhibitions include Mitchell Algus Gallery, New York [2000].

Marcel **DUCHAMP** [b. 1887, Blainville Crevon, France; d. 1968, Neuilly-sur-Seine] since his first selection of readymade objects for display [1913-17] began a dialogue that was re-explored and developed in the 1960s by artists as diverse as Broodthaers, Dine, Hamilton and Warhol. From 1915 living in New York, he was a key influence for Cage, Johns, Rauschenberg and the Fluxus artists in the 1950s. His first retrospectives were during the Pop years, at Pasadena Art Museum [1963] organized by Walter Hopps and the Tate Gallery, London [1966] organized by Richard Hamilton.

ERRÓ [Gudmundur Gudmundsson, b. 1932, Olafsvik, Iceland] settled in Paris in 1958, where he interacted with the Surrealists and emergent Nouveau Réaliste and Fluxus artists, painting, making films and collaborating with Jean-Jacques Lebel on Happenings in the early 1960s. As the Vietnam war escalated he responded with a politicized form of figurative painting. Solo exhibitions include Kunstmuseum Luzern [1975] and Museum Moderner Kunst, Vienna [1996].

Öyvind **FAHLSTRÖM** [b. 1928, São Paulo; d. 1976, Stockholm] was an artist and writer based, from 1961, alternately in New York and Stockholm. In the early 1950s he co-founded the concrete poetry movement and developed a lexicon of painted forms he referred to as signifiguration. After 1961 his gradual incorporation of elements from comics, news media and other sources led him to produce increasingly politicized work in diverse and innovative forms. A major touring retrospective was organized by the Museu d'Art Contemporani de Barcelona in 2001.

Robert **FRANK** [b. 1924, Zurich] is a photographer and filmmaker, based in the United States since 1950, who realized the potential of structuring photographic sequences in ways analogous to filmmaking. His unprecedented 1955-57 visual diary of travel across the United States was first published in France as *Les Américains* in 1958. He was also a Beat filmmaker [*Pull My Daisy*, 1959] and developed fly-on-the-wall documentary in his portrait of the Rolling Stones on tour [*Cocksucker Blues*, 1972]. Retrospectives include Tate Modern, London [2004] and tour.

Lee **FRIEDLANDER** [b. 1934, Aberdeen, Washington] has since moving to New York in 1956 been an innovator in the tradition of photographers such as Walker Evans and Robert Frank. Often in his street images and roadside scenes single or multiple mirror reflections, or indices of the photographer's presence invite speculation on registers of representation and potential meaning. Retrospectives include The Museum of Modern Art, New York [2005].

Jean-Luc GODARD [b. 1930, Paris] was an influential film critic for *La Gazette du cinéma*, *Arts* and *Cahiers du cinéma* before he became the leading proponent of new wave cinema from 1959 until his turn towards an overtly Marxist, didactic approach during the late 1960s. His practice has returned to the notion that cinema comes into being through its own reflection upon and evaluation of itself and its history. This paralleled concerns in the work of artists such as Roy Lichtenstein and Gerhard Richter. His magnum opus, begun in the late 1980s, is *Histoire[s] du cinéma*, a video work whose subject is the entire history of film.

Ernö GOLDFINGER [b. 1902, Budapest; d. 1987, London] studied in Paris in the early 1920s, where he met Le Corbusier and worked with Auguste Perret on reinforced concrete architecture in which structural elements were exposed. He moved to London in 1934 but only received significant commissions after provisions in the 1956 Housing Act encouraged public authorities to construct high-rise buildings. His housing projects such as Trellick Tower [completed 1972] exemplify the 'New Brutalism' which Reyner Banham championed in the mid 1950s.

Joe GOODE [b. 1937, Oklahoma City] studied advertising design at the Chouinard Art Institute, Los Angeles [1959-61], alongside his friend Ed Ruscha. Their early paintings were included in 1962 in 'New Paintings of Common Objects', Pasadena Art Museum. Goode's 'milk bottle' series was followed in 1964 by a 'staircase' series. Solo exhibitions include Dilexi Gallery, Los Angeles [1962] and Fort Worth Art Center [1972].

Dan GRAHAM [b. 1942, Urbana, Illinois] has since the mid 1960s produced a body of art and theory that engages with the social and ideological functions of cultural systems. Architecture, popular music, video and television are among the subjects of his investigations in writings, performance, video, installations and architectural/sculptural works. Retrospectives include Fundação de Serralves, Museu de Arte Contemporânea, Porto [2001] and tour.

Red GROOMS [Charles Rogers Grooms, b. 1937, Nashville, Tennessee] studied at the New School of Social Research, New York, in 1956 and with painter Hans Hofmann in 1957. In 1958 he made painting-performances, which developed into Happenings based on modern metropolitan life; these led to his 'sculpto-pictoramas' of the mid 1960s. He was included in 'Four Happenings', Reuben Gallery, New York [1960]. Retrospectives include Whitney Museum of American Art, New York [1987].

Raymond HAINS [b. 1926, Saint-Brieuc, Côtes-du-Nord; d. 2005, Paris] first met Jacques de la Villeglé while studying in Rennes in 1945. Both independently and in collaboration they made décollages from torn posters since 1949. Hains' perspective on décollage derived from his 'hypnogogic' photographs of typography through a distorting lens. In the mid 1960s he made Pop objects such as giant matchboxes, exhibited at Galerie Iris Clert, Paris, in 1965. Retrospectives include Centre Georges Pompidou, Paris [1976; 2001].

Richard HAMILTON [b. 1922, London] was from 1952 a leading member of the Independent Group based at the Institute of Contemporary Arts, London, which analysed popular mass culture. He co-organized 'This is Tomorrow', Whitechapel Art Gallery, 1956. His collages and paintings of this period are considered among the earliest Pop works. In 1963 he began screenprinting, exploring relationships between painting and industrial technologies of representation. In 1960 he published his translation of Marcel Duchamp's *Green Box* notes for '*Large Glass*' [1915-23], remaking the work with Duchamp's approval in 1966. Solo exhibitions include Hanover Gallery, London [1964], Kunstmuseum, Winterthur [2002] and retrospectives, Tate Gallery, London [1970 and 1992], Museu d'Art Contemporani de Barcelona [2003].

Duane HANSON [b. 1925, Alexandria, Minnesota; d. 1996, Davie, Florida] developed a form of super-realistic sculpture in the late 1960s. He took Polaroids of a clothed subject, then made figures from casts of the model's unclothed body, adding wigs, etc., for waxwork-like verisimilitude. Early works dealt with political issues; later works the everyday in his native Midwest. His first major retrospective was at Memphis Brooks Museum of Art, Tennessee, in 1999.

Nigel HENDERSON [b. 1917, London; d. 1984, Essex, England] first met Duchamp when installing his work at Peggy Guggenheim's London gallery in the late 1930s, and Hamilton and Paolozzi when studying at the Slade School of Art, London, in 1947. To the Independent Group he contributed his Bethnal Green photographs [1948-52], photograms and collages. His wide frame of reference embraced Art Brut, documentary photography and Surrealism. Solo exhibitions include Institute of Contemporary Arts, Dover Street, London [1961].

David HOCKNEY [b. 1937, Bradford, England] is a painter and photographer, based in Los Angeles since the mid 1960s. A Royal College of Art contemporary of Boshier, Caulfield, Jones, Kitaj, Phillips [1959-62], he was identified with Pop for his early paintings' references to graffiti and commercial packaging. He began his Californian pool paintings in 1964. Solo exhibitions include Kasmin Gallery, London [1963] and retrospective, Los Angeles County Museum of Art [1988] and tour.

Hans HOLLEIN [b. 1934, Vienna] studied architecture in Chicago and California before establishing his Vienna practice in 1964. Reacting against Mies van der Rohe's constructional functionalism he explored the technological and media environment, using collages and drawings to conceptualize his ideas. He has designed many influential public buildings, such as the Städtisches Museum Abteiberg, Mönchengladbach, Germany.

Dennis HOPPER [b. 1936, Dodge City, Kansas] is an actor, filmmaker, photographer and artist. In the early 1950s he associated with Beat artists and writers, then became a film actor in Nicholas Ray's *Johnny Guitar* [1953] and *Rebel Without a Cause* [1955]. In the mid 1960s he regained a cult status as a 'screen test' subject of Warhol. He directed *Easy Rider* in 1969. Since the mid 1980s he has had leading roles in films such as David Lynch's *Blue Velvet* [1986].

Robert INDIANA [Robert Clarke, b. 1928, Newcastle, Indiana] is a poet, painter and sculptor whose work combines vernacular references such as sign painting with hard-edge formalism, in an exploration of American symbolism. Solo exhibitions include Stable Gallery, New York [1962; 1966] and retrospective, Portland Museum of Art [1999].

Alain JACQUET [b. 1939, Neuilly-sur-Seine, France; d. 2008, New York] made his first critical intervention in Pop with his 'camouflage' series [1962-63] in some of which he painted commercial logos over iconic images such as Jasper Johns' *Flag*. A cut-up 'camouflage' of a Lichtenstein was sold in pieces as a comment on art consumerism. From 1964, in association with Mimmo Rotella, Pol Bury and other 'Mec Art' artists, he explored relationships between painting and mass-production. Solo exhibitions include Galerie Breteau, Paris [1961] and retrospective, Centre Georges Pompidou, Paris [1993].

JESS [Jess Collins, b. 1923, Long Beach, California; d. 2004, San Francisco] first exhibited his paste-up collages and junk assemblages at The Place, one of San Francisco's Beat poet and artists' bar/galleries, in 1954. From then to 1959 he worked on the *Tricky Cad* series of altered *Dick Tracy* cartoons, after which he began his *Translations* series of thick impasto paintings 'translated' from found images. Retrospectives include Museum of Fine Arts, Dallas [1977] and Mable Ringling Museum of Art, Sarasota, Florida [1983].

Gérard JOANNÈS was a graphic artist who collaborated in 1967 with Raoul Vaneigem on a series of posters announcing issues of *Situationniste Internationale*. Based on comic-strip stories they showed students discussing situationist ideas, and became associated with the May 1968 revolution. They were exhibited in 'On the Passage of a few people through a rather brief moment in time: The Situationist International 1957-1972', Centre Georges Pompidou, Paris [1989] and tour.

Jasper JOHNS [b. 1930, Augusta, Georgia, USA] was among Pop art's most important precursors with his *Flag* and *Target* paintings of the mid 1950s, reproduced widely in magazines after their first exhibition in 1958. Solo exhibitions include Leo Castelli Gallery, New York [1958] and Galerie Rive Droite, Paris [1959; 1961]. Retrospectives include The Jewish Museum, New York [1964] and The Museum of Modern Art, New York [1996].

Ray JOHNSON [b. 1927, Detroit; d. 1995, New York] was from 1949-52 a member of American Abstract Artists, exhibiting abstract work alongside such painters as Ad Reinhardt. In the mid 1950s, after meeting Rauschenberg and Twombly, he began making collages from newspaper and magazine images. In the mid 1960s he pioneered mail art, founding the New York Correspondance [sic] School of Art [1968-73]. Solo exhibitions include Marian Willard Gallery, New York [1965] and retrospective, Whitney Museum of American Art [1999].

Allen JONES [b. 1937, Southampton, England] was a short-lived Royal College of Art contemporary of Boshier, Kitaj, *et al.*, expelled a year after his enrolment in 1959. At first focusing on colour, the human figure and subtle eroticism, he developed an identifiably Pop style in his fetishistic paintings of women in the mid 1960s and his fibreglass sculptures of Barbarella-like

figures in 1969. Retrospectives include Walker Art Gallery, Liverpool [1979] and Barbican Art Gallery, London [1995].

Asger JORN [Asger Oluf Jorgensen, b. 1914, Vejrum, Jutland; d. 1973 Århus, Denmark] studied painting under Fernand Léger in Paris in 1936. Returning there from Denmark after the war he met Constant [Nieuwenhuys] and in the late 1940s they joined other artists advocating total freedom of expression to form COBRA [acronym for Copenhagen, Brussels, Amsterdam]. He went on to participate in the Situationist International from 1957 to 1961. Retrospectives include Arken Museum of Modern Art, Denmark [2002] and tour.

Alex KATZ [b. 1927, New York] began in the late 1950s to develop a style of abstract-figurative painting and drawing, centred on portraits of his wife Ada, family and friends. His figures recall the style of hand-painted film and advertising posters. Solo exhibitions include Stable Gallery, New York [1960; 1961] and retrospectives, Whitney Museum of American Art [1986] and The Saatchi Collection, London [1998].

Edward KIENHOLZ [b. 1927, Fairfield, Washington; d. 1994, Hope, Idaho] with critic and curator Walter Hopps opened the Ferus Gallery, Los Angeles, in 1957. The gallery presented the first West Coast shows of Warhol, Ruscha, Bengston and others. In 1961 Kienholz made his first 'tableau', Roxy's, a recreation of an entire brothel, with surrealist overtones; later he introduced the 'concept tableau', which could be realized whenever more funds were available. Solo exhibitions include Café Galleria, Los Angeles [1955] and retrospectives, Los Angeles County Museum of Art [1966] and Whitney Museum of American Art, New York [1996].

R.B. KITAJ [b. 1932, Cleveland, Ohio; d. 2007, Los Angeles] completed his art studies at the Royal College of Art, London [1959-61], coinciding with the British 'Pop' generation, although five years their senior and with a more profound engagement with literature, history and politics. His work with images from photography and film brought some of his paintings and prints close to Pop in the early 1960s. Retrospectives include Hirshhorn Museum and Sculpture Garden, Washington, D.C. [1982] and tour; Tate Gallery, London [1994].

William KLEIN [b. 1928, New York] studied painting under Fernand Léger in Paris in 1948, remaining in France thereafter. By the mid 1950s he was pushing the boundaries of photography, using high-grain film, wide angles, extreme close-ups (often blurred) and high-contrast prints in his 1954 photo-diary of New York, followed by studies of Rome [1960], Moscow and Tokyo [both 1964]. Until the 1980s Klein then concentrated on filmmaking, starting with his 'Pop' film *Broadway by Light* [1958]. His other films include *Qui êtes-vous, Polly Magoo?* [1966] and *Mr Freedom* [1967-68]. Retrospectives include Centre Georges Pompidou [2005].

Yayoi KUSAMA [b. 1929, Matsumoto, Japan] is an artist and writer who worked in New York from 1958 to the late 1960s. Her paintings, sculpture and installations are characterized by serial repetition of patterns and forms. Her 1960s work had affinities with that of contemporaries Donald Judd, Andy Warhol, the Nouveaux Réalistes and the Zero group. Solo exhibitions include the Castellane Gallery, New York [1964], and retrospective, Los Angeles County Museum of Art [1989] and tour.

John LENNON [b. 1940, Liverpool; d. 1980, New York] is best known as the singer, guitarist and co-songwriter with Paul McCartney for The Beatles pop group. After he met the Fluxus artist and musician Yoko Ono in London in 1966 he collaborated with her on art projects and exhibited his own drawings. Once married in 1969 they created anti-Vietnam war peace actions such as their *Bed-In*, and *War Is Over* posters and broadcasts. Exhibitions include 'You Are Here', Robert Fraser Gallery, London [1968] and erotic lithographs, London Arts Gallery, London [1970].

Roy LICHTENSTEIN [b. 1923, New York; d. 1997, New York] after meeting artists such as Dine and Oldenburg began in 1961 to paint in a radically different style, deriving his compositions directly from printed cartoon strips and advertisements. From 1964 onwards he 'Lichtensteinized' many other types of subject matter, as well as historical styles of representation. Solo exhibitions include Leo Castelli Gallery, New York [1962; 1963; 1964], Ferus Gallery, Los Angeles [1963; 1964], Galerie Ileana Sonnabend, Paris [1965] and retrospectives, Pasadena Art Museum [1967] and Solomon R. Guggenheim Museum, New York [1969; 1994].

Konrad LUEG [Konrad Fischer, b. 1939, Düsseldorf, d. 1996, Düsseldorf] was the pseudonym of renowned gallery owner Konrad Fischer, during the early 1960s when he was a painter and co-founder (with Gerhard Richter and Sigmar Polke) of the German counterpart to Pop art, Capitalist Realism. Between 1962 and 1966 he exhibited at the galleries Schmela, Düsseldorf and René Block, Berlin. He covered these spaces in newspaper cuttings and wallpaper patterns, on which he displayed his paintings of cypher-like figures.

John McHALE [b. 1922, Glasgow; d. 1978, Houston, Texas] was a member of the Independent Group who in the mid 1950s made sculpture 'kits' for mass-production, collages exploring mass communication, and photographs of American roadside diners and signs. He collaborated with Richard Hamilton and John Voelcker in 'This is Tomorrow', Whitechapel Art Gallery, London [1956]. He was the author of the influential essay 'The Plastic Parthenon' [first published in *Dot-Zero* magazine, Spring 1967] and the books *Buckminster Fuller* [1960] and *The Future of the Future* [1969]. In 1962 he moved to the USA with his wife Magda Cordell McHale, also a former IG artist.

Charles MOORE [b. 1925, Benton Harbor, Michigan; d. 1993] was a teacher and practising architect who rejected modernist formalist principles in response to the awareness of environment fostered by mass cultural forms. Placing the symbolic preferences of the client first, and thus allowing for style variations ranging from wooden shed to Palladian, he is considered one of the founders of postmodern architecture. Among the buildings he collaborated on are the Sea Ranch Condominium, near San Francisco [1964-65] and the Hood Museum of Art, Hanover, New Hampshire [1981-85].

Malcolm MORLEY [b. 1931, London] is a British painter based in New York since 1958. A contemporary of Peter Blake, Richard Smith and Joe Tilson at the Royal College of Art, London, 1954-57, in New York he met Artschwager, Lichtenstein and Warhol. In 1964 he began his paintings of ships based on photographs, which developed into a 'superrealist' style that lasted until its 'cancellation' in the painting *Race Track* [1970]. Retrospectives include Whitechapel Art Gallery, London [1983] and Hayward Gallery, London [2001].

Claes OLDENBURG [b. 1929, Stockholm] settled in New York in 1956. In the late 1950s he began to stage events in Art Brut-like environments with crudely painted shapes and junk found on the streets. These were followed by The Store [1961], where he blurred distinctions between art and commerce. By 1965 he had explored 'hard', 'soft' and 'ghost' replicas of everyday objects and begun proposals for giant objects as civic monuments. Solo exhibitions include Judson Gallery, New York [1959], Dwan Gallery, Los Angeles [1963], Galerie Ileana Sonnabend, Paris [1964], Sidney Janis Gallery, New York [1964; 1965; 1966; 1967]. Retrospectives include The Museum of Modern Art, New York [1969] and Solomon R. Guggenheim Museum, New York [1995].

Eduardo PAOLOZZI [b. 1924, Leith, Scotland; d. 2005, London] studied at the Slade School of Art, London, 1944-47, then visited Paris where he met artists associated with Dada, Surrealism and their legacies. Returning to London he associated with the Independent Group, in 1952 presenting a slide lecture of scrapbook collage images at the Institute of Contemporary Arts. Published and exhibited since 1972, these are now considered among the first Pop artworks. The last of his Pop-related works, made in the 1960s, are robot-like cast metal figures, finished in bright colours that echo his silkscreen prints. Retrospectives include Tate Gallery, London [1971] and Scottish National Gallery of Modern Art, Edinburgh [2004].

D.A. PENNEBAKER [b. 1925, Evanston, Illinois] was instrumental in developing the Direct Cinema style of documentary filmmaking, also known as *cinéma vérité*. He joined the New York Filmmakers' Co-op in 1959 and made his first behind-the-scenes documentary about an election campaign: *Primary* [1960]. *Don't Look Back* [1967] followed Bob Dylan's 1965 concert tour in England. In the 1960s Pennebaker worked with Jimi Hendrix and Otis Redding at the Monterey Pop Festival in 1967 [*Monterey Pop*, 1968].

Peter PHILLIPS [b. 1939, Birmingham, England] studied at the Royal College of Art, London, with Boshier, Caulfield, Hockney, Jones and Kitaj, 1959-62. His early work combined the influence of Jasper Johns' *Flag* and *Target* paintings with imagery derived from board games, logos and pin-ups. From 1964 to 1966 he travelled in the USA, where he adopted a larger scale, and airbrush techniques. In 1967 he moved to Zurich and in 1988 to Mallorca. Retrospectives include Westfälischer Kunstverein, Münster [1972] and Walker Art Gallery, Liverpool [1982].

Michelangelo PISTOLETTO [b. 1933, Biella, Italy] studied advertising in the 1950s. In

1960 he exhibited his first portraits set against metallic backgrounds, at Galleria Galatea, Turin. His 'mirror' paintings followed, in which lifesize painted figures are superimposed on mirrored surfaces. From the late 1960s he produced more diverse work as a leading Arte Povera artist. Retrospectives include Forte di Belvedere, Florence [1982], Staatliche Kunsthalle, Baden-Baden [1988] and Museu d'Art Contemporani de Barcelona [2000].

Sigmar **POLKE** [b. 1941, Oels, Lower Silesia, now Olesnica, Poland] grew up in East Germany then moved to the West in 1953, studying at the Staatliche Kunstakademie, Düsseldorf, 1961-67, under Joseph Beuys. He is unconstrained by style and materials; for example his 'dot paintings' of the mid 1960s echo Lichtenstein's but blur and rearrange dot patterns to create unexpected images. Solo exhibitions include Galerie René Block, Berlin [1966] and retrospectives, Musée d'art moderne de la Ville de Paris [1988] and the Kunst- und Austellungshalle der Bundesrepublik Deutschland, Bonn [1997] and tour.

Cedric **PRICE** [b. 1934, Stone, Staffordshire, England; d. 2003, London] from the time he founded his own practice in 1960 was a visionary architect whose mainly unbuilt projects profoundly influenced future architecture and planning. His central belief was that new technology could give the public unprecedented control over their environment. His unrealized Fun Palace [1960-61] was the ancestor of the Centre Pompidou as well as pioneering, in its proposed siting, urban reclamation and regeneration. Retrospectives include The Design Museum, London [2005].

Arthur **QUARMBY** is an architect based in Huddersfield, England, who was a pioneer in the 1960s of the use of moulded and prefabricated plastics in architecture, ranging from multiple units for industrial and domestic structures to inflatable domes. He is the author of *The Plastics Architect* [Pall Mall Press, 1974]. In 1975 he designed and built the first modern earth sheltered house in Britain, 'Underhill', in Yorkshire. He is President of the British Earth Sheltering Association, which promotes these environmentally sound buildings.

Mel **RAMOS** [b. 1935, Sacramento, California] was taught by the painter Wayne Thiebaud at Sacramento State College [1954-58]. He began to paint cartoon characters during 1961-62, in an impasto style similar

to Thiebaud's. In 1963 he introduced female characters and the following year developed a more graphic, 'commercial' style, portraying curvaceous pin-up girls posed, semi-ironically, with consumer goods. Solo exhibitions include Paul Bianchini Gallery, New York [1964; 1965], and retrospectives, Oakland Art Museum, California [1977] and Kunstverein, Lingen, Austria [1994] and tour.

Robert **RAUSCHENBERG** [b. 1925, Port Arthur, Texas; d. 2008, Captiva, Florida] studied in Paris [1948-49] followed by Black Mountain College, North Carolina, where he met composer John Cage, choreographer Merce Cunningham, poet Charles Olson and artist Cy Twombly. Their shared ideas led him to explore 'the gap between art and life' in his Combines of the mid 1950s, and collaborations with performance and dance companies. Solo exhibitions include Betty Parsons Gallery, New York [1951], Leo Castelli Gallery, New York [1958], Galleria La Tartaruga, Rome [1959] and retrospectives, The Jewish Museum, New York [1963] and Solomon R. Guggenheim Museum, New York [1998].

Martial **RAYSSE** [b. 1936, Golfe-Juan, near Nice] was one of the founding artists of the Nouveau Réalisme group, in the early 1960s making assemblages of mass-produced objects, mainly of brightly coloured plastic. Solo exhibitions include Galerie Longchamp, Nice [1967], Stedelijk Museum, Amsterdam [1966], Dwan Gallery, Los Angeles [1967] and retrospectives, Centre Georges Pompidou, Paris [1981] and Galerie national du Jeu de Paume, Paris [1992].

Ron **RICE** [b. 1935, New York; d. 1964, Mexico] was an avant-garde filmmaker who collaborated with the performer Taylor Mead, whom he first met in San Francisco in the late 1950s. His films include *The Flower Thief* [1960], *Senseless* [1962], *Queen of Sheba Meets the Atom Man* [1963, final version completed by Mead in 1982] and *Chumlum* [1964]. The filmmaker and critic Jonas Mekas described the work of Bob Fleischner, Ken Jacobs, Rice and Jack Smith as a new form of 'Baudelairian Cinema', a cinematic equivalent to the writings of William Burroughs.

Gerhard **RICHTER** [b. 1932, Dresden] like Sigmar Polke, moved from what was then East Germany to the West to study at the Staatliche Kunstakademie, Düsseldorf [1961-64]. With Konrad Lueg they collaborated on the launch of Capitalist Realism. Since the early 1960s Richter has archived photographic images and used them as the basis for many of his

paintings. Retrospectives include Städtische Kunsthalle, Düsseldorf [1986], Museum Boymans-van Beuningen [1989] and The Museum of Modern Art, New York [2002] and tour.

James **ROSENQUIST** [b. 1933, Grand Forks, North Dakota] studied and practised abstract painting while working as a commercial billboard painter [1953-54 and 1957-60]. In 1960 he began to incorporate the subject matter and style of his advertising work into fragmentary compositions. Solo exhibitions include Green Gallery, New York [1962; 1964], Dwan Gallery, Los Angeles [1964], Galerie Ileana Sonnabend, Paris [1965], 'James Rosenquist: F-111', Leo Castelli Gallery, New York [April-May 1965] and retrospectives, Denver Art Museum [1985] and Solomon R. Guggenheim Museum [2003].

Mimmo **ROTELLA** [b. 1918, Cantanzaro; d. 2006, Milan] studied in Naples then settled in Rome in 1945. He began making décollages using torn street posters in 1953, first exhibiting them in 1954. In 1960 he began to exhibit with the French décollagistes Hains and Villeglé, and to participate in Nouveau Réalisme exhibitions. In 1963, with Alain Jacquet, Pol Bury and others, he developed 'Mec Art', which explored mechanical reproduction. Solo exhibitions include Galleria Chiurazzi, Rome [1951] and retrospective, Musée d'art moderne et contemporain, Nice [2001].

Ed **RUSCHA** [b. 1937, Omaha, Nebraska] studied commercial art at the Chouinard Art Institute, Los Angeles. In 1961 he travelled across Europe, and also began making his first paintings of words. In 1963 he began a series of artist's books, such as *Twentysix Gasoline Stations* [1963] and *Nine Swimming Pools and a Broken Glass* [1968]. Solo exhibitions include Ferus Gallery, Los Angeles [1963] and retrospectives, Museum of Contemporary Art, Los Angeles [1990], Hirshhorn Museum and Sculpture Garden, Smithsonian Institution, Washington, D.C. [2000] and 'Ed Ruscha and Photography', Whitney Museum of American Art, New York [2004].

Lucas **SAMARAS** [b. 1936, Kastoria, Greece] moved to New York in 1948. He studied at Rutgers University, New Brunswick, with Allan Kaprow and George Segal [1955-59] and participated in Happenings at the Reuben Gallery, New York, with Red Grooms and Claes Oldenburg in 1959. He began making boxes in 1960, first introducing self-portraits in 1963. In 1964 he recreated his bedroom in the Green Gallery, New York, and in 1965 began his

Transformations series of manipulated Polaroid self-portraits. Solo exhibitions include Green Gallery, New York [1961; 1964], Pace Gallery, New York [1965; 1966] and retrospectives, Whitney Museum of American Art, New York [1972; 2000].

Peter **SAUL** [b. 1934, San Francisco] lived in Holland, Paris and Rome, 1956-64, returning to California, 1964-74. His expressionistic paintings are politically engaged precursors of the 'graffiti' style of the early 1980s. Solo exhibitions include Allan Frumkin Gallery, New York [1962; 1963; 1964; 1966] and retrospective, Musée de l'Abbaye Sainte-Croix Châteauroux, France [1999] and tour.

Carolee **SCHNEEMANN** [b. 1939, Fox Chase, Pennsylvania] is a mixed media and performance artist based in New York. In works such as *Eye Body: 36 Transformative Actions* [1963] she integrated her own naked body into an assemblage/environment, inflecting a feminist perspective on the innovations represented by Rauschenberg's Combines and the environments/actions of Dine, Kaprow and Oldenburg. Other works bearing a critical relation to Pop include *More than Meat Joy*, first performed at the Festival de la Libre Expression, Paris [1964]. Retrospectives include New Museum of Contemporary Art, New York [1998].

Kurt **SCHWITTERS** [b. 1887, Hanover, d. 1948, Ambleside, England] was a leading member of the Berlin group of Dadaists until the Second World War, arriving in London as a refugee in 1941. During the 1920s and 1930s he produced a kind of collage or assemblage of materials such as printed ephemera which he called Merz, after the 'merz' in 'Commerz'. He also worked as a commercial graphic designer. In London he used comic strips brought from the USA by American soldiers in his last collages, which were unexhibited at his death but rediscovered in the early 1960s and viewed retrospectively as proto-Pop artworks.

George **SEGAL** [b. 1924, New York; d. 2000, New Brunswick, New Jersey] studied art in 1941-49 and had his first exhibition of paintings in 1953. He began sculpting with plaster over a burlap and wire support in 1958, casting from live models from 1961. He created entire environments in which the plaster figures represented people engaged in mundane tasks. Solo exhibitions include Green Gallery, New York [1962; 1964], Sidney Janis Gallery, New York [1965], and retrospectives, Museum of Contemporary Art, Chicago [1968] and Montreal Museum of Fine Arts [1997].

Colin **SELF** [b. 1941, Norwich, England] studied at the Slade School of Art, London, 1961-63. Remaining at a critical distance from most of his Royal College Pop contemporaries, he used a Pop lexicon, inflected with traces of Surrealism, to explore undercurrents of sexual fetishism and violence in consumer society and its products, the pervasive threat of nuclear annihilation, and the psychological space of the cinema and its architecture. Solo exhibitions include Robert Fraser Gallery, London [1964], Piccadilly Gallery, London [1965] and Tate Gallery, London [1995].

Martin **SHARP** [b. 1942, Sydney] is a cartoonist and graphic artist who was based in London from 1966 to 1970. He was the artist for the subversive underground magazine *Oz*, which folded after an obscenity trial in 1971. He was also instrumental in popularizing psychedelic art in Britain, producing posters of his drawings for albums and concerts of Bob Dylan, Jimi Hendrix and others. Solo exhibitions include Art Gallery of South Australia, Adelaide [2000].

Jack **SMITH** [b. 1932, Columbus, Ohio, d. 1989, New York] was a filmmaker, photographer, performer and artist. After moving to New York in 1953, he met the young filmmaker Ken Jacobs, whose *Blonde Cobra* [1959] is a portrait of Smith. Smith's *Flaming Creatures* [1962], with its transvestite orgy, became an immediate cult classic and was the subject of an obscenity trial in 1964. Warhol met Smith in 1963; they shared a star, the performer Mario Montez. Solo exhibitions include Limelight Gallery [photographs], New York [1960] and retrospective, P.S.1 Contemporary art Center, New York [1997].

Richard **SMITH** [b. 1931, Letchworth, England] was a contemporary of Peter Blake and Joe Tilson at the Royal College of Art, London, 1954-57. Inspired by the New York School painters, he went there in 1959, making his first large scale paintings in 1960 before returning to London the following year. He worked again in New York from 1963 to 1965 and moved there permanently in 1976. His work hovers between abstraction and subliminal reference to commercial designs such as cigarette packet graphics. Solo exhibitions include Green Gallery, New York [1961], Whitechapel Art Gallery, London [1966] and retrospective, Tate Gallery, London [1975].

Alison **SMITHSON** [Alison Gill, b. 1928, Sheffield, England; d. 1993] and **Peter**

SMITHSON [b. 1923, Stockton-on-Tees, England; d. 2003] as founder members of the Independent Group formulated an architecture that would exploit the low cost and pragmatism of mass-produced, pre-fabricated components. Influential projects such as Hunstanton Secondary Modern School, Norfolk [1949-54] and House of the Future [1956] responded to the social realities of the occupier rather than external formulaic principles. Retrospectives include the Design Museum, London [2003].

Daniel **SPOERRI** [Daniel Isaak Feinstein, b. 1930, Galati, Romania] moved to Switzerland in 1942, where he participated in avant-garde theatre, starting to make art in 1959. In 1960 he began his 'Tableau-pièges', in which the residues of a meal would be 'trapped' on a table top and exhibited as an artwork. His actions and works of the early 1960s explore chance and the idea of the readymade. Solo exhibitions include Galleria Schwarz, Milan [1961] and Centre Georges Pompidou, Paris [1990].

Frank **TASHLIN** [Francis Fredrick von Taschlein, b. 1913, Weehawken, New Jersey; d. 1972, Hollywood] was a film director who made the unusual progression from drawing animated cartoons such as the Looney Tunes series of the mid 1930s to writing gags for actors Lucille Ball and the Marx Brothers in the mid 1940s, and finally directing film comedies such as *The Girl Can't Help It* [1956] and *Will Success Spoil Rock Hunter?* [1957]. Their underlying structures of narrative and comic timing were influential on the early work of Jean-Luc Godard.

Paul **THEK** [b. 1933, Brooklyn; d. 1988, New York] was primarily a painter until the mid 1960s when he produced the *Technological Reliquaries*, a series of wax sculptures which resemble raw meat or human limbs, encased in Plexiglas vitrines. Full body casts followed, such as the self-portrait *Death of a Hippy* [1967]. Retrospectives include Institute of Contemporary Art, Philadelphia [1977] and Witte de With Centre for Contemporary Art, Rotterdam [1995] and tour.

Wayne **THIEBAUD** [b. 1920, Mesa, Arizona] worked during the 1940s as a freelance cartoonist and illustrator before studying painting [1949-52]. By the early 1960s his canvases had progressed to close-up views of subjects such as cake displays, which combined compositions often reminiscent of cropped commercial photography with a painterly impasto technique. Solo

exhibitions include Allan Stone Gallery, New York [1962; 1964] and retrospectives, Pasadena Art Museum [1968] and San Francisco Museum of Modern Art [1985].

Joe **TILSON** [b. 1928, London] is a painter, sculptor and graphic artist based in London, Venice and Cortona, who studied at the Royal College of Art, London, 1952-55. The works of his Pop period [1961-69] explore the interplay between visual, textual and three-dimensional elements, in carved and painted wooden objects, reliefs and screenprints. Solo exhibitions include Marlborough Fine Art, London [1962], British Pavilion, Venice Biennale [1964] and retrospectives, Museum Boymans van-Beuningen, Rotterdam [1973] and Royal Academy of Arts, London [2002].

Jean **TINGUELY** [b. 1925, Fribourg; d. 1991, Bern] in the 1950s developed kinetic sculptures resembling functionless machines, made from discarded waste objects. In 1960 he presented his auto-destructive work *Hommage à New York* at The Museum of Modern Art, New York. While in New York he and his partner the artist Niki de Saint Phalle met Robert Rauschenberg and Jasper Johns, who collaborated with Saint Phalle on some of her 'Tir à volonté' ['Shoot at will'] works. He was included in 'International Exhibition of the New Realists', Sidney Janis Gallery, New York [1962]. Retrospectives include Centre Georges Pompidou, Paris [1997].

Robert **VENTURI** [b. 1925, Philadelphia], Denise **SCOTT BROWN** [Denise Lafoski, b. 1931, Nkana, Zambia] and Steven **IZENOUR** [b. 1940, New Haven, Connecticut] of architectural practice Venturi, Scott Brown & Associates, are based in Los Angeles. In 1950s London Scott Brown encountered the work of the Smithsons and the Independent Group. In the mid 1960s Venturi, Scott Brown and Izenour made a detailed study of Los Angeles street architecture, published in 1972 as *Learning from Las Vegas*. Venturi and Scott Brown have written extensively and curated exhibitions, advocating an architecture that arises from consumer-generated forms. They view their work as a continuation of modernism (although others have viewed it as exemplifying postmodern architecture).

Jacques de la **VILLEGLÉ** [b. 1926, Quimper, Brittany] studied painting, then architecture, in Rennes and Nantes in the 1940s. In 1945 he met Raymond Hains and after moving to Paris in 1949 he collaborated with Hains on some of the earliest décollages. He was a founder member of the Nouveaux

Réalistes in 1960 and has continued to work with torn posters and language. Solo exhibitions include the studio of François Dufrêne, Paris [1959] and retrospectives, Moderna Museet, Stockholm [1971] and Magasin, Centre national d'art, Grenoble [1988].

Andy **WARHOL** [b. 1928, Pittsburgh; d. 1987, New York] was an artist and filmmaker who made some of the most transformative contributions to Pop representation from his first comic-strip based paintings [c. 1960-61] onwards. A successful commercial artist, Warhol began using silkscreen paintings in 1962. In November 1963 he established the Factory at 231 East 47th Street, New York, becoming a central figure in the New York art and underground filmmaking scene. In 1968 he was shot and seriously injured by a Factory acolyte, Valerie Solanas. Solo exhibitions include Ferus Gallery, Los Angeles [1962; 1963], Stable Gallery, New York [1962; 1964], Leo Castelli Gallery, New York [1964; 1966], Galerie Ileana Sonnabend, Paris [1964]. Retrospectives include Institute of Contemporary Art, Philadelphia [1965] and The Museum of Modern Art, New York [1989]. The Andy Warhol Museum, the largest collection of his work, opened in Pittsburgh in 1994.

Robert **WATTS** [b. 1923, Burlington, Indiana; d. 1987, Vermont] studied mechanical engineering in the early 1940s before studying art, producing abstract paintings, experimental film and kinetic structures during the 1950s. From 1960 he was associated with the Fluxus movement, staging events and producing ephemeral objects such as fake stamps. In the mid 1960s he began to fabricate chrome-plated replicas of everyday objects. Retrospectives include Leo Castelli Gallery, New York [1990].

John **WESLEY** [b. 1928, Los Angeles] began painting in the late 1950s after working as an aircraft riveter and then as an illustrator in an aircraft engineering department. He moved to New York in 1960, developing a hard-edge style to depict ironically or erotically suggestive figures and sometimes emblems that play on repetition and decorative framing devices. Solo exhibitions include Robert Elkon Gallery, New York [1963; 1967; 1969] and retrospectives, Stedelijk Museum, Amsterdam [1993] and P.S.1 Contemporary Art Center, New York [2000].

Tom **WESSELMANN** [b. 1931, Cincinnati; d. 2004, New York] was recognized as one of the leading New York Pop artists from 1962 onwards when he first exhibited works from his

Still Life and *Great American Nude* series of
paintings with collage, which continued
throughout the 1960s. In 1962 he began to
combine painting and collage with assemblage
of mundane domestic found objects, notably in
the *Bathtub Collage* works started in 1963.
Solo exhibitions include Tanager Gallery,
New York [1961], Sidney Janis Gallery, New
York [1966], Galerie Sonnabend, Paris [1966]
and retrospective, Musée d'art moderne et
contemporain, Nice [1996] and tour.

Robert **WHITMAN** [b. 1935, New York]
co-founded EAT [Experiments in Art and
Technology] with Robert Rauschenberg and
engineers such as Billy Klüver in 1966, to
facilitate artists' experimentation with
new technologies. His works use live
performance, slide projection, film and other
media. Solo exhibitions include the Jewish
Museum, New York, and the Museum of
Contemporary Art, Chicago [both 1968] and
The Museum of Modern Art, New York [1973]. His
performances have toured to the Moderna
Museet, Stockholm [1987; 1989] and the Centre
Pompidou, Paris [2001; 2002].

Gary **WINOGRAND** [b. 1928, New York;
d. 1984, New York] was a street photographer
and documenter of urban life. A prolific and
incisive user of the snapshot aesthetic, his
year-long American road trip, echoing Robert
Frank's, was collected in the series *1964*.
Solo exhibitions include Image Gallery,
New York [1960], The Museum of Modern Art, New
York [1963; 1977; retrospectives, 1988; 1998]
and International Center of Photography,
New York [2002].

BIBLIOGRAPHY

1960. Les Nouveaux Réalistes Musée d'art moderne de la Ville de Paris, 1986

2000 BC: The Bruce Conner Story Part II eds. Peter Boswell, Bruce Jenkins and Joan Rothfuss, Walker Art Center, Minneapolis, 2000

6 Painters and the Object Solomon R. Guggenheim Museum, New York, 1963

À 40° au-dessus de Dada Galerie J, Paris, 1961

Alloway, Lawrence 'Technology and Sex in Science Fiction: A Note on Cover Art', *Ark*, 17, Summer 1956

_____ *American Pop Art*, Whitney Museum of American Art, New York, 1974

Amaya, Mario *Pop as Art: A Survey of the New Super-Realism*, Studio Vista, London, 1965

Ameline, Jean-Paul *Les Nouveaux Réalistes*, Éditions du Centre Pompidou, Paris, 1992

American Pop Art and the Culture of the Sixties New Gallery of Contemporary Art, Cleveland, Ohio, 1976

Americans 1963 The Museum of Modern Art, New York, 1963

Amerikanste Pop-Kunst Moderna Museet, Stockholm, 1964

Années Pop, Les ed. Mark Francis, Éditions du Centre Pompidou, Paris, 2001

Archigram Éditions du Centre Pompidou, Paris, 1994

Architectural Design Special issues: 'Pneumatics', June 1967; 'Pneu World', June 1968

Arman Galerie nationale du Jeu de Paume, Paris, 1998

Artschwager, Richard ed. Richard Armstrong, Whitney Museum of American Art, New York, 1988

Bailey, David, and Peter Evans *Goodbye Baby & Amen. A Saraband for the Sixties*, Condé Nast, London, 1969

Bande dessinée et figuration narrative Musée des arts décoratifs, Paris, 1967

Banham, Reyner *Megastructure: Urban Futures of the Recent Past*, Thames & Hudson, London, 1980

_____ *Design by Choice*, Academy Editions, London, 1981

_____ *A Critic Writes: Essays by Reyner Banham*, ed. Mary Banham, University of California Press, Berkeley and Los Angeles, 1997

Banes, Sally *Greenwich Village 1963: Avant-garde Performance and the Effervescent Body*, Duke University Press, Durham, North Carolina, 1993

Battcock, Gregory *The New Art: A Critical Anthology*, New York, 1973

Beat Culture and the New America 1950–1965 ed. Lisa Phillips, Whitney Museum of American Art, New York/Gallimard, Paris, 1996

Belz, Carl I. 'Three Films by Bruce Conner', *Film Culture*, 44, Spring 1967

Billy Al Bengston: Paintings of Three Decades Contemporary Arts Museum, Houston, 1988

Blam! The Explosion of Pop, Minimalism, and Performance 1958–1964, ed. Barbara Haskell, Whitney Museum of American Art, New York, 1984

Boatto, Alberto *Pop Art*, Laterza, Rome and Bari, 1983

Bockris, Victor *The Life and Death of Andy Warhol*, Da Capo Press, New York, 1997

Bourdon, David 'An interview with Ray Johnson', *Artforum*, 3:1, September 1964

_____ *Andy Warhol*, Harry N. Abrams, New York, 1989

Branzi, Andrea and Natalini Adolfo Introduction, *Superarchittetura*, Galleria Jolly 2, Pistoia, 1966

Brecht, George Museum Ludwig, Cologne, 2005

Brecht, George, Allan Kaprow, Robert Watts, *et al.* 'Project in Multiple Dimensions', 1957–58; published in *Robert Watts: The Invisible Man of Fluxus and Pop*, Museum Fridericianum, Kassel, 1999

Broodthaers, Marcel Galerie nationale du Jeu de Paume, Paris, 1991

Burckhardt, François, and Cristina Morozzi *Andrea Branzi*, Éditions Dis Voir, Paris, 1998

Carrick, Jill *Le Nouveau Réalisme. Fetishism and Consumer Spectacle in Postwar France*, Bryn Mawr College, Bryn Mawr, 1997

Cassavetes, John 'What's Wrong with Hollywood', *Film Culture*, 19, 1959

Chatman, Seymour, ed. Paul Duncan *Michelangelo Antonioni: The Complete Films*, Taschen, Cologne, 2004

Clouzot, Claire *William Klein: Les Films*, Marval, Paris, 1998

Codognato, Attilio ed., *Pop Art: Evoluzione di una Generazione*, Electa, Milan, 1980

Comic Art Show, The. Cartoons in Painting and Popular Culture ed. John Carlin and Sheena Wagstaff, Whitney Museum of American Art/Fantagraphics, New York, 1983

Comic Iconoclasm ed. Sheena Wagstaff, Institute of Contemporary Arts, London, 1987

Compton, Michael *Pop Art*, Paul Hamlyn, London, 1970

Cook, Peter 'Zoom and "Real" Architecture', *Amazing Archigram*, 4, 1964

_____ *Architecture: Action and Plan*, Studio Vista, London/Reinhold Publishing Corporation, New York, 1967

_____ *Experimental Architecture*, Studio Vista, London, 1970

_____ *Archigram*, Studio Vista, London, 1972

Cooke, Lynne 'The Independent Group: British and American Pop Art, a "Palimpsestuous Legacy"', in *Modern Art and Popular Culture: Readings in High and Low*, eds Kirk Varnedoe and Adam Gopnik, The Museum of Modern Art, New York, 1990

Crow, Thomas. E. *The Rise of the Sixties: American and European Art in the Era of Dissent*, Harry N. Abrams, New York, 1996

D'Arcangelo, Allan. Paintings of the Early Sixties Neuberger Museum, Purchase, New York, 1978

Dalí, Salvador 'The King and the Queen Traversed by Swift Nudes', *ARTnews*, 58:2, April 1959

Debord, Guy *Panegyric*, Vols 1 & 2, Verso, London, 2005

Designing Disney's Theme Park: The Architecture of Reassurance ed. Karal Ann Marling, Canadian Center for Architecture, Montreal

Diawara, Manthia *The 1960s in Bamako: Malick Sidibé and James Brown*, Andy Warhol Foundation, New York, 2001

Douchet, Jean [with Cédric Anger] *Nouvelle Vague*, Éditions Hazan, Paris, 1998

Drury, Margaret *Mobile Homes: The Unrecognized Revolution in American Housing*, Praeger, New York, 1972

Dunlop, Beth *Building a Dream: The Art of Disney Architecture*, Harry N. Abrams, New York, 1996

Dylan, Bob *Chronicles*, Vol. 1, Simon & Schuster, New York, 2004

Environments, Situations, Spaces Martha Jackson Gallery, New York, 1961

Evans, Walker & Dan Graham Witte de With, Rotterdam/Whitney Museum of American Art, New York, 1992

Expendable Ikon, The. Works by John McHale Albright-Knox Art Gallery, Buffalo, New York, 1984. Texts by Lawrence Alloway, Reyner Banham, Richard Hamilton, John McHale.

Fahlström, Öyvind. Die Installationen/The Installations ed. Sharon Avery-Fahlström, with Eva Schmidt, Udo Kittelmann, Gesellschaft für Aktuelle Kunst, Bremen/Kölnischer Kunstverein, Cologne, 1995. Texts by Öyvind Fahlström, Mike Kelley, Jane Livingston

Fahlström, Öyvind. Another Space for Painting eds Sharon Avery-Fahlström, Manuel J. Borja-Villel, Jean-François Chevrier, Museu d'Art Contemporani de Barcelona, 2001

Feuerstein, Günther *Visionäre Architektur Wien 1958-1988*, Ernst & Sohn, Berlin, 1988

Film Culture 45, Summer 1964 [Special isssue on Andy Warhol]

Finch, Christopher *Pop Art: Object and Image*, Studio Vista, London/E.P. Dutton, New York, 1968

_____ *Image as Language: Aspects of British Art, 1950-1968*, Penguin, Harmondsworth, Middlesex, 1969

Fluxus: Selections from the Gilbert and Lila Silverman Collection ed. Clive Phillpot and Jon Hendricks, The Museum of Modern Art, New York, 1988

Foster, Hal *The Return of the Real: Art and Theory at the End of the Century*, MIT Press, Cambridge, Massachusetts, 1996

Francblin, Catherine *Les Nouveaux Réalistes*, Éditions du Regard, Paris, 1997

Friedman, Yona and Robert Aujame 'The Future [Mobile Architecture]', *Architectural Design*, August 1960

Frith, Simon *Art into Pop*, Routledge, London and New York, 1987

Fuller, Richard Buckminster *The Buckminster Fuller Reader*, ed. James Meller, Jonathan Cape, London, 1969

Gablik, Suzi 'Crossing the Bar', *ARTnews*, 64:6, October 1965

_____ 'Protagonists of Pop: Five Interviews conducted by Suzi Gablik', *Studio International*, July-August 1969

_____ and John Russell, *Pop Art Redefined*, Thames & Hudson, London and New York, 1969

Garrels, Gary ed., *The Work of Andy Warhol, Discussions in Contemporary Culture*, Dia Art Foundation, New York/Bay Press, Seattle, 1989

Gidal, Peter *Andy Warhol: Films and Paintings*, Studio Vista, London/E.P. Dutton, New York, 1971

Gillett, Charlie *The Sound of the City: The Rise of Rock and Roll*, Souvenir Press, London, 1971

Global Village: The 1960s ed. Stéphane Aquin, The Montreal Museum of Fine Arts, 2003

Graham, Dan *Rock My Religion: Writings and Art Projects, 1965-1990*, ed. Brian Wallis, MIT Press, Cambridge, Massachusetts, 1993

Greenberg, Clement 'Pop Art', undated lecture, c. early 1960s, first published in *Artforum*, October 2004

Grooms, Red 'A Statement', 1959, in Michael Kirby, *Happenings: An Illustrated Anthology*, E.P. Dutton, New York, 1966

Grushkin, Paul D. *The Art of Rock*, Artabras, New York, 1987

Hains, Raymond Musée d'art moderne et d'art contemporain, Nice, 2000

Hall of Mirrors: Art and Film after 1945 eds. Kerry Brougher and Russell Ferguson, The Museum of Contemporary Art/Monacelli Press, Los Angeles, 1996

Hall, Stuart and Paddy Whannel *The Popular Arts*, Hutchinson, London, 1964

Hamilton, Richard. Retrospective Walter König, Cologne, 2003

Hand-painted Pop: American Art in Transition 1955–62 cur. Donna De Salvo, Paul Schimmel, The Museum of Contemporary Art, Los Angeles, 1992.

Hansen, Al *A Primer of Happenings & Time/Space Art*, Something Else Press, New York, 1965

happening & fluxus ed. Harald Szeemann and Hans Sohm, Kölnischer Kunstverein, Cologne, 1970

Hebdige, Dick *Subculture: The Meaning of Style*, Methuen, London, 1979

_____ 'In Poor Taste: Notes on Pop', *Block*, 8, 1983

_____ *Hiding in the Light: On Images and Things*, Routledge, London and New York, 1988

Hendricks, Jon *Fluxus Codex*, Harry N. Abrams, New York, 1988

Hess, Alan *Viva Las Vegas: After Hours Architecture*, Chronicle Books, San Francisco, 1993

Hickey, Dave *Air Guitar: Essays on Art & Democracy*, Art Issues, Los Angeles, 1997

Higgins, Dick and Wolf Vostell *Poparchitektur: Concept Art Higgins Vostell*, Droste Verlag, Düsseldorf, 1969

High & Low: Modern Art & Popular Culture ed. Kirk Varnedoe and Adam Gopnik, The Museum of Modern Art, New York, 1990

Hockney, David *David Hockney by David Hockney*, Thames & Hudson, London, 1976

Hollein, Hans and Walter Pichler *Architektur*, Galerie Nacht St. Stephan, Vienna, 1963

Hollein, Hans *Historisches Museum der Stadt Wien*, Vienna, 1995

Image in Progress Grabowski Gallery, London, 1962

In the Spirit of Fluxus ed. Elizabeth Armstrong and Joan Rothfuss, Walker Art Center, Minneapolis, 1993

Independent Group, The. Postwar Britain and the Aesthetics of Plenty ed. David Robbins, The Institute of Contemporary Arts, London/ The Museum of Contemporary Art, Los Angeles/MIT Press, Cambridge, Massachusetts, 1990. Includes texts by Lawrence Alloway, Magda Cordell McHale, Theo Crosby, Richard Hamilton, Eduardo Paolozzi, Denise Scott Brown, Alison and Peter Smithson, James Stirling

Inflatable Moment, The. Pneumatics and Protest in '68 ed. Marc Dessauce, Urban Center, New York/IFA, Paris/The Architectural League, New York, 1999

Internationale Situationniste Éditions Champ libre, Paris, 1975

Information. Joe Tilson, Peter Phillips, Allen Jones, Eduardo Paolozzi, Ronald B. Kitaj, Richard Hamilton Badischer Kunstverein, Karlsruhe, 1969

Jacquet, Alain. Oeuvres de 1951 à 1998 Musée de Picardie, Amiens, 1998

James, David E. *Allegories of Cinema: American Film in the Sixties*, Princeton University Press, Princeton, 1989

Jencks, Charles *Architecture 2000: Predictions and Methods*, Studio Vista, London/Praeger, New York, 1971

Johns, Jasper ed. Kirk Varnedoe, The Museum of Modern Art, New York, 1996

Johnson, Ellen H. 'The Image Duplicators – Lichtenstein, Rauschenberg and Warhol', *Canadian Art*, 23, January 1966

Johnson, Ray ed. Donna De Salvo, Whitney Museum of American Art, 1999

Joseph, Branden W. *Random Order: Robert Rauschenberg and the Neo-Avant-Garde*, MIT Press, Cambridge, Massachusetts, 2003

Kaprow, Allan 'The Legacy of Jackson Pollock', *ARTnews*, 57:6, October 1958

_____ *Assemblage, Environments and Happenings*, New York, 1966

_____ 'Pop Art: Past, Present and Future', *The Malahat Review*, 3, July 1967

Kellein, Thomas *Fluxus*, Thames & Hudson, London, 1995

Kitaj, R.B. Hirshhorn Museum and Sculpture Garden, Smithsonian Institution, Washington, D.C. Texts by John Ashbery, Joe Shannon, Jane Livingston

Koch, Stephen *Stargazer: Andy Warhol's World and His Films*, Praeger, New York, 1973

Koolhaas, Rem *Delirious New York: A Retroactive Manifesto for Manhattan*, Thames & Hudson, London/Oxford University Press, New York, 1978; Monacelli Press, New York, 1994 (2nd ed.)

Kozloff, Max 'Pop Culture, Metaphysical Disgust and the New Vulgarians', *Art International*, vi, 2, March 1962

Kultermann, Udo *Art-Events and Happenings*, Mathews Miller Dunbar, London, 1971

Kureishi, Hanif and Jon Savage eds., *The Faber Book of Pop*, Faber & Faber, London, 1995

LA Pop in the Sixties Newport Harbor Art Museum, Newport Beach, California, 1989

Landau, Royston *New Directions in Architecture*, Studio Vista, London/George Braziller, Inc., New York, 1968

Leacock, Richard 'For an Uncontrolled Cinema', *Film Culture*, 22-23, Summer 1961

Lebel, Jean-Jacques *Le Happening*, Éditions Denoël, Paris, 1966

Leider, Philip 'Joe Goode and the Common Object', *Artforum*, 4:7, March 1966

Lichtenstein, Roy ed. Diane Waldman, Solomon R. Guggenheim Museum, New York, 1994

Lichtenstein, Claude and Thomas Schregenberger eds., *As Found: The Discovery of the Ordinary*, Lars Müller, Baden, 2001

Lippard, Lucy R. *Pop Art*, preface by Lawrence Alloway, Thames & Hudson, London, 1966; revised 1970

Livingstone, Marco *Pop Art: A Continuing History*, Thames & Hudson, London, 1990

_____ *Pop Art UK. British Pop Art 1956-1972*, Galleria Civica di Modena, 2004

Lobel, Michael *Image Duplicator: Roy Lichtenstein and the Emergence of Pop Art*, Yale University Press, New Haven, 2002

Loran, Erle 'Cézanne and Lichtenstein: Problems of "Transformation"', *Artforum*, 2:3, September 1963

MacDonald, Scott *A Critical Cinema: Interviews with Independent Filmmakers*, 3 vols, University of California Press, Berkeley, 1988-98

McCabe, Colin *Godard: A Portrait of the Artist at 70*, Bloomsbury, London, 2003

_____ *Performance*, British Film Institute, London, 1998

McLuhan, Marshall *The Gutenberg Galaxy: The Making of Typographic Man*, University of Toronto Press, 1962

_____ *Understanding Media: The Extensions of Man*, McGraw-Hill, New York, 1964

_____ and Quentin Fiore, Jerome Agel *The Medium is the Massage*, Random House, New York, 1967

Machine as Seen at the End of the Mechanical Age, The ed. K.G. Pontus Hultén, The Museum of Modern Art, New York, 1968

Madoff, Steven Henry ed., *Pop Art: A Critical History*, University of California Press, Berkeley and Los Angeles, 1997

Mahsun, Carol A. *Pop Art and the Critics*, UMI Research Press, Ann Arbor, Michigan, 1987

_____ ed., *Pop Art: The Critical Dialogue*, UMI Research Press, Ann Arbor, Michigan, 1988

Malanga, Gerard and Andy Warhol *Screen Tests: A Diary*, Kulchur Press, New York, 1967

Marcus, Greil *Mystery Train: Images of America in Rock 'n' Roll Music*, E.P. Dutton, New York, 1975

_____ *Lipstick Traces: A Secret History of the Twentieth Century*, Harvard University Press, Cambridge, Massachusetts, 1989

_____ *Invisible Republic: Bob Dylan's Basement Tapes*, Henry Holt, New York, 1997

Marshall, Richard D. *Ed Ruscha*, Phaidon Press, London and New York, 2002

Massey, Anne *The Independent Group: Modernism and Mass Culture in Britain, 1945-1959*, Macmillan, London, 1995

Melly, George *Revolt into Style: The Pop Arts in Britain*, Penguin, Harmondsworth, Middlesex, 1972

Michelson, Annette ed., *Andy Warhol*, October Books/MIT Press, Cambridge, Massachusetts, 2001

Modern Dreams: The Rise and Fall and Rise of Pop The Institute for Contemporary Arts, The Clocktower Gallery, New York/MIT Press, Cambridge, Massachusetts, 1988. Texts by Lawrence Alloway, Reyner Banham, Judith Barry

Moos, Stanislaus von *Venturi, Scott Brown and Associates*, The Monacelli Press, New York, 1999

Morley, Malcolm. In Full Colour Hayward Gallery, London, 2001

My Country 'Tis of Thee Text by G. Nordland, Dwan Gallery, Los Angeles, 1962

Mythologies quotidiennes Musée d'art moderne de la Ville de Paris, 1964

Neo-Dada: Redefining Art 1958–62 ed. Susan Hapgood, American Federation of Arts/ Universe Publications, New York, 1995

Neue Realisten & Pop Art Akademie der Kunste, Berlin, 1964

New Forms–New Media, I Martha Jackson Gallery, New York, 1960. Texts by Lawrence Alloway, Allan Kaprow

New Painting of Common Objects Pasadena Art Museum, 1962. Text by John Coplans

New Realists Sidney Janis Gallery, New York, 1962. Texts by John Ashbery, Pierre Restany

New York Painting and Sculpture: 1940-1970 ed. Henry Geldzahler, Metropolitan Museum of Art/E.P. Dutton, New York, 1970

Nieuwe Realisten Gemeentemuseum, The Hague, 1964

Nouveaux Réalistes, Les Galleria Apollinaire, Milan, 1960. Preface by Pierre Restany

Oldenburg, Claes ed. Barbara Rose, The Museum of Modern Art, New York, 1970

Oldenburg, Claes: An Anthology Solomon R. Guggenheim Museum, New York, 1995

On the Passage of a Few People Through a Rather Brief Moment in Time: The Situationist International, 1957-1972 ed. Elizabeth Sussman, The Institute of Contemporary Art, Boston/MIT Press, Cambridge, Massachusetts, 1989. Texts by Troels Andersen, Mirella Bandini, Mark Francis, Thomas Y. Levin, Greil Marcus, Elisabeth Sussman, Peter Wollen, and Situationist anthology

Osterwold, Tilman *Pop Art*, Taschen Verlag, Cologne, 1989

Out of Actions: Between Performance and the Object, 1949-1979 ed. Paul Schimmel, The Museum of Contemporary Art, Los Angeles/Thames & Hudson, London, 1998

Paolozzi, Eduardo 'Metamorphosis of Rubbish: Mr Paolozzi Explains His Process', *The Times*, London, 2 May 1958

Paris 1960–1980 Museum Moderner Kunst, Vienna, 1982

Paris–New York Éditions du Centre Georges Pompidou, Paris, 1977. Texts by Alfred Pacquement, Pontus Hultén

Pettena, Gianni *Superstudio 1966-1982: Storie, Figure, Architettura*, Electa, Florence, 1982

Pistoletto, Michelangelo Museu d'Art Contemporani de Barcelona, 2000

Pop Art ed. Suzi Gablik and John Russell, Hayward Gallery, London, 1969

Pop Art America–Europa dalla Collezione Ludwig Forti di Belvedere, Florence, 1987

Pop Art: An International Perspective ed. Dan Cameron and Marco Livingstone, Royal Academy of Arts, London, 1991

Pop Art and the American Tradition Milwaukee Art Center, 1965

Pop Art: US/UK Connections, 1956–66 The Menil Collection, Houston, 2001

Pop Art in England: Beginnings of a New Figuration 1947–63 Kunstverein, Hamburg, 1976

Pop Art: Nieuwe figurative/Nouveau Réalisme Casino Communal, Knokke-le-Zoute, 1970. Texts by John Russell, Pierre Restany

Pop Art, Nouveau Réalisme Musée des Beaux-Arts, Brussels, 1965

Pop Art USA Oakland Art Museum, 1963. Text by John Coplans

Pop Art USA–UK Odakyu Grand Gallery, Tokyo, 1987. Texts by Lawrence Alloway, Marco Livingstone

Popular Image, The Washington Gallery of Modern Art, Washington, D.C., 1963. Text by Alan Solomon

Price, Cedric 'Fun Palace [Joan Littlewood and Cedric Price], with Frank Newby as consulting engineer and Gordon Pask as systems consultant', *Architectural Review*, January 1965

_____ feature in *Architecture d'Aujourd'hui*, December 1967

Quarmby, Arthur *Plastics and Architecture*, Praeger, New York, 1974

Quattordicesima Triennale di Milano Palazzo del'Arte al Parco, Milan, 1968

Rancillac, Bernard *Le Regard idéologique*, Éditions Somogy et Guéna, Paris, 2000

Rauschenberg, Robert: The Early 1950s ed. Walter Hopps, The Menil Collection, Houston, 1991

Rauschenberg, Robert: A Retrospective ed. Walter Hopps and Susan Davidson, Solomon R. Guggenheim Museum, New York, 1997

Raysse, Martial Galerie nationale du Jeu de Paume, Paris, 1992

Reichardt, Jasia 'Pop Art and After, *Art International*, 7, February 1963

Restany, Pierre 'Le Nouveau Réalisme à la conquête de New York', *Art International*, vii, 1, January 1963

_____ *Les Nouveaux Réalistes*, Paris, 1968, revised as *Le Nouveau Réalisme*, Paris, 1978

_____ 'Pop Art, un nouvel humanisme americain', *Aujourd'hui*, 55-56, January 1967

Richardson, John Adkins 'Dada, Camp, and the Mode Called Pop', *The Journal of Aesthetics and Art Criticism*, 24, Summer 1966

Richter, Gerhard Exhibition catalogue and catalogue raisonné, 3 vols, Kunst-und Austellungshalle der Bundesrepublik Deutschland, Bonn/Edition Cantz, Ostfildern, 1993

Rose, Barbara 'The New Realists, Neo-Dada, Le Nouveau Réalisme, Pop Art, the New Vulgarians, Common Object Painting, Know-nothing Genre', *Art International*, vii, 1, January 1963

_____ 'New York Letter: Pop Art Revisited', *Art International*, 6, December 1964

_____ 'ABC Art', *Art in America*, 53, October 1965

Rosenberg, Harold *The Anxious Object: Art Today and Its Audience*, Horizon, New York, 1964

Rosenquist, James. A Retrospective Solomon R. Guggenheim Museum, New York, 2003. Texts by Sarah Bancroft, Walter Hopps

Rotella, Mimmo. Rétrospective Musée d'art moderne et d'art contemporaine, Nice, 1999

Ruscha, Ed *Leave Any Information at the Signal: Writings, Interviews, Bits, Pages*, ed. Alexandra Schwartz, October Books/MIT Press, Cambridge, Massachusetts, 2002

Ruscha, Edward: Catalogue Raisonné of the Paintings. Volume I: 1958–1970 Gagosian Gallery, New York, Los Angeles and London/Steidl Verlag, Göttingen, 2004. Texts by Walter Hopps, Yve-Alain Bois

Russell, John 'Pop Reappraised', *Art in America*, 57, July-August 1969; see also Gablik, Suzi

Ryan, Susan Elizabeth *Robert Indiana. Figures of Speech*, Yale University Press, New Haven, 2000

Sandford, Mariellen R. ed., *Happenings and Other Acts*, Routledge, London and New York, 1995. Includes texts by Claes Oldenburg, Allan Kaprow, Jean-Jacques Lebel, Carolee Schneemann

Sandler, Irving 'New Cool Art', *Art in America*, 53, February 1965

_____ *American Art of the 1960s*, New York, 1988

Schwartz, Barry N. 'Psychedelic Art: The Artist Beyond Dreams', *Arts Magazine*, April 1968

Scott Brown, Denise 'Learning from Pop', *Casabella*, December 1971

Seckler, D.G. 'Folklore of the Banal', *Art in America*, 50, Winter 1962

Self, Colin 'Statement', *Studio International*, September 1967

Colin Self's Colin Selfs Institute of Contemporary Arts, London, 1986

Shapiro, David *Jim Dine: Painting What One Is*, Harry N. Abrams, New York, 1981

Signs of Life: Symbols in the American City cur. Denise Scott Brown in collaboration with Robert Venturi, Steven and Elizabeth Izenour, *et al.*, Renwick Gallery, National Collection of Fine Arts, Smithsonian Institution, Washington, D.C., 1976

Sitney, P. Adams *Film Culture Reader*, Praeger, New York, 1970

Sixties Art Scene in London, The ed. David Mellor, Barbican Art Gallery/Phaidon Press, London, 1993

Smith, Jack: Flaming Creature: His Amazing Life and Times ed. Edward Leffingwell, Carole Kismaric, Marvin Heiferman, The Institute for Contemporary Art/PS1 Museum, New York, 1997

Smithson, Alison and Peter *Without Rhetoric: An Architectural Aesthetic*, Latimer New Dimensions, London, 1973

_____ *The Charged Void: Architecture*, Monacelli Press, New York, 2001

Sontag, Susan 'Jack Smith's Flaming Creatures', *The Nation*, 13 April 1964; reprinted in *Against Interpretation*, Farrar, Straus & Giroux, New York, 1966

Spoerri, Daniel 'Tableau-pièges' [December 1960], *Zero*, 3, July 1961

Steinberg, Leo *Other Criteria*, Oxford University Press, 1972

Structures gonflables Musée d'art moderne de la Ville de Paris, 1968

Superstudio *Superarchittetura* [with Archizoom], Pistoia, 1966; Modena, 1967

Sylvester, David 'Art in a Coke Climate', *Sunday Times Magazine*, 26 January 1964

Taylor, Paul ed., *Post-Pop Art*, Giancarlo Politi Editore, Milan/MIT Press, Cambridge, Massachusetts, 1989. Texts by Roland Barthes, Jean Baudrillard, Andreas Huyssen, Dick Hebdige, Dan Graham, David Deitcher, Mary Anne Staniszewski

This is Tomorrow Whitechapel Art Gallery, London, 1956. Texts by Lawrence Alloway, David Lewis, Reyner Banham

This is Tomorrow Today eds. Brian Wallis and Thomas Finkelpearl, The Institute for Contemporary Art/PS1 Museum, New York, 1987

Tillim, Sidney 'Further Observations on the Pop Phenomenon', *Artforum*, 3, November 1965

Times, The Chronicle and The Observer, The ed. Douglas Blau, Kent Fine Art, New York, 1990

Tono, Yoshiaki *The Pop Image of Man*, Mizue, Tokyo, 1971

Tuchman, Phyllis 'Pop! Interviews with George Segal, Andy Warhol, Roy Lichtenstein, James

Rosenquist and Robert Indiana', *ARTnews*, lxxiii, May 1974

Vanderbeek, Stanley 'On Science Friction', *Film Culture*, 22-23, Summer 1961

Venturi, Robert *Complexity and Contradiction in Architecture*, The Museum of Modern Art, New York, 1966

_____ Denise Scott Brown, Steven Izenour *Learning from Las Vegas*, MIT Press, Cambridge, Massachusetts, 1972

Walker, John A. *Cross-overs: Art into Pop/Pop into Art*, Comedia, London, 1987

Warhol, Andy *The Philosophy of Andy Warhol*, Harcourt Brace Jovanovich, New York, 1975

_____ with Paul Hackett, *POPism: The Warhol 60s*, New York, 1980

Warhol, Andy: A Retrospective ed. Kynaston McShine, The Museum of Modern Art, New York, 1989

Warhol, Andy. Catalogue Raisonné Volume 1: Paintings and Sculptures 1961–1963 ed. Georg Frei and Neil Printz, Phaidon Press, London and New York, 2002

Warhol, Andy. Catalogue Raisonné Volume 2: Paintings and Sculptures 1964–1965 ed. Georg Frei and Neil Printz; executive editor Sally King-Nero, Phaidon Press, London and New York, 2003

Warhol, Andy. das zeichnerische Werk 1942–1962 ed. Rainer Crone, Württenbergischer Kunstverein, Stuttgart, 1976

Warhol, Andy. The Late Work ed. Mark Francis, Prestel Verlag, Munich, 2004

Warhol Look, The: Glamour, Style, Fashion eds. Mark Francis and Margery King, Bulfinch, Boston, Massachusetts, 1996

Whiteley, Nigel *Pop Design: Modernism to Mod. Theory and Design in Britain 1955-72*, Design Council, London, 1987

Whiting, Cecile *A Taste for Pop: Pop Art, Gender and Consumer Culture*, Cambridge University Press, 1997

Wolf, Sylvia *Ed Ruscha and Photography*, Whitney Museum of American Art, New York, 2004

Wollen, Peter *Raiding the Icebox: Reflections on Twentieth-Century Culture*, Indiana University Press, Bloomington, 1993

_____ *Signs and Meaning in the Cinema*, Secker & Warburg/British Film Institute, London, 1969

Youngblood, Gene *Expanded Cinema*, Studio Vista, London/E.P. Dutton, New York, 1970

INDEX

Page numbers in italics refer to illustrations

PUBLISHER'S ACKNOWLEDGEMENTS
We would like to thank all those who gave their generous permission to reproduce the listed material. Every effort has been made to secure all permissions and the editors and publisher apologize for any inadvertent errors or omissions. If notified, the publisher will endeavour to correct these at the earliest opportunity.

We would like to express our gratitude to all the artists, authors and their representatives who have contributed to the making of this volume; in particular: Sharon Avery-Fahlström, Öyvind Fahlström Archives, Museum of Contemporary Art, Barcelona; Mary Banham, London; Estate of Roland Barthes; Jean Baudrillard, Paris; Gretchen Berg, New York; Françoise Buisson, Centre Georges Pompidou, Paris; Eleanor Bron, London; Benjamin H.D. Buchloh, New York; Jacob Burckhardt, New York; Bruce Conner, San Francisco; Estate of John Coplans; Arthur C. Danto, New York; Umberto Eco, Milan; John Ferry, Estate of R. Buckminster-Fuller, Santa Barbara; Robert Frank, Gagosian Gallery, London, New York and Los Angeles, Maria Gilissen, Brussels; Dan Graham, New York; Richard Hamilton, Henley-on-Thames, England; Simon Herron; Lars Hjelmstedt, University of Uppsala, Sweden; Hans Hollein, Vienna; Dennis Hopper/Alta Light Productions, Los Angeles; Andreas Huyssen, New York; Mike Kelley, Los Angeles; William Klein, Paris; Julie Martin, Estate of Billy Klüver, New York; Greil Marcus; Jonas Mekas, Anthology Film Archives, New York; Laura Mulvey, London; Claes Oldenburg and Coosje van Bruggen, New York; Arthur Quarmby, Yorkshire (West Riding); Gerhard Richter, Cologne; Robert Rosenblum, New York; Ed Ruscha, Los Angeles; Simon Salama-Caro, New York; Sylvia Sleigh; Soraya Smithson, The Smithson Family Collection, Stamford, Lincolnshire; Joe and Jos Tilson, London; Venturi Scott Brown Associates, Los Angeles; Robert Watts Archive, New York; Matt Wrbican, Warhol Archives, The Andy Warhol Museum, Pittsburgh.

We would also like to acknowledge the following individuals and organizations: Sir Kenneth Adam, London; Albright-Knox Gallery, Buffalo, New York; Mitchell Algus Gallery, New York; Thomas Ammann Fine Art, Zurich; Anthology Film Archives, New York; Apple Corps, London; The Estate of Diane Arbus; Arman Studio, New York; ARTnews articles © 1963 & 1964 ARTnews, LLC, reprinted by permission of the publisher; David Bailey, Camera Eye Ltd, London; Becht Collection, Naarden, The Netherlands; The Boyle Family, London; Andrea Branzi, Milan; British Film Institute, London; The Estate of Rudy Burckhardt/Tibor de Nagy Gallery, New York; Canyon Cinema, San Francisco; Centre Canadien d'Architecture, Montreal; Centro de Arte Moderna, Fundação Calouste Gulbenkian, Lisbon; Christie's Images Ltd, London; 'The Rolling Stones' © 1965 Nik Cohn, reprinted by permission of International Creative Management Inc.; Magda Cordell-McHale, Buffalo, New York; Corita Art Center, Immaculate Heart Community, Los Angeles; Dennis Crompton, Archigram Archives, London. All Walt Disney Imagineering images, Walt Disney Imagineering Collection, Glendale, California © Disney Enterprises, Inc.; Disney characters © Disney Enterprises, Inc. Used by permission from Disney Enterprises, Inc. Documentation générale du Musée national d'art moderne, Centre Georges Pompidou, Paris; Friedrich Christian Flick Collection. All works by Robert Frank © Robert Frank. Fraenkel Gallery, San Francisco; Fredericks Fraser Gallery, New York; Galleria Civica d'Arte Moderna, Turin; David Geffen, Los Angeles; Howard Green Gallery, New York; Solomon R. Guggenheim Museum, New York; Hamburger Kunsthalle, Hamburg; Hirshhorn Museum and Sculpture Garden, Smithsonian Institution, Washington, D.C.; Hood Museum of Art, Dartmouth College, Hanover, New Hampshire; Indianapolis Museum of Art; IVAM: Instituto Valenciano de Arte Moderno, Valencia; Estate of Ray Johnson/Richard L. Feigen & Co., New York; 'In the Galleries: Roy Lichtenstein', 'Claes Oldenburg' © Judd Foundation/Licensed by VAGA, New York, NY; Edward Kienholz Estate/L.A. Louver Gallery, Venice, California; Michael Kohn Gallery, Los Angeles; Kunsthalle, Tübingen, Germany; Kunstmuseum, Basel; Yayoi Kusama, Tokyo; Ludwig Forum für Internationale Kunst, Aachen; Los Angeles County Museum of Art; Louisiana Museum of Modern Art, Humlebaek, Denmark; Jonathan Louwrie, London; The Estate of Ian MacDonald; Mayor Gallery, London; The Menil Collection, Houston; Robert Miller Gallery, New York; Moderna Museet, Stockholm; Musée d'art contemporain, Val de Marne/Vitry, France; Museum of Contemporary Art, Chicago; Museum Ludwig, Cologne; The Museum of Modern Art, New York; Museum Moderner Kunst Stiftung Ludwig, Vienna; Museum für Moderne Kunst, Frankfurt am Main; Musée national d'art moderne, Centre Georges Pompidou, Paris; Museum Tinguely, Basel; National Gallery of Art, Washington, D.C.; National Gallery of Canada, Ottawa; National Museum of Wales, Cardiff; S.I. Newhouse, Jr; Norfolk Contemporary Art Society/Norwich Castle Museum and Art Gallery, Norwich, Norfolk; Orange County Museum of Art, Newport Beach, California; PaceMacGill Gallery, New York; Philadelphia Museum of Art; Royal Institute of British Architects, London; RIBA Drawings Collection, Victoria & Albert Museum, London; Sammlung Frieder Burda; San Francisco Museum of Modern Art; Carolee Schneeman, New York; Kurt Schwitters Archiv, Sprengel Museum, Hannover; Sintra Museu de Arte Moderna, Sintra, Portugal; Stadt Köln, Rheinisches Bildarchiv, Cologne; Stedelijk Museum, Amsterdam; 'Notes on Camp' © 1964, 1966, renewed 1994 by Susan Sontag, reprinted by permission of Farrar, Straus and Giroux, LLC and The Random House Group Ltd; Tate, London; Galerie Daniel Varenne, Geneva; Victoria & Albert Museum, London; Virginia Museum of Fine Arts, Richmond; Yale University Art Gallery, New Haven; Walker Art Center, Minneapolis; The Andy Warhol Foundation, New York; The Andy Warhol Museum, Pittsburgh; Whitford Fine Art, London; Whitney Museum of American Art, New York; William S. Wilson, New York; 'Las Vegas [What?]' © 1965, renewed 1993 by Tom Wolfe, reprinted by permission of Farrar, Straus and Giroux, LLC; and those private collectors who wish to remain anonymous.

PHOTOGRAPHERS
Albright-Knox Art Gallery: p. 119; © Photo CNAC/MNAM Dist. RMN/© Christian Bahier/Philippe Miegeat: p. 143; Martin Bühler/Kunstmuseum, Basel: p. 65; Poul Buchard/Strüwing: p. 135; Rudy Burckhardt: pp. 108–9; 158–9 [print Jacob Burckhardt, 2004]: 161; 162–3; Prudence Cumming Associates, London: p. 125; Susan Einstein: p. 78; Allan Finkelman: p. 155 [bottom]; David Gahr: p. 70 [right]; Geoffrey Clements: p. 82 [bottom]; Sheldon C. Collins, Jnr: p. 143 [bottom]; © 1960 Allegra Fuller Snyder, courtesy Buckminster Fuller Institute, Santa Barbara, California: p. 115; Hans Hammarskiöld/Tiofoto AB, Stockholm: p. 4; Richard Hamilton: p. 19 [left; centre]; Martha Holmes/Time & Life, Inc.: p. 81; James Isberner: p. 131 [bottom]; Robert R. McElroy: pp. 80, 83; Norman McGrath: p. 177; Ian McMillan: p. 182; © Photo CNAC/MNAM Dist. RMN/© Philippe Miegeat: p. 107; © Photo SCALA, Florence/Museum of Modern Art, New York 2004: pp. 52; 124; 158–9; Billy Name-Linich, New York: pp. 29; 164; National Gallery of Canada: p. 140; Kevin Noble, p. 54; John R. Pantlin [prints RIBA Photograph Library]; Eric Pollitzer: p. 134 [top]; p. 56; Reiner Ruthenbeck: p. 134 [bottom]; Steven Sloman: p. 141; Studio Hollein/Arch. Sina Baniahmad: p. 114 [top; middle]; Rheinische Bildarchiv, Cologne: p. 168; © Photo CNAC/MNAM Dist. RMN/© Adam Rzepka: p. 82 [top]; Axel Schneider, Frankfurt: p. 150; Ed van der Elsken: p. 106; Robert Watts Studio Archive, New York: p. 126; © The Estate of Gary Winogrand, courtesy Fraenkel Gallery, San Francisco: p. 147

AUTHOR'S ACKNOWLEDGEMENTS
Many thanks first to my friend and collaborator on this project Hal Foster, and to our editor Ian Farr, whose sympathy for the subject made the process a great pleasure. Ian's wider editorial role at Phaidon was taken on by Tamsin Perrett, who very successfully brought this project to completion. Editorial assistance and caption writing was kindly provided by Kathleen Madden and Aaron Moulton. I much appreciate the tireless work done by Adam Hooper, designer, and Bill Jones, production controller at Phaidon.

Much of the research is common to the catalogue for 'Les Années Pop' which I edited for MNAM, Centre Georges Pompidou, Paris in 2001: I thank my colleagues there for their contributions which survive into the present volume: Catherine Grenier, Jean-Michel Bouhours, Chantal Beret, Susan Morgan, Martin Bethenod, Françoise Marquet, Françoise Buisson, Valérie Séguéla and Isabelle Merly. Cristina Colomar is, as always, a constant support.

My consideration of Pop in its various forms is especially indebted to Matt Braddock, Dan Graham, Richard Hamilton and Rita Donagh, Walter Hopps, Fred Hughes, Claes Oldenburg and Coosje van Bruggen, and Peter Wollen. My early enthusiasm for the subject has not diminished but been enriched by later conversations with John Cale, Marianne Faithfull, and Patti Smith. As ever, the book is dedicated to Sheena, Queen of the Jungle.

Mark Francis
London, 2005

Phaidon Press Limited
Regent's Wharf
All Saints Street
London N1 9PA

Phaidon Press Inc.
180 Varick Street
New York, NY 10014

www.phaidon.com

First published 2005
Abridged, revised and updated 2010
© 2005 Phaidon Press Limited
All works © the artists or the estates of the artists unless otherwise stated.

ISBN 978 0 7148 5663 6

A CIP catalogue record of this book is available from the Britisah Library.

Designed by Hoop Design

Printed in China

cover, Richard Hamilton
Just what is it that makes today's homes so different, so appealing?
1956 (detail)

pages 2–3, Ed Ruscha
Standard Station, Amarillo, Texas
1963

page 4, Claes Oldenburg carrying Giant Toothpaste Tube, London 1966
Photograph by Hans Hammarskiöld